ART IN A SEASON OF REVOLUTION

EARLY AMERICAN STUDIES

Daniel K. Richter and Kathleen M. Brown, Series Editors

Exploring neglected aspects of our colonial, revolutionary, and early national history and culture, Early American Studies reinterprets familiar themes and events in fresh ways. Interdisciplinary in character, and with a special emphasis on the period from about 1600 to 1850, the series is published in partnership with the McNeil Center for Early American Studies.

A complete list of books in the series is available from the publisher.

Art in a Season of Revolution

Painters, Artisans, and Patrons in Early America

MARGARETTA M. LOVELL

PENN

UNIVERSITY OF PENNSYLVANIA PRESS

Philadelphia

Copyright © 2005 University of Pennsylvania Press
All rights reserved
Printed in Canada on acid-free paper

10 9 8 7 6 5 4 3 2 1

Published by
University of Pennsylvania Press
Philadelphia, Pennsylvania 19104-4011

Library of Congress Cataloging-in-Publication Data

Lovell, Margaretta M.
 Art in a season of revolution : painters, artisans, and patrons in early America /
Margaretta M. Lovell.
 p. cm.—(Early American studies)
 Includes bibliographical references and index.
 ISBN 0-8122-3842-7 (cloth : alk. paper)
 1. Art, American—New England—18th century. 2. Art, Colonial—New England.
3. Art patronage—New England—History—18th century. 4. Art and society—
New England—History—18th century. I. Title. II. Series.

N6515.L68 2004
709.74'09033 22 2004043099

CONTENTS

PREFACE

Culture is an intricate web that people weave together every day. The assumptions they make, the actions they take, the laws they obey, the language they speak, the spaces they traverse, and the objects they use—these define the coordinates of individual and social lives. This book looks intently at the visual aspects of such dailiness in eighteenth-century New England as symptoms and as eloquent fragments of the whole. It looks at surviving objects as points of entry into the thinking that brought them into existence. It looks at design, patronage, trade patterns, education, and family with an eye to understanding the texture of living and the mainsprings of action, not on the stage of public events, but in the ordinary zones of private life. It looks at the cultural work objects effected in shaping and organizing social life. If humans spend much of their time creating order out of ambient and threatening chaos—political order, social order, economic order, spatial order—then the art object is the quintessential expression and the agent of that will-to-order, for it is a finite microcosm, a bulwark against the infinitude of possibilities and instabilities the flow of time creates. A drawing of a town plan, a house façade, a chest of drawers, a portrait, each uses a language of symmetry, mimicry, visual rhyme, visual quotation, to suggest wholeness and completion and referentiality in a world which daily evidences disorder, incompletion, and the unraveling of yesterday's solutions.

The origins of this book go back to my qualifying exams. Being allowed to present a course as one of the arenas of interrogation, I designed "American Material Culture: A Theory of Objects" on the premise that museum collections, whole buildings, in fact the townplan and city itself could be, for a cultural historian, as important, as valuable, and as instructive a locus of inquiry as a laboratory is to a scientist. I had in mind a kind of scholarship somewhat unlike that which I had been taught in my studies in art history, archaeology, literary criticism, American studies, and history although it drew on all those fields, their generative theories, and working methods.

Subsequently, the kinds of questions I find myself pursuing often start with objects and the problem of their legibility. The past is a silent place but it is a highly visual place: the town plan of New Haven, the cityscapes of Newport, Rhode Island, the American Wing at the Metropolitan—in such places we can see and feel the past in British North America, its scale, its usages, its trading partners, its visual vocabularies, and its rules of precedence and deference. And we can see what intervening generations have decided (and chance has determined) will be the residue of that past to survive for us to scrutinize. But historians might ask—indeed have asked—is that a past that *matters*? It does, I would propose, when the questions pertain to the unvoiced premises of culture, to the qualities of quotidian experience, and to continuities across time and space. The historian's sub-

ject, we are told, is change, and the historian's search for evidence follows the "least/best rule," that is: gather the least amount of the best evidence to construct a convincing argument about an issue of significance. Using objects complicates this project, not in the least because it is so difficult to build a "toolbox" to read them, for they are both self-evident and deeply coded. Read carefully, they can tell us both what the makers (and their patrons, inhabitants, and users) intended them to "say" and what they reveal unbeknownst. Objects, I take as my premise, are like Freud's dreams: vivid, seemingly intellectually inconsequential, but to the patient observer, full of eloquence and import. They can meet the "best" evidence rule. Objects can tell us things about which the written record is silent, or about which the written record deliberately obfuscates. They can enrich our understanding of identity-construction, the consumer revolution, patriarchy, and memory-construction among early Americans. Objects can point to systems of education and knowledge-construction among the builders, painters, and artisans whose skills realized in concrete form abstract ideologies as well as useful things. It is my hope that this book will give some indication of the pleasures, the methods, and the payoffs of using objects as historical evidence.

In looking at and thinking about the matters that are the subject of this volume I have not been alone—many others have played the parts of ally, straight man, and devil's advocate. Of all the pleasures attendant on writing this book, the opportunity to thank the many people whose wisdom, knowledge, patience, and good will contributed to my thinking and writing is one of the most satisfying.

It would have been impossible to think through these ideas without the attentive reading and extraordinarily helpful conversations with a wide circle of friends and colleagues. Many kindly responded to drafts put in their hands. Although I have not always been able to resolve the difficulties and omissions they have pointed out, the text is, in the whole and in its parts, stronger and more readable for their invaluable advice. Those who have generously read and commented on drafts of individual chapters (and in some cases, groups of chapters) include Michele Bogart, Derrick Cartwright, Nancy Cott, Pat Crown, Paul Groth, Patricia Hills, Richard Hutson, Joseph Koerner, Louise Lippincott, Kathleen Moran, Louise Mozingo, Jules D. Prown, Mary Ryan, Christine Rosen, Marc Simpson, Paul Staiti, Roger Stein, Laurel Thatcher Ulrich, Dell Upton, and Bryan Wolf. Those who read and commented helpfully on the whole draft manuscript include Robert Gross, Larry Levine, and Alan Wallach—their suggestions concerning tone and clarity as well as bibliography and argument have been invaluable in helping me mend and shape the book. Those most responsible for its conception and realization are Shelley Bennett and Robert Blair St. George—both have not only read drafts of the book, made numerous helpful suggestions, and provided me with encouragement when my own spirit flagged, they have also put into my hands plums from their own archives which have enriched my thinking and which they will find gratefully incor-

porated. All of these colleagues have also, in their different ways, provided me with important scholarly models.

Also essential to the development of this book have been the graduate students in the Berkeley Americanist Group, especially Carma Gorman, Linda Graham, Elizabeth Leavy, and Jessica May, who acted as research assistants on parts of this project. I am also pleased to mention here three particularly memorable mentors whose lessons, admonitions, and cautionary tales are both distant memories and still very present in my thinking: R.W.B. Lewis, Richard Young, and David Huntington. Many other important individual and collective intellectual debts, too numerous to note here, are indicated in the notes.

Providing invaluable friendship, technical assistance, insightful advice, and philosophical perspective throughout were Debra Pughe and Jon Winet. Providing extraordinary humor and models of humane forbearance were Doug and Singie Williams, who live so vividly in the eighteenth century and in the present.

Research grants from the American Council of Learned Societies, the National Endowment for the Humanities, a public agency, the University of California, Berkeley (President's Research Fellowship and Humanities Research Fellowship), and, especially, Jay D. McEvoy, Jr. (in memory of his sister, Clare McEvoy) made available essential time and resources. A grant from the McNeil Center at the University of Pennsylvania contributed to the important inclusion of color in this volume. I am most grateful for research interludes at the Rockefeller Foundation Bellagio Study Center, the Library Company of Philadelphia, the American Philosophical Society, and at the Henry E. Huntington Library and Art Gallery (especially a year there as the R. Stanton Avery Distinguished Fellow) which have been instrumental in the development of my ideas and the writing of this text. The colleagues, professional staffs, and resources at these incomparable institutions have enriched every facet of this project.

Certain aspects of the research that helped shape this volume would have been impossible without the assistance of hard-working museum professionals. I am particularly grateful to Shelley Bennett (Huntington Library and Art Gallery), Georgia Barnhill (American Antiquarian Society), Helen Fitch Emery (Wayland Historical Society), Amy Meyers (British Art Center, Yale, formerly Huntington Library and Art Gallery), Carrie Rebora (Metropolitan Museum of Art), and Rodris Roth (Smithsonian Institution). I am also indebted for their patience and professional acumen to the staffs of the Fine Arts Museums of San Francisco, Yale University Art Gallery, the North Carolina Museum of Art, and the Newport Historical Society. They have been generous with their time as well as their collections.

A general debt is also owed, and here gratefully acknowledged, to the historians, antiquarians, householders, curators, and caretakers of all kinds who have preserved the physical evidence of the past. From the intact landscape of the great Burying Ground in Newport to the dusty portraits in basements and the

sturdy chest of drawers forgotten in a barn, the material culture of the eighteenth century owes its preservation to the attention, forethoughtfulness (and sometimes the salutary neglect), of many whose names are unrecorded. Guardianship does not necessarily involve interpretation but interpretation of the material world would be impossible without resourceful guardianship.

The Artist, the Artisan, the Patron, and the Product

This book is the result of a decade-long engagement with eighteenth-century objects that had roots in a curiosity that began much earlier and extends beyond those arts I consider here—painting, drawing, architecture, and the craft of furniture-making. It is an exploration of terrain traversed by others but which, nevertheless, still defies familiarity. These chapters represent an effort to map anew some of the key aspects of the aesthetic and social dimensions of that distant cultural landscape.

In terms of scope, the focus here is on the culture of eastern-seaboard urban settlements (especially Boston and Salem in Massachusetts, and Newport in Rhode Island) seen within the larger framework of the Atlantic world. The subject necessarily also involves consideration of London and touches on the Caribbean, for eighteenth-century New England experience was conditioned and culturally bracketed by its source cultures and its markets. Colonial material culture participated in every sense in a nonsubsistence international economy, deriving ideas, pigments, conventions, and mahogany from abroad, and reexporting them (in some cases) in artists' and artisans' efforts to enlarge market opportunities and personal reputations.

Unlike some treatments of colonial artists and their products, this study is not designed to give a full or chronological account of major figures or major stylistic developments nor—despite the repeated appearance of certain figures such as John Singleton Copley—is it in any sense monographic. Rather, it focuses on a cluster of central issues: the relevance of aesthetic production to social hierarchies; the nature and conditions of artisan career trajectories; the role of replication, imitation, originality, and the real in the creation and marketing of art products; and the constituent elements in individual identity for makers, for the patrons who were their subjects, and for the creations that were their objects. In considering both paintings and decorative arts, this study departs from standard practice and resituates painters (including Copley, who protested but acknowledged the role) as artisans. Above all, this book attempts to understand the interaction of people and things (and people *as* things within portraits) in the early modern period on the periphery of the British Empire.

Since the era of the 1876 Centennial when things Anglo-colonial moved from the status of "old" or "quaint" to images and objects considered aesthetically and ideologically useful (and not, incidentally, economically valuable), scholars have sought to order and explain these works as eagerly as collectors

and museums have sought to gather and display them. The direction of most of this literature has been toward authentication, connoisseurship, biography, and descriptive formalism. This study departs from that trajectory, and from the diachronic, developmental ameliorative armature on which it is usually hung. It also resists a long tradition of filiopietistic interpretation that strives to position the art and social context of the eighteenth century as familiar and continuous with our own economic, political, ideological, and familial relations.[1] This too-comfortable vision, wedding worldly prosperity, moral virtue, and individual power with aesthetic taste, has been indirectly problematized by insightful models of visual culture and human motivation presented in recent work on eighteenth-century British art by scholars such as David Solkin, Ann Bermingham, and Marcia Pointon from whom I take—in part—my cue.[2] Similarly, the emphasis in most writing on American painters and artisans and their products emphasizes individual artistic genius and enlightened (or, recently, "refined") individual merchant patrons. These chapters do not. They situate the act of creation (of career and artistic identity as well as of individual object) and the acts of consumption within communities, specifically within the community of the extended patriarchal family. This is not to say that newer models of wage-based workshop units were absent, for, indeed, as is argued in Chapter 7, such developments and the attendant struggles between labor and management (visible in the account book of John Cahoone discussed there and most dramatically signaled by the publication of Price Lists by journeymen craftsmen, resisting the power of master craftsmen as early as 1750) were already on the horizon.[3] However, the family-based production unit and the family-based consumption unit were dominant in eighteenth-century British America. Similarly, models of solitary invention and garret studio production—familiar clichés of the artistic life in the nineteenth century—are of little use in understanding the colonial period. The application of the romantic trope of solitary genius to the production of art in eighteenth-century America is inappropriate—given the absolutely essential role that family webs performed in apprenticeship and training, marriage and business partnerships, workshop practice, patronage development, and other artistic and social structures of support. The audience for the artwork once commissioned, purchased, and brought within the domestic sphere, was also primarily the family, both in its synchronic identity as a mélange of class, caste, age, and gender-defined satellites circling around the head of household, and in its diachronic identity as abstract genetic line defined by name, inheritance, reputation, and sometimes specific real estate, through multiple generations.

Art in pre-Revolutionary America circulated within the family, in private. No public exhibitions, sales galleries, even studio visitations expanded its audience and its impact, and this fact is essential in our understanding of how it was seen by its creators, its purchasers, and its circumscribed audiences.[4] This is also the most salient fact in our project to resituate it within its era as an active participant in its culture. Social and psychological theories of class rivalry and emulative spend-

ing explicitly critiquing patrons and patronage that have been proposed recently by some scholars as correctives to the earlier filiopietistic scholarship seem equally problematic as they fail to convincingly propose systems of visual access that might trigger the envy that is key to their psychosocial readings.[5]

Art in eighteenth-century America was intimately tied to the family sphere, but it was also firmly rooted in the world of coastal, hemispherical, and global commerce. Evidence points to craftsmen and painters vigorously identifying, servicing, and promoting certain markets. This goal, however, was pursued and achieved laconically. The rich pool of art criticism and art theory that scholars of British and continental eighteenth-century art have to call on to gloss "reception" and to build rich interpretive models concerning displaced political and social public contests echoed in the canvases and material culture of their patrons, is not found in America. No newspaper articles or magazine reviews, no theory tomes, no Boswellian biographies exist. However, this dearth of verbal evidence gives us opportunity; indeed, it forces us to read the objects themselves.

In terms of method, the study offered here locates its evidence, its missing public commentary on art production and reception, primarily by interrogating the objects themselves and by triangulating from a diverse collection of primary sources—account books, maps, letters, diaries, town ordinances, novels, advertisements, surviving artifacts. It considers art objects and images using two fundamental structures or methods of inquiry: first, extended *explication de texte* of single, resonant objects, and, second, consideration of objects and images in sets, families. Whether the point of departure is a single artwork or a broad object set, this study tends not to treat these artworks as singular productions of ingenious originality as is so often the case, nor does it attempt to position them within the center-periphery model defined most eloquently by George Kubler as a cosmology of prime objects and their secondary and tertiary progeny.[6] The attempt here is to unfold a reading of the object (or the set) from within a synchronic analysis of its production and use. The project is to look at objects and images to understand culture, not to look at cultural background to better understand singular objects. Underpinning this approach is the belief that while attentive, formalist study of single objects can always offer some commentary on the process of design, production, and patronage, it is synchronic analysis moving outward from such a preliminary view of case-study objects, on the one hand, and focused attention to object sets, on the other, that can yield nuanced readings of both objects and the culture in which they are deeply embedded. Sets of objects, by the power of their reiteration, by the formulation and repetition of visual cues, tell us about culture, about shared expectations, and about visual literacies. The fact that blockfront desks, for instance (or family portraits), constituted a genre of a particular type at a particular moment within the context of a particular geography suggests that that genre had social, communicative as well as aesthetic value, and that it therefore is an indexical cultural symptom valuable to us as belated analysts of eighteenth-century

cultural systems. Objects in this model are imagined, designed, and made to resolve certain needs, problems, desires for certain class- and gender-defined purchaser-owner-users and therefore they point to those shared needs, problems, and desires.

The simple, often-repeated cliché is that these are all luxury goods evidencing, at base, economic power, acquisitiveness, pride, envy, colonialism, and a host of other invidious personal and social qualities. This is, in the end, basically an unproductive or at least, a highly limited line of reasoning, one that suggests few distinctions of interest in its haste to correct the unblinking regard of earlier writers by judging (or projecting) a vision of class-specific faulty human nature.[7] The task of this study is to look more closely and interrogatively at evidence suggesting how these objects were produced and how they were read, valued, and understood by their contemporaries in as three-dimensional a manner as possible.

The other methodological strategy used here—the outward-moving synchronic analysis of single objects—begins with these objects, not as quickly solved inquiries into making and patronage but as almost-inscrutable center points which prompt a series of ever-expanding interrogatives. In both cases—the "sets" model and the *explication de texte* model—the material-culture method used here differs from that common in art history in that it reads objects to unfold our knowledge about culture rather than reading culture to better our appreciation of singular artworks.

It is perhaps self-evident to maintain that a culture speaks through the products it calls into being (and preserves) about its governing values, interests, preoccupations, and assumptions. That object sets and thickly described individual objects comment on aesthetic values and preoccupations is self-evident, but I also propose that they comment on the use of time, the importance of memory, the value of optical (as distinct from cerebral, aural, theological) experience, the structures of economic life, and the nature of the family—that site in which they were made, contextualized, and experienced. The home was not, in the eighteenth century, the marginalized zone of consumption and leisure it has become; it was the site of production and labor for professional and merchant as well as for farmer and artisan, women, and servants. It was the realm in which, on average, eight or nine individuals of diverse age and social background spent their days and nights. Ruled by a system of precedence and deference marked physically by who sat where in what kind of chair, who had access to the desk, and who moved through the doorway first; it was ruled by permanent caste differences (women, chattel slaves), and temporary class differences (junior men, indentured servants, apprentices). The authority of the head of household was underscored in the hierarchy, symmetry, and compartmentalized clarity of its architectural container, and guarded in terms of material and sexual prizes by physical barriers and omnipresent locks.

Looking carefully at objects we can get a sense of how patriarchy was enacted, how it worked in the British colonial context. Beyond legal codes and

polemical tracts such as Robert Filmer's *Patriarcha*, everyday life was experienced in space, and experienced through visual and tactile contact with objects as well as with other people.[8] Paintings depict not only singular recognizable individuals but also ideal postures and human spatial relationships. They incorporate and prescribe appropriate roles for and relationships between men, women, and children, as well as inscribe individual identity.

The primary assumption in these chapters is that the physical world contributed to and commented on eighteenth-century American social organization in the most abstract as well as in the most concrete manner. It was instrumental in the achievement of social goals and eloquent in the maintenance of social order: portraits as much as locks point toward a daily surveillance of authority and duty. Because contemporary colonial commentary on practices governing social conventions and expectations is as thin as on art—indeed in some cases naturalized beyond comment—visual evidence is sometimes the *primary* resource available to us in our search for a cognitive map of eighteenth-century social and economic as well as spatial and kinesthetic relationships.

For different reasons and in different ways, I take as my models such disparate exemplars as those proposed by Michael Baxandall and Laurel Thatcher Ulrich. Both ask difficult questions about objects and about culture. Both seek an embedded prospect, that is, a point of view internal to the culture(s) of the objects under scrutiny. Baxandall, in "The Period Eye" section of *Limewood Sculptors* proposes that in reading objects from inside contemporary systems of vision, cultural idioms, and material culture the investigator "tests and modifies one's perception of the art, one enriches one's general visual repertory, and one gets at least some intimation of another culture's visual experience and disposition. Such excursions into alien sensibilities are a main pleasure of art."[9] In an essay on an eighteenth-century painting, he admonishes us to be attentive to whether the connection(s) being formulated between an artwork and its culture are "properly complex and specific."[10] Similarly, but with different intent, Laurel Thatcher Ulrich reminds us of the importance and value of attending to objects, of reading the "unseen technologies, interconnections, and contradictions that lie beneath audible [historic] events."[11] Both exhort us to attend to the object, even in its most microscopic (and invisible) dimensions at the same time they demonstrate the value in asking the broadest possible questions. I hope in the following chapters to keep all questions sufficiently "complex and specific" and all answers sufficiently attuned to "interconnections and contradictions that lie beneath" the audible and the visible in my project to begin to map the American eighteenth-century "commerce in goods and ideas" surrounding the making of goods and the expression of ideas.[12]

Focusing on the work of American artists and artisans in the eighteenth century, this book sets out to position both well-known painters such as John Singleton Copley and little-known artisans within systems of education, patronage, and exchange through which they moved in the creation of notable careers

and memorable objects. But it is not a text on self-fashioning or a study of singular artful objects. Rather, it strives to give equal play to the lives of the makers and to the lives of the objects they made, to study both within the interdependent social and economic webs linking local and distant populations of workers, theorists, suppliers, and patrons throughout the mercantile Atlantic. This study looks at objects and paintings in eighteenth-century British America within the framework of these thematic concerns: economic life, identity (recognizability of individuals, of goods), family (as a unit of production and as a unit of consumption), antiquity (providing models for bodies and buildings as well as governments), geography (stressing the interconnectedness of the Atlantic world), and reproduction/originality (as polarities of design). It attends to gender and class as these categories were inflected in all aspects of eighteenth-century life. The quarry is culture; the evidence is primarily art and material objects but includes primary sources of all kinds. These themes echo the concerns of those speaking and acting from within the period; they are embedded in objects and documents alike, and here they have been excavated into argument.

These chapters address, from various perspectives, a constellation of questions, questions concerning the body, the family, memory, craft practices, social practices, money and commerce, and the nature of replication, fiction and originality. In general, they focus on the conditions of production and the social functions of art and craft in urban seaboard eighteenth-century British America. The project is to map how sets of objects formed an organic part of cultural life, constituting an integral aspect of the way in which certain individuals situated themselves. While decisively beyond the means of the vast majority of the population, the objects considered here signal neither idleness nor leisure but rather the aestheticization of that deemed essential. The elite figure here not (or perhaps not only) as ideology-dispensers, sermon-writers, power-wielders, or capital-accumulators but as furnishers of their personal and family material landscapes and as patrons of artists in whose hands they placed central aspects of their identity. In these crafted objects, they become subjects of a reflexive gaze that we can begin to glimpse across the abyss of cultural and temporal distance.

In 1728 a curious debate took place in the Boston newspapers concerning the cost of living. While there was some disagreement about details, the consensus was that for an urban family of eight or nine "of a Middling Figure who bore the Character of being Genteel," £350 per annum (a sum considered beyond the reach of most) provided barely adequate income. Almost two-thirds of this amount is allocated in the proposed budget for food (a diet based on bread, milk, meat, butter, cheese, eggs, sugar, pickles, root vegetables, fruit, and small beer). Also included are house rent, firewood, candles (three a night for the whole family), shoes, materials for washing, and wages for a maid (at £10 per year). But this minimum budget did not include "Hospitality or Occasional Entertaining . . . Pocket expenses either for Horse-hire, Traveling, Convenient Recreations, Postage for letters. . . . Buying, mending or repairing Household

Stuff or Utensils [or] . . . Cloaths." Nor did it include "Nursings, Lying in, Sickness, Apothecaries, Doctors, Schooling for Children; Books, Pens, Ink & Paper; Charity Contributions; the barber, the hatter, the glover, the tobaconnist; Pictures, Plate [silver], Glass, China wares; nor anything for the tea-table, the Chocolate-Bowl, and the Punch Bowl . . . [or] a variety of other desirable tho' expensive comforts of human Life that are very common in Families of but moderate size and Rank."[13] Such an account highlights consumption priorities in urban New England during the early modern period and also makes clear the fact that "Pictures" and "Household Stuff or Utensils" were categorized with "expensive comforts" rather than with baseline necessities.

Were there no other evidence, such a tabulation would make it clear that portraits and mahogany furniture were beyond the means of families "of a Middling Figure." They were decisively beyond the means and perhaps even beyond the interest of these marginally "Genteel" Bostonians but not, I would argue, irrelevant to or beyond the concerns of society as a whole. The culture that produced the artisanal products discussed here was immensely complex and perhaps, most important, interdependent. A vast and international population of factors, sawyers, color merchants, printers, sailors, craters, bookkeepers, slaves and slavers, weavers of canvas, boilers of linseed oil, and miners of lapis lazuli was mobilized in the production and distribution of these goods. Images and objects were in every sense the products not just of proficient craftsmen servicing aesthetically acute individual patrons but of a collaborative social organism. The collapse of social normalcy and commercial networks at the outbreak of the Revolution highlights the central fact of a fragile interdependence at the core of aesthetic production. Financial means and artistic talent were still available, but supply and production links were broken. Talented artists and artisans scattered or starved, or eked out meager livings repairing hencoops. An infrastructure of multifaceted interdependence was—as its absence proved—the single critical ingredient in the production of art in eighteenth-century America. It was also, although perhaps less self-evidently, at the center of its contextualized meaning.

Painters and Their Customers

As a consumer product, a painting is eccentric. On the one hand, it resisted modern, profitable production techniques, retaining through the eighteenth, indeed the nineteenth, century the same basic materials and methods that had been established three hundred years earlier. On the other hand, by its very nature a painting partakes of exactly that kind of straw-into-gold magic that is the admiration, in fact the goal, of the modern entrepreneur. As the English theoretician and painter Jonathan Richardson put it early in the eighteenth century: "I have observ'd heretofore, that there is no Artist [artisan] whatsoever, that produces a piece of work of a value so vastly above that of the materials of Natures furnishing as the Painter does, nor consequently that can Enrich a Countrey in any Degree like Him."[1] The materials are negligible, common, and cheap; the product can be unique, soul-stirring, and immensely valuable. While there is, of course, an aesthetic dimension with economic value in all design, from the humblest earthenware teapot to the most exquisitely crafted cabinet, in a painting this ratio of aesthetic power to economic value exists in its purest form. As the value of an object is determined not only by its craftsmanship and its desirability to a wide and economically empowered audience but also by its portability, paintings suggest themselves as logical, pleasurable, liquidatable investments, retaining the virtues and associations of handcraftsmanship but participating in newer patterns of economic behavior.

It is curious, then, that while the English gentry expanded the market and the role for painting in the eighteenth century, acquiring both modern and old masterworks in a wide variety of genres for personal pleasure, social display, and active investment, their American counterparts resisted this trend.[2] Not just a result of colonial remoteness from Europe or of provincial pragmatism (indeed, Americans expended substantial fortunes on many types of luxury goods), this phenomenon suggests active choice, for painting did exist, in fact could be said to have flourished, in America during this period, although only within narrow confines. Americans bought portraits. They did not buy landscapes, still lifes, or genre scenes; they did not even branch out into portraits of horses or houses. They focused solely—but enthusiastically—on portraits of individuals, couples, and, occasionally, families. The common belief that colonists were preoccupied by utilitarian concerns of settlement and somehow failed their artists by not expanding their repertoire of art commissions (a reiterated trope in the literature and a sentiment articulated by at least one painter, John Singleton Copley, within the period) does not explain the consistent absence of one luxury good and the presence of another. Portraits, it seems, occupied a different niche in

mimetic ecology; they did not so much displace rivals as actively fulfill a specific, chronic, social need. They represented an aesthetic indulgence of a distinctive and eccentric kind.

While this ready market for portraits generated a livelihood, even wealth, for a considerable number of painters in America, it represented a meager—in fact a negative—investment opportunity for the purchaser. Its cost was high (about that of a silver tankard or a teapot, or nine weeks' wages for a skilled journeyman artisan), but, unlike the expense of a silver object or a landscape painting or even sartorial display, its cost was unrecoverable. It had virtually no resale value. A portrait was not an exchangeable investment commodity; its value was as nonfinancial as that of a tombstone. This fact is difficult to imagine today when circumstances are very different and a stunning Copley or Charles Willson Peale portrait commands the marketplace as readily as another magnificent painting. Given what we are told so often about the pragmatic nature of eighteenth-century Americans, what kind of cultural meaning can be ascribed to the acquisition of such valueless commodities by so many patrons? Why were so many so willing to spend so much to achieve—from an investment point of view—so little? And how, from the other point of view, did the artist-entrepreneur respond to this ever-expanding market? To recast the question, what economic and cultural roles did painting play in eighteenth-century British America, and how do these roles intersect with other evidence of a burgeoning consumer economy and with questions of colonial self-presentation and self-knowledge?

What then, was a portraitist selling, besides an object that was expensive, effectively useless, and, as an exchange commodity, valueless? Clearly he was selling something both abstract and deeply rooted in the culture. Because portraits are mute and enigmatic to the stranger—their function was to present the achieved self to the self and to one's immediate circle—and were judged in their own time by criteria we today cannot measure (to what extent is the image "a good likeness"?), they have received relatively little attention from scholars of American art except as a succession of stylistic exempla exhibiting successive waves of imported painterly styles or as the preferred genre of artists treated largely monographically. What were the social functions of these portraits in Atlantic America? Surely portraiture serviced a need deeper than personal vanity and more focused than a repeated hymn to the virtues of post-Renaissance individualism. Its impetus, we suspect, was also more complex and more interesting than that capsulized in the popular assumption that painters gave their subjects a better, more flattering view than the looking glass by adjusting their physiognomies closer to norms of beauty and by displaying the body in a pose and costume perhaps slightly above their station. Vanity, individualism, and flattery were not new in the eighteenth century, but wider distribution of wealth was. It seems more reasonable, therefore, to see the expanding market for portraiture in relation to family substance rather than individual virtues or vices because portraiture—even of single individuals—was fundamentally a family matter.

Beginning with painting and with the conditions of its production, this chapter sets the practice of portrait painting—the principal art form considered in this book—in eighteenth-century America within the context of the Atlantic consumer revolution, itself the subject of considerable provocative scholarship.[3] Specifically, I analyze the painting careers of John Smibert in the early eighteenth century and of John Singleton Copley in the later eighteenth century (two artists for whom we have detailed documentation, who have been the subject of substantial research, and who will figure in subsequent chapters) for the key ingredients in their professional success. Second, I compare the practice of making and selling paintings to the related but more modern market evolving in prints. How paintings (as handmade, unique, bespoke objects) and their creators fit into the economy, and how they resisted or participated in the consumer revolution rapidly evolving around them will be central concerns. On the face of it, the competing medium of engraving—with its techniques of mechanical reproduction, anonymous middleman marketing, cheap unit price, and wide spectrum of purchasers—is more obviously expressive of the new market conditions. I propose that portraiture flourished in the new economic climate not because its practices changed to create more profitable production methods (as other crafts did) but because the consumer revolution increased inheritable wealth and therefore, paradoxically, the need for portraits, an argument that is developed further in Chapter 2.

BUYING AND SELLING PORTRAITS

The relationship between wealth and portraiture was not a simple one of luxury expense requiring discretionary income but rather a more subtle one involving the movement of wealth between generations. Eighteenth-century small tradesmen and journeymen artisans were infrequent patrons of the portraitist, not because they could not afford his wares (presumably they could if they forewent other small luxuries) but because they did not *need* portraits. The need arose when there was inheritable substance, and the consecutiveness of the family line—the preservation of the "house" in the most medieval sense—was at stake.[4] For this reason, almost all private portraits were made at the time of an individual's achievement of majority, inheritance, marriage, or first issue—moments that mark the movement of family substance in an orderly, prescribed manner. Portraits, then, are documents of the family line in operation, of the rules being followed, of chaos and litigation avoided, of family acquiescence to a new order in the all-important arena of money. They are generational documents with a diachronic as well as a synchronic audience not just celebrations of personal prerogative, beauty, charm, taste, or mere acquisition. Because there was more inheritable wealth (as distinct from prosperity that earns and consumes generously but equally) in more hands with each passing decade of the eighteenth century in America, there was an ever-increasing demand for portraits.

Therefore, while they represent an established, even archaic, art form and they document the vestiges of a semifeudal sense of the family, portraits participated in the modern economy of the eighteenth century with as much energy and power as the newer revolutionary consumer products such as ceramic tablewares.

Such evidence as we have suggests that a family's portraits were hung together, often in pairs (see, for instance, figs. 55 and 56), in one of the principal downstairs rooms.[5] Here, we can assume, they were observed by social and business visitors, but more frequently and perhaps more important, by the family members themselves. As Richardson remarked in his *Essay on the Theory of Painting*, "The Picture of an absent Relation, or Friend, helps to keep up those Sentiments which frequently languish by Absence and may be instrumental to maintain, and sometimes to augment Friendship, and Paternal, Filial, and Conjugal Love, and Duty."[6] The portrait acts as a mnemonic, he suggests; it excites the bonds of affection but also, more important, those of duty. It functions, even in the physical absence of the imaged personage, to cement the social hierarchy and to remind family members of the facts of familial duty, urging a recognition of and acquiescence to authority. A group of portraits diagrams the vital statistics not just of individual existences but also of the family's more abstract and therefore more vulnerable existence. It insists on the social order within that microcosm of the state that is the family.

Portraits of public figures (and prints after them) functioned similarly but in a larger arena. They documented the victories of generals, the succession of monarchs, and the memorable remarks of divines whose prerogatives and achievements were a source of public pride and civic order. These publicly displayed oil or widely distributed print portrait images simultaneously solicited admiration, respect, and, in Richardson's terms, "duty." Unlike the individual family portraits, however, they were not commissioned by the imaged individual or that individual's kin but by government entities or publishers (a book of sermons sold better with an engraved portrait frontispiece), or they were executed as speculative ventures by printmaker-entrepreneurs who wished to tap the public interest in illustrious personages.[7]

The ever-widening market for private portraits provided opportunities for increasing numbers of artists, drawing numerous immigrant practitioners to America. They brought with them not only their training and technique but also their collections of prints, copies of old master paintings, even plaster casts of the Venus de Medici.[8] They emigrated for a number of reasons. For example, according to his epitaph, John Smibert, about whom we know more than most, "preferred [America] for health's sake." English contemporaries reported perhaps more frankly that he found the profession as it was practiced in London too nasty ("he could not well relish, the false selfish griping, overreaching ways too commonly practiz'd here") and, having taken a measure of his talent, he "was not contented here, to be on a level with some of the best painters but desir'd to be w[h]ere he might at present, be lookt on as at the top

[of] his profession."[9] For any individual there were probably a variety of complex, overlapping reasons to embark on such a venture. Whatever their rationale for emigrating, artists soon found that the American appetite for pictures, while keen, was considerably narrower than the British—focusing, as noted, solely on portraits of persons—and that talent did not ensure success or even a suitable livelihood. Being a painter in America meant not only producing but actively marketing an expensive, rather singular commodity.

Like the immigrant painters, native-born artists were also, in a sense, strangers to the communities they came to serve, and this was a key factor in the struggles of both groups to secure patronage and market their wares. America's artists were self-recruited from artisan backgrounds, while portrait purchasers—by definition members of families with inheritable substance—were overwhelmingly merchant- and gentry-class figures. America offered the artist no long-term courtly patronage; indeed, this form of support for artists and poets was virtually extinct in Europe by the mid-eighteenth century. Yet the newly established patronage forum of the public exhibition was unknown in the colonies, leaving the artist somewhat adrift, but also nominally independent, in a risky, competitive marketplace. In America, the portrait painter and the patron engaged in a contract that lasted only until the painting was finished. Typically it involved the payment of half the agreed-upon price at the time the painter accepted the commission and the balance upon satisfactory completion of the work. From the notebook of John Smibert early in the eighteenth century and the surviving accounts of John Singleton Copley late in the colonial period, it is evident that successful portraitists painted, on the average, one portrait every two weeks (although production was often faster, especially during painting tours, and occasionally much slower or intermittent).[10] The business of the artist, however, as the careers of these two best-known successful portraitists exhibit, involved more than talent, training, orderly scheduling, and self-presentation before an eager market. Hungry as they were for the product, portrait patrons evidently were reluctant to trust their pictorial immortality to any but an artist who would be as sensitive to class-defined body language, fashion, and taste as they. The artist had to present himself as one of their own; for the portraitist, living like a gentleman was not just the reward of success but also the criterion of success.

Louise Lippincott, in her remarkable analysis of the account book of the successful London portraitist Arthur Pond, has chronicled in detail the complex ingredients of the carefully constructed reputation of this painter, printmaker, and dealer who was correspondent and supplier to Smibert in Boston.[11] We can see both Smibert and Copley using many of the same strategies for securing and publicizing the accoutrements of gentility and the aura of skill, taste, and success. Smibert, the son of a Scottish wool dyer, brought with him from Europe prints, copies of old master paintings, plaster casts after the antique, a reputation garnered in a short but successful portrait career in London, and, as

we will see in some detail in Chapter 6, association with George Berkeley's proposed New World university. Copley, however, was a tobacco seller's son from Long Wharf in Boston. His stepfather, the mezzotint engraver Peter Pelham, was probably the key figure not only in his choice of vocation and early art education but also in his acquisition of the arts of gentility, for Pelham ran, among other enterprises, a finishing school for young gentry, and his lessons surely were not lost on the adolescent Copley.[12] Perhaps more important, both Smibert and Copley married well, that is, not only to their great financial advantage but also to the advantage of their continued professional rise. Smibert's father-in-law built him a house, studio, and shop; Copley's marriage resulted in his purchase of twenty acres on Beacon Hill, a choice property adjoining that of the immensely wealthy Hancock family.[13] At least in part because their homes were their places of business, these artists lived well. Smibert's inventory, taken in 1752, is that of a wealthy gentleman, and exhibits—with its silver-hilted sword, five looking glasses, forty-six chairs, and substantial real estate—a fivefold increase in luxury goods over the quite-substantial furnishings with which he had equipped his London studio and dwelling three decades before.[14] Unlike post-romantic artists, who deliberately position themselves outside the establishment, creating works for an unknown speculative market with the assistance of merchant middlemen, eighteenth-century painters accepted and executed projects directly from and for the patron group in the very personal area of the portrait commission and therefore, necessarily, assumed the guise of the client group.

Although, in general, the market for portraits was always good, even the successful portraitist-entrepreneur had a chronic problem: he had no repeat customers. Even Copley, whose genius was as apparent to his contemporaries as to subsequent generations, had only a 10 percent return rate for sitters.[15] Because portraits marked decisive moments in an individual's assumption of new roles in the family line (most often marriage), only one was needed in a lifetime. If subsequent portraits were called for, the new commission almost always went to a different artist for variety.[16] Because it behooved the artist to act like a gentleman as well as live like one, he charged his customers not in pounds but in guineas, the medium of exchange among gentry and professionals, but he suffered the disadvantage of necessary public reticence. Both Smibert and Copley, for instance, eschewed advertising their availability as portraitists in the newspapers, although they did advertise for a runaway slave and for non-painting offerings of other merchandise such as prints. Some American artists advertised their portrait skills, but London artists did not, and the more upscale American artists did not.[17] Nor—with the conspicuous exception of William Hogarth—did portraitists hang out shop signs. Consequently, their need for a new circle of customers was chronic, but their guise as gentlemen working with gentry inhibited the more public announcements of availability. Instead, they depended on word of mouth or, in both the gentlemanly and artistic sense, reputation. And this went far, especially within the basic structure in which and

for which portraiture flourished: the family. Bound by ties of interest, money, and genuine affection, eighteenth-century families were strong vehicles for the transmission of ideas, behavior, and goods, and so it is no surprise that we find strong kinship ties in the patron lists of portraitists. In his exhaustive study of Copley's patrons, Jules David Prown noted that 80 percent of Copley's patrons over a quarter of a century fit onto just twenty-eight family trees.[18] This is not just evidence of the close-knit nature of colonial wealth and power but also an indication of the lines along which that amorphous but instrumental quality known as reputation flowed, a subject that will be explored in Chapter 3.

While most scholars of American eighteenth-century painting are dismayed to find evidence of artists engaged in activities that drew them away from full-time painter status and see this as evidence of an inhospitable environment for art, one might better see these activities as conscious and useful forays into potential new customer groups. For example, in the "colour shop" adjacent to his studio, Smibert sold prints, professional equipment, and materials for amateurs, such as fan paper and fan mounts for the then-fashionable activity of painting fans.[19] Just as Arthur Pond's drawing lessons for women amateurs gave him entrée into court circles, resulting in portrait commissions, surely Smibert found among his print purchasers and fan enthusiasts leisured, moneyed gentlefolk who could easily note his primary offering: portraiture.[20]

Another strategy for locating new customers was the painting tour. Often interpreted by recent scholars as the plight of the itinerant hack whose hometown had few customers or whose talent was too modest to find ready buyers, the painting tour was, in fact, used by such prominent artists as Smibert, Copley, and their London counterparts to locate new customers—usually with letters of introduction and a certain number of commissions pre-secured. Although it was a nuisance, the painting tour was—in cases best documented—highly profitable.[21]

Perhaps the most effective strategy for attracting new customers was the relatively novel device of the artist's signature. In the seventeenth century, American painters did not sign their work; in the eighteenth, however, we find increasing numbers of artists signed their paintings on the painted surface clearly and systematically, usually in a lower corner where an observant visitor could note easily the name and the gentlemanly Latinate *pinx* (see fig. 21). Usually attributed to a burgeoning "pride," these signatures seem more likely to have been both guarantees of quality for the assurance of the purchaser—not unlike the silversmith's touchmark or the clockmaker's dial-imprinted name—as well as covert messages addressed to potential purchasers.[22] (An important instance of the marketing intent of artisan signatures, touchmarks, and labels is discussed in Chapter 7.) In a business that depended on personal contact, it was only logical that the eighteenth-century painter should attempt to extend his reach through whatever means appeared appropriate, profitable, and polite.

In John Smibert's notebook—a meticulous account of 175 paintings executed

in London and 241 executed in America, in which he lists dates, sitters, canvas sizes, and costs—there is a single laconic entry made late in 1738 that reads "a vew of Boston."[23] It is the only entry in which there is no notation of canvas size or price, and one could surmise that it was that vacant right column, usually so plump with guineas, that warned him not to venture again beyond the comfortable world of commissions and portraits. From the perspective of the early twenty-first century, it seems strange that Smibert did not indulge his interests and educate his patrons to this taste for landscape painting. In 1743, he confided to Arthur Pond, his fellow artist and materials supplier, "You know I was always fond of Landskips," and in his last months he wrote, "I grow old, my eyes has been some time failing me, but . . . [I am] diverting my self with somethings in the Landskip way which you know I always liked."[24] Smibert died a very wealthy man, with land, goods, and luxuries that bespeak the possibility of a discretionary use of time. Yet only these references and one landscape painting survive as testaments to his genre restlessness. His business was painting portraits, and both he and his customers were too habituated to this mode to venture into the painting of unbespoke artworks or the buying of expensive artworks they did not need, as they felt they needed portraits.

If Smibert grew wistful about his lot as a portraitist, Copley grew truculent, even rebellious. While Copley also had enough of a financial cushion to experiment with alternative genres, to educate his patrons in new aesthetic possibilities, he declined to do so, emigrating instead to England, where he knew there were established markets for a wide range of genres, and a functioning forum—the Royal Academy exhibitions—in which artists with works done speculatively could offer them to potential customers. It was not until the very end of the century that a few artists gained the confidence (or devised a forum) to offer uncommissioned paintings to a curious public in America.

BUYING AND SELLING PRINTS

While few colonial painters ventured into the realm of speculative art production, printmakers and print vendors discovered and began to exploit the market potential of anonymous retail sales from the mid-eighteenth century. By definition, a print is a multiple, and while it takes little time or money to make a single print, the investment involved in making the plate from which the prints are pulled is considerable. To be profitable, then, a print, with its modest per-item profit, must sell in volume. A few portrait prints of noted clergymen were made in America early in the eighteenth century, usually to serve as frontispieces to collections of sermons or tracts. Other prints of noted ministers were paid for by subscription. After mid-century, prints, especially mezzotints with their newly introduced velvety texture and graduated values imitative of oil paintings, were made of secular public figures as well, and increasingly as speculative ventures independent of both book publishing and the complications of subscription sales.[25]

The most successful American print ventures were related to topical figures and subjects such as the Louisbourg campaign of 1745.[26] However, even a popular issue (for example, the repeal of the Stamp Act) and the depiction of a well-known figure such as William Pitt could not ensure the financial success of Charles Willson Peale's overcomplex and slightly bathetic engraving of the notable statesman.[27] The decision to issue a print was a risky one and, like all speculation on public demand and taste, it involved the specter of loss as well as the promise of profit. Perhaps the best-known (and possibly worst-executed) eighteenth-century topical American print is the *Bloody Massacre* (fig. 1), dramatizing the incident involving the shooting of colonial citizens by British troops that had become known as the Boston Massacre; it is credited to Paul Revere but known to be plagiarized from Henry Pelham's design.[28] As Pelham admonished Revere in a letter of March 29, 1770: "after being at the great Trouble and Expence of making a design[,] paying for paper, printing, &c, [I] find myself in the most ungenerous Manner deprived, not only of any proposed Advantage, but even of the expence I have been at, as truly as if you had plundered me on the highway."[29] Revere's desire for profit here overcame his scruples. He proceeded to complete the engraving, hired Christian Remick to hand color the sheets to add drama and value to the image, and offered it to the public under his own name.[30] The fact that his reward has not been infamy but profit and fame indicates the value at which his contemporaries held entrepreneurship. Less controversial (and better executed) is Revere's print of Harvard College, discussed in Chapter 6 (see fig. 89). The innovations in the area of prints during the eighteenth century included new subjects, expanding retail audience; ad hoc commercial, informal markets; and, it seems, profits for which one might risk public censure.[31]

If the American painter's inescapable problem was the absence of repeat customers, the printmaker's was the competition of cheap and technically polished English and continental wares. Like other products of mechanical reproduction (such as textiles, buttons, and furniture brasses), European prints generally presented colonial makers with higher quality at lower cost than they could effectively challenge. One of the novel aspects of the eighteenth-century British art market, these widely available prints, especially mezzotints, usually reproduced paintings—cheaply and with reasonable accuracy—in black and white on a readily portable scale. In its volume, impersonality, and emphasis on novelty, this trade is more obviously linked to other aspects of the consumer revolution than its parent art of painting.[32] Although all kinds of artworks were reproduced in the London shops, including landscapes, views of Rome, and genre series (beginning with William Hogarth's *Harlot's Progress* in 1731), those that found the readiest market in America were images of famous personages. Unlike the artist who painted portraits on commission, the mezzotint artist or publisher who produced a print from a painting elected his own subject, and he did so in response to a sense of what would sell in a spontaneous, anonymous, ready-made, rather than bespoke, marketplace. The audience in America (as in Britain) bought

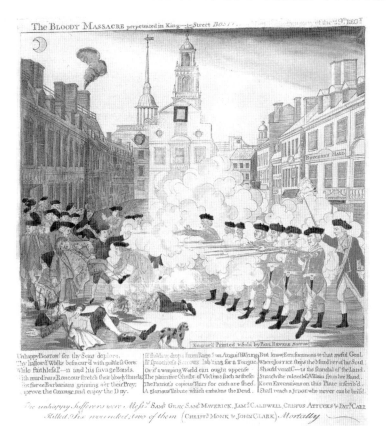

FIG. 1. Paul Revere after Henry Pelham, *Bloody Massacre*, 1770. Print. 10¾ × 9¼ in. (27.3 × 23.5 cm). Henry Francis du Pont Winterthur Museum.

prints (after paintings) of men who were illustrious by virtue of their aristocratic lineage, their prowess in the pulpit, or their military accomplishments, and they bought prints (after paintings) of women who were illustrious by virtue of their beauty (figs. 2 and 3). In purchasing such prints, the colonials were consumers not just of the specific artwork but also of the "body rhetoric" such works imaged. We can assume that many purchasers studied these prints as models in the matter of costume, pose, gesture, accoutrements, even anatomy. We know the artists did so. They frequently based entire paintings on English mezzotint sources, mimicking the attitudes and finery, even the dogs and background trees, of remote English aristocrats.[33] This "borrowed body" syndrome is one of the most interesting aspects of eighteenth-century art; it has been explained variously as timidity and self-education on the part of the colonial artist, or pseudoaristocratic ambition on the part of the sitters.[34] In fact it seems to point to the exploration and appropriation of ever-new concepts of the body by way of this novel commodity, the portrait print. For the human form and its management is as subject to fashion, signaled by patterns of emulation and change, as the clothes that adorn and display it.

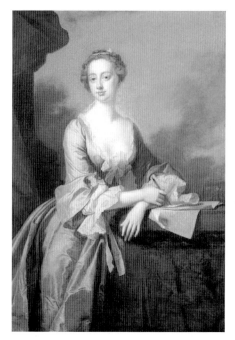 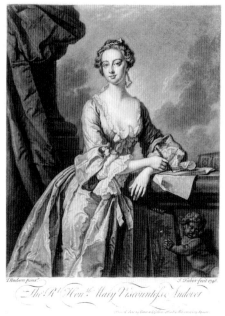

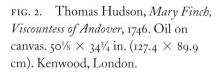

FIG. 2. Thomas Hudson, *Mary Finch, Viscountess of Andover*, 1746. Oil on canvas. 50⅛ × 34¾ in. (127.4 × 89.9 cm). Kenwood, London.

FIG. 3. John Faber, Jr., *The Right Honorable Mary Viscountess Andover*, after a portrait by Thomas Hudson, 1746. Engraving. 12¼ × 9⅞ in. (31.2 × 24 cm). Huntington Library, Art Collections, and Botanical Gardens.

It has been assumed that colonial patrons and colonial artists, eager to ape court body rhetorics used prints as props to supplement their ignorance of elite deportment codes, but, as will be argued more fully in Chapter 3, the use of prints as models for painted portraits was equally common among the most successful London artists and their most aristocratic patrons. Painters and those whose bodies they recorded availed themselves of the new plethora of print models as an easily animated medium of somatic communication. John Faber, Jr., offered *The Right Honorable Mary Viscountess Andover* after a portrait by Thomas Hudson (1746), for instance, as a "beauty," a young woman whose parentage, opportunities, talent, tutelage in grace, and most significantly, her comeliness, made her a pleasure to gaze upon, an exemplar for others well beyond the aristocratic family context in which the unique portrait would have been hung or in which the original young woman would have been viewed (see figs. 2 and 3). Her image circulated in dozens of multiples and well beyond the circle in which she would have appeared in person (it has been estimated that an eighteenth-century copper mezzotint plate could produce about four hundred prints).[35] The transfer of her attributes to canvas fixed her personhood,

and the transfer of that fixity to line, burin, and miniaturized inked imitation translated her into a generic. So even while she remains in the print highly particularized with shimmering silk skirts, graceful S-curved leaning posture, a cupid's bow mouth, smooth expansive chest, and frank direct gaze, she has also become, on paper, a type.

Because *Mary Viscountess Andover* has become a mezzotint, her image has—unlike the person or the painting—circulated uncontrollably in America, in Wales, in wherever. The paper person has become an object floating freely into that geographic and social promiscuity that marks the print as a product of a new age, as a product that garnered unto itself multiple new meanings in unexpected venues. The rich shadows and gray shades to which mezzotint lent itself so well, mimicked the qualities of three-dimensional corporeality and presence valued in the original painting. So it was a relatively simple and straightforward matter for other artists—both those in London and those in the provinces such as John Singleton Copley—to reanimate and resingularize this "beauty" by using the image—except for the face, the "likeness"—in a reconstituted but novel identity. In Copley's *Mrs. Daniel Hubbard (Mary Greene)* she is again life-size, rendered in vivid color and a unique personage seen only in the family context, yet an ocean away (see fig. 33). Prints and painted portraits—while very different kinds of images with different relations to persons and to property—nevertheless shared an entangled reciprocal relationship throughout the eighteenth century.

Although these conventionalized, print-inspired poses sometimes tell us less than they might about specific individual identities, they are solid evidence about cultural ideals and preoccupations. Mary Viscountess Andover instructs us in transatlantic standards of beauty, acceptable decolletage, and the importance of drawing as a gentry "accomplishment," for instance (a topic that will be discussed in Chapter 6). In other cases, we can see in portraits traces of body rhetorics prescribed in English deportment guides, traces that suggest fluency in courtly self-presentations (or seeming fluency) that we might not otherwise identify as colonial practice or concern. While several commentators remark on the importance of a well-rounded calf to a man's personal appearance and suggest ways of standing that will exhibit these assets appropriately, for instance, without the full-length portraits we would have little idea of the naturalizing of this posture with its descriptive side and frontal calf elevations (fig. 4). These and other conventions concerning the body and its depiction in portraiture suggest that the consumption of body language, learned and democratized through the mime of the inexpensive portrait print (and incorporated into painted portraits), was yet another, albeit abstract, commodity in the marketplace of American visual culture.

More than almost any other eighteenth-century commodity produced or sold in America, mezzotint engravings embody cultural paradox, bridging as they do disparate economic and social worlds. Imaging individuals, they were sold

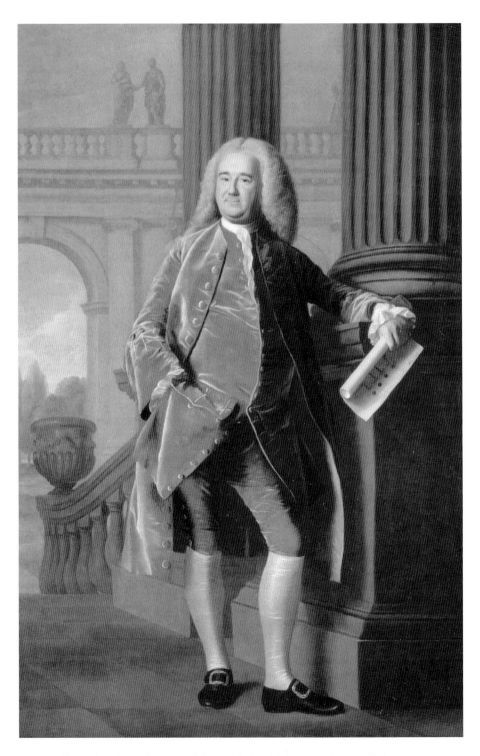

FIG. 4. John Singleton Copley, *Colonel Nathaniel Sparhawk*, 1764. Oil on canvas.
91 × 59 in. (231.14 × 149.86 cm). Museum of Fine Arts, Boston, Charles H.
Bayley Picture and Painting Fund; 1983.595. Photograph © 2003 Museum of
Fine Arts, Boston.

impersonally at booksellers; picturing aristocrats and aristocratic prerogatives, they were available to all; and asserting feudal relationships of mutual duty and obligation, they figured prominently in the rapid, cheap commodity production and exchange that characterized the ideology of capitalism. They operated both as endorsements of the status quo and as objects of democratization, injecting courtly body language and novel definitions of art into an eager and ever-broadening marketplace.

ART IN SITU

Once purchased, artworks entered the colonial home and competed in a complex ecology of two- and three-dimensional objects for visual attention and use value. From probate inventories we can get a sense of whose households included art, how those objects were described, which rooms they inhabited, and how much they were valued relative to other objects of art, craft, and use.[36] Probate inventories (taken as a matter of law on the death of a head of household to protect the interests of heirs) were usually taken by men in the same trade as the decedent and give cryptic but useful information about period terminology, household contents, assemblages of objects, and room use. Looking at a sampling of Boston inventories of the 1740–1774 period we find that while American colonials did not invest in or encourage their artists to paint landscapes, still-lifes, or emblematic works, they did purchase such subjects in inexpensive print form, and these prints were often inventoried and hung (or stored) in sets, as for instance, "The 5 Sciences . . . 4 Hunting pieces . . . and 23 India Pictures," in one merchant's house, although important prints such as William Hogarth's "1 large midnight Conversation" were sometimes named and inventoried separately (see fig. 44).[37] Prints were frequently inventoried on the walls of the principal stairwell, and in the front hallway. "At the Entrance of the Front Door" one wealthy man hung "12 Caesar's Heads Painted with Black Frames [hand-colored prints]" together with sixteen landscapes.[38] Painted portraits, however, when they appear at all, are not listed in this most public of the home's interior spaces but in a "Closet" (a small private room often used by professional men to write), or in the "Best Parlour" (a ground-floor room, often the master bedroom), as in the case of Charles Apthorp, for instance, who hung his "6 Family pictures" in his "Best Parlour." He also had a "Great Parlour" in which the probators found "4 Philosophers heads and a plate warmer 1/16/0."[39] These philosophers, promiscuously lumped with the plate warmer, were probably prints and were assigned value, whereas the "6 Family pictures" (oil portraits) in the smaller room were not.

The rare presence of artworks, especially family portraits in the possession of those of very small estates appears to signal not class pretension but class slippage. The whole estate of Captain John Chick totaled £68/14/9½ (that of Apthorp totaled £16,402/14/5), yet he died possessed of "9 mezzo[tint]s,"

"29 small pictures," "5 Pictures in Glasses" (that is, prints framed and glazed), "14 large Pictures mostly old in Black frames," and, most important for our purposes, "3 Family pieces."[40] These three family portraits—expensive but valueless residual markers of earlier wealth or an earlier wealthy generation—provide a poignant record of a household that, by mid-century was decisively on its uppers.

In a few exceptional cases, inventoried portraits were assigned monetary value. In 1740, one Bostonian died in possession of "Judge [Samuel] Sewall, Judge [Nathaniel] Byfield, & Judge [Robert] Auchmuty's Pictures 30/0/0."[41] These were unusual oil portraits, recording the faces of three of Boston's most notable public personages. These men had been painted by John Smibert who also produced several copies that he marketed like superprints, that is, original oils that were also replicas, portraits of private personages that were sold to nonfamily members.[42] Smibert charged as much for the copies as the originals, suggesting high demand, and, a decade later in the inventory, they are valued at about half the purchase price, suggesting considerable residual value. This is unusual, however. The portraits of the three judges (being public personages) were valued in 1740 at £10 each, yet a cluster of portraits left on the artist's hands at his death in 1752 were valued at less than £2 each, suggesting that the inventory-takers expected only two or three of the thirty-five to be redeemed for their contracted value.[43] In general, once commissioned, executed, and delivered (or refused and left on the painter's hands), family portraits had virtually no monetary value.

Prints, however, as noted above, tended to retain some of their value, and, as the probate inventories record, mahogany furniture was as good as money. One Bostonian in arrears on his rent paid the estate of his landlord £9/12/4 cash and "a Mohag.^y Chest of Draws, value £9" to satisfy a debt (the latter redeemable at that value if he could raise the cash within a year).[44] While our culture privileges and extracts oil painting from the interior landscapes of eighteenth-century houses as the category identified as "art" and worthy of high value, the makers and patrons of those portraits would have seen very different alignments of monetary importance. Prints were commodities, available in an anonymous market; portraits were unique, expensive bespoke goods, repositories of family value (as we will see in Chapter 4) but not of cash value. Mahogany furniture partook of the qualities of both (as we will see in Chapter 7).

By the end of the colonial period, the artist in America had two potential careers and patronage relationships from which to choose. The first was the realm of painted portraits, with its ever-widening circle of potential customers with inheritable wealth but with its limitations in genre and the solicitation of customers. Unprecedented escalation in wealth—from trade, land speculation, and production—ensured the portraitist a large and constantly growing population of potential patron families, but simultaneously circumscribed his self-presen-

tation and marketing mechanisms within somewhat archaic notions of gentil-
ity and personalized exchange. The depersonalized world of prints, however, was
independent of notions of the family—its obligations, hierarchy, and consecu-
tiveness—so intimately involved in portraiture. Prints were also unblushingly com-
mercial ventures, and even when they were portraits, emblazoning and making
public private individuals, they were, unlike painted portraits in the colonial period,
invariably signed, and (as the original of the likeness was almost certainly not
personally known by the purchaser) labeled.[45] Prints presented both the artist
and the consumer with newly discovered and rapidly exploited opportunities.
They served a mnemonic function as surely as painted portraits did, but their
message (even though many were portraits) was much less focused, more imper-
sonal, and less familial. They appealed to a wide range of political, ecclesiasti-
cal, aesthetic, even comic interests. Consumers seemed not only more willing
to expend at the modest level of prints but also were eager for the impersonal
exchange at the bookseller's or other retail outlets. Furthermore, the fact that the
images were made speculatively and were presented to the customer as ready-
made goods also seemed to concede to the print purchaser apparent control of
the exchange.

The greatest difficulty colonial printmakers negotiated was that—unlike
painters—they worked in direct competition with English and continental
printmakers whose imports found a ready market in America. For this rea-
son, the subjects that were offered by American printmakers tended to focus
on topical matters of primary concern to a wide North American audience.
Nevertheless, English printmakers early on began offering images specifically
geared toward the colonial market, electing (even when revolution threatened)
financial expediency over political allegiance, and effectively competing with
the infant colonial printmaking industry even where locals seemed to have an
advantage.

Because of the rather dramatic differences between portrait production in
oils and the print enterprise, we find that they represent alternative career paths
with little crossover—despite the fact that the eighteenth-century printmaker
almost always worked from a painting, either one already available or, more often,
one commissioned for the purpose. Copley's first known artwork was a print ven-
ture, and, as mentioned, Philadelphia's contemporary premier artist, Charles Will-
son Peale attempted to tap public sentiment with his *William Pitt*. By and
large, however, print production in America (as in Europe) was in the hands of
nonpainter specialists. The distinction was not just one of tools, technology, and
training, it was a theoretical one concerning distinctions between creation and
reproduction. The portraitist, even while imitating nature with the greatest
exactitude, was translating from three dimensions to two; the engraver (even while
imitating three dimensions) was working in two dimensions only. One impor-
tant exception to this rule of separation of trades, skills, and products is Peter
Pelham, New England's first mezzotintist and the mysterious figure who looms

as Copley's brief but most important early influence. That Pelham felt competent as a painter as well as an engraver throughout his career in Boston (and therefore could instruct the youthful Copley personally) is evident from his advertisement in the *Boston Gazette* of February 26, 1728, to produce a mezzotint of Rev. Cotton Mather "after the Original Painting after the life by the said Pelham" (now at the American Antiquarian Society), and his advertisement in the *Boston Evening Post* of October 1, 1750, to produce a series of mezzotint portraits, noting that "he has painted their Pictures for that Purpose, which Paintings may be Seen at his House." In 1737, Pelham requested and obtained the permission of Boston's Selectmen to open a school for the "Education of Children in Reading, Writing, Needlework, Dancing and the Art of painting upon Glass." Evidence suggests Pelham taught all these subjects during the period when Copley, aged ten to thirteen, shared his household. It is probable that tutelage in these skills and contact with these pupils (including, importantly, the development of potential portrait commissions through art instruction in the amateur skills of needlework and glass painting, and fluency in the body language of dancing as a kind of kinetic sculpture) proved invaluable to the precocious artist who would soon be seeking patrons.[46]

While developments in the world of art in eighteenth-century America do not present us with dramatic watersheds or remarkable moments of marketing or consuming invention and initiation, they do, on close inspection, give us some insight into new patterns of thinking and acting on the part of both the producers and purchasers of the pictorial arts. Prints, with their low cost, volume sales, and topicality, offered to an ever-widening depersonalized group of consumers a broad range of visual experiences—from reproduction of old master paintings to dignified portraits of military heroes and narrative commentary on dramatic events of the day. Painters, despite the restriction of the field to portraiture and the personalized nature of their trade, nevertheless exhibited resourceful responses to the problem of marketing themselves and their products to a willing but initially foreign and ever-new audience.

Eighteenth-century American artists evolved two distinct strategies for developing and enlarging disparate markets for these two closely related media. Printmakers allied themselves with a newer brand of consumerism, embracing the opportunities afforded by their medium's ready-made anonymous markets, unit affordability, and local topicality. Portrait painters, on the other hand changed few of the practices and strategies their counterparts had developed over three centuries, but they continued to flourish. They adopted body models from imported print sources, and began signing (and thereby "advertising" their wares); for the most part, however, they changed few of their trade's longstanding practices, confident that, as the consumer revolution brought more wealth into circulation the painter of "portraits [would] . . . always [be] in demand."[47]

Understanding the colonial portraitist's market, however, gives us only

one ingredient in recovering the ways he approached his trade. The artist's practices were also informed by specialized knowledge and theories of mimetic experience in which portraiture was understood to be a kind of magic replication, instrumental in negotiating family identity. To this aspect of practice we turn in Chapter 2.

The Picture in the Painting

Successor to Sir Joshua Reynolds as the president of the Royal Academy, Benjamin West was a major player in the British art establishment. He was also a primary figure in the development of American art during the late colonial and early national period. In 1806 West (1738–1820) painted a double portrait that includes the image of his wife, Elizabeth Shewell West (1741–1814), and of himself, the two heads inflected (as is so often the case in portraiture) toward one another (see plate I).[1] She looks out at the viewer, while the keen-eyed West, looking neither at her nor at us, rivets his gaze to the left. The work was painted in England where this pair of Philadelphians made their home. In his London studio (pictured—or imagined—in a painting known as *The American School* executed in 1765 by Matthew Pratt, Elizabeth's cousin) West—the standing figure with palette in hand—hospitably taught, advised, and, on occasion, employed three generations of aspiring American artists, including Gilbert Stuart, Charles Willson Peale, John Trumbull, Henry Benbridge, John Singleton Copley, and the artists assembled here—Pratt, among others (see plate II). They constituted a community of painters, a conscious subculture if not, in fact, a school.

Focusing on a group of portraits by West and others in his circle in the late 1760s and 1770s that contain internal portraits and self-portraits, this chapter expands on the idea of portraits as vehicles of duty and memory, as domestic objects inciting a kind of serious play with the idea of replication, and as active agents both within the immediate family sphere and within the longitudinal family line. It attends in particular to an eccentric group of portraits that, like West's *Self-Portrait*, contain internal portraits and self-portraits, and that comment on the uses of illusion and the nature of identity, replication, and portraiture. Forming a kind of bookend with Chapter 5—in which age and gender identities and relationships are foregrounded—here group portraits that include the act of painting are the focus of the artists' and hence our attention. The quest is not to see patterns of change in social ideology as we will see in Chapter 5; rather it is to get a glimpse of how artists theorized and attended to the body as a site of identity, physical presence, and memory, and to begin to get a sense of how portraitists and their audiences understood the body-turned-into-an-object to act within the context of the family in which it was hung and in which it descended. In this chapter, I propose that these artists—despite their transatlantic experience—theorized the act of painting differently than their English peers, delighting in simulation, visual puns, and illusionistic deceit. Like English practitioners, however, they understood portraits to be primarily social

agents as well as records that participated actively in power hierarchies, family obligation, and the construction of memory.

Building on the previous chapter's discussion of art in the context of its market, here I focus on the painting of portraits as a cultural practice and on the process by which a person (a body, a physiognomy, and perhaps a soul) becomes an object: an object beyond decay, change, death; an object of instruction, affection, continuity, pleasure, duty, perhaps deception; an object in which that-which-has-been can be present with that-which-is. My goal is to begin to explore how portraits of and by eighteenth-century Americans operated in the culture that produced them and how they commented on and helped to formulate that culture. This inquiry looks at self-portraiture as a special kind of play and self-commentary on the creation of illusion, and it sees that commentary positioning portraiture as a constructive fiction with serious social ends. This inquiry revolves around a series of linked, deliberately basic, questions. What is the meaning and impact of "likeness" and illusion when the object is commissioned and the subject is a human face and form? What can elaborated self-portraiture tell us about portraiture as a social practice? What, beyond the Veblenian obvious, is the relation between portraiture and wealth? How is a portrait, once commissioned, executed, paid for, and hung, understood to act on its human context? And, to pick up a question raised earlier, what does art have to do with patriarchy?

That *The American School* is about painting, especially portraiture, is a fairly straightforward reading, and one I will return to shortly. First, though, we will consider the West double portrait, known by the title *Self-Portrait*.[2] This title immediately raises questions. There is the artist's oblique gaze. Ordinarily, the mirror-generated aspect of a self-portrait gives us direct and unequivocal eye contact with the artist; in this case, he looks intently but decisively past us, excluding us from his act of self-observation. That is not the only problem, however. The absence of any reference to the second figure, West's wife, in the title seems awry until we focus on the fact that in this work she is less a "she" than an "it." She is a two-dimensional portrait within West's simulated three-dimensional studio space. The image is a self-portrait because *he* is understood to be a sentient being, whereas "she" is understood to be an object, referential but a mere simulacrum. Within the fiction of the painting, the "real" Elizabeth, her body and her being, is outside the frame, offstage to our left; we catch the trace of her location, her inferred situated self, in West's scrutinizing stare. While this is indeed a self-portrait, the act recorded in the distilled moment portrayed is the rendering of Elizabeth's, not the artist's own visage.

West's project here is notable. A search for a theory of painting among the texts left us by eighteenth-century American artists yields a thin harvest: a few letters from John Singleton Copley and some remarks by Gilbert Stuart.[3] While eighteenth-century prescriptive remarks on painting, even descriptive remarks by Americans, are rare, in such images as West's *Self-Portrait* and Pratt's *American School* we see both practice and comment on practice. Here in this group

of paintings of painters painting is to be found something like a colonial theory of painting.

In his *Self-Portrait* of 1806, West has positioned himself rather curiously, almost humbly, as a painter of domestic portraits.[4] The hierarchy of genres situated portraiture—as an aesthetic project based on the reportage of visual facts—well below history and religious painting, genres understood to be based in the realms of ideas and civic ideology, and genres that West vigorously and successfully pursued. The difference, as Reynolds in his *Discourses* clarified and codified for eighteenth-century British practitioners and patrons, was not just between the factual recording of real countenances and bodies in portraiture and the imaginative re-creation of tribal tales in history painting but between the lesser world of private life and the nobler social cement of public virtue and national ideology.

Moreover, the visual pun in which West is indulging here—his play with spatial ambiguity between two and three dimensions, between object and person—rests on the kind of baroque joke Reynolds had explicitly disdained.[5] West flies in the teeth of stricture, hierarchy, and precedent to construct a certain kind of double reading in this painting. Clearly, Mrs. West is painted with the same vibrancy, at the same scale as her husband, and she challenges us with her direct gaze; our subjectivity is acknowledged and constructed in hers. West is intent on her seeming "thereness." In this work we sense in the aging, distinguished, and urbane veteran at the pinnacle of his profession a residue of the exuberant, playful wonder that we hear best in the account of his backwoods, visually innocent contemporary, Chester Harding:

> I fell in with a portrait-painter [about 1816] . . . one of the primitive sort, . . . and was enamored at once. I got him to paint me and my wife, and thought the pictures perfection. . . . I took the pictures home, and pondered on them, and wondered how it was possible for a man to produce such wonders of art. At length my admiration began to yield to an ambition to do the same thing. I thought of it by day, and dreamed of it by night, until I was stimulated to make an attempt at painting myself. I got a board; and, with such colors as I had for use in my trade [he was a sign painter], I began a portrait of my wife. I made a thing that looked like her. The moment I saw the likeness, I became frantic with delight: it was like the discovery of a new sense; I could think of nothing else. From that time, sign-painting became odious, and was much neglected.[6]

Harding, who eventually became a polished and celebrated academic portraitist, had reached manhood without learning to read, without ever witnessing a dramatic performance, and without seeing a painting. Harding's comment on his youthful awakening to visual power and West's insistence in his 1806 double portrait on visual wit point to a firm substructure in American eighteenth- and early nineteenth-century art, to its practitioners' understanding of the raw power of illusion to draw the viewer into a state of delight and suspended dis-

belief. The successful portrait vividly, almost magically, summons the subject before the viewer's eyes.

The artist's wizardry is not the only active agent in the achievement of like-ness; the viewer is instrumental. As the philosopher David Hume wrote in 1739, "Resemblance depends on the [viewer's] memory by which we raise up the images of past perceptions. . . . Memory not only discovers the identity but also con-tributes to its production."[7] The viewer's memory, of course, is not just of the individual face captured but also of the web of social relations in which they (the human original of the image and the viewer of the image) are mutual actors.

West's double portrait, in its differential inclusion of Elizabeth as painted object and the artist as "real," prefigures that moment when he (and we) will look at the painting within the painting and know her to be chronologically, as well as situ-ationally, off stage, dead—a remembered rather than an apprehended face and being. In this sense, West's project points to a reality behind all portraiture: insofar as it images likeness and particularity it exposes the unrecoverability of the depicted moment and the soon-to-be inanimate character of the likeness's original. As such pointed prints as *Life and Death Contrasted, or an Essay on Woman* make clear, the particularity of physiognomy, costume, and gesture recorded in the portrait are inevitably subsumed into the generic and timeless condition of death (fig. 5).

FIG. 5. *Life and Death Contrasted, or an Essay on Woman*, c. 1760. Engraving, printed for Bowles & Carver, London. 9½ × 12¾ in. (24.1 × 32.4 cm). Newberry Library, Chicago.

But if West's image gestures forward in the direction of a *memento mori*—toward the inevitable personal end of the individual subject(s) pictured—it also references backward toward the mythic origins of painting. As recorded by Pliny and as re-imaged by West in an etching of 1791, the "first" artist turns away from the original and toward the subject's shadowed image which she circumscribes and renders permanent on a wall (fig. 6).[8] This turning away from the subject (in West's print) and from the object (in West's painting) mimics the artist's necessary actions in capturing the likeness on which the project of portraiture as a social practice depends. The face and the imaged face are never really interchangeable (as Oscar Wilde would have it in *Dorian Gray*), because the "original" is subject to time, but West proposes in his double portrait that they might be.

West's unusual visual pun in his *Self-Portrait* of 1806, his situating of his art-making capacity in the same universe as Harding's vernacular "likeness"-making "delight," has its counterpart in the work of a few other American painters within the orbit of West's studio during this period. West's younger contemporary and one of his many protégés, Charles Willson Peale (1741–1827), painted a portrait a decade earlier of two of his sons, known as *The Staircase Group* (fig. 7). Two life-sized figures, one equipped with the accoutrements of painting (palette, bouquet of brushes, and mahlstick) turn to face the viewer.

FIG. 6. Benjamin West, designer, *The Origin of Painting* (trade card etched by Francesco Bartolozzi for Thomas Sandby, Jr.), 1791. Etching. 9½ × 6½ in. (24.1 × 16.5 cm). Huntington Library, Art Collections and Botanical Gardens.

In a move improbable if not impossible in contemporary European practice, Peale installed the work in his gallery not in a picture frame but within a doorframe, and constructed on the bottom a wooden step below the image. We are told that no less a personage than George Washington, "as he passed it, bowed politely to the painted figures, which he afterwards acknowledged he thought were living persons," and the work was accounted a success.[9] That it was necessarily Washington, a living legend of integrity and wisdom, who was fooled by the deception is instrumental in the tale and in the culture's acknowledgment of the power of art to defy empirical experience. Art appears to have the capacity to remove its subjects from the laws by which we read visual data. In Peale's mind, it was the artist's métier and his goal to do so: "If a painter . . . paints a portrait in such perfection as to produce a perfect illusion of sight, in such perfection that the spectator believes the real person is there, that happy painter will deserve to be caressed by the greatest of mortal beings."[10] We could interpret this staircase project, its intellectual framing, and its reception as evidence of a kind of hopeless provincial naïveté. Indeed Reynolds had explicitly attributed the erroneous understanding of art as "imitation, operating by deception" to men in "a gross state of nature," such as "people taken from the banks of the Ohio."[11]

Peale's artwork-as-successful-deception might equally be seen as a calling-to-consciousness of both the artist's wondrous artistry and the audience's pleasure in recognizing a world congruent with but governed differently from that which we know through our senses. *The Staircase Group* has both an instantaneous comment to make about deception and a permanent existence as a marker of a certain epistemological stance at a certain moment. The painting is not "reflecting" any prior event or social reality; rather, it is commenting on, even actively shaping, habits of mind and ways of knowing through artfully constructed fictions that simulate with uncanny accuracy, the "real."

Peale's own direct comment on the making of portraits—"the pinning of heads to canvas," as one contemporary vividly put it—is a self-portrait in which an oval image of his wife Rachel and the figure of his daughter Angelica flank his own somber visage (fig. 8).[12] He holds a palette and cluster of brushes in his left hand while his right hand, holding a single brush, pauses between the flat surface of the palette and the flat surface of the pictured canvas. Again, in scale, coloration, treatment, and direct gaze, the face of Rachel appears to challenge its status as fiction, as flattened, inanimate object in a world of rounded, animate forms. Angelica, with an upraised finger drawing the viewer's attention to her presence and her face, appears to reach behind her father's form (attesting to the three-dimensional character of the world these two occupy) to touch the top of her father's poised brush, as though she would supplant him as the active agent in the creative process.[13] Or does she? One might equally read that third hand as Rachel's, a fixed, flat picture of a hand (her right hand, reaching across her body and curving upward to intercept the brush) as incapable of action

FIG. 7. Charles Willson Peale, *The Staircase Group (Raphaelle Peale and Titian Ramsey Peale)*, 1795. Oil on canvas. 89 × 39½ in. (226.1 × 100.3 cm). Philadelphia Museum of Art: George W. Elkins Collection.

as her painted head is incapable of will. This ambiguity, reinforced by the contrast between Peale's gravity and the impishness of his daughter, draws attention to the possibility of substitution and usurpation, as well as to the facts of artistic agency, simulation, and distinctions that do not point to difference (for, in fact, *all* the hands are painted).

FIG. 8. Charles Willson Peale, *Self-Portrait with Angelica and Portrait of Rachel Peale*, c. 1782–1785. Oil on canvas. 36 × 27¹⁄₁₆ in. (91.4 × 68.7 cm). Museum of Fine Arts, Houston; Bayou Bend Collection, Gift of Miss Ima Hogg.

While the device of a picture-within-a-painting was occasionally used in the eighteenth century to include the face of a deceased or gravely ill family member within the logic of a group portrait (as we will see shortly), this is not the case in either the Peale or West paintings discussed here. In both these instances the artist's wife was very much alive, and the immediacy of her direct address to the viewer underscores both this fact and the artist's play with her presence-absence, onstage-offstage position and with the pointed ambiguity of her status as a "real" figure or a "deception."

Thus far I have addressed Anglo-American portraiture at the end of the eighteenth century and the opening years of the nineteenth as visual experience and as pleasurable deception, a practice disapproved in English art theory but deliberately underscored in this set of what I am calling theory paintings by Americans. Peale's *Self-Portrait with Rachel and Angelica Peale*, however, complicates matters; it also comments on portraiture as social experience, as a family matter. The work incorporates a second visual pun that goes, as directly as the device of the canvas-within-the-canvas, to the problematic heart of portraiture: Peale situates himself as the active agent between a pair of similar female faces, focusing the viewer's attention on the two ways Rachel's visage can be reproduced—artistically and biologically. The replication of Rachel's features in the living lineaments of Angelica's face guarantees the mother a kind of earthly permanence different from, but operatively similar to the artist's finished canvas; both promise that an echo of her presence will outlive her body. Portraiture, then, Peale suggests, is simultaneously about likeness, magical artistic prowess, and family relations.

Likeness was the most straightforward project of portraiture and the first basis on which it was judged by contemporaries.[14] It is the empirical foundation that doomed the genre to lower status in the art hierarchy, but it is also the key to its value as mnemonic. Investing the likeness with intellectual and social meaning, then, with qualities beyond the merely observable, potentially can elevate the status of the portraiture project and create meaning beyond the delight of identity. The use of the portrait subject's face, body, deportment, expression, and accoutrements as an index of mind, character, achievements and experience, then, follows naturally.[15] Peale's painting suggests, however, that, likeness aside, even more important than investing the sitter with "character" (always problematic with female sitters) was situating the sitter within a social identity coded for class, gender, and situation within the family.[16]

Peale's and West's elaborated self-portraits are unusual paintings. By and large, when paintings occur within paintings in this period, their artifice and their role as images, as shorthand versions of larger realities and relationships, is unambiguous, as in *Mrs. Thomas Lea* by Gilbert Stuart (1755–1828), perhaps the best-known of the American portraitists tutored and encouraged by Benjamin West (fig. 9). Mrs. Lea wears a miniature painting (these were usually executed in watercolor on ivory) as a brooch. In its scale, its summary treatment of features, its location decisively within the sitter's accoutrements, it differs from the paint-

FIG. 9. Gilbert Stuart, *Sara Shippen Lea (Mrs. Thomas Lea)*, c. 1798. Oil on canvas.
29⅛ × 24 in. (73.7 × 61 cm). Collection of the Corcoran Gallery of Art,
Anonymous gift.

ings within paintings we have been considering. The comment it makes on the
role of painting is straightforward—the miniature oval of a boy performs the
function of mnemonic for Mrs. Lea in the same fashion that her full-scale image
on the wall in her home points its viewers to her face, her form, her role, and
her position within a family web.

It is no accident that Stuart's miniature portrait, the image of Peale
with his wife and daughter, and the painting of West with his wife all posi-
tion women and children as the objects of art, as images rather than beings.
More rarely we find images of men within paintings, as in the portrait of Arch-
bishop Robert Drummond included within Benjamin West's portrait of the
churchman's two sons and daughter-in-law (fig. 10). The elder Drummond,
one of West's most important patrons, died the year this group was painted
and may have been too ill to sit, but the expedient of including his visage as
a framed canvas creates an unsettling and aesthetically unsatisfactory solution.[17]
This, after all, is the family patriarch and his reduction to inert object displaces
him in scale and presence to a kind of cipher, which brings us to the gender
and power relations within the family that lie at the core of portrait practice
in the eighteenth century.

Let us return for a moment to *The American School* and to the question of links
between visual proprieties, family order, and the function of the portrait as social

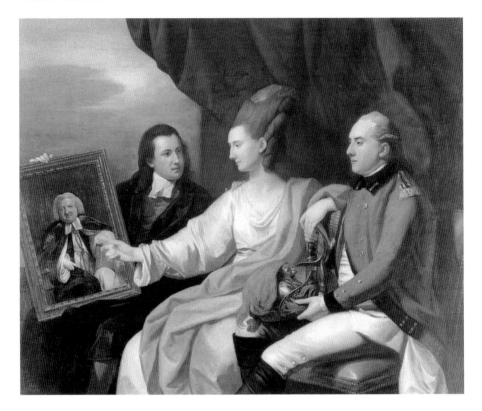

FIG. 10. Benjamin West, *Three Members of the Drummond Family*, 1776. Oil on canvas. 60 × 72 in. (152.4 × 182.9 cm). Minneapolis Institute of Arts, William Hood Dunwoody Fund.

participant (see plate II). As mentioned earlier, this ambitious work is by Matthew Pratt, seen in profile at the easel, and its subject is his wife's kinsman, Benjamin West (in the hat) mentoring a young artist on the left. This painting, more straightforwardly than any of the others considered here, is a theory painting. Susan Rather sees it as Pratt's account (derived from Continental theorists) of the appropriate education of the artist, the auspicious leadership role projected for American painters in Dean George Berkeley's prophetic "Westward the Course of Empire Takes Its Way" (published a decade earlier), and Pratt's own potential role as coequal with Benjamin West in that happy development.[18]

The work was exhibited in London with its current title, *The American School*, in 1766, and it clearly proposes for Pratt a role larger than that of the one-notable-work artist he became. On the right, we note Pratt's profile figure silhouetted against an almost-blank canvas on which we find his signature. On his palette, colors are arranged, with recent vigorous activity suggested in the blue and green pigments. These are the colors found in the costumes of the more distant pupils (suggesting Pratt's authorship of the whole canvas), as well as those found in the conventional drapery swag bracketing the upper corner of the studio canvas against which his head stands out or, read another way, onto which his head is laminated.

Ultraviolet photography of the work suggests that the outlines of a figure were painted on that now-vacant canvas, lines that their author apparently intended to be legible but that have subsequently faded to invisibility to the naked eye (fig. 11).[19] Rather interprets this partial outline (in light of the absence of a female sitter in the room) as the figure of an imagined Muse, suggesting that the newly begun project—and the practice of art in general among these artists—was history painting.

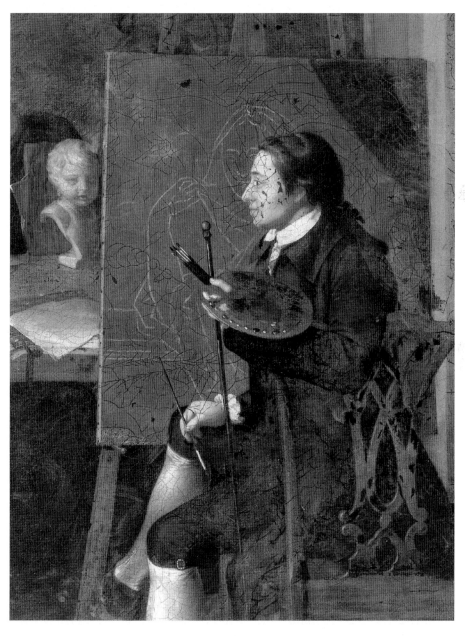

FIG. 11. Matthew Pratt, detail of *The American School*, 1765, Plate II, showing right side of the painting under ultraviolet light. Metropolitan Museum of Art, Gift of Samuel P. Avery, 1897 (97.29.3).

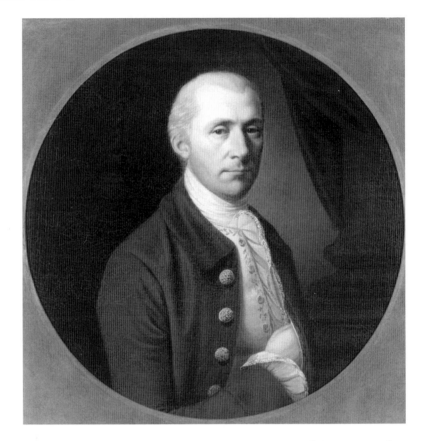

FIG. 12. Henry Benbridge, attrib., *Robert Shewell, Jr.*, c. 1775. Oil on canvas. diameter 25⅞ in. (65.7 cm). Fine Arts Museums of San Francisco, Gift of Mr. and Mrs. John D. Rockefeller, 3rd.

Given the disposition of this fugitive figure and the convention for portraits—not history paintings or allegorical works—to be set off with drapery swags, however, it is more reasonable to read these traces of white zinc pigment as the initial steps in making not an allegorical work but a portrait, one similar in scale and pose to that of Mrs. Robert Shewell, Jr. (fig. 13). Although his work and its pair, *Robert Shewell, Jr.* (fig. 12), have been attributed to Henry Benbridge, another artist in West's orbit at this time (and another cousin of Mrs. West), they may actually have been painted by the author of *The American School,* Matthew Pratt.[20] Mrs. Shewell was Pratt's cousin and the sister of Elizabeth Shewell West; in this linkage between family and patronage we see a pattern typical of eighteenth-century artistic and commercial life, a pattern explored in Chapters 3 and 7. In the spandrels of her roundel portrait hidden by the frame (see fig. 13), white and red paint outlines on a buff ground reveal initial steps similar to those recorded on the "canvas" within *The American School*. That there is no female sitter present in Pratt's group of busy artists can be explained by the painter's work on the drapery rather than on the sitter (the sitter's presence was

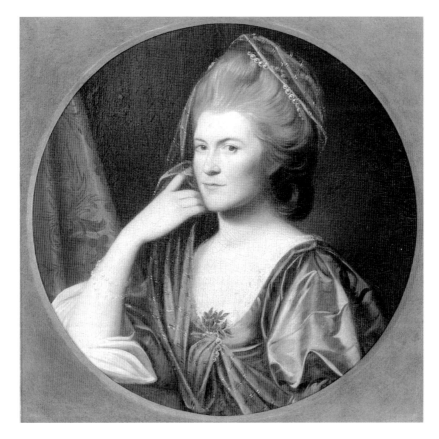

FIG. 13. Henry Benbridge, attrib., *Sarah Boyer Shewell (Mrs. Robert Shewell, Jr.)*, c. 1775. Oil on canvas. diameter 25⅞ in. (65.7 cm). Fine Arts Museums of San Francisco, Gift of Mr. and Mrs. John D. Rockefeller, 3rd.

not required, as we will see in Chapter 3, during the painting of accoutrements) and the general focus in the painted scene on stages of instruction and development in the life of the artist.

I am proposing that *The American School*—a genre scene and an assemblage of portraits—may well prescribe and endorse the traditional stages in art education from drawn copies after plaster casts to painted figures after life, but the end product is the *portrait*, complete with such visual clichés as the drapery swag. With the notable exception of John Singleton Copley, who volubly chafed (at least in his correspondence with those who devalued portraiture) at the social and aesthetic role of the portraitist, the artists West befriended and advised—including Pratt, Benbridge, Stuart, and Peale—went on, apparently happily, to careers as portraitists.[21] They were as familiar as we are with the hierarchy of genres and its bias against portraiture; indeed they must have watched West formulate, design, and execute his complex history paintings. One recalled "a gallery filled with sketches and designs for large [history] paintings—the spacious room through which I passed to the more retired atelier—the works of his

pencil surrounding me at every side—his own figure seated at his esel [*sic*], and the beautiful composition at which he was employed."[22] Yet they became portraitists. It has been presumed that their "settling" on portraiture represents a lack of ambition or talent, a surrender to expediency or to their patrons' unworthy taste. But perhaps they understood portraiture and its uses, indeed its necessity, differently than do we. Perhaps they saw it as so common, so embedded in social structures of individual, class, and family identity, that it had no need for the elaboration of theory constructed around the more obviously political and ideological (as well as potentially more profitable) project of history painting.

The fact that Pratt's *American School* was exhibited shortly after its completion—as were West's *Self-Portrait* with Elizabeth and Peale's *Staircase Group*—suggests that these paintings, despite their familial subject, were, to a degree, public statements and, therefore, potentially statements about the art of painting and the meaning of painted portraits.[23] Most obviously, exhibited portraits were statements about the artists' technical skills and availability for portrait commissions. Each of these three works is signed, indicating not that the artists took particular pride in claiming these works, but that each artist wished to communicate his identity directly to potential patrons who would note this information in the relative novelty and anonymity of the public exhibition hall.[24] As one contemporary put it, "these [exhibitions] are all for honour—there is no prophet [*sic*] arising from it. It only tends to Create a name that may hereafter produce business."[25] These three name-creating, business-enhancing works also have in common one additional characteristic—they were not commissioned and therefore they could accrue monetary value to the artists only as billboards, as mechanisms to expand patronage. They were also actors in the theater of social values, and it is in this realm that I wish to place them, as documents about the meaning of painted faces and painted bodies. That portrait painting was, to a degree, about conjuring, is clear; it provided an aura-bearing object that hovered on the threshold between personhood and objecthood. But to what end? I propose that the portrait primarily marked and negotiated critical relations within communities.

A fourth painting that seems intended at least in part as an essay on the art and practice of painting, especially portrait painting, is Charles Willson Peale's monumental *Peale Family Group* of 1773 (it is over seven feet long), perhaps the most elaborate painted text of this kind (see plate III). It was executed a few years after Peale's return to the colonies from West's London studio and includes the artist's brothers (St. George and James), his wife (Rachel), his sister (Elizabeth), his mother, and two of his children seated at a table. Peale himself, his sister Margaret Jane, and the family nurse (Peggy Durgan) stand.[26] Most obviously, "family" for Peale, and for his contemporaries, signaled a more heterogeneous group of individuals than it usually does today; not only the nuclear group of a couple and their children but also grandparents, adult siblings, even servants were incorporated easily within this elastic concept. Less obvious but equally familiar to Peale and foreign to us is the codified hierarchical order of family governance that clar-

ified the relation of each of these individuals as subordinate to, deferential to, and legally dependant on a single, male head of household who was responsible for the direction and the well-being of the whole.[27] Beyond the expanded cohabiting family unit, ties of kinship—as we have already seen in the integration of Elizabeth West's family within her husband's student and client groups—bound even larger kin networks into communities of mutual support and collective interest often through the alliance of families cemented by marriage.

In identifying this structure as "patriarchy" I do not mean the generalized pan-historic social, economic, and sexual arrangements specifically disabling to women described and critiqued eloquently by such writers as Gerda Lerner.[28] Rather, I mean more narrowly and descriptively the specific system of familial governance prevailing in British North America in the eighteenth century in which the male head of household maintained authority over and responsibilities toward females and subordinate males within the group. As a social structure it also incorporated a system of hierarchy within the household among males and among heads of households in each civic unit. I intend to point particularly here to patriarchy characterized not only by codified economic and social relations but also by physical relations diagrammed in the disposition of space, the use of furnishings, and the smallest gestures and movements of the body. Deference, subordination, and hierarchy were not just concepts and legal relations, and they were not just the marks of gender relations, they were enacted in an infinitely subtle mime show at every encounter between people—especially between males—within the household and within the community. As easy and natural as the actors in these portraits may appear, the system of family these eighteenth-century portrait subjects enact involves visual rhetorics as complex and as communicative and as capable of original but comprehensible utterance as language.

Peale's *Family Group* gathers a circle of figures before the gaze of the onlooker whose implied presence closes the ring. It also depicts a number of artworks. An oil painting in a gilt frame is suggested in the upper right, where we also find three sculptural busts Peale modeled in England: Benjamin West, Peale himself (it is reported that he used this bust as a model in the difficult task of painting his obliquely foreshortened self-portrait here), and an important British patron.[29] Behind the painted figure of Peale, a stretched canvas on an easel bears the outlines of an allegorical work in progress, and two chalk drawings—one of foliage partially rolled in Margaret Jane's hand and one of figures on which St. George labors—complete the assemblage of media and genres, unless we also include the ephemeral artwork of the carved eponymic fruit peel in the foreground. The identification of family with art, especially its production (at least three members of the household are identified here as art makers), is reiterative and central to our reading of the image.

At the center of the canvas and at the core of the family group is Rachel, who calmly anchors the composition and returns the viewer's gaze. In their role as mothers, I will argue in Chapter 5, women in this period were pictorially priv-

ileged. While the organization of the painting around Rachel's serene countenance may be an indication of Peale's personal regard, it is also characteristic of its era. Similarly, Peale's seeming reticence about his own presence (his body blocked by other figures, his face obscured by shadow) is also common in this period, while subtle markers of his patriarchal status that would have been quickly legible to his contemporaries—his hand on Rachel's shoulder, the gold frogging and buttons on his jacket—do much to reconstitute his true status in this circle. From three vantage points—the bust on the mantelpiece, the palette-wielding instructor on the left, and the unseen recorder of the scene returning Rachel's gaze—Peale and his proxies observe, surround, and control the tableau of extended family.

The Peale Family Group is a tight, well-ordered, symmetrical universe orbiting around Rachel; five figures on her right are balanced by five figures (if we count the dog Argus) on her left. The table and her shoulders are aligned with the picture plane. There are eight adults in the family group and eight mature fruits before her. The exact center of the canvas and the painting's vanishing point coincide in the patch of skin revealed at Rachel's throat. The metaphors here for harmony, linkage, and congruency—and their cognates, stability, order, permanence—resonate and reverberate. Yet there are also notes of disorder, contingency, and temporality: St. George's red erasure cloth and the fruit knife, tipping precariously over the table's edge, the peach pit and its peel evidencing if not a death certainly the disappearance of a player. These metaphors and countermetaphors signal the world as this culture strove to construct itself—ordered, stable, hierarchical, symmetrical—but they also acknowledge the world as its denizens knew it to be, liable to accident, temporality, and decay.

The Peale Family Group, then, was neither constructed to be nor understood to be the record of a single event, a "real" day or site but rather the record of that world as art can make it, a diagram of how it ought to be, and, at halcyon moments, might seem to be. Most "real" are the family members—they are described volumetrically and in color. The artworks, for all their proliferation, are monochromatic, linear, "unreal" by comparison. They belong, Peale suggests, to the realm of abstraction, in a realm beside and linked to but not to be mistaken for life. Of the three artworks in process here—the landscape, the portrait, and the allegory—only the latter two need concern us here. The landscape drawing will be touched on in Chapter 6.

Most prominent is St. George's drawing of his mother and her grandchild, an exercise and lesson in portraiture reaching across and out of the canvas. (In Charles's portrait the child gives us eye contact, in St. George's, Grandmother Peale does so.) The second is a group of drapery-clad, "classical" women in black and white "chalk" on the canvas within the painting, women who have been identified as the Three Graces and whose linked arms and hands provide a model for the Peale family's affectionate touching. Goddesses personifying charm, grace, and beauty (physical, intellectual, artistic, and moral), these celebrants were also associated with favor and gratitude for favor and, as such, in this context,

they evoke reciprocity and mutual obligation as well as benefit. When Peale returned to this canvas in 1808, his alterations included the elimination of the words "Concordia Animae" (harmony of the soul) originally painted across the Three Graces, "the design being sufficient," as he put it, "to tell the subject." That is, he felt, the relation between the abstract allegory and the concrete cluster of Peales was sufficiently clear without this verbal legend. [30]

This work has been interpreted as a record of Charles Willson Peale's personality and of his unfailing good-fellowship.[31] I would suggest instead that it is not so much recording a personal bonhomie as reiterating a familiar cultural message, one ensconced in law and normative social relations as well as architecture and painting: the well-ordered hierarchical family unit, bound by ties and recognized structures of mutual obligation and duty as much as affection, was the primary unit and the mirror of the well-ordered, peaceful, prosperous state. Order, not personality, created harmony, and the project of painting in the eighteenth century was not to record things as they are but to "teach us," as John Barrell puts it, "a way of *conceiving* of our relations to other people."[32] Peale's project was not to show methods of art instruction, to disclose his frustrated longings to paint allegories, or to record an especially warm moment in his family's history but to engage in memory-construction, to imagine and project a more generalized and naturalized prescriptive code of behavior, using his kin as exemplars.

As noted in the last chapter, the widely read eighteenth-century British theorist Jonathan Richardson reminded his audience that the object of the portrait was to "be instrumental to maintain and sometime augment Friendship, and Paternal, Filial, and Conjugal Love, and Duty."[33] This instrumental social role of the mute canvas served to remind the viewer and reiterate for his or her benefit not just bonds of affection and details of physiognomy but the more critical bonds of family duty. Mutual obligation, then, and the codified harmony it constructed at the bedrock of social order, is at the heart of the portraiture project.

Portraits were, in the eighteenth century, family matters. As noted, they were often commissioned in pairs, in which the husband and wife complement or mirror each other in pose, scale, and format. They were frequently commissioned at the time of, and mark transitions in status, especially the birth of an heir, the attainment of majority, or, most often, marriage. Death, on the other hand, was marked among families of substance not by a rectangular canvas commissioned to hang within the orthogonal envelope of the family's daily experience but by a lozenge-shaped canvas hatchment posed outside, above the front door (fig. 14). Dramatically askew to the architectural order of the structure's spatial volumes and forms, these very different products of the same colonial painters' efforts summarized in two dimensions, in the abstract language of heraldry, the identity and concrete daily enacted familial relations that had been terminated by death. No further marriages or achievements or progeny could alter the human (and hence economic) relations so diagrammed. Hatchments (a corruption of "achievements") expressed, in armorial code, the key aspects of the deceased's

lineage, honors, and relations to closest family—whether spinster or bachelor, wife, husband, second wife, and so on—and in doing so clarified not only the familial state of the deceased but also the resulting status of survivors (widower, heiress, etc.). In a society in which rights and expectations were based on familial state as well as age, gender, and wealth, such clarification before the community was not superfluous display, and such clarification within the household and economy of the family unit was equally important. It is apparent that while the issue of lineage was frequently (but not always) moot in America, the issues of inheritance, familial state, power, and honor were not and therefore this English tradition survived the Atlantic crossing.[34] Although they performed different functions, portraits and hatchments were related forms; the former was a private simulated likeness of life whereas the latter gave, in two-dimensional public code, personal and familial resumes in death. While few American painted hatchments survive, they were an important art form in the colonial period, one explicitly related to the genre of portraiture, and one we will return to in Chapter 4. In those canvases marking shifted relations among the living, paired, balanced, reciprocally inflected images of husband and wife predominate. Characteristic is the pair consisting of the portrait of Benjamin West's sister-in-law considered earlier and that of her husband, Robert Shewell, painted by either Benbridge or Pratt (see figs. 12 and 13).

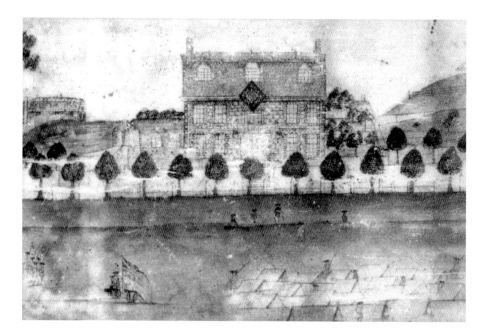

FIG. 14. Christian Remick, detail of *A Prospective View of Part of the [Boston] Commons*, 1768. Watercolor on paper. Concord Museum, Concord, Massachusetts. The painting bears a dedication to John Hancock whose house, with a hatchment over the front door, is pictured in this detail.

Today the practice of portraiture is often associated with the basest aspects of human nature—vanity, pride, an appetite for self-aggrandizement, narcissism, and attempts to claim undue status; the purported vices differ for males and females, but the specter of overweening self-love is constant in this interpretive schema. Little evidence argues that this is how painted portraits were understood in the eighteenth century. Others have proposed that eighteenth-century portraiture was about self-fashioning among competitive elites, specifically older, established merchant elites locating ways to evade the challenges of their nouveaux riches rivals. David Solkin, for instance, speaking about English (male) portraiture, sees the portrait project as primarily about style, the battlefield on which class emulation, the retreat of the elite, and visual quotation duke it out for political and social capital.[35] While I would agree that eighteenth-century Anglo-American portraits were centrally about money, I do not see them, at least among Americans, as fundamentally structuring competitive relationships among anxious patriarchs.

It is a truism that only people with discretionary money bought portraits in the colonial and early national period. However, as argued in Chapter 1, portraits were a curious kind of purchase, one that resulted in a temporary congruence between an owner and his property. And, unlike other items of expense and display—such as clothing or silver teaware, which retained commodity value after purchase—portraits cost substantial amounts but had no residual market value.[36] The burgeoning market for portraits during this period reflects the fact that more people had wealth, by which I mean inheritable substance beyond that required to sustain a household. The relation between portraits and money is not a simple matter of the rich finding yet another commodity to buy, however. Consider, for instance, Copley's monumental *Pepperrell Family* and West's *Arthur Middleton Family* (see plate IV; fig. 15). These are canvases on which more than money was expended and in which more than competitive bravura was invested. Both mark, more than any other quality, the hoped-for eventual transition of substance to an heir pictured at the dead center of both the images and the families.

As important to the portrait project as wealth was the genetic path along which it moved. The key anxiety was not which elite had the most cash or which power structures were in the ascendancy. The anxiety at the base of the patriarchal system among the wealthy was that its weakest link coincided with its greatest benefit. Around the sexual behavior of women, the culture erected complex legal, ideological, and aesthetic codes, dictating and confirming through her person the orderly transfer of wealth and power to rightful heirs.[37] Patriarchal authority expressed in legal codes, in social behavior, in architecture, and in the arrangement and form of furnishings, was also encoded in portraits where it assisted in the clarification and essentialization of potentially ambiguous, potentially contested relations, which, if unleashed, might lead to chaos, animosity, discontinuity, and aggression—those qualities so rigorously edited out of, and controlled by Peale's *Family Group* and, less obviously, all eighteenth-century portraits.

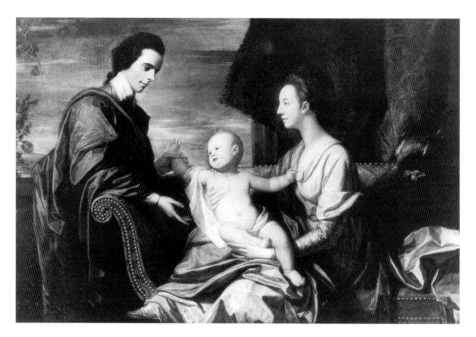

FIG. 15. Benjamin West, *Arthur Middleton, His Wife Mary (née Izard) and Their Son Henry,* 1772. Oil on canvas. 44¾ × 66 in. (113.7 × 167.6 cm). Middleton Place Foundation, Charleston, South Carolina.

With exaggeration but precision, essayist William Hazlitt critiqued the intentions of these portrait patrons: "They wish to be represented as complete abstractions of persons and property."[38] The double helix of persons and property, twining with prescribed harmony, is mapped in fixed form on these portraits. Small countermetaphors of disruption and contingency are permitted in these canvases, alluding to the accidents of nature, but the realm of ordered human relations, which these images labor to maintain, is seamless. The first job of the portrait was to depict a unique, almost magical likeness, bringing the sitter into the presence of the viewer. The second task was to situate the individual within recognizable, easily legible, and replicable codes of dress, address, and familial social order.

The commissioning and hanging of these works in the domestic setting resulted in a situation in which the patron owned his own replica, anticipating that it would in time be owned, along with the substance it represented, by his true (biological) replicas, his descendants. While the future was unpredictable to a degree, if family members dutifully maintained the order prescribed by and encoded in these works, the correct, harmonious outcome would be, as much as possible, ensured.

The primary audience for eighteenth- and early nineteenth-century portraits was neither ourselves, unknown strangers wandering in museums hundreds of years after the fact, nor the patrons' neighbors. The primary audience was the domestic circle of the participants themselves, those familiar with the sitters, their

likenesses, their foibles, their inevitably changing, aging selves, and the architectural markers (symmetry, hierarchy, and harmonious variation) that reiterated the portraits' design. The paintings remained present as mute, changeless witnesses and reminders not of a specific moment in a family's history—indeed the Pepperrell family pictured in plate IV had already lost to death the mother who forms its columnar core when the portrait group, celebrating the arrival of the heir, was painted—but of a proposed way of being, a way of understanding themselves as a family bound by invisible lines of mutual obligation and often by more affectionate ties. These paintings represent a manufactured memory but not a falsified record.

In American hands, perhaps because the practice of painting in the colonies was so singularly a matter of painting heads and families, the lower genre of portraiture began to invade the higher calling of history painting. In British theory and practice, these were exclusionary practices; the first set out private, individual instances and familial relations, while the second told tales critical to public memory. Beginning in the 1760s, however, the American expatriates West, Copley, and that pupil of both, John Trumbull, all injected portraits into history painting and succeeded by this innovation in catching the attention, and sometimes the acclaim, of those more firmly schooled in genre distinctions.[39] Why they made this move rather than reiterate the protocols of those presumed to be more knowing, is unknown, but it is reasonable to believe that they did so as a result of early schooling in that strong tradition of capturing faces—to the exclusion of all other genres—that flourished in the colonies.

Despite their subsequent training in Italy and London, these Americans retained a particular enthusiasm for the authenticity of a particular, recognizable face, for the pleasure of the artist's wondrous capacity to double that which was unique, to freeze the clock for distinct individuals destined to change and die. In the eccentric self portraits discussed here we can glimpse this group of artists theorizing their face-painting practice, consciously playing with and commenting on their extraordinary toolbox of illusion and visual deceit. In such paintings as West's *Self-Portrait* (with Elizabeth) (see plate I) and Peale's with his daughter (and with Rachel) (see fig. 8) or with his assembled family (see plate III), the artist wonders out loud, as it were, at what he can *do*. He not only casts himself as the recorder of specific truths, the ingenious creator of recognizable images that will outlive death, but he even positions himself as Pygmalion, infusing his creation with life and endowing the beloved wife-as-artwork with existence. These works also suggest a kind of self-consciousness, a kind of visual wit and irony that seems very comfortable with our postmodern habits of mind. The commissioned portraits in which they exercised these skills of duplicating the immediacy of present persons are still, in a sense, convincing. Indeed, one of the key problems in approaching eighteenth- and early nineteenth-century painting today is that we resist making it strange, distant, the borrowed property of a culture other than our own.

In portraits by the extraordinary group of Americans of the Revolutionary

generation who passed influential years in Benjamin West's London studio—Peale, Copley, and Pratt, among others—we see faces, poses, and gestures, in short, persons, who appear to be immediately accessible and straightforward. We are taken in by their apparently frank gazes, by the artists' apparent fidelity to visual facts, by our own presumption of cultural continuity. But the portrait project, as Chester Harding suggested, is a kind of wondrous deception. Portraiture deals in visual facts, but to its own ends; it is a kind of truth-telling but one that moves by indirection in its honesty. The truth it tells is a certain set of prescribed cultural truths to which we might not otherwise have access, as well as a localized physiognomic truth. Its business is, these images tell us, to displace the aura of individual beings onto an inert object with an eye to the construction of the immediate future's long-term memory. In this group of eccentric self-portraits we glimpse the awareness among these artists of their power to raise the dead, fool the living, and describe a truth that is simultaneously recognizable and invented.

Having looked generally at the position of eighteenth-century American paintings and painters within a framework of economic markets and what we can call an applied aesthetic theory of serious play invoking such terms as replication, imitation, and originality on the one hand and familial governance and harmony on the other, the next order of business is to look more closely at the social dimensions of art in the British colonial context. To this end, what follows in Chapters 3 and 4 are two case studies, focusing on exemplary portraits that allow us to parse in both micro and macro terms the relationship of portraits to individual identity, to family identity, and to empirical evidence.

The Empirical Eye

Copley's Women and the Case of the Blue Dress

While Chapter 1 broadly framed the subject of the production of art within the changing economic picture of the eighteenth century and Chapter 2 considered the role of portraiture as a kind of magic replication instrumental in negotiating family identity, Chapters 3 and 4 turn to single works of art as points of departure to explore issues concerning the fabrication of individual and family identity, the interconnectedness of the Atlantic marketplace, and the polarities of reproduction and invention in painting. This chapter looks closely at a single portrait and inquires into the circumstances—in terms of the life of the sitter, the kinship, college, business, and political links of the patron, and the education and practices of the artist—that surrounded its execution. Further, this chapter explores broader issues involving systems of representation, vision, and communication that an analysis of that painting (and others associated with it) can point us toward. This work—and Copley's work in general—is thus situated at the intersection of singular realities painstakingly replicated (face, dress, lace, shell) and the invocation of general, appropriate forms (format, body management, setting) that contemporaries would have found legible as types. Negotiated between the truth-telling "deception" of verisimilitude and a host of prescribed cultural ideals, these paintings embody disparate languages to a single coherent end. My argument attends to material culture represented in the painting as both material and metaphorical, considers the economy through which these objects moved, and examines the family relationships within which the paintings were commissioned, hung, compared, and eventually, descended.

In 1763, when Boston artist John Singleton Copley painted a portrait of Mary Turner Sargent, he was twenty-five years old and she was nineteen (see plate V). Almost life size, her youthful image appears—despite the unfamiliar setting and shimmering material world that she inhabits—immediate and present to us. A few years later Copley rendered his own visage in pastels, recording not only his features but also—in his embroidered waistcoat, silk banyan and powdered hair—his new status and confidence as *artist* in a land that was only beginning to understand the European meaning of the word (fig. 16).

They came from decidedly different worlds. He was the son of Irish immigrants (his father was a tobacco seller on the wharves) who had, with the brief tutelage of his stepfather, Peter Pelham (a London-trained engraver and painter, the son of a man who dubiously styled himself "Gentleman") learned prodigiously young how to paint and how to deport himself among the gentry.[1]

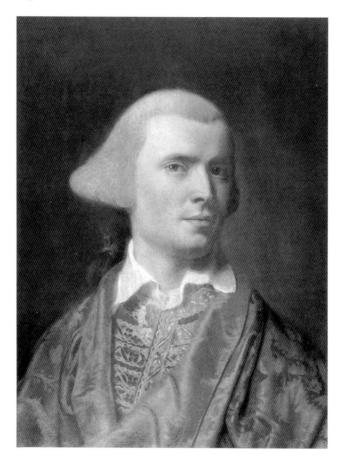

FIG. 16. John Singleton Copley, *Self-Portrait*, 1770–1771. Pastel on paper. 23⅛ × 17½ in. (58.7 × 44.5 cm). Winterthur Museum.

In the eighteenth century, as noted earlier, it was necessary for a portraitist to assume the guise of gentleman in order to pursue his profession. Succinctly put by contemporary theorist Jonathan Richardson, "As his business is chiefly with people of condition, he must think as a gentleman."[2] And, for a painter, as discussed in Chapter 1, the custom of "people of condition" was all there was—portraits being the sole genre flourishing in the colonies before the Revolution.

Copley did not balk at this artistically necessary upward mobility. In 1769, he married Susanna Farnham Clarke, a woman of established family and considerable fortune. Her mother was Elizabeth Winslow, descendant of prominent seventeenth-century merchants, artisans, and public servants, and her father was an important merchant, trading with the British East India Company. Copley recorded this family group—including his wife, children, himself, and his wife's father (Richard Clarke)—in *The Copley Family*, a work discussed in Chapter 5 (see fig. 62). It was tea consigned to Clarke that went into Boston harbor during the tumultuous event known as the Boston Tea Party. With the

assistance of his father-in-law, Copley bought considerable property on the edge of Boston Common across from the governor's house and adjacent to the mansion of John Hancock behind its allée of trees, the site visible in a watercolor made by an unskilled but eager contemporary of Copley's, Christian Remick (fig. 17). The three buildings on the left in this image, situated on twenty acres of choice land, including barns and orchards, became Copley property in a series of acquisitions beginning at the time of his marriage.[3]

The scale, location, and prominence of this property, "Copley's Hill," is clear from the map of Boston drawn by Copley's half brother, Henry Pelham, during the Revolution (fig. 18). Copley's motivation in purchasing this property and embarking on an ambitious rebuilding project (discussed in Chapter 6) was not only a desire to display the wherewithal his painting talent and his advantageous marriage had brought him and to declare his currency in the novel Italianate building forms featured in his renovations, it was also a business necessity for in the eighteenth century a householder's home was not only his residence, it was also his place of work.[4] Copley was less smartly situated when he painted Mrs. Sargent, but we may nevertheless imagine a suitably upscale site where he diligently recorded Mrs. Sargent's lineaments, her dress, and a setting suitable to both.[5] She stands before us, fresh, natural, and convincingly occupying three-dimensional space—the record of the artist's mastery and of our optical reception of

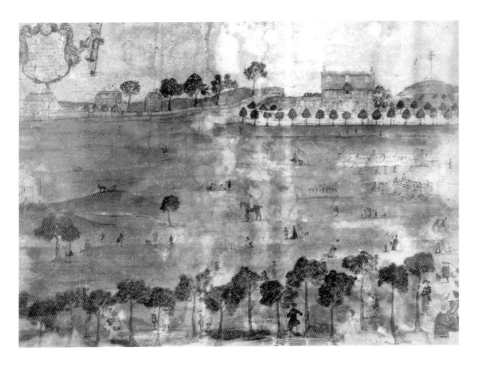

FIG. 17. Christian Remick, *A Prospective View of Part of the Commons*, 1768. Watercolor on paper. 28½ × 19½ in. (72.2 × 49.5 cm). Concord Museum, Concord, Massachusetts, Gift of John Brown, 1889, photograph by David Bohl.

an image that is arrestingly "real." Indeed, Copley has long been heralded as a realist, the first American artist to master the difficult language of Renaissance painting, convincingly rendering matter (flesh, bone structure, silk, mahogany) three dimensionally, with exactitude in simulation of those forms and features before his eyes. Many historians of American art have seen in Copley's painting the beginning of a defining three-century tradition of realism in American painting. Scholars of this school emphasize Copley's seemingly self-taught nativist artistic achievement and tend to both celebrate and identify with the artist, the patrons, and the aesthetic of "realism" in which the subjects are rendered. As Wayne Craven, for instance, puts it, these "two beautifully-matched parties— the native-born artist and his provincial mercantile patron" were guided, in his view, by the virtues and values "of industry, frugality, sobriety, and moderation." They "sought a middle course between the lower level of the dull-witted poor and the extravagances and vanities as they existed in the corrupt and immoral segments of European aristocracy," expressing their American "materialism, pragmatism, utilitarianism, and egalitarianism, . . . independence, self-sufficiency, and self-confidence" with pictorial assemblages of rich goods exhibiting an appropriate cultural Calvinism—"prosperity was a reflection of God's favor."[6]

An opposing interpretation of Copley's work downplays its realism, its replication of empirical vision, and emphasizes instead the artist's capacity to fictionalize under the guise of verisimilitude, focusing on Copley's embrace

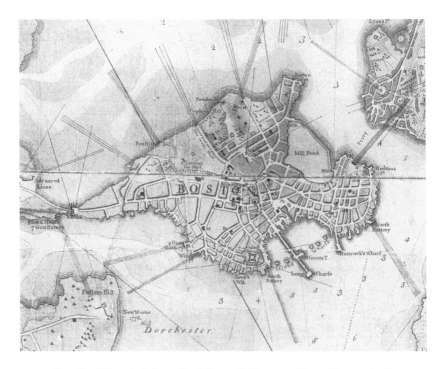

FIG. 18. Detail of Francis Jukes after Henry Pelham, *A Plan of Boston in New England with Its Environs*, 1777. Engraving. American Philosophical Society.

of artifice, imitation, and convention. These younger scholars contend that he was not, in fact, a realist—that neither the faces nor the material culture with which he equips his sitters in his portraits are records ("likenesses") of optical experience. Copley was, they propose, essentially choreographing theatrical pantomimes calculated to flatter pretentious nervous provincials. Constructing a psychosocial drama in which, to use their terms, a "conflicted" Copley was "complicit with" "insatiable" "covetous" Bostonians whose "inflated sense of self-worth" expressed "provincial anxiety" and "dreams of upward mobility," these scholars, notably Timothy Breen and Paul Staiti, vigorously distance themselves from Copley's subjects and, indeed from Copley. While the older scholars frame their discussion in terms of a judgmental moral tale in which honest Americanisms triumph over corrupt Europeanisms, these scholars invoke a moral tale in which individual vices (such as "envy") and personal neuroticisms (such as "obsession") are ascribed to a whole social class.[7] Both approaches hyperbolize morality plays of class-based virtue and vice and, in the end, tell us more about ourselves, our heroes, our politics, and our anxieties than about Copley, his paintings, and his patrons.

While the grounds of discussion and dispute appear to revolve around painterly conventions and working habits, in fact, both of these parties are arguing about what could be broadly termed the moral tone of colonial elites and Copley's position as an instrument of their self-imaging. Here I attempt to look beyond these flattened, belated, politically polarized agendas to recover the complexity of eighteenth-century visual, social, and artistic systems of representation. By looking with focused intensity at one work in as broad a spectrum of social evidence and material culture evidence as possible, I set out to interrogate and perhaps recover the social as well as the aesthetic dimensions of Copley's empiricism and the period systems of vision it expressed. While he was not (yet) part of the West circle discussed in Chapter 2, Copley in 1763 shared the aesthetic practices and principals we saw Pratt, West, and Peale consciously exploring in that "school." Shortly after completing this commission, Copley began sending canvases to West, soliciting his contemporary's mentoring. In part because of his isolation in Boston, Copley's exuberant verisimilitude was both more marked and less self-conscious, less playful than that of the Americans resident in London.

I approach Copley's much-noted realism by circling around the issue with an inquiry into the nature of his artistic project and his systems of representation from multiple viewpoints. Is his art, to ask a useful question that has not been asked, perspectival, or does it achieve its effect of rounded form (concrete bodies responsive to gravity and light) and spatial recession from chiaroscuro—the muting of the colors of distant objects, or the distant side of near objects—and differential focus alone? Is the viewer's subjectivity in Copley's oeuvre established primarily by the direct gaze of the sitter? More broadly, what role do period concepts of art, of sources of knowledge, of family, of social relations play in establishing what Copley saw and therefore rendered? And what might

we make of the possibility of antirealist ingredients here, such as artifice, imitation, and social convention, visual metaphors of social ideals such as Peale's harmonious balanced family unit in *The Peale Family Group* discussed in Chapter 2 (see plate III)? Potentially seen from a twenty-first-century perspective as invidious and unworthy, as the purview of lesser beings, these "fictive" elements might in fact contribute to the construction of an even greater regard for the artist who could weave such disparate threads together with optical fidelity into a seamless whole. Positioned as a sample, perhaps a representative sample, of the masterful yoking of the local and the imagined, the seen and the conjured, the unique and the culturally prescribed, *Mary Turner Sargent* provides us with a challenge and an opportunity to inspect seemingly irreconcilable elements with a view to better understanding Copley's way of seeing, his artistic practice, and his patrons' expectations concerning identity.

NINETY HOURS

Copley's sitter, the newly married Mrs. Daniel Sargent, had spent her first nineteen years as Mary Turner of Salem, Massachusetts. She was the great-granddaughter of Barbados merchant Captain John Turner (1644–1680), whose estate in 1680 was valued at a staggering £6,788. Her grandfather was the original owner of a house immortalized by Nathaniel Hawthorne as the House of the Seven Gables, and her father was the fourth John Turner (1709–1786), merchant and justice of the peace who built his own Georgian mansion in Salem in 1748.[8] The continuing eminent position of the family in that town is clearly indicated by the waterfront acreage on which Mary grew up (lower right corner of fig. 19). The young Mary Turner was fixed in a prosperous, well-established, well-connected tightly-woven web of kin, and Copley found in her extended family loyal and regular patrons; six members of her family and seven of her husband's commissioned portraits from him from his earliest efforts in 1758 to his final colonial achievements in 1774.[9]

In 1763, the year her portrait was painted by Copley, Mary Turner became the bride of her cousin, Daniel Sargent of Gloucester, another seaport town just north of Salem. His was an equally distinguished and prosperous family of Harvard-educated ship owners, trading along the Atlantic coast and in the Caribbean.[10]

The only curious aspect of this commission is that, while it was frequently the case that portraits were ordered in pairs, no companion portrait of the groom appears to have been painted. More typically, during this same decade, Mary's brother and his wife, Daniel's parents, and his aunt and her husband were all memorialized by Copley in paired portraits. The singleton nature of Mary Turner Sargent's image, however, is certainly not aberrant and may reflect, on the ideological level, the fact that marriage for women in the eighteenth century was the defining life event (whereas men had access to a wider lexicon of achievement and its

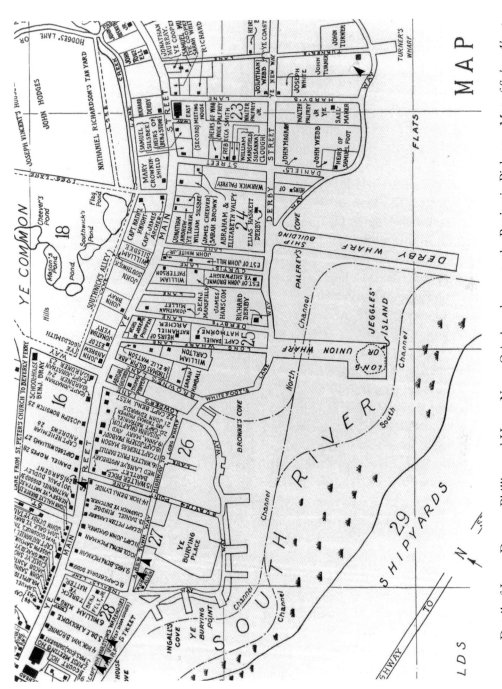

FIG. 19. Detail of James Duncan Phillips and Henry Noyes Otis, *Map of Salem About 1780*, 1937. Engraving, inset in James Duncan Phillips, *Salem in the Eighteenth Century* (Boston: Houghton Mifflin, 1937). Sargent, Turner, Pickman, Browne, and Holyoke homes indicated.

markers) and, on the practical level, the press of business on the new husband's availability for sittings, a topic we will pick up in Chapter 4.

The occasion for the commissioning of this portrait was the entry of this young woman into what was understood in the eighteenth century to be her full realization: "The utmost of a Woman's Character," wrote Richard Steele in the *Spectator,* "is contained in domestic life. . . . All she has to do in this World, is contained within the duties of a Daughter, a Sister, a Wife, and a Mother," and of these the defining moment was the point of marriage.[11] Beyond focusing her own life's duties, this rite of passage also sealed alliances and solidified relationships among men and precipitated a future to which Mary Turner's impressive lineage then became recast as preamble. The fact that hers was not an exogamous match (her aunt and uncle became her mother- and father-in-law) only reinforces the impression that the family was of sufficient substance to abjure the usual necessity for alliances.

A son of this couple, Henry Sargent, who grew up to become a painter himself, recorded his mother's memory of the making of this painting: "[Copley] painted a very beautiful head of my mother who told me that she sat to him fifteen or sixteen times! six hours at a time!! and that once she had been sitting to him for many hours, when he left the room for a few minutes, but requested that she would not move from her seat during his absence. She had the curiosity, however, to peep at the picture and to her astonishment, she found it all rubbed out."[12] The exclamation points in this account suggest the truly extraordinary nature of the time Copley required to paint this, a standard half-length (50″ by 40″) canvas. His contemporary, Sir Joshua Reynolds, working in London, told an inquiring potential patron, "It [the entire portrait process] requires in general three sittings about an hour and a half each time but if the sitter chooses it the face could be begun and finished in one day[;] it is divided into separate times for the convenience of the person who sits[;] when the face is finished the rest is done without troubling the sitter."[13] In corroboration of Reynolds's five-hour estimate we have the record of one patron who told the artist's biographer, "I sat to him five hours, in which time he finished my head, and sketched out the rest of my figure."[14] Similarly, the author of a popular mid-century text on painting in the widely circulated *Universal Magazine* outlined the process by which a portrait was to be executed in three sittings, totaling about ten hours, almost the entirety of which was devoted to the process of painting the face (fig. 20).[15] Assisting the painter in the expeditious execution of commissions was the standardization of formats, including *whole length* (94″ by 58″), *half length* (that is, half the size of a full-length canvas, the format preferred by Copley's patrons), and *bust* (30″ by 25″, including one or both hands). Colormen on both sides of the Atlantic provided stretched, primed canvases in these sizes, and artists charged their customers according to these sizes. Copley, for instance, charged eight guineas for a half length in 1762, fourteen guineas for a half length in the 1770s, and twenty when on tour in New York (that he charged in guineas rather

FIG. 20. Unknown, *The Art of Limning*, 1748. Engraving. 8 × 9 in. (20.4 × 22.9 cm).
In *The Universal Magazine* vol. 3 (London, 1748), p. 225. By permission of the
Huntington Library, San Marino, California.

than pounds emphasized his status as a professional, dealing with gentlemen).
Each format incorporated set expectations and conventions concerning portions
of the body to be included and the position of the head on the canvas.[16]

Even accounting for Reynolds' optimism in his effort to secure a client (in
fact Reynolds's ledgers reveal that for most portraits more than three sittings
were required) and Copley's novice, provincial status, the disparity is enor-
mous—ninety hours with the sitter as opposed to Reynolds's five or eight.[17] It
suggests that Copley needed the sitter present to evaluate and capture every nuance
of color, tone, and form. It suggests that Copley was a ruthless empiricist, eras-
ing from his mind all thoughts of convention and memory, concentrating firmly
on and rendering purely those form and color sensations received by his retina.
Henry Sargent's report of his mother's account accords with Copley's reputa-
tion among twentieth-century scholars as a *realist*, as an artist who could con-
vincingly render the world before him with painstaking accuracy, clarity, and
precision.

A second corroborating account of Copley's working methods has come
down to us from his colleague Benjamin West, who reported that Copley "was
the most tedious of all painters. When painting a portrait, he used to match with

his palette-knife a tint for every part of the face, whether in light, shadow, or reflection. This occupied himself and the sitter a long time before he touched the canvas."[18] We imagine, then, Copley working with his palette almost continuously in Mrs. Sargent's face as he created hundreds of tints and held them up to the reality of her visage and form for evaluation before returning to the easel to apply those that had stood the test. Surprisingly, evidence of this indecision and redecision, of the lengthy tedium of this procedure is erased from the final product, both from the expression of the sitter and from the paint surface.

The result is a painting of great freshness and unity. The awkward passages that we sometimes see in Copley's portraits of men—who, due to the pressures of business, were apparently less patient of the ninety-hour portrait process—are entirely absent from this and his other portraits of women.[19] As in most Copley portraits, there is little overt drama; these are little dramas in which a sense of poise and balance and nuance prevail, a sense of one crystalline moment representing many. That they also were perceived to incorporate a Zeuxis-like deceptively magical replication of reality ("likeness") is suggested by a tale recounted to one of Copley's sitters of the patron's fifteen-month-old child who, when he "eyed your Picture, he sprung to it, roared, and schriched, and attempted gripping the hand, but when he could not catch hold of it, nor gett You to speak to him, he stamp'd and scolded, and when any of us askt him for Papa, he always turned, and pointed to the Picture. What think [you] of this proof of the Painters Skill in taking Your likeness?"[20] The innocent vision of the unacculturated child is, in this account, fooled and frustrated by Copley's precise mimicry of his father's face. That adults also took Copley's portraits seriously as substitutes for the individuals depicted is indicated by the fact that, in the heated riots that preceded the Revolution, a mob entered Harvard Hall and cut the "heart" from the Copley portrait of Governor Francis Bernard hanging there—the sort of effigy damage usually inflicted on three-dimensional full-scale figural sculpture in periods of political crisis.[21] Despite their foundation in the exact replication of certain aspects of the three-dimensional world before the painter, however, all portraits are, to some extent, based on convention, artifice, and fiction, and all respond to the strictures of their culture in terms of dress, body type, deportment, accoutrements, even facial expression.

Mrs. Sargent stands in an elaborate blue gown in the open air, reaching with a scallop shell into a sheet of falling water that issues from a dressed ashlar wall. She does not directly engage the viewer but instead looks off to our left so her face is seen nearly in profile. It is a sympathetic face, soft and dreamy. She wears an entirely natural expression, but it is also that prescribed for a woman dancing—that is, socially presenting herself as a work of art: "Let the Eyes appear lively and modest, and the Face express neither Mirth nor Gravity, but the Medium, which will form an admirable Mien and always be agreeable."[22] Her hair is unpowdered, unpadded, and unconfined by a cap or hat; it is tied simply into a knot and set off with a small bouquet of silk roses.

Although echoing, no doubt, the sitter's personal choice, this was an established substyle of the period in Anglo-American head treatment as noted by an Englishwoman in correspondence with a friend: "You must wear no cap, and only little flowers dab'd in on the left side."[23] Mary Sargent's graceful neck is set off with a narrow white ruff tied with a pink ribbon, echoing the note of rose introduced in the hair to accent the predominantly blue-white-brown color scheme of the painting. More important, her cheeks, bracketed and heightened by these two notes of pink, display a blush, indexical of feminine virtue. Explicitly yoking the flushed cheek with female chastity, an English fictional protagonist of the period opined characteristically, "A delicate virtue is like a delicate chastity, that will blush" with a reddening "which, in scripture, is called the most becoming cloathing and best ornament of woman."[24] The reference is to Proverbs 31: "the sweet blush of modesty, more beautious than the ruby seems." This involuntary body language, perhaps revelatory of her personal character, also squarely situates the bride in an eighteenth-century social cosmology of gender-specific virtue. Her culture's hostility to the counterfeit blush is evident in the text of an (unsuccessful) Parliamentary Bill put forward in 1770, declaring that "women of whatever rank . . . that shall . . . seduce and betray into matrimony, any of his Majesty's subjects by . . . scents, paints, cosmetic washes . . . shall incur the penalty of the law now in force against witchcraft, and that the marriage upon conviction shall be null and void."[25] In both such documents and in the prescriptive literature concerning the presentation of the body, naturalness—whether of cheek or posture—was underscored as an explicitly prescribed value.

Occupying the central portion of the painting and rendered without differential focus, is the elaborate dress that gives the work its dominant rococo tone. Of an unfigured silk, the gown—this type is known as a sack—is elaborated on its surface with serpentine ruched trimmed robings and at its edges with French lace. The sack, worn open in the center front to disclose a matching elaborated petticoat, came into vogue among the gentry in France, England, and America in the 1740s and was apparently worn on a wide variety of occasions until the 1780s, when it became primarily the costume of the court. Appropriate for everyday wear, for visiting, and for balls, it was usually worn with a hoop—the more formal the occasion (and the more formal the dance if that occasion were a ball) the larger the hoop. Mrs. Sargent wears a small hoop, "only of a size to lift the dress from clinging" as one contemporary put it.[26] Although the elaboration of dress through the elaboration of supporting armature was not without controversy in the colonies, hoops had become, by mid-century, commonplace among the gentry and appropriate wedding gifts from men to their brides. They contributed to a sartorial display that impressed foreign travelers, including an Englishman who, visiting Boston, observed, "Both the ladies and gentlemen dress and appear as gay in common as courtiers in England on a coronation or [Royal] birthday."[27]

Beyond its fashionability, the sack signaled Mrs. Sargent's new marital sta-tus; as one mid-century British commenter informs us, "Few unmarried women appear abroad in robes or sacques; and as few married ones would be thought genteel in anything else."[28] Mary Sargent's sack is apparently made of a deep-blue satin weave heavy silk fabric, probably paduasoy. Silk had been imported to the colonies from the earliest years of settlement and remained throughout the colonial period a fabric associated with the elite among colonists of both gen-ders as well as, perhaps surprisingly, some Native Americans.[29] While legisla-tion throughout the colonial period encouraged the development of a North American silk culture (including an inefficacious sumptuary edict in Virginia in 1621 forbidding "any but the council and the heads of hundreds to wear gold in their cloaths or to wear silk till they make it themselves"), most silk bought in America came from Asia and continental Europe and therefore was either highly taxed or smuggled and consequently extremely expensive.[30] That some silk was produced in America in the eighteenth century is evidenced by travel-ers' accounts and such paintings as Ralph Earl's *Mrs. Charles Jeffrey Smith* (New-York Historical Society), of 1794, which includes a small crop of cocoons as the sitter's principle attribute, but local production was always modest and demand high.[31] Mary Sargent's dress, then, suggests in the intrinsic value of its visible imported materials, the unpicturable value of its wearer as legatee of an extraordinary patrimony, and in the social value of its form, the sitter's identity as bride on the threshold of her personal destiny.

Mary Sargent appears to be very much at home, to move and behave with naturalness, in her sack. From dance manuals we learn that while generally it was not good form to touch one's dress, it was permissible to take hold of one's skirt at the sides, but only with the forefinger and thumb, as Mrs. Sargent does here. In this gesture she exhibits at once the sheen of the dress fabric, the transparency of the sleeve lace, and the artistry of the painter in capturing the flesh tones and articulation of fingers that eluded so many other painters.[32]

On the other side of the canvas, under the fall of water, and beneath Mrs. Sargent's right hand, we find the artist's signature: "John Singleton Copley / pinx 1763" (fig. 21). Fewer than a quarter of Copley's American portraits bear his signature, and this seeming lacuna was customary in a world of face-to-face commissions in which the purchaser had no question concerning from whom he had purchased the painting or when. Later, however, when Copley emigrated to London, seeking a wider reputation, he began displaying his wares in the pub-lic arena of the Royal Academy exhibitions and his pictures are uniformly signed. We will look at a prominent instance in Chapter 5. This deliberate shift in prac-tice suggests that, to Copley, the signature acted as a signboard, communicat-ing his name to those who might see the works, be impressed by his skills, and be inspired to commission paintings. As Copley, chafing at his provincial sta-tus, put it in correspondence with a friend, "With regard to reputation, you are sensible that fame cannot be durable where pictures are confined to sitting

FIG. 21. Detail of Plate V, John Singleton Copley, *Mary Turner Sargent (Mrs. Daniel Sargent)*, 1763. Oil on canvas. Fine Arts Museums of San Francisco, Gift of Mr. and Mrs. John D. Rockefeller 3rd, 1979.7.31.

rooms."[33] By extension, then, he probably anticipated correctly when he was a novice in colonial Boston that his painted name in the Sargents' "sitting room" would receive at least important circulation among their large and prosperous kinship network, securing regard in the community of that family and further portrait commissions.

To ensure that we see the name despite its modest size and veiled location under the cascade, Copley placed it in strategic proximity to Mrs. Sargent's right hand. This is the only part of the image in which there is action. After the head, this hand is the focus of our interest and curiosity as it provides a bit of "stage business" that is interesting in itself and unusual for Copley and for a Boston venue—a point to which I shall return. Water splashes off of the large scallop shell, which Mrs. Sargent holds tautly but gracefully in her right hand (fig. 22). Again, the foreshortening and the handling of anatomy, hue, and tone are masterful.

The gesture is executed with an air of natural movement, but it is also socially codified and prescribed. In such contemporary manuals as *The Rudiments of Genteel Behaviour*, illustrations are offered, indicating how one is "to give or receive," namely, in grasping objects, use the fingers rather than the full palm and turn the wrist up (fig. 23). While we read Mrs. Sargent's gestures and posture—her

FIG. 22. Detail of Plate V, John Singleton Copley, *Mary Turner Sargent (Mrs. Daniel Sargent)*, 1763. Oil on canvas. Fine Arts Museums of San Francisco, Gift of Mr. and Mrs. John D. Rockefeller 3rd, 1979.7.31.

body management—as natural and realistically portrayed, these are also highly codified behaviors, recognized by both the subject and the artist, and as necessary to a successful portrait as "likeness" (the recognizability of a unique physiognomy). The emphasis in eighteenth-century tracts on manners and public management of the body stressed "a graceful address, and an air of ease" and it is Mary Sargent's successful execution of this "ease" as well as Copley's successful recording of it that we note almost without thinking.[34]

Mary Sargent's "air of ease" is an entirely different matter from that recorded by Copley's contemporary, Benjamin West, in his image of a London street scene (fig. 24). West's project is to capture the postures and actions by which we recognize his subjects to be workingmen as much as by their clothing or attributes. I am not offering one set of postures as natural and the other artificial; Mary Sargent's deportment is not artificial or, in eighteenth-century terms, *stiff* (in fact, any suggestion of stiffness was emphatically proscribed); for her, an "ease" that involved slumping, gracefully or otherwise, was entirely out of the question.

The constraints to her self-presentation were not just a well-internalized understanding of the gentility manuals or, more likely, prescriptions reiterated to her orally by adults of both genders since birth. She was also corseted with whalebone. As we learn from the costume historians, "the more severe the cut and boning of the corset, the higher the lady's class."[35] The modifications of natural body

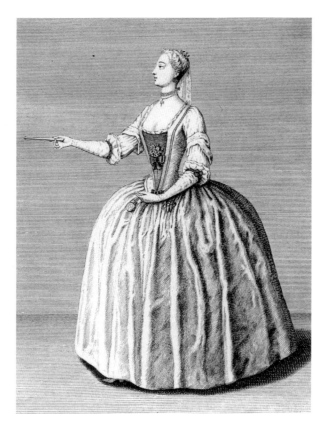

FIG. 23. L. P. Boitard after B. Dandridge, *To Give or Receive*, 1737. From François Nivelon, *The Rudiments of Genteel Behavior* (London, 1737), plate 2. Engraving. 8⅝ × 6¼ in. (21.9 × 15.9 cm). By permission of the Huntington Library, San Marino, California.

form achieved by a corset include the elimination of slumping, of course, but the real aim was to force the shoulders back, and the bosom up toward the receding edge of the stomacher. "The fashion is now," one eighteenth-century woman remarked, "to shew as low as one possibly can."[36] The color and texture of her expansive chest (and of the exposed skin of the face and arms) is quite white, perhaps recording her paleness but also acknowledging the social proscription of skin exposed for sustained periods to the sun, or, one might add, to smallpox or other alteration. As in our own culture with its terror of wrinkles, smooth skin figured as a marker and a metaphor for youth and, therefore, health. Exposure-damaged skin was not sought, even in men, as an index of experience.

Setting off the whiteness of her skin is the lace that echoes it and the blue silk that contrasts vividly with it. Blue is a curious color. It has aristocratic connotations, of course—"blue blood," "true blue"—and it is conventionally associated with the sky and divine powers. The Virgin Mary's robe is traditionally blue, often painted with ultramarine (crushed lapis lazuli) in a conjunction of

FIG. 24. Benjamin West, *A Drayman Drinking*, 1796. Oil on canvas. 15½ × 21 in. (39.4 × 53.4 cm). Dr. and Mrs. Henry C. Landon III.

iconographic sign, hardwired psychological response, and absolute value rivaled only by gold. In heraldry, it is called "azure," retaining etymologically its association with precious lapis lazuli. In the eighteenth century, blue was associated with true faith, continued affections, and constancy. But blue is also linguistically negative—we feel "blue" or sing the "Blues"—and therefore culturally speaking, blue is ambivalent. In art it is the color of celestial space but also of distance and shadows. Moreover, in both vernacular and academic color theory, it is classed as a "cold" color.[37]

Sir Joshua Reynolds, in his *Discourses*, a milestone work on eighteenth-century art theory and practice, explicitly directed painters to avoid blue:

> It ought, in my opinion, to be indispensably observed, that the masses of light in a picture be always of a warm mellow colour, yellow, red, or a yellowish white; and that the blue, the grey, or the green colours be kept almost entirely out of these masses, and be used only to support and set off these warm colours; and for this purpose, a small proportion of cold colours will be sufficient.
>
> Let this conduct be reversed; let the light be cold, and the surrounding colours warm, as we often see in the works of the Roman and Florentine painters, and it will be out of the power of art, even in the hands of Rubens or Titian, to make a picture splendid and harmonious.[38]

Although published some years after Copley's *Mrs. Sargent* was executed, this remark was codifying wisdom well circulated in Reynolds's culture rather than revolutionizing theory or practice. Copley echoed this advice in 1774 when he encouraged Henry Pelham to "get into your Picture a hew [hue] of Colours that is rather gay than otherwise, at the same time rich and warm."[39]

Copley's *Mary Turner Sargent* flies in the face of this wisdom and, it could be argued, disproves it. In fact, Reynolds himself had painted a "blue" portrait in *Susannah Beckford* (Tate Gallery), executed in 1756, three decades before his articulation of this antiblue theory. In many ways, this image provides a model for the Copley work but one that Copley, of course, some three thousand miles away, had never seen in person. Copley, out on the periphery of empire, did not know the work of his contemporaries at the center, but he (and his patrons) knew *of* that work from verbal descriptions, artist's manuals, and reduced-scale prints as discussed in chapter 1 and pursued below. He did know firsthand, though, the cachet of the blue-and-white palette, a cachet that derived from its use on Chinese Ming porcelains. No ordinary object of trade, porcelain, was a substance virtually unknown in Europe until the early modern period when, in the late seventeenth century the secret of its manufacture was mastered by the tardy Europeans. Throughout the sixteenth, seventeenth, eighteenth, and even nineteenth centuries, Chinese porcelains set the standard for ceramic manufactures in the West and were widely admired, eagerly sought, bought, prized, and imitated. While a few Chinese export porcelains in variant colors reached Europe and America, the majority were in the ware's signature blue and white—cobalt on vitrified translucent white kaolin clay. That Copley and his patrons were alert to this taste is suggested by the blue-and-white palette of Mary Turner Sargent's rendered figure and directly evidenced in another portrait by Copley of this period. In *Elizabeth Oliver Watson* (1765) the sitter, Copley's future wife's first cousin—and he—exhibit the precious porcelain not in metaphorical but in its literal form as a blue-and-white vase holding an equally precious and coveted Dutch tulip (fig. 25).

The cultural references encoded by the Sargents and Copley into her portrait extend beyond the realm of deeply desired trade goods from East and West, porcelain and silk. There is also that curious business with the masonry setting and the fountain. On a descriptive level, the sort of architecturally dressed garden Copley alludes to in *Mary Turner Sargent* was unknown in America except in its rendered form in such prints as *Architecture* by an unknown British engraver (fig. 26). I say this with a little caution, knowing that there were extensive showplace gardens in America before the Revolution, but we know little of them and there is reason to believe they did not make extensive use of masonry pergolas and waterworks. Nevertheless, Copley showed a keen interest here and elsewhere in such architecturally defined, sunlit, outdoor spaces. In general, however, we read the portrait of Mrs. Sargent as "real," or, as a contemporary described a similar work, "so finely painted that it appeared alive" because of the convincing light-defined roundedness of her form (what Copley called "releiff"),

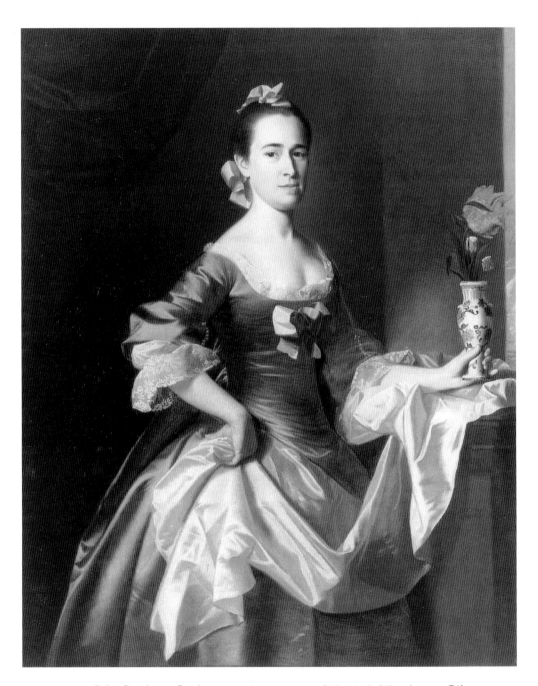

FIG. 25. John Singleton Copley, *Mrs. George Watson (Elizabeth Oliver)*, 1765. Oil on canvas. 49⅞ × 40 in. (126.6 × 101.5 cm). Smithsonian American Art Museum. Partial gift of Henderson Inches, Jr., in honor of his parents, Mr. and Mrs. Inches, and museum purchase made possible in part by Mr. and Mrs. R. Crosby Kemper, through the Crosby Kemper Foundations, and the Luisita L. and Franz H. Denghausen Endowment.

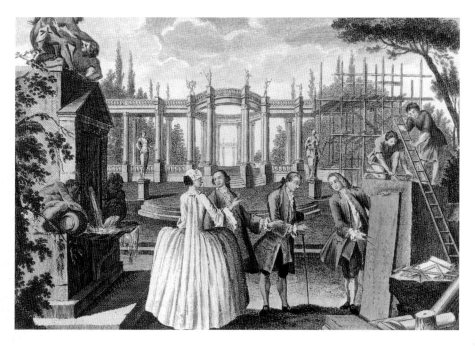

FIG. 26. Unknown, printed by R. Marshall, London, *Architecture*, c. 1750–1755. Engraving. 10⅛ × 13⅞ in. (25.7 × 35.3 cm). Colonial Williamsburg Foundation.

not because the architectural space she occupies simulates optical reality.[40] In short, this and other pre-1775 works by Copley—like most eighteenth-century portraits, especially the half length (three-quarter figure) canvases favored by Boston patrons—consist of foreground figure and background setting rather than figure-in-space. It was not until the next decade when he attempted his first history painting—and here we see Copley's life-long interest in architectural space intersecting with his painterly interest in rendered space—that he discovered the utility of perspectival precision: "I am certain Raphael pursued a Method something like this," he excitedly wrote to Pelham when he finally reached Italy, "you see in his School of Athens in perticular that it has a kind of ground plan."[41] *Mary Turner Sargent* shows only a primitive regard for such a "ground plan," the fixing of elements meaningfully in space. Here the artist privileges the single figure; it was only after his move to Europe that he studied and mastered pictorial space based on the relationships of orthogonally or perspectively located buildings and bodies.

The individual masonry ingredients included in *Mary Turner Sargent*—high rusticated wall, flattened pilasters, and stately balustrade—are illustrated in designs for aristocratic homes, royally sponsored college buildings, and structures for the Established Church in James Gibbs's *Book of Architecture Containing Designs of Buildings and Ornaments* (London, 1728), which Copley owned and may well have utilized—along with folios of mezzotints—in com-

posing the backgrounds of his portraits.[42] That is not to say that these elements are "unreal" or unimportant, however. Perhaps in invoking these massive balusters and masonry blocks Copley is merely offering his clientele a quick class upgrade. Staiti has argued, along these lines, that the cultural work these "false" ingredients were called on to do was to feed a "voracious" "anglophilia" that expressed both poor cultural self-esteem ("insecurity about their provinciality") and overweening self-esteem ("inflated self worth") and that resulted in pictorial markers of "fantasies" and "dreams of upward mobility." This line of interpretation—attributing "awe, envy, and mortification in the shadow of English culture" to "virtually every American in the 1760s"—is quickly exhausted.[43] Let us look beyond this rather alienated view of culture to both the painting itself and to its broadest context. Like colonial language, costume, law, furniture and town planning, its terms, rhetorics, and principals echo and draw on English and European practice. Indeed these "Americans" were English. If the use of Gibbs and other transatlantic visual quotations are not simple diagnostics for cultural neurosis, what might their incorporation tell us about Copley's working methods, Copley's patron (the unseen Daniel Sargent), and Copley's society? Certainly in terms of the scene as a whole, as a scene incorporating an optically perceived figure with deliberate, pointed visual quotations, it belongs to a family of paintings that circle around the fingertip contact of elegantly dressed women with garden fountains.

The grandly scaled architecturally defined garden setting in which Copley placed Mrs. Sargent may not have existed in the Boston area in the 1760s, but more modest versions certainly did. In 1778, Daniel and Mary Turner Sargent moved into a large wooden house on Atkinson (now Congress) Street in Boston proper. Their son Lucius Manlius Sargent described it: "There was a fine garden attached to this house. . . . [The building] had a gable end to the street and faced the garden, which bounded on a high brick wall, covered with a magnificent creeping woodbine. There was a pretty summer house there, covered with honey-suckle. A landscape was painted on the back of the summer house by my brother Henry, before he went to London, to study under Benjamin West."[44]

The garden in which Copley's Mrs. Sargent appears so at home has no "creeping woodbine" or "pretty summer house." Its Brobdignagian walls close out the verdure and serpentine chaos of natural growth in favor of stone cut and water shaped by the orthogonals of culture. Nature here—stone, water, woman, silk filaments—has been brought under the rule of order signaled primarily by parallels (woven silk, laid blocks) and perpendiculars (the fall of the water, the corseted upright posture of Mary Sargent; and the pilasters behind her figure). Curves are reintroduced into the lexicon of shapes in certain areas of costume, but here they signal "work" and "workmanship" of lacemaker and of mantua-maker, not the accidents of growth, the variations of twig and mountain profile.

The shell with which Mrs. Sargent interrupts the smooth sheet of falling water appears to be the only unprocessed natural form introduced into this image. It is a scallop shell with regularly alternating radiants spreading outward from the umbo (or hinge point) at which she grasps it, near which the organism is anchored in its protective covering and at which it joins its symmetrically opposing (but here missing) other half. Shells were omnipresent in Mary Sargent's coastal Massachusetts world—littering the beaches of her native Salem and her husband's home of Gloucester, they were gathered and used to pave garden paths in the eighteenth century. Shells were also the discarded by-products of a mollusk-rich diet, especially among the poor, many of whom, one New York contemporary reported, "lived all year long upon nothing but oysters and a little bread." Shells were also, in eighteenth-century England and Europe, commodities collected as scientific exemplars and as the primary aesthetic booty of global colonialism. They were exhibited, bought, coveted, and auctioned in a market very like that for Old Master paintings.[45] But perhaps more important, shells had a long pedigree among artists, as accoutrements associated with Neptune (the subject of Copley's youthful efforts at history painting), Venus, and the sea. Probably the most popular motif used on decorative arts objects of the eighteenth-century eastern seaboard (fig. 27), shells figured as an aspect of Mrs. Sargent's visible world inside the house, outside in the garden, and at the border between the human environment of the town and the natural environment of the sea. Shells were an aspect of the quotidian and of the symbolic—they were simultaneously the useless refuse of everyday life and the potent symbol of her husband's and her culture's source of wealth and identity. The shell here is a liminal "threshold" object, connecting the still sitter with the active stream of water, its own natural element. It is incomplete, a half, just as Mrs. Sargent is, in the social cosmology of eighteenth-century Boston, half of the basic unit of social, political, and psychological identity—the married couple.

Let us consider for a moment this painting within the larger context of garden-woman-fountain images. Copley painted two others that reiterate this conjunction: *Abigail Allen (Mrs. Jonathan Belcher)* of 1756, and *Alice Hooper (Mrs. Jacob Fowle)*. A fountain also appears in Copley's portrait of Mrs. Sargent's aunt and mother-in-law, *Mrs. Epes Sargent II (Catherine Osborne)*.[46] The motif, then, had social currency and familiarity in mid-eighteenth-century Boston, perhaps springing from the celebrity of the antique recumbent sculpture "Nymph with a Shell" (variously, "Venus and the Cockle Shell") known in England through engravings and copies imported from Rome in the seventeenth and early eighteenth centuries. Perhaps more important, the specific conjunction of fountain and shell in *Mary Turner Sargent* references a long tradition in Dutch art of prints, portraits, and illustrations based on the critical meeting scene in Act I of the Italianate pastoral tragicomedy *Granida* by Pieter Corneliszoon Hooft (1581–1641), in which a strolling Persian princess is offered a drink of spring

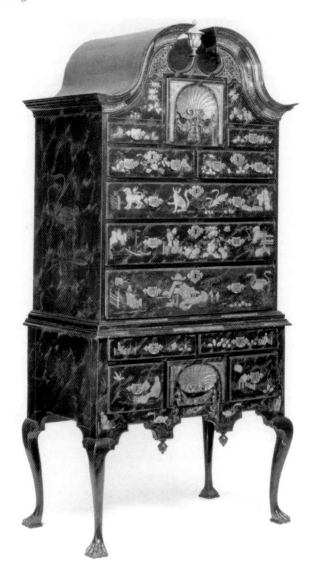

FIG. 27. Attributed to John Pimm (cabinetmaker) and Thomas Johnson (japanner), High Chest of Drawers, Boston, 1740–1750. Japanning on maple and white pine. 95¾ × 42 × 24½ in. (243.2 × 106.6 × 62.2 cm). Winterthur Museum.

water in a shell by a rustic shepherd who subsequently elopes with her. Works by Copley's British contemporaries such as Reynolds's *The Hon. Harriot (Forrester), Mrs. Edward Walter* (1757) point to a shared Anglo-American usage of this conceit in the eighteenth century.[47]

Indeed, important instances are known from the previous century, as in Sir Peter Lely's portrait *Anne Hyde, Duchess of York* of 1660 (fig. 28). Each presents a genteel, betrothed, or recently married woman enjoying the pleasures of a garden fountain. The implied narrative seems innocent enough: a young woman

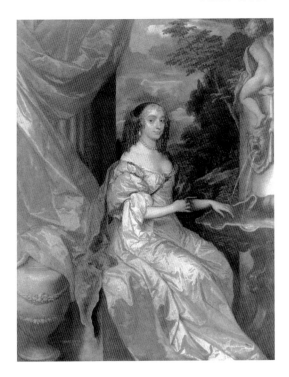

FIG. 28. Sir Peter Lely, *Anne Hyde, Duchess of York,* c. 1660. Oil on canvas. 71¾ × 56¾ in. (182.3 × 144.1 cm). Portrait Gallery, National Galleries of Scotland, Edinburgh.

strolls alone within a garden and, coming across a fountain, delicately touches the falling sheet of water. Such a seemingly inconsequential subject allows the artist to display his ability to render convincingly the hand, and allows the patron to express subtly his apparent command of the financial resources and technological skill necessary to channel water (and, by extension, nature) from use value to aesthetic value. The Lely portrait was commissioned by the sitter's father, the first Earl of Clarendon, soon after her marriage in 1660 to the Duke of York. Her father is said to have remarked "that he had much rather his daughter should be the Duke's whore than his wife."[48] In saying so, whatever his source of pique, he strikes a note of sensuality and sexuality that is evident as an undercurrent in this whole set of images.

In genre works such as *The Alarm* by Jean François de Troy (1723) (fig. 29) and *The Amorous Proposal* by François Le Moyne (c. 1726) (fig. 30), the line is crossed, and this fountain play gets an onstage or offstage male participant and a decisively erotic tone. I do not mean to imply that the artist who painted or the husband who commissioned Mrs. Sargent's portrait is playing a cruel and lascivious joke on her, but that certain allusions, certain displaced metaphoric meanings were, like the broad expanse of frankly erotic chest, permissible and proper in the eighteenth century in ways they have not been since within the realm of gentry self-image.

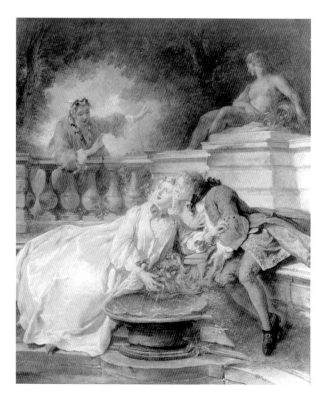

FIG. 29. Jean Francois de Troy, *The Alarm*, 1723. Oil on canvas. 27⅜ × 22¾ in. (69.7 × 57.9 cm). Victoria and Albert Museum, London.

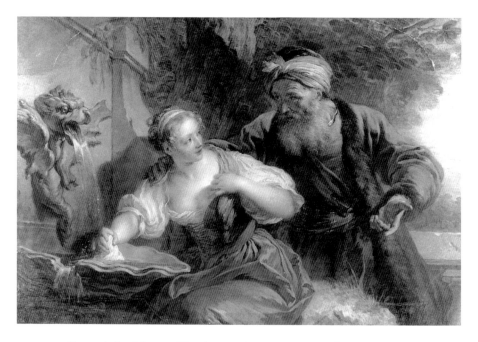

FIG. 30. François Le Moyne, *The Amorous Proposal*, c. 1726. Oil on canvas. 39 × 57 in. (99.1 × 144.8 cm). Sterling and Francine Clark Art Institute, Williamstown, Massachusetts.

IDENTITY AND REPLICATION

Thus far we have approached Copley's painting of Mary Turner Sargent as a rendition of a "real" slice of eighteenth-century life, which also incorporates prescribed and naturalized codes of deportment for the body and metaphorical contexts to enhance the viewer's understanding of the sitter and her transition to a sexually active and sexually available state. Copley's optical empiricism is intact. But now we are confronted with a problem. In the same year that Copley painted Mary Turner Sargent, he painted another bride, Mary Toppan Pickman, in the same dress (fig. 31). How can that be? The first solution that

FIG. 31. John Singleton Copley, *Mrs. Benjamin Pickman (Mary Toppan)*, 1763. Oil on canvas. 50 × 40 in. (127 × 101.5 cm). Yale University Art Gallery, Bequest of Edith Malvina K. Wetmore.

FIG. 32. John Singleton Copley, *Mrs. John Amory (Katherine Greene),* 1763. Oil on canvas. 49⅞ × 40 in. (126.7 × 101.6 cm). Museum of Fine Arts, Boston, M. and M. Karolik Collection of Eighteenth-Century American Arts; 37.36. Photograph ©2003 Museum of Fine Arts, Boston.

FIG. 33. John Singleton Copley, *Mrs. Daniel Hubbard (Mary Greene),* c. 1764. Oil on canvas. 50¼ × 39¾ in. (127.6 × 100.9 cm). Art Institute of Chicago, Purchase Fund 1947.28, reproduction. Art Institute of Chicago.

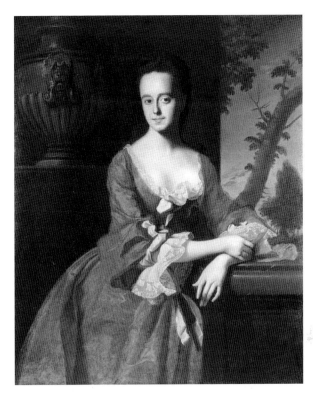

FIG. 34. John Singleton Copley, *Mrs. John Murray (Lucretia Chandler), 1763.* Oil on canvas. 49⅞ × 40 in. (126.7 × 101.6 cm). Worcester Art Museum, Worcester, Massachusetts, Bequest of H. Daland Chandler.

proposes itself is that *there was no dress*, that he painted both from a print of a dress with somebody else's body in it. This is certainly the strategy he used in his portraits of *Katherine Greene (Mrs. John Amory)* (fig. 32), *Mary Greene (Mrs. Daniel Hubbard)* (fig. 33), and *Lucretia Chandler (Mrs. John Murray)* (fig. 34), all painted at the same time he executed the images of Mrs. Sargent and Mrs. Pickman we have been considering. Their heads are immortalized above a dress they never saw in a posture they probably never assumed. Directly copied from a mezzotint by John Faber, Jr., after a Thomas Hudson portrait of *Mary Finch, Viscountess Andover* (1746), these three Copley works reiterate the viscountess's pose, dress, accoutrements almost verbatim (see figs. 2 and 3). Why should Copley do such a thing? It has been proposed that in mimicking mezzotints either Copley is emulating his betters (and this is a difficult move for historians of American art because of this artist's status as self-made realist and heroic pioneer) or (and this position they take more readily), Copley's *patrons* are emulating *their* betters, being more interested in the cachet of known aristocratic forms than veracity and, presumably, forcing the artist's reluctant collaboration. Copley has also been defended in this verbatim replication of mezzotint sources as "practicing" with English forms, using them as "instructional device[s]," and reusing them but "not slavishly."[49] I would suggest, rather, that he borrowed from portrait prints in the Amory-Hubbard-Murray

images not because he needed "practice" or because he or his patrons were nerv-ous provincials engaged in a "perceptual conspiracy" as others maintain but because he knew that that is what was done in London.[50] Recalling the let-ter from Reynolds to a prospective portrait patron that concludes, "When the face is finished the rest is done without troubling the sitter," consider the stu-dio practice of this president of the Royal Academy who commanded the car-riage trade at the hub of the empire. According to his assistant, Reynolds kept in his studio a portfolio "containing every print that had been taken from his portraits; so that those who came to sit had this collection to look over, and if they fixed on any particular attitude [pose], in preference, he would repeat it precisely in point of drapery and position; as this much facilitated the busi-ness, and was sure to please the sitter's fancy."[51] Many English artists followed the same practice, including the well-documented Arthur Pond who displayed prints after his own portraits and those of other painters on his studio walls for the benefit of sitters. Many London artists sent the almost blank canvas with finished head together with the chosen print to a subcontractor, a drapery painter, for completion, or even sent the finished head on a small canvas to be applied to a larger canvas for "body-work" and completion. These "pasted heads" were not by inferior artists for ignorant patrons but included Allan Ramsay's 1769 portrait of Queen Charlotte and her two eldest sons. Other court por-traitists are known to have ready-made bodies onto which faces could be expeditiously appended, such as Lely, whose studio inventory included "whole length postures No. 8 & 1."[52] Among prominent English eighteenth-century artists, only Thomas Gainsborough and William Hogarth apparently eschewed the services of drapery painters, as these body-specialists were called.[53] There is only slight evidence that Copley made use of, or indeed had access to, such "painter Taylors," or such proto-industrial practices, complaining to Ben-jamin West in 1768 that "I am obliged to do all parts of my Pictures with my own hand." By 1769, however, he appears to have begun to make use of the services of his stepbrother Henry Pelham, as studio assistant, to set up his palette and complete the backgrounds in portraits.[54] While he did not have access to the professional drapery painters of London who were accustomed to copy-ing prints, he certainly had access to, and made good use of mezzotints in imi-tation of Reynolds's practices as much as of Reynolds's postures.

While we find the subsuming of individual identity within general form visible in these practices surprising, it is important to note that they are congruent with other eighteenth-century practices such as the use of character blanks for obituaries. As described by a Boston vendor of these wares, they were designed to "soften the Labours" of those charged with drafting for "the Public [news]Papers, the Virtuous actions, blameless Lives, and christian Deportment of Deceas'd Persons" for "the Instruction, and Edification of the surviving Generation." Specifically, he had "prepar'd a Set of Characters [descriptions of

character], suited to both Sexes, Engraven on Copper Plates . . . with Void spaces for Name, Age, Distinction, and Profession, or such Particular and Eminent Qualities, as do not properly fall under the Notice of General Description."[55] Our model of eighteenth-century personhood (as well as our admiration for period entrepreneurial spirit) needs to take into account the acceptability of these reproductive processes and practices with regard to personal identity. At the intersection of unique being and general type, the individual was understood literally to be both. In character as in physiognomy there were socially recognized coordinates, yet, were humans "as like as Eggs laid by the same Hen," as one contemporary put it, "What a Subversion of all Trade and Commerce[!] What hazard in all Judicial Proceedings[!]"[56] Absolute uniformity, then, was impossible in a world where personal responsibility was foundational; absolute and instantaneously recognizable singularity, therefore, was understood to be as essential to functional society as predictable social type.

The replicability or plagiarism of personhood, which we find to a degree alarming or amusing in the literary and pictorial practices of "character blanks" and interchangeable portrait bodies did give pause to some like the visiting Frenchman in London who commented that "at some distance one might easily mistake a dozen of their portraits for twelve copies of the same original. . . . Excepting the face, you find in all, the same neck, the same arms, the same flesh, the same attitude [pose]."[57] The sine qua non of the portrait, as these "minimum" projects suggest, was, therefore, the unique recognizable face, the "likeness" (and of the obituary "character," the unique name); all else was, it seems, negotiable, replicable, or potentially imitative.[58] Because we, in our post-Romantic culture, set great store by originality, or seeming originality, it is difficult to conceive of this systematic replication of bodies ("excepting the face") outside of the realm of the reprehensible fallback practice of the inept, provincial, or unoriginal artist, and as an activity potentially embarrassing to the patron. However, the practice, in theory, stood on comfortable ground in eighteenth-century Britain. As Reynolds remarked: "he who borrows an idea from an ancient or even from a modern artist not his contemporary, and so accommodates it to his own work, that it makes a part of it, with no seam or join appearing, can hardly be charged with plagiarism; poets practice this kind of borrowing without reserve. But an artist should not be contented with this only; he should enter into a competition with his original and endeavor to improve what he is appropriating to his own work. Such imitation is so far from having anything in it of the servility of plagiarism that [rather] it is a perpetual exercise of the mind, a continual invention."[59] What Reynolds is condoning—in fact, prescribing—is the process by which visual quotation (of all kinds) works. The viewer sees the novel object, and sees it as a whole, but also sees in it deliberate partial evocations of other artworks imported to establish a chord of familiarity and resonance in the beholder's mind. This was a lesson Cop-

ley learned well and applied in his history paintings as well as his portraits (see, for instance, Chapter 5, where his "imitation" of a classical figure triggers a self-imitation of that imitation). So unusual was an absence of "borrowing" and an exact rendering of one's own accoutrements that one portrait patron in England commented on his experience of his own literal translation into paint (by Allan Ramsay) as singular; the work, he reports, is "not only an Exceedingly good likeness, but a very good Piece of Painting: the Drapery is all taken from my own Clothes, & the very Flowers in the lace, upon the Hat, are taken from a Hat of my own. . . . The Ruffles are done charmingly, and exactly like the Ruffles I had on when I was drawn, you see my Taste in Dress by the Picture, for everything there, is what I had had the Pleasure of wearing often."[60] T. H. Breen, who is persuasive in his analysis of important narrative fictions in the pre-Revolutionary period, misunderstands eighteenth-century usage on both sides of the Atlantic concerning this key concept of visual "likeness" and replication in relation to pictorial fictions. He speaks of these women with their mezzotint-derived poses derisively as "playing at being English"; but it is difficult to imagine the realm's queen as also "playing at being English" in not having her own body painted.[61] Clearly, concepts of personal and cultural identity in the early modern period differ from those we extrapolate from our own culture. It is instructive on the point of provincial "Englishness" to read Bostonian Mrs. Amory's diary concerning her excursion outside London to the "house that my Mother was born in & where my Grandfather carried on business many years." It is clear from her detailed musings that neither the earlier emigration of her parents to the colonies nor her own re-emigration to England (where she died) were perceived by her as culturally discontinuous or clearly hierarchized. She understood herself to be English not as pretension but as a matter of political and personal fact just as Copley understood his practices to be au courant London usage and not provincial makeshift.[62]

The Amory, Hubbard, and Murray portraits were not so much symptoms of intercultural envy directed at London as they were residual evidence of a distinctive localized familial discourse. These three kinswomen certainly saw each other and each other's portraits in situ in their respective family houses. Mrs. Amory's portrait hung in her own home until the she and her husband left America in 1775, when it was taken by her father, Rufus Greene, to his home for safekeeping. In both sites it was undoubtedly seen by the sitter's cousin, Mary Greene Hubbard, and by Mr. Greene's sister-in-law's sister, Lucretia Chandler Murray.[63] The replication of pose and dress among these "triplets" was conscious, deliberate, witty, and a key aspect of familial communication and recognition.

While most authors who have commented on these images presume that the women and their husbands must have wanted *difference*, in fact erroneously and baldly stating that "each sitter appears in a dress of a strikingly *different* color,"

the commissions clearly emphasized convergence and identity. Indeed what is striking about these three paintings generated from a black-and-white print is that not only are the poses all derived from the same print, all the dresses are the same color—a golden brown.[64]

What constituted the successful portrait, apparently, was the exactitude of the face (recognizable as the unique, named individual by family, friends, and acquaintances) and the appropriateness—whether owned or visually borrowed—of pose, context, and costume to gender, life stage, and station. Were portrait sitters annoyed or alarmed at seeing accoutrements that they did not own or the replication of "their" body attached to another head in another household? Apparently they were not. Mrs. Hubbard and Mrs. Amory were first cousins (who knew each other well, traveled together, and socialized together and with the Copleys); Mrs. Murray was their aunt's sister.[65]

It appears that one of the explications of this conjunction of identities is that we are seeing evidence of active, collaborative sitter (or patron husband) choice, as well as urbane artistic practice. For such eighteenth-century writers as Dr. Samuel Johnson, "imitation" was a mode of wit, "a kind of middle composition between translation and original design, which pleases when the thoughts are unexpectedly applicable, and the parallels lucky."[66] In this case, these kinswomen were, with the instrument of visual quotation and the collaboration of their husbands and the artist, establishing their own witty intertextuality.

THE ITINERANT DRESS

Does the *Amory-Hubbard-Murray* frank replication of each other and of the mezzotint source answer the situation of Mrs. Pickman "in" Mrs. Sargent's dress? Probably not. No mezzotint source of this distinctively and richly elaborated dress in either pose has been found, and the dresses appear from such different angles, with such a difference in the disposition of the drapery that it seems unlikely. Indeed it would have been far easier to copy from a dress in the studio than to have copied from a mezzotint while changing every fold. Perhaps other common English eighteenth-century studio practices were responsible for the replication of the blue sack.

If an original pose was wanted and yet the sitter preferred to not be troubled by tedious sittings or the painter preferred to not be troubled by tedious sitters, the artist employed a lay figure. Jointed, usually miniature dolls equipped with extensive and detailed wardrobes (sixty-four items of both men's and women's clothing are preserved with the surviving lay figure originally owned by amateur British artist, Ann Whytell, for instance), these obedient, silent and still mannequins were widely used in the eighteenth century (fig. 35). Popular published accounts of how portraits were to be painted, while quite detailed concerning the technical aspects of grounds and pigments, omit discussion of the

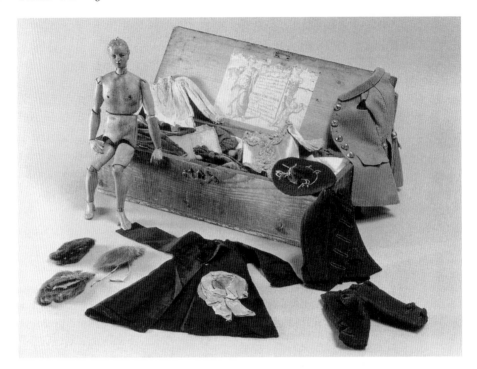

FIG. 35. Ann Whytell (designer of clothes) and Simon Hennekin (designer of figure), England, Artist's Lay Figure in Original Wooden Box with Male and Female Wardrobe, 1769. Wood and fabric. 11½ × 3¾ × 2¼ in. (29.2 × 9.6 × 5.7 cm). Los Angeles County Museum of Art, Purchased with funds provided by the Elsie DeWolfe Foundation. Photograph © 2003 Museum Associates/LACMA.

use of mezzotints, lay figures, and similar common painterly aids that we know of primarily from surviving material and anecdotal information.

Copley is known to have owned a lay figure during the 1770s and may have owned one as early as the 1760s, when *Mary Turner Sargent* and *Mary Toppan Pickman* were painted.[67] Given Copley's painstaking technique, such an aid would have been a great benefit, and would explain the repeated use of one of the lay figure's costumes. However, most lay figures were miniaturized. Their use is documented, for instance, in the work of such notable artists as Gainsborough whose portrait known as *Blue Boy* records an adolescent wearing the same Van Dyke-style costume in which a full-grown Gainsborough patron also appears.[68] While possible, it seems unlikely that the use of a lay-figure costume explains the Sargent-Pickman portraits. Where doll-sized mannequins were used (as in the work of Arthur Devis or the Gainsborough example), the costumes are rendered in rather generalized form, but Copley appears to have described this dress in minute and particular detail. In this, he again violated Reynolds's dicta but presumably, in making a portrait of the dress as well as the person, satisfied the visual appetite of his sitters and patrons for particularity in design and detail.[69]

A third possibility is that these dresses are the same because Copley had the dress sewn to his specifications as a studio prop to be made available to sitters eager to borrow finery they could not afford. Such a hypothesis presupposes, though, that such elegance was not routinely available in America or that it was beyond the means of the Toppans, Pickmans, Sargents, and Turners, and yet within the means of the twenty-five-year-old Copley.

Certainly the dress Mrs. Sargent and Mrs. Pickman wear is a fine one. It is absolutely up to date as is evident from a fashion-magazine plate illustrating the same form of dress (open down the front with matching petticoat or skirt) and surface ornament as "The Dress of the Year 1761," published in London in 1762, the year before these portraits were so painstakingly painted.[70] That silk dresses of great elaboration were made and used in colonial America is evident from newspaper advertisements, travelers' records, account books, and the physical survival of a few examples. In 1759, for instance, George Washington ordered for his bride Mrs. Martha Custis, a sack from London of silk with "ruffles to match of Brussels [bobbin] lace or point [lace] . . . to cost twenty pounds." Such a dress as the Pickman-Sargent sack, with or without hoops, would cost as much, and use up to twenty yards of expensively produced heavily taxed silk, another eighteen yards of trimmings, and several yards of lace imported or smuggled from France or Belgium at a cost equal to that of the other materials together.[71]

George Washington was not the only man to centrally involve himself in the design and procurement of a dress. We have good documentation of men directing the minutest aspect of trim on the new dresses for their fiancées and wives.[72] It was the husband, after all, who would pay for it and own it as well as be its primary admirer when it became a kind of kinetic sculpture on the body of his wife. It is worth noting that women's clothing was the husband's property in law, and were a woman to run away from even an abusive husband she could be arrested for theft if she were wearing clothing.[73] So it would not be out of the ordinary that Copley, then a bachelor, might design, order, and have available such a dress. Indeed, because of their high cost and considerable residual value, it was standard procedure to have elaborate costumes on hand in busy London studios. But it is doubtful that Copley, at the age of twenty-five and still six years away from his marriage to financial security, would have been willing and able to make the major investment such a costume would represent (£15 to £20 sterling at a time when the value he placed on his production of a "head" was £5/12/o) and a half length £8/8/o.[74] Some years later, he appears to have contemplated and rejected the idea of maintaining studio costumes: "Nor indeed can I be suplyed with that variety of Dresses here as in europe, unless I should put myself to a great expence to have them made."[75]

However, such an investment in costume was by no means out of the ordinary for the husbands, fathers, and fathers-in-law of Mrs. Pickman and Mrs. Sargent. They were extremely wealthy men, and such display was apparently far

from unusual. One young lady of comparable degree set out from Connecticut for Boston to attend boarding school in 1771 with "twelve silk gowns but her chaperone wrote that the young lady must have another gown of a 'recently imported rich fabric,' which was at once procured [to signal] her rank and station."[76] In the year Mrs. Benjamin Pickman wore this dress and produced the next generation's Benjamin Pickman, her father-in-law, already possessed of a dozen properties, built himself a new mansion house, eventually accruing almost £12,000 in real estate alone.[77] The Toppans, Turners, and Sargents were equally established families with substantial wealth, so it is far more likely that the dress did exist, was by no means uncommon in this class, and was the property of one of the husbands of these women.

Indeed, we have some direct evidence of Benjamin Pickman's attitude and his personal interventions concerning the costuming of his family. His letters to his wife in Salem from England, where he passed ten years during the Revolution (while she managed, with considerable expertise, we are told, her husband's lands and business), include two significant directives concerning dress. In May 1775, soon after his arrival in Britain, he wrote to his wife, "Polly, . . . I send you by my Friend Mr. Ingrahm a Piece of Brocade which I desire you to make up immediately and wear." This directive is disarmingly straightforward. That he expects no extensive thanks is as evident as the fact that he expects no dispute concerning taste, color, or design. The passage is routine, part of a spousal discourse with more than a decade of history at this point. He wants her in brocade and she shall be so attired. The following year he wrote: "I have perfect Confidence in your Management of the Family, however permit me to suggest one or two Things which I have much at Heart. As to the Education of our Children I desire it may be the best the Country affords at this distracted Time—I would they should go better dressed than my Fortune admits of, rather than otherwise."[78]

That Mary Toppan Pickman was able to effect her husband's charge we have no doubt—beyond her excellent (in fact, profitable) management of her husband's affairs during his long absence, she was an heiress in her own right to her father's considerable fortune on his death the year before these two paintings were made.[79] Pickman was clearly a clothes-conscious man, keenly aware of the social signifiers of physical presentation. In this he was not at all unusual for his era. In light of such anecdotal evidence, we must entertain the possibility, indeed the probability, that men were the primary agents in the dressing and portrait-making of these two daughters, wives, and daughters-in-law.

But then we find ourselves near where we were at the outset: two women who were not close kin wear the exact same dress. But we also can surmise that there was a dress (rather than a print or a miniaturized lay-figure costume) and that the women share the garment with the knowledge, perhaps even the directive of their husbands. Looking at *Mary Toppan Pickman* and *Mary Turner Sargent* together one is struck by the reiterated facts of near replication. Beyond the

identity of their dress, both women are seen at the same scale within the same format, on canvases of similar size. They share a blue-white Chinese porcelain palette against brown masonry garden structures (one wall of which is perpendicular to the picture plane while the other, more distant wall, lies parallel to the picture plane) and a glimpse of blue sky. In both cases, a diagonal shadow on the distant wall relieves its flat surface and accentuates the head. In three dimensions, both the figures are inflected at forty-five degrees to the dominant architectural framework. Both portraits reiterate the same references to exotic materials and to ordered, geometricized nature. These echoes appear to be very deliberate, underscoring, I would propose, friendship between two Salem neighbors of the same age cohort whose families and whose husbands' families had associated with one another for decades.[80]

In 1763, when these two works were painted, all four of these young adults—Mary Turner Sargent, Daniel Sargent, Mary Toppan Pickman, and Benjamin Pickman—lived or had close kin who lived on Essex (later Main) Street in the center of Salem. Situated daily in close physical proximity, the Turners, Toppans, Pickmans, and Sargents had also in the past been linked by intermarriage. Mary Turner Sargent's great-uncle was Timothy Lindall (d. 1699), an early Salem resident who was also Benjamin Pickman's great-grandfather. Lindall's house on Essex Street had been torn down in 1750 by the elder Benjamin Pickman to build the mansion in which he and then his son and wife, Mary Toppan Pickman, resided (and in which her portrait by Copley hung) (see fig. 19, no. 10). It was situated next to the house built in 1710 by Mary Toppan Pickman's grandfather and owned by her uncle until 1774 when her mother and then she inherited it (no. 9). Four houses down was the home in which Mary Turner Sargent's aunt (Mary Bowditch) resided until it was conveyed in 1763 to Benjamin Pickman's brother-in-law, who had, at the outset of his career, boarded with one of the Turners further down Essex Street (no. 5). Next to that house, in 1744, the widow of one of Salem's wealthiest men, Samuel Browne (whose estate was valued at £21,000 in 1742), Catherine Winthrop Browne, brought her new husband, Epes Sargent—grandfather of the future Daniel Sargent—to reside (no. 4). Widowed again in 1762, she moved to a new house next door (no. 3) in 1763 and lived there until her death in 1781. Our four protagonists—the two sitters and their husbands—would have known this Salem neighborhood well since earliest childhood. Benjamin Pickman was born here; Mary Toppan Pickman would have visited her grandfather and then her uncle here. Daniel Sargent would have journeyed from adjacent Gloucester to see his (unusually matrilocal) grandfather, and Mary Turner Sargent would have walked up from the harbor area (where the real estate of her father, John Turner, is bisected by Turner's Lane and Turner's Wharf) to visit her aunt. In a two-block area, then, on the oldest street in Salem, at the heart of the town, we can imagine these families in virtually constant visual and oral contact, slowly reshuffling the property and family partnerings that constituted their arena of worldly and social value.[81]

The similarities we see in the portraits of Mary Turner Sargent and Mary Toppan Pickman are not, we note, of the same type that we observed in the Amory-Hubbard-Murray mezzotint-inspired trio, where different beings depend almost wholly on different faces to mark their different identities. Mrs. Sargent and Mrs. Pickman's faces are equally individuated, but their natures are also differentiated by distinct poses, and very different attributes. Unlike Mrs. Sargent, Mrs. Pickman visually addresses the spectator, turning her frank and genial gaze onto the viewer, and she holds an open umbrella rather than a shell. Like Mary Sargent, Mary Pickman wears her hair pulled back from her face, topped not, however, by a cluster of small roses but by a "mercury" or "pompon." So while much about these two portraits is the same—the dress, the overall setting and palette, the women and their images are very different in important respects, including address to the spectator and attributes. These differences point to personal differences between women who, in so many other respects, share identities. Mrs. Sargent with her roses and shell is identified more closely with the realm of nature while Mrs. Pickman with fabrication and art.

Mary Pickman's hair ornament, of the type sometimes known as a "Chinese pompon," was fashionable during the mid-eighteenth century not only as an object of dress but also as an object of craft. Although they could be purchased in finished form, it is evident that they were frequently fabricated by the wearers themselves as one of several "accomplishments" considered appropriate for gentry production and identity.[82] Similarly, Mrs. Pickman's umbrella could have been bought in Boston for about the same price as the portrait, or she could have purchased just the wooden umbrella frame and made it herself, as several artisans offered "unmade Setts of Sticks for Umbrilloes for those who wish to cover them themselves."[83] Despite their remarkable similarities, then, these two portraits suggest nuanced differences in the talents, predilections, and personalities of these two women Copley has been at such pains to relate to one another. While emphasizing their similarities, he nevertheless suggests important differences between these two recently married nineteen-year-old neighbors who, I would propose, were friends, collaborating in this elaborate mime or directed in it by their husbands.

To complicate matters but perhaps to resolve them, we find there is yet a third portrait by Copley in which another woman wears the same blue sack (fig. 36). The painting was done at the same time, possibly in the same year, but the sitter comes from a distant town in the Boston area and is older than the other two.

She is Mercy Otis Warren (1728–1814) of Barnstable on Cape Cod who had married James Warren of Plymouth in 1754. A woman who would become well known in the next decade as a bluestocking poet, dramatist, historian, and political activist, Mercy, as pictured by Copley in the blue sack about 1763, already appears a formidable force.[84] Situated almost sideways to the picture plane in the act of plucking a meandering nasturtium, Mercy Otis Warren turns her head to directly and penetratingly scrutinize the viewer. The pose reveals new

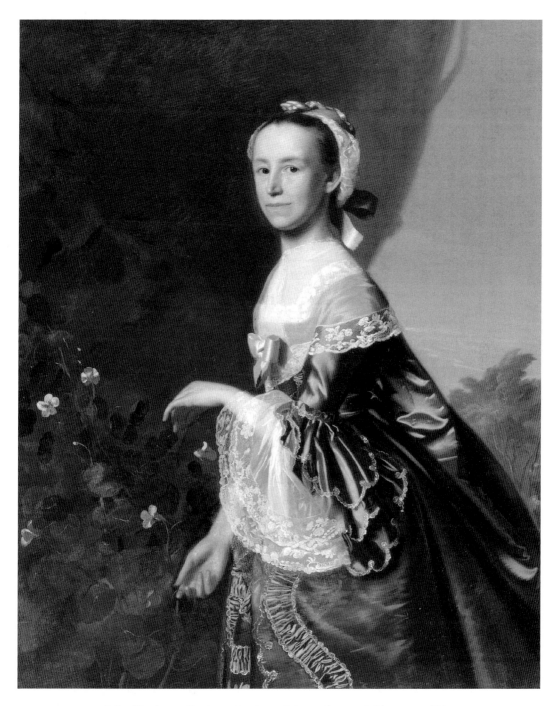

FIG. 36. John Singleton Copley, *Mrs. James Warren (Mercy Otis)*, c. 1763. Oil on canvas. 49⅝ × 39½ in. (126.1 × 100.3 cm). Museum of Fine Arts, Boston, Bequest of Winslow Warren; 31.212. Photograph © 2003 Museum of Fine Arts, Boston.

views of the blue sack and its potential as kinetic sculpture. The gaze reveals a woman of extraordinary poise and intensity. Indeed, in a satirical letter of advice to a young lady, this enthusiast for history from earliest childhood sardonically chided: "If you have a Taste for the Study of History let me Urge you not to Indulge it least the Picture of human nature in All Ages of the World should give Your Features too serious a Cast."[85] Her role was sufficiently prominent and public that, in 1818, looking back at the 1760s and 1770s, former President John Adams in discussing the writing of the history of that era, included "James Warren and his wife" in his "long catalogue of illustrious men, who were agents in the Revolution."[86]

If the Pickman-Sargent use of this dress can be explained by the friendship, kinship, and physical proximity of the women and their husbands, how does this third player figure in this silent conversation? Search as one might for a direct connection between these three women by kinship, schooling, geographic proximity or similar lines of female community, it appears that the threads drawing together the three women were woven by politics and the unpictured men who were their husbands and brothers. The connections between Mercy Otis Warren and the pair of Salem women—Mary Toppan Pickman and Mary Turner Sargent—are two. First, Mercy Otis Warren's younger brother, Samuel Alleyne Otis, was a Harvard classmate of Benjamin Pickman (class of 1759) and a near classmate of Mary Toppan's brother Thomas (Harvard, class of 1757). Otis and Pickman had returned to Cambridge to take their M.A.'s in 1762, and the memory and comradeship of those formative years would have been fresh in their minds in 1763 when the portraits were executed.[87] Second, Mercy Otis Warren's older and favorite brother, James Otis, the fiery lawyer, had been engaged by the merchants of Salem to argue against the crown's petition for new writs of assistance on the death of George II in 1760. These writs were in fact search warrants, giving the crown broad powers to search for smuggled goods, and they were vigorously opposed in Superior Court at Boston in 1761 by James Otis on behalf of the Salem merchants. According to John Adams, who witnessed the proceedings, "Then and there, was the first scene of the first act of opposition, to the arbitrary claims of Great Britain. Then and there, the child Independence was born."[88] That families involved in this incident should have formed or solidified tight bonds is no surprise. That they should express community and friendship through a memorialized dress exchange is.[89]

It seems probable that the dress originally belonged to James and Mercy Warren and that it was their gift (or loan), probably to Benjamin and Mary Toppan Pickman, who shared it with Daniel and Mary Turner Sargent specifically for the purpose of sitting for these portraits. When Mercy wears the dress a double row of lace-trimmed gauzy *engageants,* or ruffles, accentuate her forearms. Densely worked with complex and multiple leafage, this lace border (probably a *point d'Alençon* needle lace) is repeated on the edge of a diaphanous fichu secured by a pale-gray breast knot. This lace survived in her family at least until the late

THE EMPIRICAL EYE 87

nineteenth century.[90] Such imported lace as she wears in this 1763 Copley por-
trait became the subject of defiant public political proscription in the next
decade, and the object of her own critique in "Lamira" a poem she published
in 1774 castigating those who would not forego imported "Lawns and [silk] lus-
terings—blond and mechlin laces / Fringes and jewels, fans and tweezer cases."
It was a temporary lapse; by 1780 she was exchanging enthusiasms about "sat-
ten" and "sewing silk" with Abigail Adams.[91]

When acquired by the younger women, the dress was retrimmed with less
costly lace, probably a Mechlin bobbin lace with a more straightforward and open
pair of figures (or toile)—a scallop chain meander and a quatrefoil. In these por-
traits and in many he painted, especially in the 1760s, Copley was extremely atten-
tive to lace trims. Beyond the face and hands, lace seemed to command his greatest
attention. Indeed, the Amory-Hubbard-Murray paintings, which are so very iden-
tical in so many respects, exhibit individual differences (portraited likenesses) in
the sleeve laces as much as in the faces (see figs. 32, 33, and 34). The figures in Cop-
ley's laces are repeated with precise focus, and the play of hue and tone through
and around the semitransparency of the *reseau,* or ground, appear to have pre-
occupied the young artist.[92] He appears to have seen laces differently than we see
laces, indeed all textiles, today. Not only did he see them with sharp focus over
their entire extent, he also saw and portrayed them as identifiable individual art-
works. One could claim a stolen sleeve from these pictures more easily than one
could recognize a stolen child from today's mass-mailing "missing person" alerts.
In the most basic sense, laces represented to Copley a sort of rival for gentry cus-
tom; as one historian has put it, "on a yard-by-yard basis, silk damask was just
as costly as oil on canvas, and the elaborate trimmings [such as lace sleeve ruf-
fles] were much more."[93] While some lace was made in America, Mercy Otis War-
ren is pictured wearing about £10 of imported lace in a painting that probably
cost less than £10. Copley's attentiveness to the closely worked foliage of art, it
seems, signals more than his awestruck recognition of the financial power the lace
represented or his admiration for the design and workmanship involved in its cre-
ation by fellow artisans; his focus points, in fact, to a difference in the way he under-
stood and saw these finely wrought, highly individual textile constructions.

As much a subject of protective legislation and encouraging royal subsi-
dies as porcelain, lace in the eighteenth century was equally important, more com-
pact, and easier to smuggle. That it was economically significant as well as socially
indexical is evident in the ritual public burning of contraband lace, and such edicts
as that which proscribed all but British-made laces at the royal wedding of 1764.[94]
It is difficult for us to see these gauzy creations on a par with computer chips
today, significant players in international balance of trade wars, but they seem
to have been critical trade goods (economically far more important than the paint-
ings that record them) as well as key ingredients in the daily wear of both men
and women, signaling rank, age, and, for women, marital status.

In the social realm, laces participated in a universally legible mime of

hierarchy based on quick visual assessment of rank and prerogative. While we can see in the deportment manuals certain gestures prescribed to give a man or woman a "graceful air" in the gaze of peers, we cannot see the kinetic gestures that signaled the fine degrees of deference—based on age as well as title and wealth. In the words of one contemporary, "Precepts resemble Pictures; they have Form and Colour, but want life and Motion."[95] In verbal address these differences were signaled, for instance, by "Capt.," "Hon.," or "Esquire" (titles appended successively, for instance, to the names of three generations of John Turners, the last being Mary Turner Sargent's father). In the kinetic realm, hierarchy, especially among males, was marked by the minute observation of degree (and, therefore, one suspects the ritualized avoidance of conflict) for strangers and family as well as acquaintances in terms of who sat where in the coach, who walked next to the wall and who the open street, who walked a half-pace behind whom, and who read a letter in the presence of whom. These rules pertained to strangers as well as to acquaintances and were used as cues to appropriate behavior when "true" status was unknown. Visual clues to class and prerogative were, apparently, more reliable in the eighteenth century when textiles and dyes were less imitable than they became in the nineteenth.[96]

Particularly telling are the gestures to give and to receive (where physical contact takes place) in which the man of lower degree or younger age bows and enacts submission, underlining the absence of physical threat. Gauzy white lawn, in this realm, located around the face and hands performed two functions—in its degrees of elaborateness it gave a finely coded visual clue to the behaviors expected of the observer and, especially in the glowing gossamer ruffles and bobbin laces of the eighteenth century it underlined the most minute motion, whether a nod or turned hand. Not just personal display, laces and ruffles participated in a finely graduated drama of deference that preserved order and degree among those who valued these qualities as essential social norms.

This is not to say that eighteenth-century gentry were nicer to one another than people are today. Indeed we have good evidence that verbal violence was at least as acute as it is in our culture—Mary Toppan Pickman's father, for instance, was, in the opinion of at least one contemporary—"the Greatest Rogue upon Earth."[97] But physical violence was evaded and social order preserved with the hourly observation of rituals of deference and prerogative. How else, for instance, could the community sentence a malefactor to service within the intimate circle of his victim's household? Or deliberately place in the town's model homes its most marginal members for correction, instruction, and care?[98]

Given the variability of the poses, the minute observation of its details, and its differences when worn by these three women, we can conclude that Mrs. Sargent, Mrs. Pickman, and Mrs. Warren in fact posed in a real dress and that Copley painted it in intricate ninety-hour exactitude three times on these three different women. To my knowledge, this is the only such instance of this type of dress replication in his oeuvre and suggests in that alone a unique working

out of a specific set of requirements. In another sense, however, these paintings exhibit the "rules" of all Copley's compositions, they just underline a more social dimension than we usually can see.

We know that the majority of Copley's portraits were designed to be set into relation to a second, that of the spouse. Designed to answer in terms of size, scale, frame, format, coloration, attributes, tone, and the inflection of the bodies toward one another, these images may also have referenced specific objects and architectural contexts. The case of the Amory-Hubbard-Murray paintings suggests that kinship references may also have been designed into paintings, and the case of the Sargent-Pickman-Warren portraits suggests that this medium might also have been used to underscore friendship and alliance among individual men and larger families. That these three blue-dress portraits were a medium of communication is self-evident; that their messages might be complex, relational, and political is more difficult for us to see, distanced as we are in time and culture.

The movement of this dress between the bodies of Mercy Otis Warren, Mary Toppan Pickman, and Mary Turner Sargent, and between the households of their husbands became memorialized and permanentized in the painted images of these women. Necessarily involved in costume decision making as well as in the purchase transactions, the husbands were also, in fact perhaps primarily, involved in this mute act of communication, of relation, of community. Unaccustomed as we are today to male direction in the matter of dresses, to wardrobe movement, and to wardrobe signifiers of friendship or alliance that appear to have been understood in the eighteenth century, we can, nevertheless attempt to imagine this supralinguistic exchange between the parties.

Copley's "realism" is constructed by some scholars as a mark of American heroic difference. Avoiding both the presumed fantasy and flattery of aristocratic modes and the irrelevant metaphysics of abstraction, Copley, in these accounts, demonstrates rootedness in the material world and continuity with experience as we know it. Burdened with ideological, political, and epistemological freight, Copley, in interpretations such as Craven's, remains firmly in the world of concrete bodies responsive to gravity and light, and bestows a patrimony of authenticity on American art and social relations. Inverting the European hierarchy of imagination (history painting) and reality (portraiture, still life) Copley appears, in this interpretation, to prefigure pragmatism, and to critique pretension in social values as in art, while he hymns not the common of nineteenth-century realism but the actual of presumed eighteenth-century experience. Other scholars embed him in a web of unworthy fictionalizing, creating "purely self-congratulatory" theatrics and "gratuitous display" of "idleness and self-indulgence."[99] It is curious that value structures so diametrically opposed should be imported to explain Copley's art—his realism, his patronage structure, his efforts to produce objects of value. It is probable that he would be startled by both these perspectives.

Copley's only direct verbal comment on the process of rendering the three-dimensional reality of the visible world into coherent and contained two-dimen-

sional painted mimes occurs in his letters of 1775 to his half-brother in Boston from Europe as he struggled with the problem of multifigure, story-based canvases. Studying a work by Raphael, he was convinced (or convinced himself) that the master had painted "all parts of it from nature," by which he means from direct vision of human and object models. Plotting the expressions, gestures, and positions, he argues, "this part is Ideal," that is, generated out of the artist's imagination. But, he goes on, "All our Ideas of things is no more than a remembrance of what we have seen, so when the Artist has a model in his Appartment and Views it, than [then] turns to his picture and marks whatever he wishes to express on his Picture, what is it but remembrance of what he has seen? at the same time I will allow the man whose memory is such as to retain what he has seen a year or two before as perfectly as I can one or two Seconds, is on a footing with me when he paints not having the life before him. But this I believe no Man can do."[100]

By this alchemy, Copley makes of Raphael a cousin and reassures himself that the recording of optical experience, with which he is familiar, is the basis of history painting, which is his chosen future. That in his London studio in the 1780s he put this insight into practice and tried the patience of professional models for his history paintings as he had Mrs. Sargent for her portrait is evidenced by one who complained "of Copley's behaviour to Her, who would make her sit a longer time than she could well bear . . . she had resolved not to go to him any more."[101] By setting up an opposition between ideas and Nature as a reconcilable dialogue between "a remembrance of what we have seen" and "the life before him," Copley suggests that only *time* stands between the literal and the imagined, the model and the painting. He bridges a gulf for himself as he labors to imagine the applicability of his experience to his ambitions, but he evades the issue of *how* he sees and how he discriminates between and generates syntheses of visual facts.

As the foregoing discussion of the Sargent-Pickman-Warren portraits suggests, both the artistic project and the social project legible in that artistic project are far less straightforward than scholars have assumed. Certainly Copley labored ninety hours to render the nuanced facticity of Mrs. Sargent and her dress, and an equal number of hours on the other two sitters. But what he rendered was conditioned by what he saw and what he understood, and the mission to record vision was only one of the project's aims. To call him too quickly a "realist" denies him his extraordinary mastery of convention, artifice, and period systems of object and social legibility that are obscure to us today. Copley wants us to see not just the figure of his sitter before us on a canvas as though in three-dimensional space but a whole world of reference beyond that single, localized form in his allusions to Chinese ceramic arts, to French textile arts, to domestic "accomplishments," to English garden design, and to gentry deportment codes. The aim is not to expand the class markers of the patron but to remark on his own literacy in matters necessarily beyond his ken. He used these paintings to reconstitute in larger scale and in color certain secondary ele-

ments (such as the masonry walls) from black-and-white prints, to interject such references to both shared culture and individual identity as the shell and umbrella, to spin a web of intertextual "play" among a group of patrons, to follow the conventions of his profession in the paintings' most basic terms, and above all, to wed all these disparate ingredients into a seamless whole.

In the eighteenth century there were two recognized ingredients in gentry status: birth (intrinsic) and education (extrinsic). Copley—through his association with Peter Pelham—came into the circle of those whose business it was to instruct and exhibit the extrinsic aspects of gentry status. Peter Pelham, Jr., Copley's stepfather, taught dance (as well as reading, writing, and painting); Peter Pelham III, Copley's older stepbrother, taught harpsichord, voice, and other musical skills; and stepbrother Charles was tutor and schoolmaster, living with Isaac Royall—one of Copley's earliest patrons. Peter Pelham Sr. was attached to an aristocratic household in London, and his two sisters were in service (apparently as paid companions) in rural aristocratic households. While many scholars suggest "Pelham [Jr.] was driven to the makeshift of opening a dancing school," evidence points rather to his and his family's long-term interest, expertise, indeed professionalism in a broad range of arts associated with gentility and civility— a category that they appeared to view as inclusive of (and not opposed to or "beneath") the pictorial arts. Far from servicing an unworthy local taste for pretentious behavior, Pelham's introduction of dance instruction and exhibitions in Boston met with consternation and may even have resulted in his resolve to leave Boston for Newport, Rhode Island; Pelham's accomplished harpsichordist son found it necessary to relocate to South Carolina to find sufficient patronage.[102]

Copley was thirteen when his stepfather died and—instead of being bound out as apprentice to learn a trade as custom and law dictated—he took up Pelham's engraving and painting tools in an act that asserted his education was complete. That his mother and grown stepbrothers permitted this to happen suggests that it was, at least in the critical matter of his education in visual systems of deportment and physical signs; and in the secondary matter of access to tools, materials, and shop, it was uncontested.

Instructing and orchestrating the exhibition of the skills of dancing, harpsichord playing, and—in portraits—deportment, artistic "accomplishments," and costume, Copley and the Pelhams assisted in the realization and demonstration of gentle birth and civil behavior. If birth was a primary (but in America not necessary) ingredient of gentility, performance was its absolute (and necessary) essence. Therefore enactment, including costume (and such records of enactment as portraits), were essential social markers. This is not to say that daily costume or memorial portrait were inherently false or pretentious, just that they were a matter of preoccupation and concern that we find puzzling or mysterious today. How curious it seems to us that the enormously and ancestrally wealthy Benjamin Pickman directed that his children "should go better dressed than my fortune admits of." And, at the other end of the gentry scale we wonder at Peter

Pelham, Sr., "Gentleman" of London (Copley's step-grandfather), who confessed, "I am very much putt to it to find my self in necessarys in outward apparrell, for which I Cannot free myself from Debt," even though keeping a proper "gentleman's" costume and keeping silver meant boarding with a grocer, and keeping his sisters in lifelong penurious service to the lesser aristocracy.[103] This preoccupation with dress cannot be attributed in these cases to the nervous ambition of bounders or the anxiety of established elites in the face of challenge; it seems to have been at the center of self-definition in ways that we cannot easily understand and we would be wrong to judge hastily by belated standards.

Copley portraits, such as those considered above are the record of a synthesis of two distinctly different types of seeing, thinking, and understanding truth; they are the result, even, of two kinds of education. On the one hand, there is the observed—those knitted dabs of pigment so painstakingly mixed and tested and applied in response to visual facts like so many dabs of empirical stimuli on the tabula rasa of the artist's mind and the canvas's surface. In this record, we locate primarily the unique individual portrayed. On the other hand, there is a panoply of the observed, the symbolic, the imagined, the synthesized, the reconstituted—generated only in part out of what is seen, and ruthlessly measured against what is known from many instances, what must be present to mark that individual as an inhabitant of the portraited social class and to set that individual in relation to others.

The audience for this performance was most logically intraclass for there its nuances were most completely read and access is comprehensible. Those who see colonial portraits as markers of interclass competition, constructing a psychosocial model based on individual and group envy, emulation, and evasion, have yet to account for access and for the nature of the language in which portrait messages are inscribed.[104] Far more appropriate material culture to deciphering that very real issue of interclass definition and competition are carriages, architectural facades, deportment, and costume—these are the material ingredients of eighteenth-century public display and class commentary, but they remain almost wholly unexplored in contemporary scholarship.

Copley played this game of defining individual and group identity well. No enemy to appearances, Copley was unusually deft in the moves we see him make in self-costuming, in real estate, and in self-presentation in his letters. It is clear he was an apt pupil of his stepfather's tutelage, receiving a social education most obviously validated in his marriage into gentry circles, but also evident in his early and continued success with portrait patrons, a cohort acutely alert to nuances of manner. His job was not, as we have seen, simply to record their faces but rather, as bricoleur, it was to construct a tableau in which the sitter was recorded accurately and her body, costume, gesture, setting, and accoutrements were recorded in what was understood to be an *appropriate* manner, referencing recognized cultural norms and narratives. As we have seen, this appropriate manner could include mezzotint borrowings given family meaning in multiple reiteration (as in

the Amory-Hubbard-Murray set), or it could be a complex series of visual moves, involving repetition, variation, allusion, and witty intertextuality (as in the Sargent-Pickman-Warren portraits). The synthesizing agent was the artist's imaginative and recording skill; the measure of his success was in the patrons' validation of the vision by purchase and integration of the canvas into the domestic visual and social landscape.

Copley was unusually gifted, but the moves he made in constructing a vision of and for his clients were not unusual. A tenacious empiricist, he was also a resourceful compositor of sources; he recorded visual facts faithfully, but he also deployed and manipulated conventions. Above all, he adroitly marshaled visual tropes to give such portraits as *Mary Turner Sargent* witty and deliberate reverberations with other paintings, both those painted a century earlier by his European predecessors and those he painted himself for a tight circle of friends and political allies. If this analysis gives us a deeper sense of how such a painting was thought, constructed, and understood by its artist, sitter, and patron— as a deliberate aggregation of complex meanings—a question still remains concerning the way a painting accrued and lost meanings over time. An eighteenth-century portrait had two intended audiences—the immediate family context of the patron and his posterity. If a portrait is, in its second guise, a bulwark against the fragility of human memory, a fixed and stable point of reference for a person's and a family's identity, how well did it do its job? It is to this question we turn in Chapter 4.

The Remembering Eye
Copley's Men and the Case of *Joshua Henshaw*

In the last chapter we looked at John Singleton Copley's Boston-based painting practice, eighteenth-century identity-construction, and unforeseen social "conversations" in which portraits were enlisted, taking as a point of departure a single image—*Mary Turner Sargent* of 1763—moving outward beyond the contours of that portrait into the social context of the sitter, the training of the artist, contemporary aesthetic theory, and customary studio practices. The questions pursued in that chapter revolved around vision and were largely synchronic in nature. Here we also take as our primary text one Copley painting, but our inquiry concerns memory, history, and the diachronic dimension in identity and value. We turn from a study attentive to spatial relations to one in which time is our primary coordinate. We also shift focus from issues central to identity in Copley's women to the somewhat different issues summoned by the corpus of Copley's men. In both these chapters, however, family, identity, money, and transatlantic epistemological structures frame the foreground narrative.

Perhaps the most common of Copley's male types, the stately merchant in half-length format, of which Copley's *Joshua Henshaw* is exemplary, also seems the most laconic (see plate VI). Nevertheless, an inquiry which extends to the details of the frame takes us into alternative period identity systems—namely, the coat of arms and the hatchment—and also into a diachronic investigation of the descent of wealth, naming patterns, and the physical canvas itself. The portrait commission figures here as a characteristic event within Revolutionary-era culture and as a singular event that brings into focus family disequilibriums already in the 1770s three generations old. Following the biography of the portrait over its 230-year trajectory in a kind of animated provenance further clarifies both the initial integral relation of family to image and the dissolution of that relation over successive generations.

Picking up on the points of intersection between portraits, wealth, family identity, and the idea of artistic and genetic replication discussed in Chapter 2, I will argue that Copley's *Joshua Henshaw* is, above all, about money and the family line, about the construction of identity as *fixed* in a world in which identity (personal, familial, hierarchical, transmissible to posterity) was, in fact, *unfixed*, that is, subject to the machinations of other men, to the calamities of war, and to the erosions of time. This image is offered not as singular or exceptional but rather as representative of objects of its class, of portraits commissioned and drafted to duty within the social framework of family. Consequently, although

the project here is, in part, to focus on the moment of the portrait's creation, our interest extends both backward in time and forward to the present. The quest is not only to better understand the forces (of memory, politics, economics, and personal identity) that coalesced in bringing it into being but also to fore-ground and investigate—taking a cue from Igor Kopytoff—the social biogra-phy of this portrait as it became an actor in successive cultural histories and in the lives of successive generations of owners and viewers.[1] Every painting has a story. Every painting is part of many other stories.

The portrait of Joshua Henshaw was commissioned in Boston about 1770 (like the majority of Copley's New World works it is not signed or dated) when the artist was about thirty-two, recently married to the wealthy Susanna Clarke, and, thanks to a generous father-in-law, recently possessed of prime real estate bor-dering Boston Common (see Chapters 3 and 6, figs. 18 and 90).[2] The sitter, Joshua Henshaw (1703–1777), was sixty-seven in 1770, living in an elegant house on Sudbury Street acquired many years earlier through the generosity of *his* father-in-law, Hon. Richard Bill (see Henshaw family tree).[3] Henshaw was a suc-cessful older merchant, anticipating passing on to his four children the kind of sub-stantial patrimony he himself had enjoyed (and the kind of patrimony that had attracted the alliance with the even wealthier Bill family at the outset of his career). The image is one constructed by a confident artist, adroitly managing paint to describe the silk drapery, brown tailored worsted suit, diaphanous sleeve ruf-fle, and glowing flesh of an equally confident sitter. Henshaw appears magiste-rial, inevitable, and permanent. But, in 1770, both sitter and patron had reason to question apparent certitudes; all was not well in the Boston that Copley and Hen-shaw called home. Since 1768, British troops had occupied the city; altercations between colonial power structures and the Crown were escalating.[4] Copley would soon find it convenient to go on a painting tour to New York, and Henshaw—who had had several dramatic face offs with the Royal Governor, Francis Bernard—would soon find it necessary to abandon the city altogether.[5] Indeed, when asking why the painting was commissioned at this juncture, two primary motives pro-pose themselves—one having to do with family, specifically a recapitulation of an act Henshaw's own father had done three decades earlier to engage family mem-ory in *his* advanced years, and the other as an act of commemoration of the sit-ter's bold, public, and risky behavior in the volatile political climate of the day.

Although many of Copley's portraits were commissioned in pairs—indeed Henshaw's son Joshua and his wife were painted as paired pendants by Copley at this time—this painting was not.[6] Henshaw's wife, Elizabeth Bill (1712–1782), had been painted many years earlier, a work apparently commissioned by her father before or at the time of her marriage.[7] So we can conclude that Copley's *Hen-shaw* was primarily about the distinguished merchant's achievements as a mature man and his identity as a man within a family line of Joshua Henshaws (because this was a family in which consecutiveness of identity was marked, in part, by repetition and replication of name).

Chart 1
Henshaw Family Tree

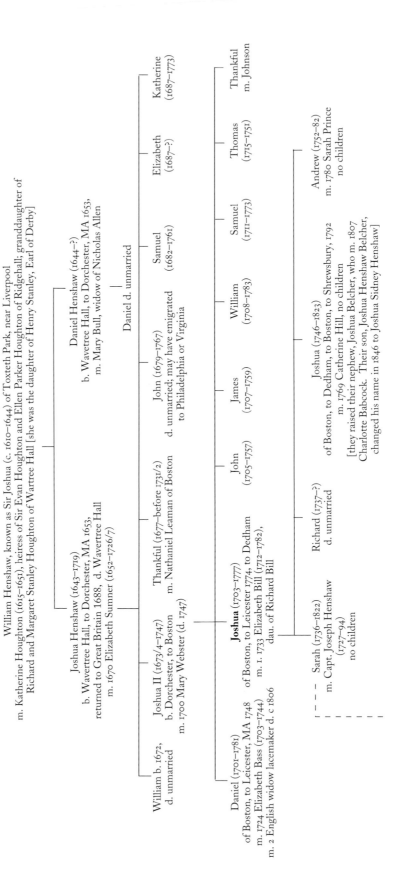

William Henshaw, known as Sir Joshua (c. 1610–1644) of Toxteth Park, near Liverpool
m. Katherine Houghton (1615–1651), heiress of Sir Evan Houghton and Ellen Parker Houghton of Ridgehall; granddaughter of
Richard and Margaret Stanley Houghton of Wartree Hall [she was the daughter of Henry Stanley, Earl of Derby]

Joshua Henshaw (1643–1719)
b. Wavertree Hall, to Dorchester, MA 1653,
returned to Great Britain 1688. d. Wavertree Hall
m. 1670 Elizabeth Sumner (1652–1726/7)

Daniel Henshaw (1644–?)
b. Wavertree Hall, to Dorchester, MA 1653,
m. Mary Bull, widow of Nicholas Allen

Daniel d. unmarried

William b. 1672,
d. unmarried

Joshua II (1673/4–1747)
b. Dorchester, to Boston
m. 1700 Mary Webster (d. 1747)

Thankful (1677–before 1731/2)
m. Nathaniel Leaman of Boston

John (1679–1767)
d. unmarried; may have emigrated
to Philadelphia or Virginia

Samuel
(1682–1761)

Elizabeth
(1687–?)

Katherine
(1687–1773)

Thankful
m. Johnson

John
(1705–1757)

James
(1707–1759)

William
(1708–1783)

Samuel
(1711–1773)

Thomas
(1715–1751)

Daniel (1701–1781)
of Boston, to Leicester, MA 1748
m. 1724 Elizabeth Bass (1703–1744)
m. 2 English widow lacemaker d. c1806

Joshua (1703–1777)
of Boston, to Leicester 1774, to Dedham
m. 1 1733 Elizabeth Bill (1712–1782),
dau. of Richard Bill

Richard (1737–?)
d. unmarried

Sarah (1736–1822)
m. Capt. Joseph Henshaw
(1727–94)
no children

Joshua (1746–1823)
of Boston, to Dedham, to Boston, to Shrewsbury, 1792
m. 1769 Catherine Hill, no children
[they raised their nephew, Joshua Belcher, who m. 1807
Charlotte Babcock. Their son, Joshua Henshaw Belcher,
changed his name in 1846 to Joshua Sidney Henshaw]

Andrew (1752–82)
m. 1780 Sarah Prince
no children

A genealogical chart (family tree). Entries as transcribed:

- Daniel (1725–92)
- Joshua (1726–52) m. Mary Rockwell — Joseph
- Capt. Joseph (1727–94) of Shrewsbury, m. 1758 Sarah Henshaw, no children
- Benjamin (1730–1793) b. Boston, to Middletown, CT, m. 1. Elizabeth Lord, m. 2. Hulda Summer
- John (1732–48)
- Adj. General William (1735–1820), m. 1. Ruth Sargeant (d. 1769), m. 2. Phebe Swan, 13 Children
- Elizabeth Bass Henshaw (1737–1787), m. Samuel Denny
- Mary Belcher (1739–1823)
- Hannah (1742–1820)
- David (1744–1808) of Leicester, MA, m. Mary Sargent

- Sarah Henshaw (1787–1863) m. 1809 Andrew Henshaw Ward

- Elizabeth Denny (1760–1846) m. Thomas Walter Ward

- Benjamin (1754–1828)
- Elizabeth (1755–1847) m. Meigs
- Daniel (1762–1825) m. Esther Prentis to Leicester in 1774 after 1782, to Shrewsbury
- Joshua (1765–1840) m. Elizabeth Burnham
- Sarah (1768–1849) m. 1785 Dr. Samuel (Lemuel) Hayward of Boston and East Sudbury (Wayland), MA

- Andrew Henshaw Ward (1784–1864) of Newton, MA m. 1809 Sarah Henshaw, cousin

- Joseph Henshaw Hayward (1789–1853)
- Sarah (1794–1884) m. Morris Dorr (1855–1911)

- Caroline
- Harriet Stillman Hayward (1803–83) m. Com. Thomas W. Wyman

- Dr. George (1791–1863) of Wayland, m. twice, no children builds Post Road house 1832

- Charles (1754–1828) m.?
- Dr. Joshua Henshaw Hayward (1797–1856) of Boston and Wayland m. 1830 Sarah Ann McLean

- Sarah Henshaw Hayward (1839–92)

- Dr. John McLean Hayward (1836–86) of Boston and Wayland m. Katherine Cobb (1839–1917)

- Sidney Willard Hayward (1871–1950) of Wayland, MA m. Beatrice Herford (?–1952) no children

- Josephine (1836–1917) m. Henry P. Binny, son (and 7 other children)
- Mary Binny m. G. Kennard Wakefield of Milton, MA

- John White Hayward (1786–1832) m. Louisa Bellows of Walpole, NH

- Waldo Flint (1831–97) of Walpole, NH

- John White (1828–?) of Walpole, NH

- Louisa (1826–?) m. Rev. Charles Canfield of South Boston

- Benjamin (1754–1828)

Before discussing this particular commission, sitter, and portrait in any depth it will be useful to situate it as a type within the corpus of Copley's oeuvre as a whole. Overall, there are more surviving portraits of men than women from the colonial period, and more surviving portraits of colonial men than women in Copley's known corpus.[8] This is to be expected. Men were the purchasers of portraits, the most interested parties in matters pertaining to the generational transfer of wealth, and, as Louise Lippincott makes clear, while portraits of women in the early modern period tended to be about marriage, portraits of men were about marriage *and* personal achievement, so multiple moments of importance, and moments later in life, might be so commemorated.[9] In the medieval period, marriage and significant personal achievements were marked by additions to the heraldic signifiers on coats of arms (the word "hatchment," as noted in chapter 2, is a corruption of "achievement").[10] By the eighteenth century the less abstract (but equally referential) system of portraiture was enlisted to similar ends.

Joshua Henshaw is a standard fifty-inch by forty-inch half-length portrait.[11] The figure is life-size, centered on the canvas, and stands in a dim unspecified room leaning against a support cloaked in a fluidly disarranged deep red silk curtain. A bright shaft of light spotlights the head and right hand, allowing Henshaw's tailored brown suit to recede from our view and attention. A forthright gaze—neither welcoming nor hostile—engages the viewer and suggests that this man is a direct dealer—savvy, experienced, confident. What else or who else he might be will require more attentive reading, which we will defer for the present. Our inquiry into what kind of man Copley has described here, whether he is typical or unusual in the spectrum of eighteenth-century gentry, is usefully framed by considering what kinds of men Copley portrayed in general.

Of the ingredients in identity visibly legible to one's contemporaries, portraits record dress, body management, and address to the viewer; we will consider all three. Karin Calvert reminds us that as boys matured from infants into adults their costume changed dramatically several times marking age and prerogative cohorts.[12] Although the most decisive change occurred about age six when a boy was "breeched," leaving petticoats permanently to those of lower rank, further adjustments to costume were made as the child gradually achieved manhood. The point of these publicly legible markers was to clarify male systems of deference and dominance by age as well as by class. The specific rhetorics involved fabric, trim, and cut of the outer layers, and the elaboration and form of underlayers visible at neck and wrist. Costume for girls, on the other hand, remained virtually unchanged from infancy to adulthood in form although it varied in materials, corseting, and trim with social class.[13] Modest differences in form marked married as distinct from unmarried status (see Chapter 3), but generally, women of all classes and ages dressed far more alike than did their male counterparts. It mattered more for men (who held power) to mark and clarify degrees of power. Given this broader lexicon, men took care to express themselves, their achievements, and their cohort in their dress. Because portraits marked

family transitions (such as marriage or first issue) and the personal achievements of men among those who anticipated passing wealth on to progeny, they can give us an opportunity to see and sort colonial men as they saw and sorted each other.

MODEL MEN

How, we can ask, did Copley's tumultuous generation define model masculinity? What tales did they tell themselves about themselves in their documentation of their lives as representative, honorable, role-model-worthy men? Our answer to that question—if we use Copley's portraits as a gauge—is that a rather wide spectrum of variant models were available to men of wealth and power during the Revolutionary decades. Being attentive to posture, costume, accoutrements, and gaze in these half-length canvases depicting a single male figure, one finds several fairly clearly defined types of men, ways to enact model masculinity (while also recording, of course, recognizable individuals), and it will be useful to consider them briefly.

Perhaps the smallest group is that representing military men. Erect in posture, direct in gaze, with weight equally borne by both feet, such commanders of armies as General Thomas Gage wear classic eighteenth-century gentry male clothing (fig. 37). As befits men of action, they wear their own hair (pulled back and tied), and their coat cuffs are abbreviated, but in the width of lapels, length of coat and waistcoat, the superfluity of gold thread ornamenting oversized buttonholes, and the presence of a wide linen ruffle at the wrists, these men signal their membership among the elite.[14] Moreover, in directly supporting their own weight (rather than leaning) they inhabit and sustain an older idea of masculinity, one that asserts its power directly (see Chapter 5, and fig. 54). They carry appropriately martial attributes, primarily swords, spyglasses, and, as in the portrait of General Gage, batons. The sites and instruments of their exploits (in this case a small regiment of foot soldiers and cavalry) fill the expressive void in the distance in typically perspective-less Copley fashion.[15] Gage was a commander of British forces, a fact that reminds us that Copley—insisting on the apolitical nature of the artist's position—painted *both* sides in the increasingly unreconcilable camps during the 1760s and 1770s, decades marked by violence and aggression, both orderly and disorderly, as much as by Enlightenment concepts of the freedoms and Rights of Man.

Second, and a somewhat larger group, are those portraits recording merchants (and some artisans) as men of opulence and fashion whose dress borders on the splendor of the dandy. Comfortably seated with their lower bodies at complete ease, their legs crossed, and their arms relaxed, the gaze of these hawkeyed merchants, nevertheless, portrays alertness and complete engagement in the here and now. Nabobs like Nicholas Boylston elected for their portraits an air of informality, even intimacy, projecting, in their billowing floral silk banyans, satin waistcoats, and velvet skullcaps, an image of relaxed exoticism (fig. 38).[16] But lest we suspect these elegant men of indolence or leisure, such accoutrements as the background merchantman briskly sailing toward Boylston, the hefty ledgers near

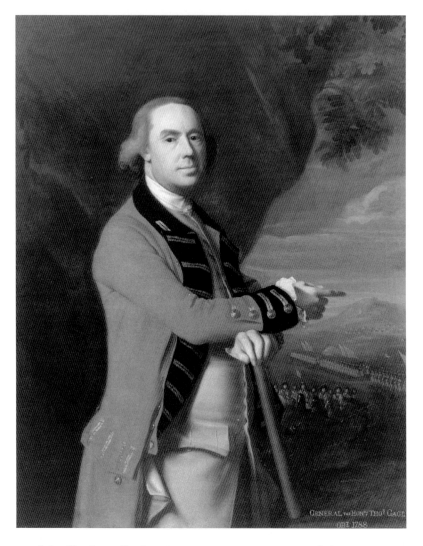

FIG. 37. John Singleton Copley, *General Thomas Gage*, c. 1768. Oil on canvas. 50 ×
39¾ in. (127 × 101 cm). Yale Center for British Art, Paul Mellon Collection.

at hand under his left elbow, and the posture of taut attentiveness and direct eye
contact, all suggest men quickly focused on matters that matter. These are not, Cop-
ley underlines, men mired in self-indulgence and superficial consumption but rather
men to be reckoned with, their richly hued finery an outward sign of financial power,
knowledge of lucrative exotic markets, and entrepreneurial attack.[17] Moreover, con-
temporaries would have recognized in Boylston's costume only superficial infor-
mality; that is, they would have seen the immediate potential of the sitter to spring
to full commanding formality—for his fine hose, breeches, waistcoat, and linens
are all in place, and his head is shaved, ready to accommodate the wearing of the
large powdered wig we do not see but know to be waiting nearby with the appro-
priate tailored worsted outer coat. The damask banyan (also known as an "Indian

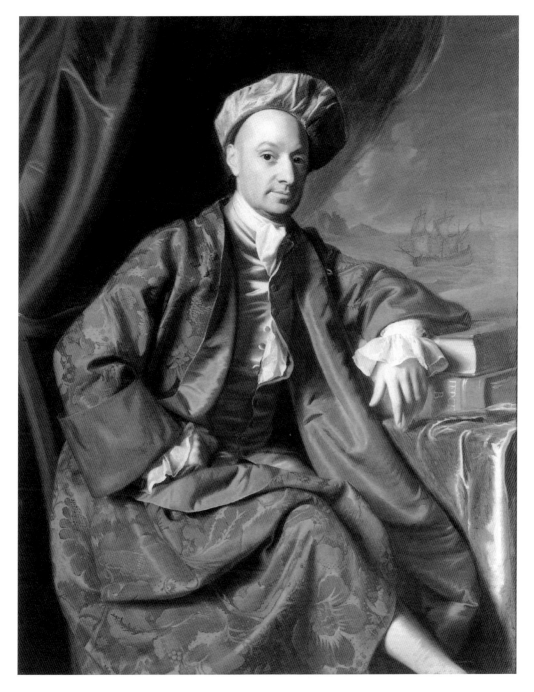

FIG. 38. John Singleton Copley, *Nicholas Boylston*, 1767. Oil on canvas. 49¼ × 39¼ in. (125 × 99.5 cm). Harvard University Portrait Collection, Bequest of Ward Nicholas Boylston to Harvard College, 1828.

gown") is not, then, a bathrobe but a sort of smoking jacket, a garment loose in fit but very fine in fabric, standing in at home for the final layer of full formal male dress.[18] The emphasis in these portraits is on a kind of attentive informality studded with every marker of lavishness. In the narrative of relations, this portrait constructs the viewer as an equal (that is, also seated), an intimate (one for whom a banyan and velvet cap rather than wig and formal outerwear was appropriate), and the moment captured that in which two men exchange views on matters of importance (matters concerning money or politics or both).

A third type of man we find in Copley's portraits—one quite unlike the martial man whose sense of command is at the center of his identity or the opulent merchant whose potential to swiftly move to a formal power position is inherent in his gaze, posture, and dress—the sensitive man appears to disengage the power position altogether. Slouched in contemplative ease, signaling complete physical relaxation, this rare colonial figure, the sensitive man, is so deep in reverie, so outside of that portraited body, that he remains unaware of the presence of the viewer (fig. 39). John Bours's suit is a muted, uniformly greenish-brown very expensive velvet. It has the wide cuffs and long skirts that signal an extremely wealthy man, but no gold thread, shimmering silk, or figured brocade elaborate the uniformity of its absorptive surface or distract our attention from the absorptive mood of the figure. He sits almost profile to his audience; knees crossed, his right elbow hooks the arm of a comfortable mahogany corner chair (a type of seating usually used at a desk) while his left elbow is propped on the flat expanse of the chair's other arm and permits him to touch—and almost support—his head with his left fingertips. Cast in deep shadow and cradled by his palm, that left side of his face is mysterious. His right hand holds loosely a small leather-bound volume in which his invisible thumb marks a place. The book is a duodecimo, that is, the size and format for a book of essays, a novel, a collection of poems. It is not the sort of ledger book we saw under the elbow of Nicholas Boylston. Copley accessorizes most colonial merchant sitters with the heavy quarto and folio volumes in which columns of names, sums, and goods provided a very different kind of daily reading, volumes necessitating two hands and a table, volumes suggesting pen, ink, and active calculation. This little book is held easily in one hand, but it can trigger intense contemplation. We intuit that the sitter averts himself from our gaze not out of unsociability or pique but out of pensive engagement in the deep thoughts and emotions roiled by the words, perhaps the poem, he has just read.

Bours positions himself not as a man of action or calculation but as a man of contemplation and sentiment, a kind of early version of the Romantic figure whose emotional response to and philosophical understanding of ideas, art, nature, and human events are foremost in his character.[19] The life of the mind here is foregrounded and that of action backgrounded. The assertion of power (so clear in the martial images and scarcely cloaked in Boylston) is here oblique, suppressed, although by no means absent. Power here involves thoughts, words,

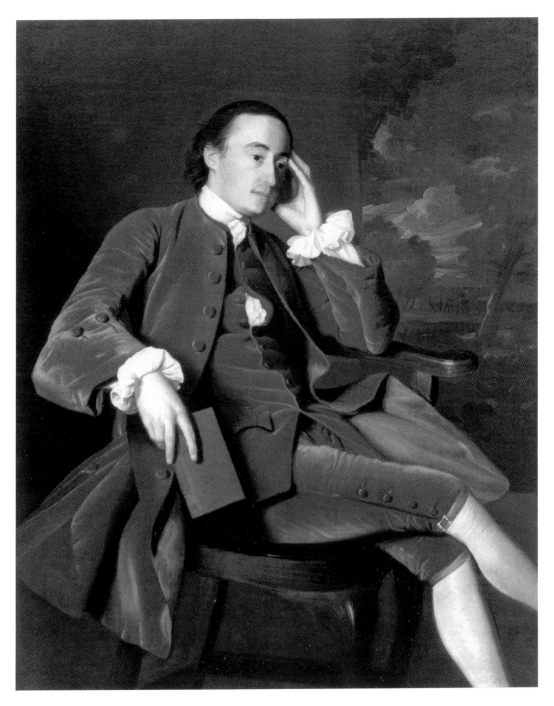

FIG. 39. John Singleton Copley, *John Bours*, 1758–1761. Oil on canvas. 50¼ × 40¼ in. (127.6 × 101.9 cm). Worcester Art Museum, Worcester, Massachusetts, purchased with funds from the bequest of Mrs. Hester Newton Wetherell.

perception, and perhaps sympathy, but not action, force, or the making the most of every opportunity. Above all, Bours's contemplative passive posture signals a capacity, a struggle to understand. Bours was a merchant, but his long-term involvement in Newport's Redwood Library and in the theological as well as the management aspects of Trinity Church suggest that he may indeed have had a contemplative soul as well as a contemplative persona.[20]

Other sensitive males in Copley's repertoire include two images of his younger half brother, Henry Pelham, who turns from the viewer in deep study or quiet contemplation (John Singleton Copley, *Henry Pelham*, around 1760, private collection; John Singleton Copley, *Boy with a Squirrel [Henry Pelham]*, 1765, Museum of Fine Arts, Boston). These are portraits of the artist as a young man—as Henry sought to follow in the artistic footsteps of his talented sibling—and provide us with a sort of alter-ego for the artist himself. We might add parenthetically to this group the black sailor whose task at the apex of the boatful of stretching, pulling, throwing rescuers in *Watson and the Shark* of 1778, is simply *to feel* compassion, "concern and horror," in the words of one contemporary, to contemplate the enormity of the event he is witnessing (see fig. 69).[21] This work was painted some fifteen years later on the other side of the Atlantic in a different genre but nevertheless incorporates an aspect of model masculinity glimpsed in the colonial Bours and Pelham portraits. Life-threatening events such as a shark attack or armed confrontation between British forces and British subjects, called for martial masculinity, but they also called for the *contemplative* man. His job is not to physically act but to absorb and understand the events and present a model of intellectual response for the viewer of the painting for whom contemplation is the only possible role. The contemplative man is the historian and the poet, the thinker and the drawer of inferences. His understanding is not passivity; it has a Burkian scope.

Fourth—and this is also a circumscribed group—there is artisanal masculinity: contemplative, like the sensitive man, like the poetry-reading John Bours, Copley's Paul Revere, the artisan silversmith and patriot, holds his head in reverie but he directs his gaze fully at the viewer. He cradles not a book of abstract or emotional content in his other hand but a silver teapot ready for its engraved inscription or coat of arms (fig. 40). He works at an expensive polished mahogany table but wears his own hair, completely unbuttons his waistcoat, and exposes the linen of his shirtsleeve to our gaze. The penumbra ruff that we saw at the wrists of the soldier, the dandy, and the contemplative man here gives way to the artisan's banded cuff with only the slightest ruffle on the lower edge.[22] Even Revere's competitor, Nathaniel Hurd who associates himself with the merchant gentry in sporting a beautiful red-green silk banyan and shaved wig-ready head, marks his difference by opening his shirt collar (fig. 41). The silversmith makes things, using silver that is money (even when in tankard or teapot form). He is king among artisans, a banker among merchants, a man whose skill is manual but also mental, who works with his hands but is on equal footing with some of the richest and most respected men in town. He is a little cheeky and Copley captures this cheek.[23]

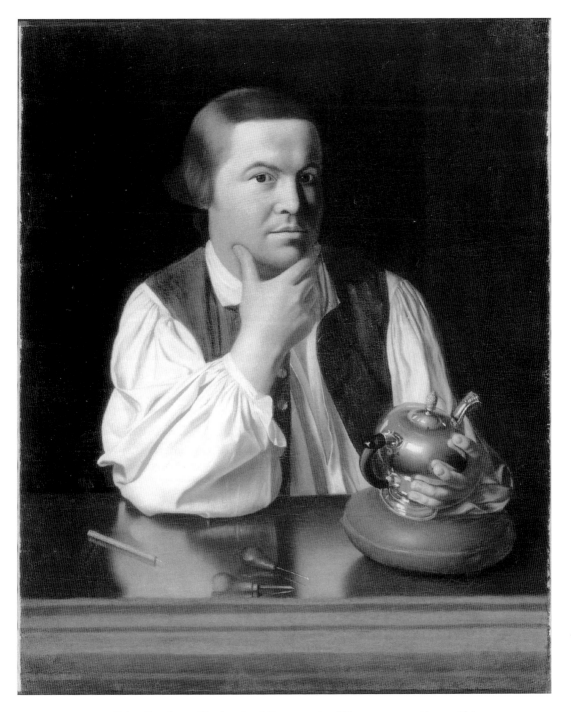

FIG. 40. John Singleton Copley, *Paul Revere*, 1768. Oil on canvas. 35⅛ × 28½ in. (89.22 × 72.39 cm). Museum of Fine Arts, Boston, Gift of Joseph W. Revere, William B. Revere and Edward H. R. Revere; 30.781. Photograph © 2003 Museum of Fine Arts, Boston.

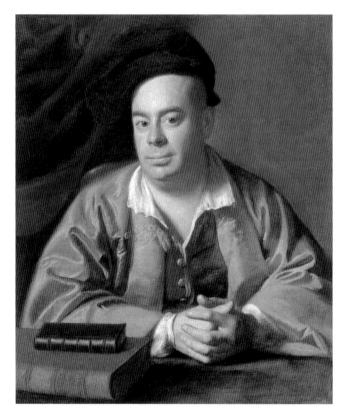

FIG. 41. John Singleton Copley, *Nathaniel Hurd*, c. 1765. Oil on canvas. 26⅛ × 26 in.
(66.5 × 66.3 cm). © Cleveland Museum of Art, Gift of the John Huntington Art
and Polytechnic Trust, 1915.534.

The silversmith, like the painter, tended to the identity of his patrons. As
Copley's step-grandfather reminds us, the universally understood ingredients of
"gentleman" status (especially on the marginal lower edge of this class) in the
eighteenth century were primarily "outward apparrell" and silver—the one to be
visible to all, the second to be visible to one's peers within one's home.[24] The sil-
ver in question was what one could understand to be money made aesthetic and
useful but still money; silver objects were inventoried by weight and they were
often marked on the bottom with their weight, as the value they retained and
represented *as money* was gauged by ounces, grams, and pounds, not the more
abstract concepts of art or workmanship. They were also often marked on the
most visible, central part of the body with heraldic devices within ornamental
cartouches. This second kind of marking, the kind of engraving Paul Revere is
engaged in within the fiction of his portrait by Copley, points not to monetary
value but to identity and bestowal value. When Mary Toppan (see fig. 31) mar-
ried Benjamin Pickman in 1763 (the year Copley painted the young couple), for
instance, Love Pickman commissioned Boston silversmith John Coburn to
make the bride, her daughter-in-law, a teapot emblazoned with their husbands'

family crest. It, and a considerable collection of Toppan silver (already in the mid eighteenth century a century old), became part of a large group of silver objects passing from generation to generation of Pickmans and their kin from the seventeenth century until 1931 when the assemblage was given as a group to the Museum of Fine Arts in Boston (fig. 42).[25] The recognized elements of identity in eighteenth-century colonial English America included personal signature (or certified mark), recognizable physiognomy, name, and, for some, a coat of arms. That so many surviving silver objects from the eighteenth century bear armorial engraved marks is important—this was a specialized language legible and important to the patrons and scribed by the artisans. It was the silversmith-engraver who had the heraldic dictionaries (as we see prominently in the foreground of *Nathaniel Hurd* John Guillim's tome, *Display of Heraldry* of 1724), and necessary engraving skill (as is implied in Revere's contemplative address to the job of applying the engraving tools by his right elbow to the recently completed teapot cradled against a sand bag in his left hand). From newspaper ads, we understand that purloined objects marked with initials or arms were easier to identify and perhaps recover (which may be one reason for emblazoning silver and initialing linens), and from the corpus of surviving provenanced objects we can infer that marked objects became generationally transmitted markers of continuing family lines. Thus, silver objects—especially large forms like Revere's work-in-progress or the Pickman teapot, behaved in many ways like portraits—they marked gentry status, they were associated directly with the identity of the men

FIG. 42. John Coburn, Teapot with Pickman Arms, c. 1762. Silver. H. 6½ in. (16.5 cm). Museum of Fine Arts, Boston, Gift of Mr. and Mrs. Dudley Leavitt Pickman; 31.239.

(and occasionally the women) who commissioned, owned, used, and bestowed them, and they passed between generations as markers of memory, and family continuity. Unlike portraits, however, they retained their cost as monetary value. The silversmith, then, was not only a banker of sorts, he was also, like the portraitist, an identity-broker within the longitudinal construct of the patron's family line.

That Revere and Hurd had their portraits painted is a fact in itself that positions them among those with wealth and "name," that is, dynastic perspectives concerning that wealth.[26] But it is interesting to note that although Revere, Hurd, and Copley himself in his self-portrait of about 1770 sport some of the most vibrant apparel we also see on the most opulent merchants—both Hurd and Copley wear silk banyans—none of these three artisans wears the linen that appears so consistently to mark the costume of their patrons (see figs. 16, 40, and 41). They lack most conspicuously the wide gauzy ruffles at the cuff which, I suggest, served to underscore the fine degrees of gesture with which men of power indicated deference and precedence among themselves (see Chapter 3), and they lack the long stock tie that uniformly cordons the necks of Gage, Boylston, Bours, and their peers (whatever else their differences in costume and personal identity) and that embodies and remembers the prerogatives of "equestrian" even in an urban pedestrian context. The ruffled cuff that introduces the hand, and the stock that frames the head—these appear to be the *sine qua non* of gentry male self-presentation among Copley men. Copley's *Hurd, Revere* (and other artisans) may wear silk robes and velvet skullcaps, but they display their linen in a fashion that would have been conspicuously "artisan" to contemporaries.

In sum then, to a degree, the emblazoned silver teapot is like the portrait, and the silversmith is like the portraitist in supplying identity-vehicles to patrons who needed those vehicles to define themselves as individuals and as agents within family lines. Silver also commemorated (as portraits such as those commissions of the Louisbourg heroes also did) singular achievements and incidents that loomed large in a public and regional sense of identity and solidarity (see fig. 54). Perhaps the best-known (and most reproduced) silver object made in colonial English America is that commissioned in 1768 to memorialize the solidarity of the ninety-two members of the Massachusetts House of Representatives against the incursions of the Crown, in what that body believed was the defense of Magna Carta and English Liberties (fig. 43). They commissioned a great bowl (made of three pounds of Spanish silver) from the hands of Paul Revere. This was a most important commission—to make an object that would celebrate and, in its engraved embellishments, emphatically mark the identity and the solidarity of a cohort of elite men who would then gather and re-perform solidarity (by drinking from it). The Liberty bowl also reminds us that while gentry *women* expressed their Revolutionary fervor by laboring at huge spinning and weaving gatherings to make cloth and blankets for the Continental army, the newspaper accounts of gentry men's patriotic gatherings focus not on production but on *con-*

FIG. 43 Paul Revere, Sons of Liberty Bowl, 1768. Silver. H. 5½ in. (14 cm). Museum of Fine Arts, Boston, Gift by Subscription and Francis Bartlett Fund; 49.45, Photograph © 2003 Museum of Fine Arts, Boston.

sumption, especially on the consumption of great quantities of rum from bowls such as this (in offering stirring toasts to freedom) and the consumption of a great deal of roast pig.[27] Revere's Liberty bowl memorializes bravery of an unmartial kind, the bravery of a merchant elite willing to risk their homes, their ships and all their goods, to put into doubt their expectation to pass on to their progeny their labor and expertise in the form of accumulated wealth. Many men, Henshaw among them, took this risk and lost substantially, ending their days boarding in the homes of others in provincial towns, while the British appropriated their homes and warehouses. It was at the time of this important commission of a silver bowl that is also a defiant public document that Revere commissioned Copley to paint his portrait. His mien is that of a player, certainly an artisan but also a man among men. He positions himself as a man with achievements to mark just as his patrons so identified themselves in commissioning their portraits.

We have looked thus far at several disparate models of identity among Copley's men: the military commander, the opulent merchant, the sensitive man, and the artisan. The first three present the viewer with very different costumes, postures, and address to the viewer but they are uniform in the use of linen (the stock tie and the ruffled cuff), and unlike in this respect the successful painter and the silversmith whose identity overlaps at many points with the patron group. There is one further group to consider—the large group of substantial but not visually extravagant merchant portraits within which *Joshua Henshaw* figures. Copley's merchants and professional men generally wear wigs, uniformly dark suits, and direct gazes. Half relaxed and half attentive, they sit or stand with grave dignity. They

are associated with account books, ledgers, and letters, the outward signs of unpicturable wealth. Many of the conventions that Copley uses to depict their position, their wealth, their power, their dignity, and their masculinity derive from those developed in Italy and used to depict *its* merchant aristocracy, conventions and ideas exported to the New World in the early eighteenth century along with Italian accounting systems, Italian building traditions, and Italian velvets.

COPLEY'S *HENSHAW*

Copley's *Henshaw* falls centrally into this large category. He stands, leaning slightly against a support cloaked by a tumble of deep-red damask drapery, which hangs from a great height. This drapery suggests grand architecture even in the absence of architectural or spatial cues. He wears a dark-brown suit, the waistcoat opened slightly, where, we learn from other portraits, eighteenth-century gentlemen often inserted and rested the right hand. Pictorially, this bright sliver of white relieves the somber expanse of his body and points our attention to his head. The two areas of highest value (spotlit by a crisply bright, unseen single light source in the upper left) are his head and his right hand, beautifully painted and set off from the darkness by, as we have learned to expect, a wide ruffle of the finest translucent lawn. Such ruffs, as noted earlier, emphasized the motion of the hands, which, we learn in etiquette manuals, gave finely calibrated signals of greeting, inquiry, dismissal to other males who were equally finely tuned to comprehend this gestural shorthand. As Lord Chesterfield advised his son: "Take particular care that the motions of your hands and arms be easy and graceful; for the genteelness of a man consists more in them than anything else."[28] Older and younger men of the same station, men of lesser station, all governed themselves by these mime signals, asserting authority or granting deference or obedience. Henshaw and his fellow patriots believed in and risked all for what they called *equality*, but it is not what we call equality.

Henshaw's left hand is gloved and appears to hold another glove. But this hand is strangely formed, shadowed, indistinct. Most telling, it is set off from the coat sleeve by *no ruffle*. This hand does not signal. Perhaps paralyzed, or otherwise impaired, this hand is treated differently from other hands in Copley's repertoire, but it is not hidden—neither Copley nor his patrons were in the habit of hiding things (portly bellies, hairy moles, triple chins—they are all there in the record as they were, we can assume, on the bodies of his sitters). No verbal record survives to help us understand this hand but Copley's record seems sufficient: it is impaired.

Almost invisible above the left hand and under Henshaw's arm we can just make out a hat of the sort carried and worn by British and American men. Gentry men do not wear their beaver felt hats in Copley portraits, although they sometimes carry them, having, in the fictive narrative of the painting, removed them from their heads in a gesture of respect to the viewer, presumed by this sign

to be a male of equal or greater stature. The doffing of headware, with accompanying bow, was the most emphatic gesture of deference available in their lexicon of movements and gestures. These hats were made from the pelts of New World beavers whose fur was the only material that made a felt that would retain its shape when wet, that is, the only hat suitable for males who might go out into the rain anywhere in Europe or its colonies throughout the world. The beaver pelt then, became, from the earliest years, coin of the realm in the Atlantic trade, and was responsible for the fierce international competition for control of waterways and Native American alliances in the interior, for it was the Native Americans who hunted the beaver and used this beaver-pelt capital to acquire goods and power from the French, British, and American governments and trading companies.[29]

Henshaw's head is surmounted not by his hat but by an impeccably tidy wig. It sits on his shaved head with elegance and balance. Brushed, powdered, curled like a kind of sculpture, it frames his features and, we can conjecture, impedes spontaneous or nonvertical movements. In other words, it acts to keep the carriage erect and dignified, as its mismanagement could only lead to embarrassment and the kind of buffoonery exhibited in such works as William Hogarth's *A Midnight Modern Conversation* (fig. 44). Wigs, like gestures, involved and signaled a finely-calibrated hierarchy of differences between males. As far as I can discover, women in colonial British America did not wear wigs, but men most certainly did—Loyalists, patriots, merchants, and artisans found them essential to their iden-

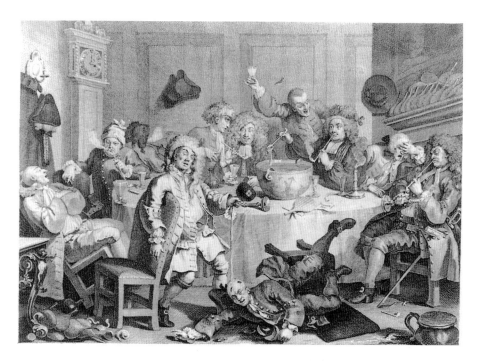

FIG. 44. William Hogarth, *A Midnight Modern Conversation*, 1733. Etching and engraving. 13⅜ × 18⅜ in. (34.1 × 46.8 cm). Lewis Walpole Library, Yale University.

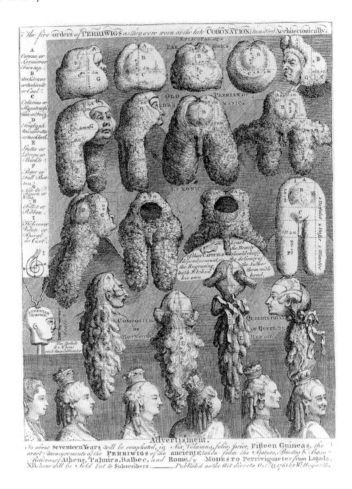

FIG. 45. William Hogarth, *The Five Orders of Periwigs as they were worn at the late Coronation measured Architectonically*, 1761. Etching. 11⅞ × 8⅝ in. (30.1 × 22.2 cm). Lewis Walpole Library, 761.10.15.1.2.

tity and their dignity. In standard parlance, Henshaw's is a "physical" wig, a type favored by the older, wealthier of Henshaw's peers, that is, in Jonathan Swift's coinage, by Boston's "bigwigs." In his *Five Orders of Periwigs*, William Hogarth, the British artist and theorist, pokes fun at the business of wig-wearing, establishing a typology akin to the Five Orders of Architecture, each order governed by minute rules of form, proportion, and appropriate use (fig. 45; see also fig. 83).

For Henshaw, the wig expresses a formality and a regularity that we understand to be integral to his character. For Copley, the wig affords the artist an opportunity to lay tiny rhyming scrolls of white lead paint on top of a smoothly rounded mass that reads as perfected hair, a kind of painting that differs in technique from that used elsewhere in the image. The artificial snowy wig frames the sitter's face just as the fluid gestural strokes of the cuff ruffle frame his hand, and the gilt Rococo carving of the frame frames the portrait as a whole. The wig

is a frame within a frame, a penumbra that—in its absolute order, predictabil-
ity, and categoricality—signals abstract concepts of power and generic maleness
in contrast to the singular features it embraces that mark human uniqueness and
individual nameable identity. Marcia Pointon further associates the wig, "this pros-
thetic ambiguity," with concepts of male potency, as a "potentially disorderly site
of sexuality."[30] In *Joshua Henshaw,* disorder of every kind is kept at bay; it is per-
mitted to inhabit only the corners and edges. Masculinity as a controlled and
controlling cultural construct, however, figured in that steady cloud of white-
ness, is very much at the center of things.

In its tone, costume, accoutrements, disposition of the forms, coloration,
and direct address to the spectator, *Joshua Henshaw* is characteristic of the vast
majority of Copley's men. These men are neither flamboyant nor contempla-
tive; they do not insist on the outward signs of international power and wealth,
exhibiting instead relaxed posture and muted suits, but they do seem to insist
on a canny mien, an alert engagement with the world, and they wear all the ele-
ments of costume (such as wide cuffs on their coats and appropriate linen) that
mark them unequivocally as gentlemen. That these portraits are about individ-
ual personal identity and group gentry identity is pretty straightforward. That
they are also about individual achievement and family line is the argument of
this case study. That they have a somewhat uniform look I will broach first.

It has been noted by others that this, the largest group of Copley's male
portraits, has a sameness about it: although the faces and hands are carefully indi-
viduated, the dark coloration, spotlit head, and leaning posture constitute a kind
of reiteration.[31] One could easily note that the members of any group tend toward
social mimicry—the dark suit is even more a recognizable "uniform" of urban
business today than it was in the eighteenth century. Perhaps more important,
however, Copley had a problem inherent in his working method, which this move
toward pared-down visual elements may have been designed to help resolve. As
was discussed in the last chapter, and as his colleagues Benjamin West, Gilbert
Stuart, a professional model, and others in a position to know, commented, Cop-
ley's painting technique was unusually "tedious."[32] It took him much longer to
complete a portrait than it took others in his trade and, in some cases, than his
patrons would tolerate, resulting in inconvenience, annoyance, and complaints
on the part of both the artist and his sitters. In 1768, for instance, Copley com-
plained of one male sitter: "if Mr. Rogers could have spared time to have sat as
I found occasion for him, but the preparations for his Voyage to London took
up so much of his time as to leave me to the disagreable necessaty [*sic*] of fin-
ishing a great part of it in his absence," and "I was Obliged sometimes to beg
sometimes to scold in order to" have his presence at sittings.[33] On the other side,
Joshua Wentworth of Portsmouth, New Hampshire, wrote in some pique con-
cerning portraits Copley had begun of himself and his wife: "After Mrs. Went-
worth had set many days, and myself one, . . . and my business call'g me hither,
[I] was oblig'd to leave Boston, without a finish of either Portrait."[34] Note that

Mrs. Wentworth "had set many days" while the patron had sat only one. This episode suggests how it is that those portraits in which one senses something off about the anatomy, or proportion of the form, are portraits not of women but of men.[35] Busy merchants apparently could sometimes give the artist less of their valuable time than their wives, and much less time than the artist felt he needed. The general simplification of figure, pose, setting, costume, and accoutrements that one finds in the large group of portraits of men that includes *Joshua Henshaw* may be Copley's attempt to solve this ongoing source of conflict with those on whom his income and potential future commissions depended.

So Joshua Henshaw's portrait belongs to this rather large class of images of successful men whose dark suits and unspecific settings understated the wherewithal the commission itself implied (or at least understated it in comparison to, for example, *Nicholas Boylston*). As noted, though, portraits of men were not just about money, position, and individual faces, they were also about family line, especially the stability of family, and about personal achievement. What achievement might Henshaw wish to fix and commemorate around 1770?

Henshaw was, at this time, in his seventh decade, but he was by no means retired from business or public life; indeed, a commemoration of his embroilment in the events of that season of Revolution might well have been an important rationale behind the commission. It happened not in his youth or in his middle years but at this juncture—when political tensions, sanctions, and consequences were escalating, when laws were being disobeyed, taxes not paid, property was being impounded, and citizens shot—that Joshua Henshaw came to Copley for a permanent record of his identity.

I will briefly summarize Henshaw's participation among the merchants and professionals of Boston as they edged their way into armed conflict with their government. In 1761, Henshaw was among the ninety-seven merchants who signed a petition to have the lenient Benjamin Barons restored as Collector of Customs for Massachusetts.[36] Henshaw was a distiller and—like outright smugglers such as Thomas Boylston—had reason to support anything or anyone who might look the other way at the entry of French molasses and other goods from non-English West Indian ports into Boston.[37] In 1765, while serving as Selectman of Boston, Henshaw formally joined with others in a gesture to applaud and commemorate the apparent pro-colonial stance of several members of Parliament with a letter of gratitude and the commission of their portraits for Boston's market house, Faneuil Hall "as a standing monument to all posterity."[38] Later that year, as chairman of Boston's Board of Selectmen, he joined with others in forcing Andrew Oliver to resign the "obnoxious office" of Distributor of Stamps, and was subsequently appointed to join with others in pressuring the governor to reopen the law courts.[39] Just over a year later, in January 1767, Henshaw signed the petition of the proto-patriot Boston Society for Encouraging Trade and Commerce to the House of Commons to lift prohibitive duties on foreign sugar and to permit direct trade in wine, olive oil, and fruit from the Iberian peninsula.[40] In 1768,

he was appointed to a committee to meet with Governor Bernard and clarify a "misunderstanding" about the impounding by the Crown of a sloop, "The Liberty," owned by prominent merchant (and Copley's neighbor and patron) John Hancock, and he subscribed to the Nonimportation Agreement.[41] In September of that year, twelve British men-of-war sailed into Boston harbor, anchored off the North End, and billeted hundreds of troops on the town causing friction at every turn with the citizens and the town authorities (see figs. 14 and 17). Henshaw, a high-profile Boston Selectman, was, according to the chronicles, "an able man, a firm 'Son of Liberty,' and [he] left nothing undone which would make the condition of the soldiers uncomfortable."[42] The next year he was again appointed to a committee, this time to "vindicate" Boston from "the false and injurious representations" made "to the Home Government by Gov. Bernard, Gen. Gage" and others, and he is present on the "Alphabetical List of the Sons of Liberty Who dined at Liberty Tree, Dorchester, August 14, 1769," and, no doubt, drank toasts there to that fraternal band from Revere's newly made Liberty Bowl (see fig. 43).[43] As a member of the House of Representatives, he was chosen to sit on the Governor's Executive Council, but, as an outspoken patriot, was rejected by the Governor. In the spring of 1770, the Boston Massacre occurred and Henshaw was appointed to a committee to request the governor remove royal troops from the city.[44] I rehearse this catechism of patriotic committee action to indicate two things: (1) the cohort nature of patriot protest and (2) the incremental and ongoing nature of almost a decade of political and personal tension for Henshaw, nine years of public exposure to the consequences of his positions and petitions: a full decade during which he had "left nothing undone" which might make the Governor or the Crown "uncomfortable." This list of public protests and patriot-cause committee assignments provides the public half of Henshaw's reasons for wishing to mark the months around 1770 with a permanent document of his identity at the time of his earnest and risky efforts on behalf of colonial interests. He had much to lose: among the 439 merchants in Boston in 1760–1776, Henshaw ranks fifth on the real-estate tax list of 1771 that one scholar uses as a measure of their comparative wealth.[45] And Henshaw was not alone; of those who stood beside him in protest against Crown policies and actions, many came to Copley's studio during these tense months (as did Governor Bernard, General Gage, and others eager to mark *their* active commitment on behalf of the Crown).

If we can attribute the timing and the somber look of this portrait at least in part to the sitter's participation in and commitment to the momentous events of the day, we must also look to those other, even more powerful functions portraiture was called on to perform within the privacy of the family in eighteenth-century British America to fully understand *Joshua Henshaw* either as an individual artwork or as an exemplar of its kind. Joshua Henshaw had married Elizabeth Bill in 1733, the only surviving child of Richard Bill (1685–1757), who was at that time "an influential and opulent merchant"; the wedding was marked by remarkable gifts.[46] Subsequently, Elizabeth's father gave to the couple a house on Sudbury Street

and sold his son-in-law Spectacle Island in Boston harbor (see fig. 50), apparently key ingredients in the extremely high real-estate tax Henshaw paid in 1771.[47] Richard Bill died in 1757 and among his effects to pass to his son-in-law was a portrait of Bill in his prime, painted by John Smibert in 1733, the year of the alliance of Bill and Henshaw fortunes (fig. 46).[48] A portrait of Elizabeth Bill, made at the same time, survived into the 1860s but is currently unlocated; the preexistence of this image suggests one of the reasons why Henshaw did not commission one of his

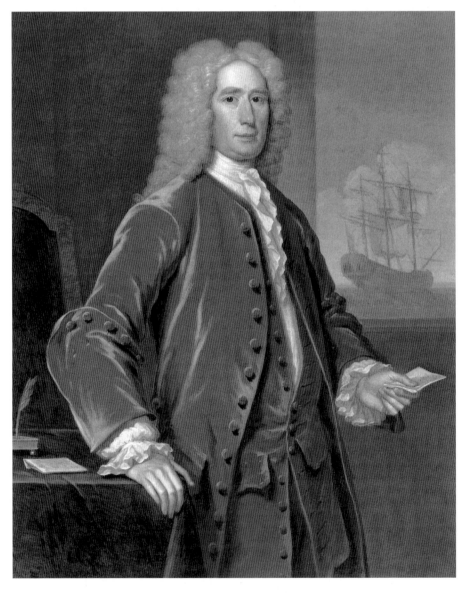

FIG. 46. John Smibert, *Richard Bill*, 1733. Oil on canvas. 50¼ × 40¼ in. (127.7 × 102.2 cm). Art Institute of Chicago, Friends of American Art Collection, 1944.28, reproduction, Art Institute of Chicago.

wife from Copley about 1770 when he bought his own image.[49] So we can imagine Joshua Henshaw looking daily for two decades upon Smibert's magisterial record of a man whose memory he (and his wife) had reason to keep alive. Henshaw, then, in commissioning his own portrait in an identical half-length format, was providing an answering visual text, and an extension of the project of family memory already begun from the distaff side. His portrait and those of his wife and father-in-law (by Smibert) would form the core of a group of portraits that would also include the four Copley heads of his son Joshua, his daughter Sarah, and their two spouses, also commissioned about 1770. What I am proposing is that *Joshua Henshaw* was not intended as the stand-alone object it has become, a free-floating signifier; rather, at the moment of conception, it was already deeply embedded in issues of memory, history, and family context, and at the moment of execution, it was already one object intended for insertion within a three-generation ensemble of eloquent similar objects.

FRAMING THE HEAD

As noted earlier, portraiture is about personal accomplishment, but, even more, it is about the family line; its job is to fix and stabilize the idea of family in its diachronic dimension. Let us begin our consideration of this aspect of the image by turning away from the illusionistic canvas to attend to the sculptural three-dimensional frame. This elaborate structure sets it (and him) off from, and appears to operate by different rules than, both those rules we see in the image and those governing the real world of quotidian objects which would have shared its domestic space and which now share its exhibition space. Perhaps most notable, the gilt exuberance of the frame somewhat qualifies and relieves the dark sobriety and fixed dignity of the figure. Almost certainly made in Boston and made explicitly for this commission, it is carved of eastern white pine and water-gilded with thin sheets of gold.[50] In form it is Rococo, that is, an open-work, light, busy assemblage of rocaille C and S scrolls with two miniature ogee scrolls of the sort associated with a broken pediment, bracketing the top edge. The whole confection appears light and dematerialized at the same time it also appears very sculptural. Tumbling down either side are a pair of garlands of flowers and fruits, suggesting the tug of gravity on a structure that otherwise seems weightless. This assemblage of natural and shell-like abstract forms is elaborate, full of implied movement, breaking like seafoam over the edge of the rectilinear inner frame and outward into the space of the wall it inhabits and enlivens. It seems to exhibit a vocabulary of ornament that comes out of a different aesthetic than the painting; although three-dimensional, it seems less "real," seemingly less substantial, than the illusion it contains. Within the image the only elements that echo its abrupt curves and plastic fluidity are the drapery that closes off the left side of the picture and the right sleeve ruffle halo-ing Henshaw's right hand.

Among the three types of frames Copley ordered for and sold with his portraits ("Dutch" ebonized molded frames, baroque relief carved and gilt frames, and Rococo carved gilt frames with sculptural openwork and undercut ornament), this falls into the last, most expensive category.[51] Copley paid his specialty suppliers for these wares (and charged his patrons) as much as half the sum he charged for painting the portraits they contained and supported.[52] The frame that was supplied for *Joshua Henshaw* is even more elaborate, more singular, than those for which a record of sale survives.[53] Surmounting the Henshaw frame is a cartouche, a coat of arms that interrupts the fluid gilt deep relief-work with a shallow-relief somber coat of arms—a red shield on which three gilt birds perch in profile and above which another, larger, bird sits.[54] The language of heraldry is a different language from the sculptural language of the frame or the illusionistic language of the painting. It is an older language, developed to mark and identify knights whose faces were obscured by, or invisible within, their armor. It was used on shields, on banners, and on tombs.

The language of heraldry was alive and well in seventeenth- and eighteenth-century Massachusetts. It did not mark warrior shields, but it marked ownership and lines of descent on silver objects (as noted earlier) and it marked death.[55] If individual identity is indicated and proven in our culture by unique face, signature, name, fingerprint, DNA, government-issued picture ID, in Henshaw's it was proven by unique face, signature, name, and pedigree. And that pedigree was not a matter of empty boast that these men knew their origins and their origins were elite, it was a claim their ancestresses had not been adulteresses and it was an accounting of the right and just descent of land and money from male patriarch to rightful male heirs. Its job was to exclude marginal claimants to things that mattered.

In medieval and early modern England, coats of arms were awarded to individual men and devolved by descent only upon the eldest son. In the New World, where rules of primogeniture in law and custom dissolved almost immediately, coats of arms were soon understood to devolve upon and signify not individuals, representing in the body of a single person in each generation a "house" and line, but whole families, incorporating the idea of a "house" and line with the family name. Coats of arms were used most publicly and most prominently in colonial New England on hatchments.[56] A hatchment is a painted lozenge and, by that shape as much as by its contents, declares that it defines identity in different terms than the linear signature, or the rectilinear portrait. Its pictorial language, in a two-dimensional diagrammatic shallow-relief shorthand, describes a kind of résumé, to a certain degree, of the individual, but also, by the eighteenth century in the Anglo-American context, of the family.

Christian Remick's watercolor of Boston Common—painted in October 1768—records the billeting of hostile British troops at the center of Boston, the three houses that became Copley's property, and—most important for our purposes here—the house of John Hancock above the door of which a lozenge-

shaped hatchment announces to the populace that the household has suffered a death, and possibly the specific identity of the decedent (see fig. 14). In Protestant Europe, these painted memorials hung above the door of the decedent's house for some weeks and then were brought to the church where they hung as memorials of individual lives, understood to be still present within the community of worshipers (fig. 47).

If much about Henshaw's portrait is characteristic of Copley's many records of prosperous Boston merchants, the crest so squarely situated above Joshua Henshaw's face is extremely unusual. It is, in heraldic terms: "Argent, a chevron sable between three moor-hens proper; . . . Crest, a falcon proper billed or beaked and membered sable, preying upon the wing of a bird, argent. Motto: 'To be, not to seem.'"[57] In shallow relief, it is chromatically bold in its gold profile birds and chevron on a vermilion ground. Unlike the three-dimensional gilt language of the frame and unlike the two-dimensional illusionistic language of the painting, this crest is pictorial but also abstract. Situated directly

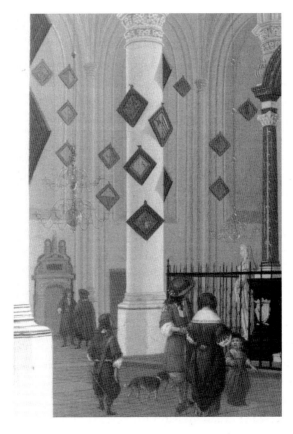

FIG. 47. Detail of Hendrik Cornelisz van Vliet, *The Tomb of Admiral Jacob von Wassenaer in the Choir of the Jacobskerk, at The Hague*, 1661. Oil on canvas. Bowdoin College Museum of Art, Brunswick, Maine, Museum Purchase, Florence C. Quinby fund, in memory of Henry Cole Quinby, Class of 1916.

above Henshaw's face, it expands his specific and individual identity, merging it with that of his familial cohort, and referencing an abstract genetic diachronic continuity.

Most, when seeing this armorial crest on the frame of the portrait of an eighteenth-century American merchant and avid patriot, conclude that this apparent claim to aristocratic background is dissonant, pretentious embroidery or, if representing true aristocratic descent, is irrelevant to the identity of a distant descendant. This is not the case. To understand the rationale for and relevance of this prominent feature on Henshaw's portrait and in Henshaw's identity, it is necessary to look backward three generations to events that the sitter would have understood to be integral to his name, his being, and his residence in the New World. It represented not only an ancestry of origin but also, for Henshaw, would have stood as a sign of a complex unresolved narrative, involving betrayal, theft, abducted orphans, and, apparently, murder.

Joshua Henshaw's great grandfather, Sir Joshua William Henshaw (1610–1644) owned lands in nine counties and a hilltop house where he resided at Toxter (aka Toxteth) Park in Lancashire, overlooking Liverpool (fig. 48).[58] He married, about 1637, Katherine Houghton, an heiress (that is, the only child and a female child of a man of substance) who brought to the marriage an even more substantial pedigree, further lands including property in Liverpool and—next to Toxteth Park—Wartre or Wavertree Hall, a mansion and estate that survived into the nineteenth century and was reputedly highly praised by that enthusiast of late medievalisms, Sir Walter Scott (see family tree on page 97) (fig. 49).[59] The couple resided at Wavertree. Joshua and Katherine had two children—Joshua and Daniel—born in the early 1640s. But in 1644 the young father, fighting on the side of Cromwell against Charles I, was killed in the Civil Wars, as was his father-in-law. A few years later, in 1651, his young wife died, leaving the boys orphans at ages six and eight.[60] There were no grandparents, aunts, or uncles to look after the interests of the boys, and in 1652 they were "fraudulently abducted" by the steward of the estate (a collateral relative), Peter Ambrose, who "sent the boys Joshua and Daniel out of England for the purpose of getting possession of their property; for before they were sent away they had lived in his care and on the estate for several years, and after their departure he retained possession and died in the occupation of the estate, Wavertree Hall."[61]

The narrative includes this extraordinary footnote: "The family tradition is, that the Rev. Richard Mather, who came from Lancashire, England, had the care of them, and of the money sent with them, for their support and education, and for setting them up in business."[62] Records indicate that Richard Mather, founder of the Puritan dynasty of divines, was, at the age of sixteen (being without funds to enter Oxford), sent "against his will to teach at the grammar school at Toxteth Park, Lancashire." [63] Four years later, in the spring of 1618, he entered Brasenose College, Oxford, and was subsequently recalled as minister at Toxteth Park, serving in that newly built chapel for fifteen years, eventually

FIG. 48. Fisher Son and Co., *Liverpool from Toxteth Park*, 1834. Engraving. 7⅜ × 9¾ in. (18.7 × 24.8 cm). From Edward Baines, *History of the County Palatine and Duchy of Lancaster*, 4 vols. (London, 1836), frontispiece. Huntington Library, San Marino, California.

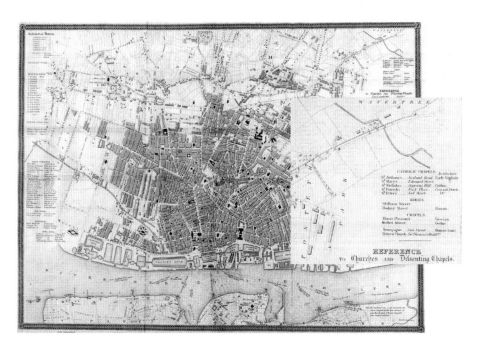

FIG. 49. B. R. Davis, engraver, Fisher Son & Co., printer, *Liverpool and Its Environs Including the Cheshire Coast*, with detail inset, 1836. Engraving. 7¼ × 9 in. (18.5 × 23 cm). From Edward Baines, *History of the County Palatine and Duchy of Lancaster*, 4 vols. (London: 1836), p. 55. Huntington Library, San Marino, California.

being "deposed" for nonconformity.[64] During the long period he was at Toxteth Park, Mather would certainly have been acquainted with the affairs of the Houghton (Stanley) and Henshaw families, among the district's principal landholders. In Toxteth Park during the early years of the seventeenth century, Mather was taught by and boarded with Edward Aspinwall, the uncle of Peter Ambrose.[65] It was presumably on the strength of this connection that Mather was enlisted in the efforts of Ambrose to defraud the children. It would have been difficult for Mather, given his longevity and his central position in both Toxteth Park in Britain and in Dorchester in Massachusetts to have *not* known the identity of Daniel and Joshua Henshaw, to have *not* been complicit in the plot. Yet he was a godly man. Perhaps, believing strongly that the future of Christ's true Church lay only in the New World, he understood the boys' souls to be better served in New England where, were they to be among the Elect, they would be ready for Christ's imminent second coming. In contemplating his own emigration, Mather wrote "the Removing from Old-England, to New . . . [is] not only lawful but also necessary," a move from "a Corrupt Church to a purer," "from a place where the Truth and the Professors of it are persecuted, unto a place of more quietness and safety," above all, away from a place "infected with an abundance of sin and sinners" from which men of conscience "are bound to preserve their Children."[66]

In 1635, Richard Mather had left Toxteth Park and embarked from Bristol on the *James* with his wife and sons, arriving in Massachusetts during the Great Hurricane that wreaked havoc on the forests, the Native American villages, and shipping in the area.[67] He became pastor of the Dorchester congregation (while also keeping in contact with the Lancashire congregation) and would have been settled in Massachusetts some sixteen years when young Joshua and Daniel were sent to Dorchester in 1651.[68]

We know little of the shadowy steward, Peter Ambrose except that he was styled "Peter Ambrose of Toxteth, Gent.," and he came from a family of vicars and schoolteachers (most educated, like Richard Mather, at Brasnose College, Oxford), several of whom had borrowed money from and owed their preferments to the Houghtons, that is, to the orphans' maternal family. Between 1650 and 1660, Peter Ambrose was appointed the Sequestration Agent for Lancaster County, and ruthlessly impounded the rents, mills, horses, and other goods of Royalists to fund Cromwell's armies and fortification construction campaigns. Apparently, Ambrose garnished these considerable revenues as the heirs of at least one beheaded Royalist whose properties were so despoiled sued him and his heirs personally for more than a thousand pounds.[69] This gentleman-ruffian had run afoul of his neighbors and civil authorities as early as the 1630s and, in the heated uncertain 1650s, he apparently found it prudent, expedient, and probably economical to ship his own two sons—Nathaniel legitimate and Joshua illegitimate—to the colonies where they both graduated from Harvard in the class of 1653, returning to Britain shortly after to take up vicarages in their

native county.[70] While in Massachusetts, their college fees were paid by Mr. John Glouer [Glover] of Dorchester.[71] John Glover was from Lancaster, and one of three Dorchester Company stockholders; he was Selectman and Deputy of the town in 1632–1651, and Assistant in 1651–1654, in other words, one of the principle administrators of a community that taxed its residents to support its minister, Richard Mather, and to support Harvard College.[72] It is probable then, that Ambrose's sons were sent to Massachusetts to be educated at public expense through the offices of their father's former neighbor (and current neighbor of Glover's four sons still in Lancashire), returning to Lancashire to take up ministerial duties about the time the Henshaw boys were sent along a similar route with very different expectations and intentions on the part of Peter Ambrose. It is said that Peter Ambrose, comfortably ensconced at Wavertree Hall, let it be known that the orphaned Henshaw boys had been sent to school in London where they had perished, but in his will of 1653 he included this provision: "Also my will and mind is and I hereby give and bequeath to Joshua and Daniel Henshawe, late sons of William Henshawe, late of Toxteth aforesaid deceased, who are now in New England, so much money as shall make up what already hath 'been' by me laid forth for them and expended for them for their voyage to New England and otherwise, the sum of thirty pounds, to be paid them at such time as they shall have attained full age and shall give a sufficient discharge for the whole thirty pounds."[73] Ambrose, then, knew the boys were alive and knew they were in New England. To ensure their permanent settlement there, he makes modest provision for setting them up in life.

Dorchester in the 1640s was described as "a frontire Town, pleasantly seated and of large extent into the main land, well watered with two small Rivers, her body and wings filled somewhat thick with houses to the number of two hundred and more, beautiful with fair Orchards, and Gardens, having also plenty of Corn-land, and store of Cattle, counted the greatest Town heretofore in New England but now gives way to Boston; it hath a Harbour to the North for ships."[74] Dorchester is just southwest of the Boston peninsula (fig. 50). The English in this place were not alone. Town minutes record bounties for the killing of wolves and, in 1657, the town set aside 6,000 acres for the use of the Indians at Punkapong Pond.[75] A further 1,000 acres were granted for the support of the school to which, no doubt, the young Henshaws were sent.[76] Certainly Rev. Richard Mather or someone similar (with the knowledge of the minister) "had the care of them and of the money sent with them, for their support and education and for setting them up in business." Their presence in the town would have been known to the authorities as both practice and ordinance dictated that "if any person in this town shall entertain any sojourner or inmate in his house above one week, without license from the Selectmen, he shall be fined."[77] It is logical that Richard Mather, who was supported by a town salary of £100 per year, would have been given charge of the boys, perhaps with an additional stipend from Ambrose.[78] Mather probably exerted himself to treat

the boys well as he is said to have himself suffered as a child at the hand of a schoolmaster who was "very severe and partial in his discipline," publicly exhorting those charged with the care of youth to exercise "Wisdome, Moderation, and Equity . . . and seek rather to win the hearts of Children by righteous, loving, and courteous usage, then [*sic*] to alienate their minds by partiality and undue severity."[79] Even so, this was a highly regulated doctrinaire patriarchal community in which "all parents, masters, and all that have the charge and oversight of any youth within this plantation" were required to "catechize their children, servants, and others within their several charges . . . upon such penalty as the Court shall see reason to inflict."[80] Mather's sons were catechized well—they attended Harvard College and became ministers in Northampton, Boston, Rotterdam, Ireland, and England. The Henshaws did not, growing to secular adulthood in Dorchester, but they kept in contact with Rev. Mather even after reaching majority. In 1664, on the accession of Charles II, Richard Mather penned a petition that includes the signature of twenty-one-year-old Joshua Henshaw.[81] Five years later, this young man was evidently living on his own, a bachelor, and was brought by the constable—with fifteen others—to the Selectmen "to take inspection of their orderly walking and submitting to family government" as a law passed that year—probably in response to patriarchal alarm at the growing population of unanchored, "ungoverned," unfathered bachelors— "requiring young men to be looked after, who were not under family government."[82] The next year he married and, in 1676, bought property in Dorchester, assimilating himself into the community he had been reared to understand as his home. Joshua's younger brother, Daniel, also married, went to Canada with an ill-fated military expedition in 1689, the survivors being awarded land in Worcester County to the west of Boston.[83] Daniel was predeceased by his only child and disappears from the record.

Human plots, then (like armorial crests, I would argue), are foundationally about money and identity. The boys grew up in what were probably comfortable Puritan circumstances but they also grew up with a memory of their early years and their early identity as sons and heirs of their parents and of the real estate that went with that identity. In 1688, with this memory in mind, the elder orphan, now forty-five years old, father of seven children, and a successful merchant, made his will and embarked for England to see what had become of his patrimony. The record resumes:

> When Joshua arrived in England he found Joshua Ambrose [of the Harvard class of 1653, Peter's illegitimate son who had resigned his vicarage two years earlier] in possession of, and claiming the [Henshaw] estates, as heir to his father Peter. Mr. Henshaw filed a bill in Chancery against Ambrose, but not being then prepared to prove his paternity, returned to Dorchester [in New England] and procured the necessary evidence. To this bill the defendant put in his answer, and at a subsequent term of the court, in 1690, the plaintiff not appearing, the bill was

FIG. 50. Detail, Francis Jukes after Henry Pelham, *A Plan of Boston with Its Environs,*
1777. Engraving. American Philosophical Society.

dismissed. . . . In 1692, after Mr. Henshaw's return to England, his case against Ambrose was restored to the docket, and kept there for nearly thirty years. In 1719 [by this time our Joshua Henshaw of the Copley portrait, grandson of this man, was born and sixteen years old], when it became certain that a decision was about to be rendered in favor of the plaintiff, Mr. Henshaw was invited by Ambrose to dinner, upon pretence of a desire to effect an amicable compromise, and soon after the dinner was seized with an illness, from which he died in a few hours. The suit was then dropped from the docket for want of a prosecutor.[84]

On the local level, we can see confirmation of this legal drama and its irresolution in the accounts of small rents for modest properties on Swine Street (subsequently High Street, Dale Street, and the Exchange), Liverpool, which show in the Borough of Leicester's Chamberlain's Accounts, rents credited in 1688 to the "heires or Executors of Mrs. Katherine Henshaw [mother of the orphans] deceased," but, subsequent to Joshua Henshaw's almost-successful recovery of his parents' property in 1719 (and well into the nineteenth century) these parcels are described as "Late Mr. Henshaw's land."[85]

The earlier family memory of tragedy, abduction, and theft then, would have been, in 1719, laminated to the new narrative of this latest outrage. Samuel Sewall, the renowned Massachusetts diarist and jurist, signed the orphan Joshua's Certificate of Probate in 1723. In 1688, when he had made his will, and, in 1719, when he met his untimely death, his wife was living and he had seven children. It is characteristic in that his testament begins: "I, Joshua Hensha of Dorchester . . . Yeoman," and goes on to bequeath to his wife, Elizabeth, the whole of his estate during her widowhood, and in that it divides that estate into eight equal portions, "Two parts whereof I give unto William my Eldest son, as his double portion, and unto each of my other Children, viz.:—Joshua, Thankful, John, Samuel, Elizabeth, and Katharine a single part or share thereof."[86] That the eldest son should be given a "double portion," that is, receive neither the bulk of the wealth nor a share equal to that of his siblings, suggests a transitional concept of property, prerogative, and obligation. In most successive generations, the siblings were given equal shares in what was to become an American pattern of bequest, with real estate (and other resources that could generate money) reserved for male children, and "moveables" for their sisters.

When Joshua the orphan died, his son Joshua (1673/4–1747), born in Dorchester, was forty-seven and a prosperous merchant in his own right, living in Boston. He did not pick up the Chancery suit, but neither did he completely put aside the affair of his father's unhappy lifelong quest; in 1743, four years before his death, he built a tomb in the Granary Burying Ground in Boston emblazoned with the Henshaw coat of arms. He would have had for his model two escutcheons brought to America in 1690 on his father's brief return to Dorchester—one the Henshaw arms and the other the arms of William Henshaw quartered with those of Katherine Houghton, for as an heiress she held rights

to a coat of arms as well as property.[87] These were probably painted (oil on canvas) escutcheons but may equally have been carved in wood or embroidered in textiles. That displaying the Henshaw arms descended three generations and shows up in the 1782 inventory of Joshua-the-orphan's grandson, Daniel, and in a notation in Harvard's documents that great-grandson Joseph (class of 1763) was "armigerous"[88] The heraldic tomb of Joshua, son of the orphan, is as unusual and yet as legible within its context as the crest on the portrait frame that would be commissioned by his son almost three decades later. Both are armorial, abstract commemorations of another existence, elsewhere, an identity incorporated in the subjunctive mode by these devices within the very present lives of these men in New England.

Joshua Henshaw, whose portrait we have been considering, was a teenager when his grandfather died at Wavertree Hall after dining with Joshua Ambrose, and he was forty-four when his father was laid to rest in the tomb in Boston's Granary Burying Ground under the Henshaw crest, a tomb carved and readied for his body four years earlier. Although he and his father and grandfather did very well in the New World—enlarging the modest capital Peter Ambrose had put forward for the two boys—by trade and by advantageous marriages, clearly the smart of old injuries and the sense of alternative destinies remained an important aspect of the subjective sense of self for all three of these men. It is no wonder, then, that in the tense negotiations and brinksmanship of the 1760s Joshua Henshaw threw in his lot with the colonials and yet retained and deployed on the frame of his portrait, purchased at the end of that explosive decade, a marker of ancestral outrage in the arms appropriate to his family as direct descendants of his abducted, betrayed, and murdered namesake. How ironic that, when the British closed Boston harbor in 1774 to control and coerce the population into compliance with what the Bostonians understood to be arbitrary rule, he was forced to flee and, once again, in occupying the city of his family's forced adoption, the British divested him of his property.

Refugees from the hostile occupation of Boston, Joshua and Elizabeth Henshaw moved in 1774 to the safety of Leicester, near Worcester, about sixty miles west of the epicenter of the pre-Revolutionary turmoil in Boston. The community there was aligned with Joshua's politics; in fact, his nephew, William Henshaw, was signatory on uncompromising communications from the Leicester Committee of Correspondence to its counterpart in Boston that urged the "unremitting care and vigilance in watching the motions of our enemies," encouraged opposition to "their wicked schemes," promised solidarity with the Boston patriots' "manly resolutions," and encouraged them "to go on as you have begun. . . . You may depend on our aid and assistance."[89] That "aid and assistance" for some came in the form of sanctuary when patriots—especially those as publicly compromised as Joshua Henshaw—found it necessary to flee the urban center. In Leicester he boarded with Rev. Mr. Conklin and enjoyed the proximity of his brother Daniel, his daughter Sarah (1736–1822), and her husband, Joseph Hen-

shaw who was Daniel's son and therefore Joshua's nephew as well as his son-in-law (see family tree on page 97).[90] Sarah and Joseph had also been portrayed by Copley about 1770 and we can imagine that—because they survived—the three Copley portraits and the two Smibert portraits accompanied them in this exile. However, there is a family tale that a repaired rent in *Joshua Henshaw* was the work of a British sword, suggesting that this portrait was, at some point during the Revolution, vulnerable to and proxy for retributive military fury.

Daniel Henshaw, Joshua's brother, was involved in the early settlement of the Worcester area (possibly on land awarded his great uncle Daniel as a result of military service). While he himself resided in Boston, a portion of the Leicester property was farmed by "two black servants"—in all probability the slaves Daniel willed to his wife in 1747.[91] In 1748, a year after his father had been laid to rest in the coat-of-arms-emblazoned tomb, Daniel, the eldest son, had removed to his father's property in Leicester, taking with him a "family coat of arms" (almost certainly one of the two escutcheons made in England for Joshua the orphan in 1690), and there raised ten children (others died young).[92] So when matters in Boston made it impossible for Joshua Henshaw to remain there, he logically found refuge among his kin in Leicester and it is in this branch of the family that the portrait which is our subject eventually descended.

From Leicester, with the Revolution continuing to rage around them and in increasingly failing health, Joshua and his wife moved once again, closer to Boston but still outside the turmoil of the city, to Dedham where they boarded with Hon. Samuel Dexter.[93] In Dedham he was close to his son Joshua (1746–1823) and his daughter-in-law Catherine Hill (this pair was also portraited by Copley), as this son had sought refuge from the port city in that town for himself and for the records of the city of Boston in his care as he was Suffolk Register of Deeds, 1776–1786.[94]

On Tuesday, August 5, 1777, Joshua Henshaw died at Dedham. As his obituary recounts: "He was a man of engaging aspect and deportment; of solid and unaffected piety; of untainted integrity and honor. . . . highly valued and beloved in public stations, a warm and unshaken friend to the civil and religious rights of his country. . . . He was one of those uniform patriots who early opposed the encroachments of the Administration, for which he was honorably distinguished by their frowns, and he died in the pleasing hope of the success for the American cause."[95]

An obituary is one way to summarize a person's existence, to give contemporaries, progeny, and perhaps historians a sense of the essence of an individual life. A portrait is as well. Both the portrait and the obituary also summarize human ideal types. Copley's portrait is a record of a very *real* Joshua Henshaw, his distinctive face, class-specific costume as a gentleman merchant, and impaired left hand. It also incorporates, as we have seen, an allusion in the family crest to a not-so-distant outrage and to the tumultuous history by which he came to live his life in Massachusetts. What other ingredients contribute to the quiet possession

of affluent, dignified *power* in Copley's image, to its status as a record of an ideal as well as to an individual person? How is model maleness incorporated into this portrait that is also a personal document and a family narrative?

To return to another beginning for a moment: How did Copley learn the ideal form, the structure, musculature, and articulation of the ideal male body? As a youngster he had learned deportment from the Pelhams (as we have seen in Chapter 3); he also copied male musculature from medical books (fig. 51) and he studied antique sculpture, most likely in print form. Scholars have long been aware of his incorporation of visual quotations from antique sources in his ambitious canvases of the late 1770s—a dramatic case is that of the beleaguered adolescent Brook Watson in *Watson and the Shark* (see fig. 69), the protagonist's nude body a direct quotation of and allusion to the antique model for what the eighteenth-century *cognoscenti* understood to be the ideal male body exerting itself under stress: *The Borghese Warrior* (see figs. 70, 72). Copley studied anatomy books, he studied

FIG. 51. John Singleton Copley, *Anatomical Drawing*, 1755. Graphite, chalk, and ink on paper. 17½ × 12 in. (44.5 × 30.5 cm). © British Museum.

antique sculpture, he studied the bodies before him, he also studied ideal forms as identified by theorists such as Hogarth. It is probable that the pose Henshaw assumes is not accidental. Perhaps expressive of personal habit, perhaps not, it clearly was agreeable to the subject as appropriate to his sense of self. If *Watson* offers us the ideal male body under stress, *Henshaw* offers us the model male body at ease. Henshaw's dignified torso traces a graceful relaxed S-curve, his left arm makes an equally graceful C (losing its natural angularity as it embraces the almost invisible beaver tricorner hat sandwiched between his elbow and his waist). The right arm on which he gently leans is propped on a draped plinth and rendered in dramatic foreshortened elegance. This is the pose William Hogarth commended in his *Analysis of Beauty* as the model of male beauty that modern (that is mid-eighteenth-century) men should learn from antique sculpture, and take to heart as a model for life as well as for art (fig. 52). Hogarth understood this to be not an arbitrary, fashionable kind of beauty but one based on eternal verities resident both in the forms of nature and in the minds of humans. His specific model is the figure known as the Belvedere Antinous (aka Hercules, Meleager, Mercury, Theseus) that had been discovered and installed in Rome's Belvedere courtyard in the six-

FIG. 52. Detail, William Hogarth, Plate I, *The Sculptor's Yard*, from *Analysis of Beauty: Written with a View of Fixing the Fluctuating Ideas of Taste* (London: J. Reeve, 1753). Etching and engraving. Huntington Library, San Marino, California.

teenth century, a sculpture Hogarth commended for its "easy and gracefully-turned attitude" as well as for its "utmost beauty of proportion."[96] By using this pose, Copley and his patron sought to tap into permanent rules of formal grace and align this canonical marble immortality with fixed (but disrupted) links between individual identity and family line. Henshaw's identity, then, incorporates disparate but reconciled and harmonious visual cues: the sign of his tumultuous family history, his disabled hand, his own unique physiognomy, and a body in the pose of a Greek god clothed in the garb of a Boston gentleman.

Thus far we have traced the prehistory of the painting, the commissioning of the portrait, and we have looked with some care at the circumstances out of which this particular record and projection of identity arose. If part of the role of an eighteenth-century portrait was to fix personal and family identity, to operate as an agent of instruction and memory within the family context, then it behooves us to consider not only the situation that resulted in the artwork but also the subsequent life of the picture. Therefore, we will turn now to the more recent after-history of the work.

It is clear that for the first three generations of Joshua Henshaws in New England the markers of family and of personal identity came to be concentrated in name and the Henshaw coat of arms. In retrospect, it seemed that the recapitulation of identity through three Joshuas from the orphan to the portrait-patron was deliberate. However, family naming practices produced a line of three Joshua Henshaws almost by accident; at the time these New World Henshaws were born and baptized, the priority appears to have been not self-replication but rather commemoration of "lost" men. By this I mean that Joshua the abducted orphan named his eldest son not after himself but after his father William whose early violent death in battle created the vacuum from which subsequent untoward events devolved. But young William died unmarried and it was the second son, Joshua, named after his father, who carried on the family line. He, in turn, named his first son Daniel after the second of the two orphans whose line had expired, and named his second son—Joshua of the portrait—after himself. It appears, then, that the project of these naming practices was to give priority to the capture and reanimation of the lives and the identities of these expired "tragic" antecedents and only secondarily to immortalize the self. The second marker of identity—the Henshaw crest, had, in the colonies, by the generation of the 1770s, come to mean "family" rather than "eldest son of man entitled to bear a coat of arms," for the man who looks out at us from under the chevron-moorhens-and-falcon is a *second* son, whose elder brother Daniel was alive and well when the portrait and its heraldic frame were designed about 1770 and was father to many surviving children. Daniel might well have regarded the crest on his younger brother's portrait frame as a replica, a copy, for he owned the thing itself. His inventory of 1782 includes (and this is a highly unusual entry, both in its inclusion and in its value) "the family Coat of Arts 12/." Valued at a little less than his "gold buttons 18/," this may have been embroidery work, carved

in wood, or an oil-on-canvas hatchment. In any event, he owned it, it was of considerable value, and his younger brother's miniaturized version would have referenced it in his mind.[97] Just as primogenitor as a residual medieval system of expectation, privilege, and obligation on the part of the eldest son expired at the Atlantic shore, so the concept of heraldic signifiers (in those few instances it did not totally evaporate) radically expanded to encompass "family." This concept of family was still primarily a diachronic line, but it evidently encompassed younger sons, and, as we shall see, eventually even women. I doubt that in 1770 either Joshua or his elder brother saw anything amiss in the Henshaw arms on the frame of the portrait of a second rather than a firstborn son—they were consciously modernizing and Americanizing a concept born elsewhere, a concept whose usefulness and acceptability would all but expire with the Revolution that Joshua Henshaw was directly party to setting in motion.

When Joshua Henshaw commissioned Copley to paint his portrait about 1770 and to embellish it with the arms "restored [in 1611] to Thomas Henshaw, Knight," his great-great-grandfather, by James I, his intention was almost certainly to create an object that would remind his progeny of the tragic tale of the beginning of their line in the New World, that would be not only a marker of his personal accomplishments in the patriot cause but also a signpost to that other Revolution, almost a century and a half earlier, against the English Crown, that had resulted in the involuntary planting of their family tree in New England.[98] I am proposing that this portrait was designed to act on its viewers, exhorting present family members and descendants above all to *remember*. Like the galleries of ancestral portraits that actively engage protagonists in Horace Walpole's *Castle of Otranto* (1764) and Penelope Aubin's *Life of Madame Beaumont* (1721), or the family portraits in Gilbert and Sullivan's *Ruddigore* (1887) coming to life and exhorting their descendant to perform prescribed deeds, the role of this portrait was not background to an ever-shifting present, a record of stuffy out-of-fashion, long-dead forgettable or venerable ancestors but an active visual admonishment, drawing each generation in the family line back toward a memory and toward a way of understanding family history and destiny as larger and stronger than any individual in that line. Of course, *Otranto* is gothic romance and *Ruddigore* is comic and Victorian, but their portrait-passages remember something serious in early modern concepts of family and of portraiture.

HENSHAW'S COPLEY

What of the "downstream" history of Joshua Henshaw's project—to what degree was his portrait successful in fixing identity and memory? To a certain degree, we can investigate the outcome of Joshua Henshaw's project by tracing the ownership and custodianship of the canvas. The intent of this animated provenance is to complete the biography of the painting as an object, to watch it move, in Kopytoff's phrase, through cultural redefinition as it was "classified and reclas-

sified into culturally constituted categories," from an initial moment as a commodity, through a long passage of decommodification, into a period of explicitly aesthetic and political veneration (mixed with family use), to a second brief passage as a commodity, into a (seemingly final) phase of decommodified aesthetization.[99] If Henshaw's project was to fix the present (about 1770) and the past (about 1650) for the sake of the future, the primary challenges to this project have been the fragility of memory and the shifting nature of culture and society. Even with a mnemonic as large, as beautifully painted, and as dramatic as *Joshua Henshaw*, its legibility as a vehicle of a narrative is still dependent on human memory, that is, on the viewer's share in the translation of visual reading, and on the verbal instruction of each generation of users. Second, in a reversal Henshaw could never have anticipated, the valuing of his portrait as an object (an aesthetic object, a commodity object) eventually overpowered its value as a family mnemonic.

Joshua Henshaw's will does not mention this painting.[100] This is by no means unusual, as most eighteenth-century wills do not enumerate specific items. Perhaps more important, eighteenth-century probate inventories—which *do* enumerate specific items of value to safeguard the interests of legatees—as discussed in Chapter 1—rarely assign valuation to portraits because, unlike prints or other genres of paintings, they had no commodity value. An eighteenth-century portrait, then, like a grave marker, would have considerable importance within a family and yet have no market value. The downstream history of this painting exhibits a gradual inversion of these disparate systems of valuation. To analyze this issue we must consider and sort out a series of "begats" which may threaten to exhaust the reader. Bear with me.

Joshua Henshaw almost certainly remained with the subject's wife, Elizabeth Bill Henshaw, through the remaining years of the Revolution until her death in 1782 in Dedham. From the moment of its creation it was not singular but rather part of an assemblage of older portraits, contemporary portraits, and prospective future portraits that gave it explicitly a *family* context and meaning. That the intended destiny of these portraits was to devolve down a line of sons we can infer from custom and from the actual path the works followed.[101] Already in 1782, however, as *Joshua Henshaw* moved out of its original ownership, this pattern was disrupted. Joshua and Elizabeth had had six children: three who died young, and two sons—Joshua and Andrew who survived into adulthood, attended Harvard College, and married—as well as a daughter Sarah. But all died without issue. The couple's short-lived firstborn son had been christened Richard after Joshua's father-in-law, suggesting his acknowledgment of having "married up" and also suggesting that he had not focused on creating a dynastic line of "Joshua Henshaws" any more than his antecedents had. This would happen later.

It is difficult to track the exact physical location of the portrait group (including initially the two Smibert Bill portraits and the half-length Copley) over the fifty years between the Henshaw's death and their next certain venue, but it is probable that the portraits moved into either the household of the couple's surviving

son, Joshua (1746–1823), who was living in Dedham near his widowed mother or the couple's surviving daughter, Sarah (1736–1822), in Leicester. But both died childless and these three core works, together with the four smaller Copleys of those siblings and their spouses, moved into the line of Daniel, the sitter's eldest brother. That the portraits moved *up* the sibling birth order (rather than to the family of one of Joshua Henshaw's younger siblings) suggests a residual sense of seniority if not primogenitor. The second logic of this line of descent is that the daughter of Joshua whose portrait is our focus here, Sarah, had married her cousin, Joseph, the son of Joshua Henshaw's eldest brother Daniel, consolidating the two family lines. Joseph had—like his cousins—attended Harvard, and then spent two years in Europe, not pursuing a will-o-the-wisp patrimony or doing a Grand Tour but studying trade conditions foundational to a subsequent career as sea captain trading with Italy. This couple remained childless as did the other of the first four children born to Daniel and his wife Elizabeth. So, while the portrait group almost certainly remained in the second generation in the hands of our sitter's children—Sarah's possession until her death in 1822, or Joshua's until his death in 1823, the group was divided at that point, the two Smiberts descending in the line of one of Daniel's younger children while three of the Copleys, *Joshua Henshaw, Sarah Henshaw* (now at Bayou Bend), and *Joseph Henshaw* entered the line of the sitter's nephew Benjamin Henshaw.[102]

Thus far, it is evident that the Henshaw family strove to align the major Copley portrait with the eldest surviving son in the second generation. However, the failure of the sitter's children to produce a direct line resulted in the custodianship of the painting passing to the children and grandchildren of his eldest brother, a process that may have weakened the investment the third generation had in *Joshua Henshaw* as a vehicle of personal and family memory. After all, from the very first generation of settlement, colonials had not strongly attached the concept of family line to family *land*, and thus part of the power of the portrait in Britain (as parodied in *Ruddigore*) was lost in the New World as the pressure exerted by the ancestral space and land (as wealth) and house (as family "seat") was divorced from family portraits. The portraits in question were not assembled into a fixed location until well into the nineteenth century, and thus, at least temporarily, they became a set of free-floating signifiers once the generation who personally knew the sitters was gone. Having to do all their work without the supporting cast of ancestral hall and landscape, the paintings—even with three assembled together—were less able to maintain the cultural pressure they were created to exert.

Other forces unforeseen by Joshua Henshaw were also at work. The custodianship of family line as a retrospective prospect had evolved by the early nineteenth century into a romantic or sentimental pursuit, something thought to be more suitable for a woman than for a man. So our ambiguity about the second owners of the painting (Sarah, the sitter's daughter and her husband, Daniel's oldest surviving married son, Joseph, who had also been painted by Copley), or Joshua,

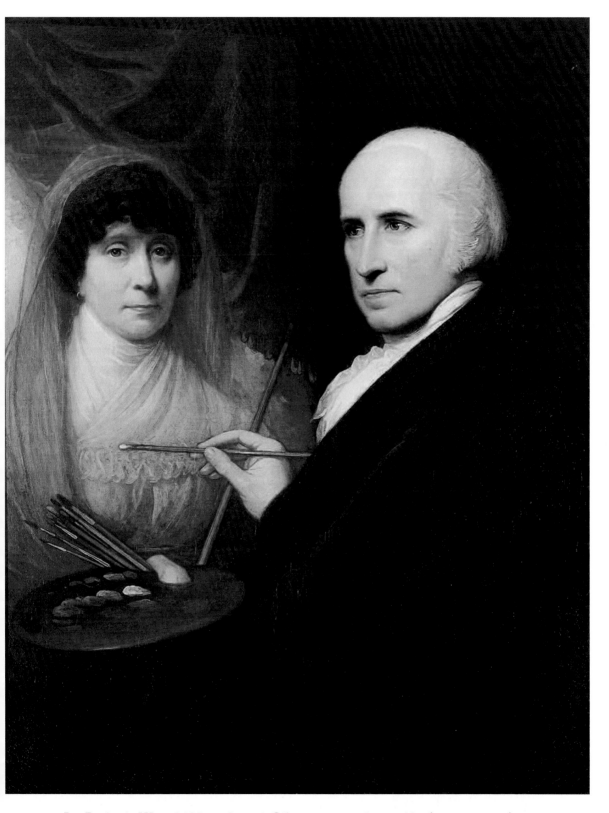

I. Benjamin West, *Self-Portrait*, 1806. Oil on canvas. 36⅛ × 28⅛ in. (91.8 × 71.4 cm).
Pennsylvania Academy of the Fine Arts, Philadelphia, Gift of Mr. and Mrs. Henry R.
Hallowell.

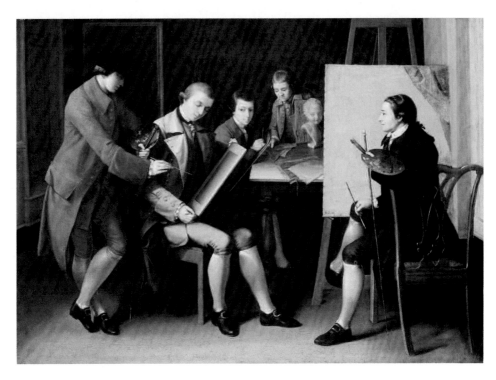

II. Matthew Pratt, *The American School*, 1765. Oil on canvas. 36 × 50⅛ in. (91.4 × 127.6 cm). Metropolitan Museum of Art, Gift of Samuel P. Avery, 1897 (97.29.3). Photograph © 1979 Metropolitan Museum of Art.

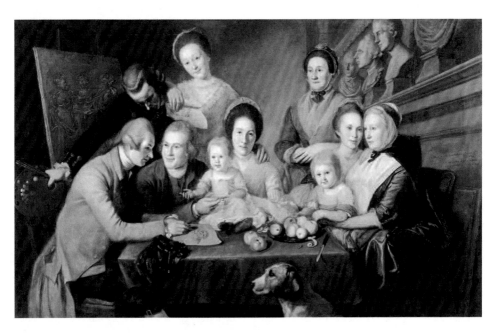

III. Charles Willson Peale, *The Peale Family Group*, 1773 (with changes 1808). Oil on canvas. 56½ × 89½ in. (143.5 × 227.3 cm). Collection of The New-York Historical Society.

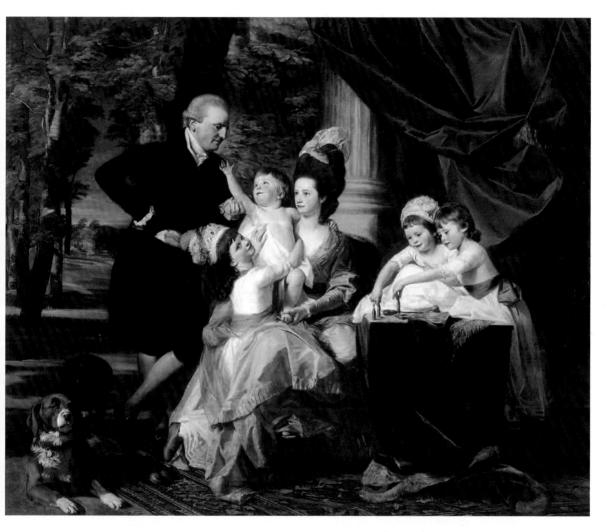

IV. John Singleton Copley, *Sir William Pepperrell and His Family*, 1778. Oil on canvas. 90 × 108 in. (228.6 × 274.32 cm). North Carolina Museum of Art, Raleigh, Purchased with funds from the State of North Carolina.

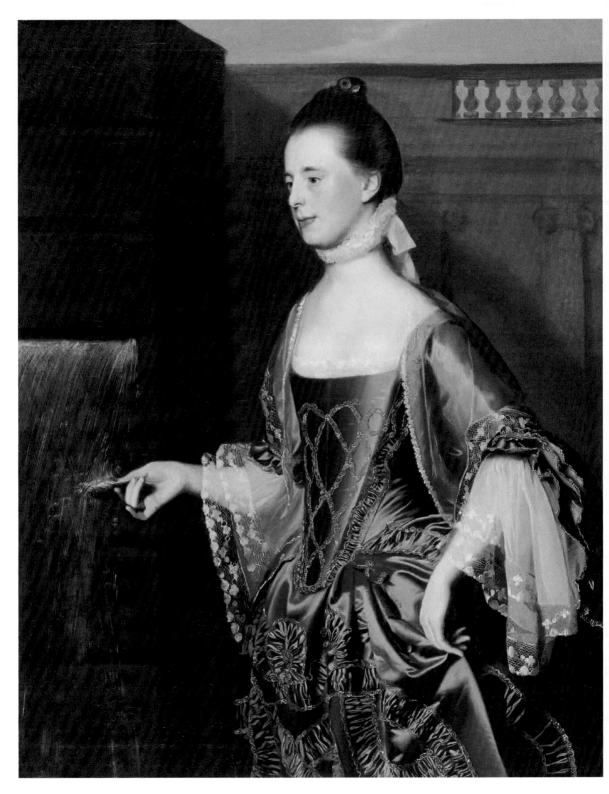

V. John Singleton Copley, *Mary Turner Sargent (Mrs. Daniel Sargent)*, 1763. Oil on canvas. 49¼ × 39¼ in. (125 × 99.7 cm). Fine Arts Museums of San Francisco, Gift of Mr. and Mrs. John D. Rockefeller 3rd, 1979.7.31.

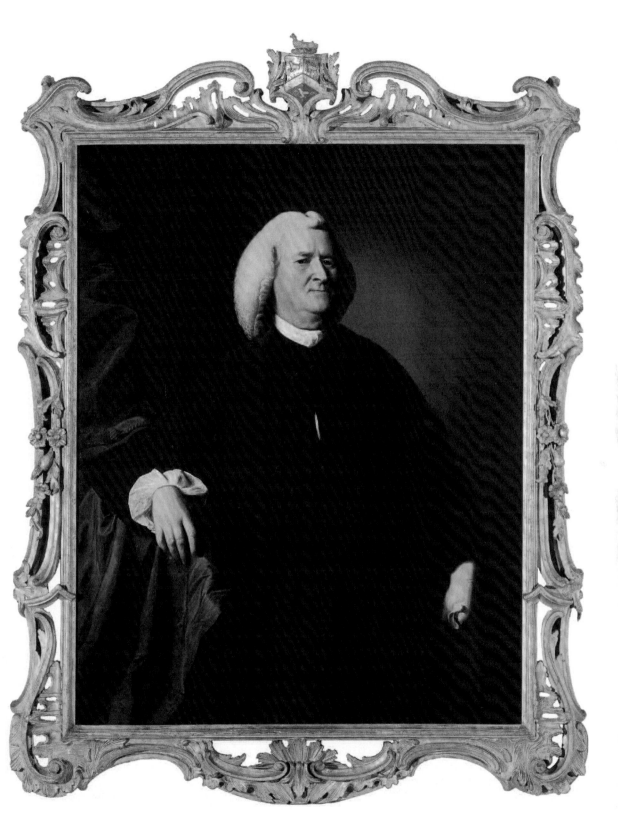

VI. John Singleton Copley, *Joshua Henshaw*, c. 1770. Oil on canvas. 50 × 40 in. (127 × 101.5 cm). Fine Arts Museums of San Francisco, Mildred Anna Williams Collection, 1943.4.

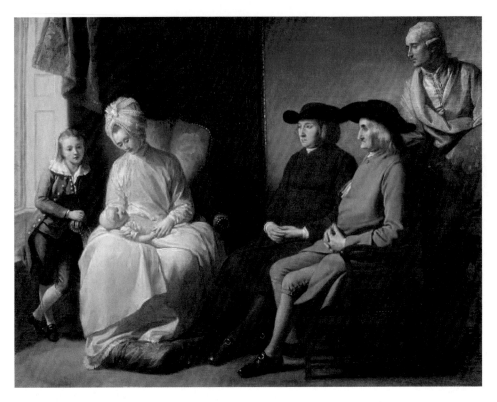

VII. Benjamin West, *The Artist's Family*, 1772. Oil on canvas. 20½ × 26¼ in. (52.1 × 66.7 cm). Yale Center for British Art, Paul Mellon Collection.

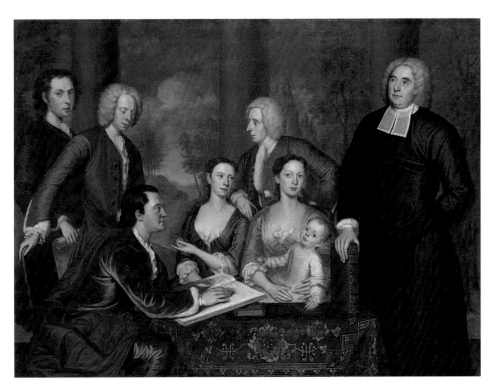

VIII. John Smibert, *Dean Berkeley and His Entourage (The Bermuda Group)*, 1729. Oil on canvas. 69½ × 93 in. (176.6 × 236.1 cm). Yale University Art Gallery, Gift of Isaac Lothrop.

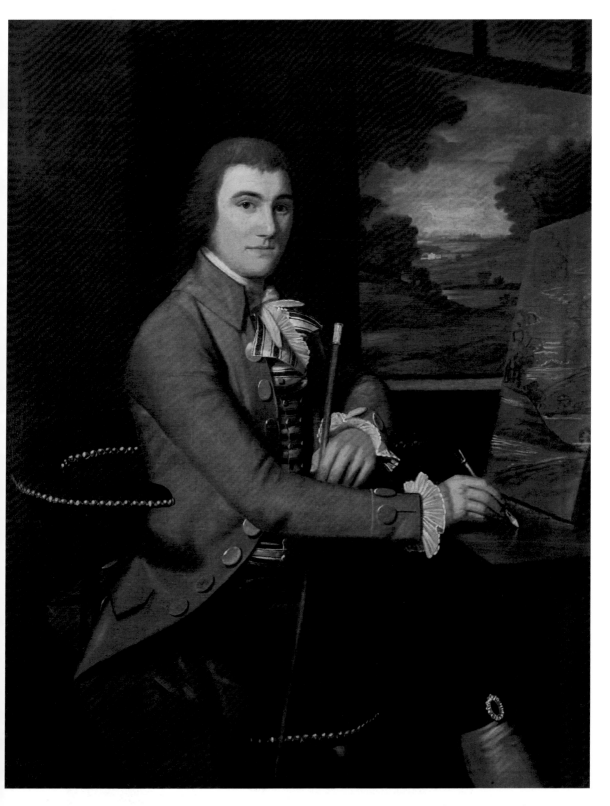

IX. Ralph Earl, *Colonel William Taylor*, 1790. Oil on canvas. 48½ × 38 in. (123.8 × 96.5 cm).
Albright-Knox Art Gallery, Buffalo, N.Y., Charles Clifton Fund, 1935.

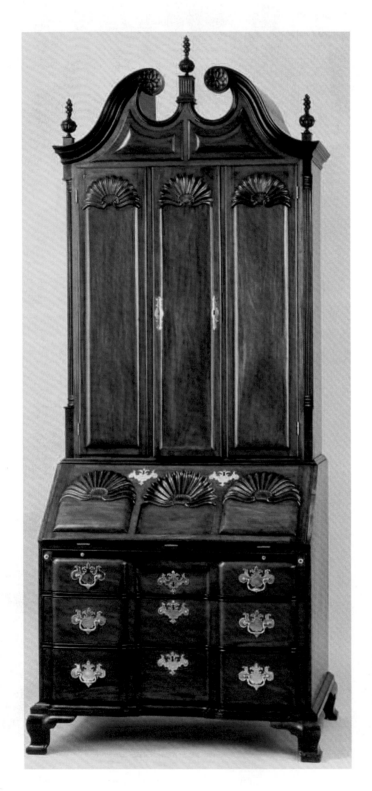

X. Desk and Bookcase,
Newport, R.I., 1760–1790.
Mahogany, black cherry,
chestnut, eastern white
pine. 106¾ × 44¾ × 25¼
in. (272.4 × 113.5 × 64.0
cm). Yale University Art
Gallery, Mabel Brady
Garvan Collection.

the sitter's son and his wife Catherine (also Copley subjects), becomes resolved in the later 1820s, because it definitely passed to the third generation in the line of Benjamin, the sitter's eldest brother's fifth child in whose line it remained for the subsequent century. In the birth order of the children of Daniel (himself the oldest son of the oldest son of Joshua the orphan), Benjamin was the oldest to produce issue. Although born in Boston, Benjamin, a mariner, lived in Middletown, Connecticut. Then, in the third generation, two curious things happened. *Joshua Henshaw* (and the two smaller Copley images of Joshua's daughter and her husband, *Sarah Henshaw* and *Joseph Henshaw*) passed not to the eldest son or to the oldest son with issue but to the youngest child who was also a woman, Sarah Henshaw Hayward (1768–1849). That these portraits passed to not only a youngest child but also a woman would probably have startled Joshua Henshaw.

We can surmise that possibly the reason *Joshua Henshaw* came into the possession of Sarah Henshaw Hayward is that she was the namesake of the childless Sarah Henshaw, daughter of the sitter (and wife to his nephew), who was also painted by Copley and who may well have been the custodian of all three Copley portraits and the two Smibert portraits in her widowhood (certainly the three Copley portraits remained together until 1942). Or perhaps she was the only one to express strong interest, her elder brothers and one elder sister feeling in the 1820s too distant from a great-uncle they could only have known personally as small children, and too detached from Revolutionary activism to desire the portrait as an icon of those distant tumultuous times. Both "history"— the painting's established domain—and "art"—its nascent domain—were becoming coded by the 1820s as antiquarian, female matters, disengaged from the daily life of the present among progressive future-oriented Americans.

Sarah Henshaw—who grew up in Middletown, Connecticut—had married (in 1785) Dr. Samuel (aka Lemuel) Hayward, a Boston classmate at Harvard of her rakish cousin Andrew (class of 1768).[103] Sarah and Samuel lived in Boston and, apparently as a response to a yellow fever epidemic in the city in 1798, from 1799 they spent the warm months in East Sudbury (after 1835 known as Wayland) eighteen miles west of Boston. It is probable that the painting came into Sarah Henshaw Hayward's hands in 1822 on the death of her aunt Sarah (or perhaps in 1823 on the death of her uncle Joshua). A wealthy widow with eight mostly adult children at the time, Sarah continued to maintain both the city and the country homes, the paintings evidently staying in the Boston house (at the corner of Hayward Place and Washington Street).[104] Sarah's husband had been a doctor, but he was also an entrepreneur, investing in real estate ensuring his children of comfortable prospects and Sarah a comfortable widowhood.[105]

It was during Sarah Henshaw Hayward's stewardship that *Joshua Henshaw* commenced its career as an art object on public exhibition. On two occasions, she lent the portrait of her great-uncle to art exhibitions, in 1827, to the Boston Athenaeum, and, in 1844, to the Third Exhibition of the Boston Artists' Association.[106] What would have persuaded Sarah Henshaw Hayward to lend her

ancestor's portrait in 1827 to the Boston Athenaeum—a membership organiza-
tion of literary men founded two decades earlier? In the 1820s, the Athenaeum
began collecting art (plaster casts after canonical antique sculpture, European
Old Masters, and works by contemporary American artists), organizing loan exhi-
bitions, and opening its doors, at least during exhibitions, to women as well as
men, nonmembers as well as members, for $.50.[107] No public collections or insti-
tutions of art existed in Boston at the time. The appeal for works to be exhib-
ited at the 1827 inaugural exhibition was published in the newspaper and
solicited "artists to furnish specimens of their works, and gentlemen possessing
valuable pictures, to contribute to the exhibition by the loan of them."[108] One
of Sarah Henshaw Hayward's cousins—David Henshaw—was a member and
he may have encouraged her. Catalogued as "Old Masters," five Copley portraits
were among the 317 pictures exhibited that year, four of these, like *Joshua Hen-
shaw*, half-length canvases depicting important Revolutionary patriots.[109] So not
quite sixty years after its creation, *Joshua Henshaw* began to be understood as "a
Copley," that is, as an aesthetic achievement and as part of a public patrimony,
as much as (and eventually much more than) a family document. That Sarah Hen-
shaw Hayward was conscious of its aesthetic and monetary value (as distinct from
its former familial value) is evident in the fact that she mentioned it in her will—
this was the first time it made such an appearance, signaling in this fact its move
from financially valueless to financially valuable object.[110]

Sarah Henshaw Hayward did not will the painting to her eldest son, John
White Hayward, Esquire—a Harvard graduate (1805) who had studied law but
only practiced until the death of his father when he inherited and moved to the
East Sudbury (Wayland) estate where he proved an enthusiastic sportsman but
a poor farmer—because that son predeceased her. John White Hayward's widow
(a Sparhawk connection) had decamped with her three young children back to
her family of origin in Walpole, New Hampshire, so Sarah did not will it to the
eldest son of her firstborn either.[111] Nor did she give it to her second son
Charles (who had produced only a daughter). She willed it to her third son, Dr.
Joshua Henshaw Hayward (1797–1856) who was the painting's namesake, had a
son, and had replicated his father's professional and domestic arrangements, prac-
ticing and living in Boston but also maintaining the Wayland property as a retreat.
In the language of Sarah Henshaw Hayward's will: "The three portraits by Cop-
ley of Joshua Henshaw, and of Joseph Henshaw and his wife [Sarah], now in
my house in Boston, I give to my son Joshua."[112] Sarah Henshaw Hayward's
fourth son, George, also a distinguished physician, built a new house in East Sud-
bury (Wayland) in 1832 that would become, two generations later, the last
domestic setting of the portrait.

During the seven years that Dr. Joshua Henshaw Hayward owned the
portrait he evidently did not exhibit it publicly, but when they inherited it in 1856,
his unmarried daughter (Sarah Henshaw Hayward) and his son (Dr. John
McLean Hayward, who also maintained the Boston-Wayland pattern of seasonal

migration) did, in 1871 (Boston Athenaeum, Summer Exhibition) and in 1873 (Perkins). A print was also made of the portrait during the John McLean Hayward ownership and published, along with an extensive genealogical account of the Henshaw family in the *New England Historical and Genealogical Register,* suggesting a resurgence of its role as family document within an antiquarian, dispersed family context.[113] It is probable that the portrait was kept at the Boston residence during these three generations of Hayward ownership. How they understood its role within the family circle is difficult to determine—especially as the distance in name and time gradually removed its immediacy, but it is clear that they understood it to be "art" and part of the general patrimony of Revolutionary Boston. Moreover, because of the genealogical research (not by the family of ownership but by a distant cousin, Andrew Henshaw Ward) published with an engraved reproduction of the portrait in the mid nineteenth century, the painting began to take on a broader Henshaw-family iconic status. Although Copley's sitter's children did not produce issue, his siblings' children did, in abundance.

Dr. John McLean Hayward died in 1886, and, in 1889, the Wayland house (built in 1778) in which he, his parents, and his grandparents had summered, burned. Neither his will nor the appraisal of his property mentions this painting specifically, but the latter document—which is rather detailed in the matter of horses, wagons, and stock—lumps "Pictures, Books and Surgical Instruments" at $100 (where a horse is valued at $75).[114] *Joshua Henshaw*, evidently kept in the Boston house together with the two small Copleys, was preserved from the fire. Dr. John McLean Hayward's widow, Katherine Cobb Hayward (1839–1917), moved into the second Hayward Wayland house, the house George Hayward, her husband's childless uncle, had built in 1832 on the Post Road. There she was recorded as residing with another widow (her husband's aunt Harriet Wyman), and probably her son, Sidney Willard Hayward (1871–1950) in 1891. The portrait group probably moved from Boston into this house, then, shortly before 1890 where it stayed until Katherine's death in 1917. By this time, the three Copleys were accompanied by several other Revolutionary-era portraits, including one by Gilbert Stuart and another by Chester Harding.[115] Wayland at the turn of the twentieth century was a prosperous town, home to three populations: summering Bostonians (as the Haywards had been until the 1890s), those working in the nine shoe factories, and—subsequent to the arrival of the Massachusetts Central Railroad in 1881—Boston commuters.[116] This branch of the Hayward family did not share in the general prosperity around them, and the house with its portraits and memories became a refuge for widows and others not quite up to the challenges of the day.

In 1917, the house and portraits devolved upon Sidney Willard Hayward, the last of this line. He exhibited *Joshua Henshaw* once (Boston Art Club) and then, in 1919, put it on long term loan at the Museum of Fine Arts, Boston where it remained until 1942.[117] The Boston museum exhibited and published it during their custodianship. Sidney Willard Hayward and his wife, Beatrice Herford

Hayward, were childless; in 1942, in ill health and reduced circumstances, they offered the painting for sale and it became, briefly, as it had when first commissioned, a commodity, exchangeable for money. Part of its value, at that mid-twentieth-century moment, was its subject, the majority of that value was its aesthetic achievement; familial provenance was primarily important to establish authenticity. In the brochure prepared at that time by the John Levy Gallery of New York, two brief paragraphs discuss Henshaw as a Revolutionary patriot and six paragraphs describe and praise Copley as an artist.[118] On the art market, history and memory, then, are positioned in supporting roles behind art in the establishment of authenticity and value. The achievement of the painter trumps the achievement of the sitter who commissioned him to fix a vision of those achievements. The family dimension of the work recedes almost to invisibility.

A collateral descendant considered purchasing the painting at this juncture but decided that it should be in a museum where it would be protected and seen by the public rather than in a house where it would be vulnerable and seen only by the family.[119] In making this decision, descendants corroborated the radical reorientation in value that had occurred, as it were, right under Joshua Henshaw's gaze. What Henshaw had sought was a kind of still point, a point of orientation from which he could summarize the past and establish a trajectory for memory in the future among his descendants. He anticipated a continuous and prosperous family line. That his project faltered was not just a matter of a failure of issue; it was a matter of a cultural inversion of values. What he could not have anticipated and would not have understood was that, of all the tangible property he (or his generation) was able to amass, protect, and pass on to heirs, nothing, not even land, would increase in value the way art would. That his descendants might see his portrait as national patrimony rather than family document and exhortation to memory would have baffled him. Yet, in all probability, it would not have displeased him. Where he sought a permanent place in a family narrative, he, quite accidentally, achieved it as a footnote to the artisan he employed, an artist whose magical capacity to create illusion has proven Henshaw's stepping-stone to a different kind of permanence in a much larger narrative.

When—over the past six decades—we have become familiar with seeing this portrait and others like it in the context of museums, assembled in chronological arrangements that narrate the development and achievement of a British American colonial "school" of painting, we have also naturalized this viewing and the ideology it entails. We tend to think of it as inevitable, as right, as democratizing elite art on the one hand, and as offering a document of American artistic meritocracy on the other. This process extracts artworks from both the synchronic context of their creation (the hows and whys of the commissions and the emplacement of portraits and objects within domestic settings, among chairs and teapots, and growing children, and brooding widows) and the diachronic context of the portrait's evolving life among successive households. The re-creation of *Joshua Henshaw* as art, as one example among many, hung on "the line" at eye level for

the five-foot-five-inch median-height American viewer, with graceful proportionate spacing the way James McNeill Whistler taught us to see and appreciate art for art's sake on the bare, white, tasteful walls of galleries—perhaps furnished with a reverential bench but otherwise empty—fills the work with one kind of meaning but completes the evacuation of another, more complicated, set of meanings, a process initiated in 1827 with its first presentation as art.

Joshua Henshaw was on the art market for a brief interlude and then was purchased by a benefactor for the Palace of the Legion of Honor (Fine Arts Museums of San Francisco) and for the people of San Francisco, as "a Copley," an important acquisition marking the opening chapter in the story of American art that successive curators would seek to tell. Resident there, three thousand miles from his New England home in a landscape Henshaw would have thought of as a foreign country (if he thought of it at all—the Spanish priests and military were only just establishing their mission and barracks in what would evolve into San Francisco during the months this painting was commissioned and executed), *Joshua Henshaw* is now, probably permanently, valorized into a decommodified value system (that is, a museum object is understood to be "invaluable") that feels to us completely natural. I say "probably permanently" because we can scarcely now imagine or credit the possibility of our art establishments being disestablished or our aesthetic judgments being reversed. "Our" being those establishments and judgments evolving over the past two centuries and presumed to be based in verities as anchored both in natural history (the hard-wired responses of the human brain as Hogarth believed his axioms concerning beauty to be in 1753) and cultural history. Yet, in including that seemingly incongruous coat of arms just above his face, out in San Francisco, exhibited as art, Henshaw continues to insist on that earlier domestic narrative of a family tale that, in his view, needed reiterative, permanent retelling. It interrupts the ahistorical (or extrahistorical) aesthetic narrative we tell ourselves. It draws us back from the reiterated tale of Copley's almost unaccountable and certainly astonishing achievement—the almost untutored wharf-rat who was born with or precociously developed skills of depiction in a language of art he could not have known by experience; it draws us back from that timeless, wondrous tale to the daily business of who Copley depicted and why. Copley knew he was good—his skills brought him prosperity and an advantageous marriage—what he grew to desire was transatlantic fame. He complained that fame would elude him as long as he painted pictures destined for the private eyes and private spaces "where pictures are confined to sitting rooms," that is, to family contexts.[120] He could not have foreseen any more than Henshaw that in the two centuries since he replanted his practice in London with that shining (but elusive) goal in view, virtually his entire colonial oeuvre would be excavated from those "sitting rooms" and placed in contexts in which his "fame" is the central message.

The tale of the portrait of Joshua Henshaw is profoundly one of unexpected reversals or at least reversals that would have been unexpected and surprising to

both principals—the artist and the sitter. What Henshaw sought was a fixed image—a lodestar to remind his descendants of a family past and to exhort them to knit that past into their futures. What in fact he bought was an image that has remained fixed while the culture in which it has been embedded has evolved radically in what it values in both the lives of men and in the lives of pictures.

In Chapters 3 and 4 we have looked at specific case studies with an eye to understanding the role of specific portraits in both the synchronic and diachronic dimensions of their lives as cultural and family documents. While I have situated them within clusters of paired portraits, groups of family portraits, and types of portraits respondent to gender models and gender ideals, most of the artworks considered here have been of single-figure images. Certainly by far the majority of paintings made in the first two centuries of settlement on the continent, these are the richest visual resource we have for understanding the complex web of identity and family, but their testimony to the latter is often oblique and only legible with extended research and indirect inference. However, there were also a handful of complex paintings executed in the eighteenth century that explicitly broach the issue of family and it is to these we turn in Chapter 5.

The Family

Painterly and Social Constructions

In 1772 Benjamin West painted a portrait of his family, one of about fifty group portraits by American artists surviving from the eighteenth century. Unlike the single-figure portraits we have been considering as resonant documents of individual and family identity—Copley's *Joshua Henshaw* or *Mary Turner Sargent*—West's *The Artist's Family* collects many family members—large and small, young and old, men and women—on one canvas (see plate VII). What can this painting and similar family groups produced of and by British Americans tell us about significant cultural issues, including the nature of the family, the identity of artists, the ideology of structures relating to gender (including motherhood and patriarchy), and cultural change over time? Unusual in the surviving corpus of works, these group paintings display not only gender-specific attributes, gestures, postures, and what can be termed psychological states, they also point to relationships between family members and, more important, changes in these relationships over time. Specifically, these paintings give us graphic expression of a shift about 1760 in ideology concerning the relationships between husbands and wives attendant on a major shift in the understanding of the "innocence" of the child and the rise of "feeling" or "sensibility."[1] The paintings as a group help us to see, in the mime show of individual families, a set of relationships valorizing emotional experience, "naturalness," and an elevation of maternal duties in a world nevertheless ruled by elaborate codes of behavior and restraint as well as customary and legal patriarchal strictures and structures.

Focusing on the circumstances of the commissioning, execution, exhibition, and reception of one of these family portraits, Copley's *Pepperrell Family* (see plate IV)—a painting done a decade later and an ocean apart from *Mary Turner Sargent* (see plate V) and *Joshua Henshaw* (see plate VI), but just down the street from and a few years after West's *Artist's Family*—I argue that the patron used the canvas to fabricate and permanitize a family identity already shattered by death and war. Copley, for his part, used it to further recognition of his name, talents, and availability in his new London venue within the polite marketplace of the Royal Academy. We, with the benefit of hindsight, can use it to better understand the importance of succession in family lines, the meaning of nudity within history and portrait painting in the 1770s, and the alacrity with which Copley adopted English scale, setting, brushwork, and tone as he

sought what he termed a "conspicuous" place in the London art world, in many respects surpassing the considerable accomplishments of his countryman and mentor, West.

In West's image of his own family the artist includes a self-portrait at the extreme right, his elder son, Raphael, by the window, the seated figures of his father and half-brother, and, on the left, his wife and infant son. West has portrayed himself and Raphael in complementary leaning poses and in similar plum-colored clothing, the two seated Quakers are dressed in somber brown and black, and all the men direct our eyes—by their gestures, poses, and gazes—toward the brightly lit maternal group. In many ways, this posed vignette portraying three generations of one family confirms our expectations of an eighteenth-century domestic group. However, the visual emphasis on the maternal pair—enthroned in a generous, damask-covered easy chair—seems slightly hyperbolic or at least disproportionate given the dignity one would ordinarily attribute to the elder West or to the meteorically successful artist himself. Observation of other late eighteenth-century family portraits confirms this "matricentric" pictorial arrangement, and comparison with works from the first half of the century indicates that paintings by West and his contemporaries represent a departure from earlier practice in the arrangement of the figures and the focus of the composition. This distinct and somewhat puzzling change, occurring about 1760, appears to point to a shift in social practice or social ideology and seems to reinforce and amplify the findings of historians investigating the late eighteenth century from other points of view.

Most accounts of family portraits by eighteenth-century American artists would treat the subject as a chronological aesthetic development, emerging as a subgenre "invented" in the colonies with the majestic *Dean Berkeley and His Entourage (The Bermuda Group)* of 1729 by John Smibert (see plate VIII). This important work portrays Dean George Berkeley and his immediate household, as well as the professional associates and adventurers who accompanied the philosopher to Rhode Island earlier that year. It includes a self-portrait of the artist that will prove central to our discussion in Chapter 6. Smibert's painting did not return to Britain with Berkeley but rather, remained—presumably as a dramatic example of the artist's talents—on exhibition for patrons who came to sit in Smibert's Boston studio. That workspace, with its plaster casts of antique statues and painted copies after Old Master paintings, remained intact and was a well-known pilgrimage site for aspiring artists throughout the eighteenth century. Presumably West knew of this painting even though he probably never saw it, and certainly it was known to the other American artists who adapted the genre when they set out to paint ambitious portraits of their own families: John Greenwood (1747); Charles Willson Peale (see plate III, 1773 and 1808); John Singleton Copley (see fig. 62, 1776–1777); William Dunlap (1788); Joseph Wright (1793). It is reasonable, then, to see this sequence of works as

answering texts, to marshal George Kubler's prime-object theory and view this as a body of work reflecting a moment of innovation and then variations on a theme.[2] From a strictly art historical point of view, one could understand the primary relationship for each of these paintings, then, as being with each other, and the primary narrative in their analysis would be one describing artists imitating or challenging each other through their display of skill in this established genre, each work a mimicry of, or slight departure from, predecessor family portraits. Here we will lay aside this established model and inquire instead into the nature, expression, and ideology of the historical family as community as it is incorporated into and legible in these paintings seen as a whole.

It is curious that, within the corpus of family portraits, we find that American artists painted important, complex, and often large portraits of their own families, while British artists apparently did not. Costing the artist precious time and materials without obvious recompense in a world in which, generally speaking, no canvas was stretched without money changing hands, these works are anomalous. We can infer, then, that they probably involved indirect payback. That they failed to prompt a flood of commissioned family portraits is evident in the relative paucity of surviving works of this sort. Colonial artists, confronted with an absence of public venues for the exhibition of art, probably painted and hung these ambitious works in their studios to reassure visiting customers that their mastery of the materials of painting and their general knowledge of the codes of posture and expression for men, women, and children was up to the task at hand. The focus of this chapter, however, is not on these interesting "conversations" between artists and their patrons, or between artists over several generations, or between marketing techniques on two sides of the Atlantic; rather it is on the relation between the ways the figures are portrayed in family portraits (both commissioned and uncommissioned) and the social context of those figures and those relationships. Our point of departure is the corpus of family portraits surviving from eighteenth-century British America (including those painted in London by colonial artists of colonial families), but our project is to read them not just as records of artistic accomplishment and as images of specific families but as documents of social ideology, of ways of prescribing and explaining familial relationships in general.

The pictures that were painted by American artists in the eighteenth century record a specific social strata: the gentry, merchant, and professional classes—precisely those groups identified by Lawrence Stone, Neil McKendrick, John Demos, and others as the "pacemakers of cultural change."[3] These were the classes in which new concepts of family relationships and new patterns of home-oriented consumerism were rapidly evolving in the mid eighteenth century, exactly that moment when family portraits were dramatically changing from earlier patterns—exemplified by Smibert's *Bermuda Group* of 1729 (see plate VIII) and Robert Feke's *Isaac Royall and Family* of 1741 (fig. 53)—to those visible in the West

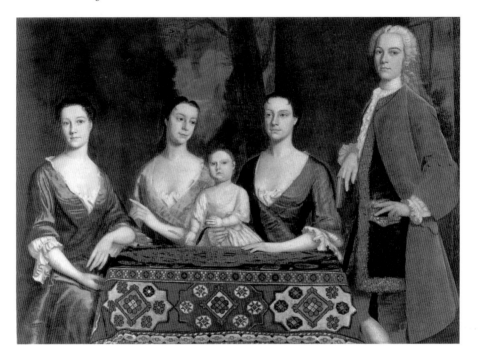

FIG. 53. Robert Feke, *Isaac Royall and Family*, 1741. Oil on canvas. 56³⁄₁₆ × 77¾ in. (149.9 × 197.5 cm). Art and Visual Materials, Special Collections Department, Harvard Law School Library.

family group in the latter decades of the eighteenth century. The matter of class is complicated in an investigation of these portraits as the artists—West, Smibert, Charles Willson Peale, John Singleton Copley, Gilbert Stuart, and others—were, by and large, born into and raised in artisan, often quite impoverished, and certainly ungenteel environments. They were, through marriage and the artistic achievements recorded in images of their own families, actively upwardly mobile themselves. The difference, for instance, between West's presentation of himself—clad in pastel, embroidered silks and a fashionable wig—and that of his father—in homely wool and with lank locks—represents more than a geographical relocation to London and a weakening enthusiasm for Quakerism; West is clearly portraying the outward signs of self-propelled success (see plate VII). Yet it is important to note that the model of upward emulation in the matter of consumer aspiration and social relationships that many historians enthusiastically endorse does not fully account for the actions, desires, or material acquisitions (or material rejections) of Americans at this period. Henry Glassie and others have suggested a "reception theory" or demand-side model of consumption and design, which postulates the priority of a felt need for an object, ideology, floor plan, façade, or style before long-extant models are appropriated

or emulated.[4] This need is based on shifting attitudes toward time, privacy, author- ity, and other basic issues rather than on a superficial desire for the objects and images of a wealthier or more powerful class. According to these alternative mod- els, the causes of change (or of resistance to change) are more complex, more fundamental, and more interesting than many have thought. An instance of apparently deliberate nonemulation in the matter of family portraits will be touched on below. This chapter is about the invention of a new way of pictur- ing—that is, thinking, understanding—the family. The engine of this change is neither artistic mimicry nor social emulation (although these ingredients are not absent) but rather a desire to express and make visible a new set of roles, roles and relationships already, as we can see in these images, internalized and operative by 1760.

Although this study has involved the detailed investigation of individual pictures, the overall direction has been to discover commonalities, groups of works and patterns of usage that indicate widespread ideology and practice rather than the invention or achievement of individual artists or the nature of individual fam- ilies. Parenthetically, it is important to note that although capturing "a good like- ness" (a recognizable face) was one of the key measures of a painting's success in the eighteenth century, there seems to have been little emphasis on penetrating the sitter's inner character or psychological state. These are works that record, above all, the physiognomy of individuals and the posture, material attributes, and "manner" appropriate to broad class, age, and gender groups. They were at least in part intended and may usefully be read as documents of socially appro- priate behavior and relationships if not (or as well as) of specific individual iden- tities and realities.

BODIES AND ATTRIBUTES

Family portraits by American artists are relatively rare. Most colonials choosing to be memorialized in portrait form in the eighteenth century were painted as single figures on canvases of roughly standardized sizes in a vertical format. Char- acteristic of the full-length portrait from the first half of the century, Feke's *Brigadier General Samuel Waldo* records the dignity and attributes of a bewigged general who clasps his baton of command in one hand, places the other hand on his hip, and assumes the conversational posture recommended in a popular eti- quette book, Nivelon's *The Rudiments of Genteel Behaviour*, published a decade earlier in London: "The whole body must rest on the right foot and the right knee, ... the Back be kept straight; the left leg must be foremost and only bear its own weight, and both feet must be turned outwards" (fig. 54).[5] The akimbo gesture and the firm grasp of a man-made instrument of action in the world (sometimes a quill pen, a sword, a walking stick, a maulstick, a cannon, or a similar elongated instrument) remain male attributes in portraits throughout the century, but the

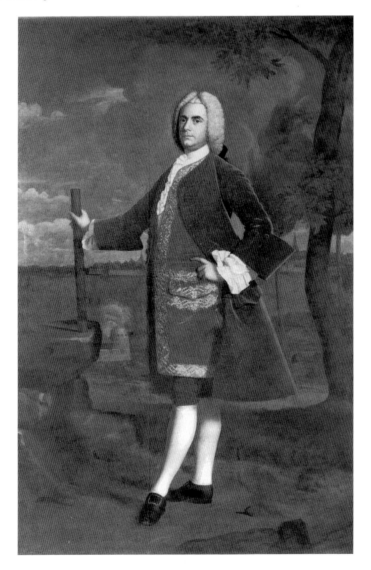

FIG. 54. Robert Feke, *Brigadier General Samuel Waldo*, c. 1748–1750. Oil on canvas. 96⅝ × 60¼ in. (245.43 × 153 cm). Bowdoin College Museum of Art, Brunswick, Maine, Bequest of Mrs. Lucy Flucker Thatcher.

freestanding "genteel" baroque stance of Feke's general does not. Men begin to cross their legs and *lean* on exterior support (as West and his elder son do in *The Artist's Family* and as Copley's William Pepperrell does in his *Pepperrell Family*) about 1750. Posture changes; attributes remain constant. Some of this "body rhetoric" is conscious and articulated (as Nivelon's text makes clear). Some is less conscious, giving us outward clues to inner assumptions, values, and attitudes.

Throughout the seventeenth, eighteenth, and early nineteenth centuries, most couples desiring to be memorialized commissioned paired portraits. In matching frames and on canvases of equal size, the almost life-size figures

slightly inflected toward one another, paired portraits such as those by Copley of Mr. and Mrs. Isaac Smith were by far the most common form of family portraiture (figs. 55 and 56).[6] The figures are equal in size and visual weight, complementary in dominant hue, and parallel in scale and posture. The major differences between them are gender-specific attributes, environments, and gestures. As mentioned, men often touch and are associated with elongated instruments of contact with the outside world, as in the case of Isaac Smith's papers and quill pen. Mrs. Smith, however, holds a bunch of grapes—characteristic of the more rounded organic objects, most commonly fruit, flowers, or dogs and other pets, that were seen as appropriate attributes for women. Beyond Mrs. Smith a pair of entwined trees suggests her married state. But most interesting is the limp, muscleless grasp with which she supports (or, rather, fails to support) a heavy bunch of grapes. In these portraits visual and very real gender-specific social conventions differentiate between the kinds of objects (man-made or natural) and the type of appropriation (firm, possessive grasp or limp gesture) that link individuals to the outside world and to outside experience.

Surprisingly rare among eighteenth-century portrait types are double portraits of husband and wife portrayed together on a single canvas. More difficult to compose than single-figure canvases, these works are probably uncommon also because childlessness was uncommon, and, as the group portraits make clear, the presence of children within the household was important enough to warrant the inclusion of even the smallest infant. The few extant examples of American dual portraits from the first half of the eighteenth century—usually of childless couples or of those with grown children; for example, *Captain Johannes Schuyler and His Wife, Elizabeth Staats* (fig. 57)—follow the English convention of a standing husband accompanied by a seated wife, as in Thomas Gainsborough's iconic *Robert Andrews and His Wife* (fig. 58). The alert verticality of the husband's posture is balanced by the sedentary horizontal or pyramidal figure of his wife—a balancing composition of opposites. Parenthetically, although most of what I have found to be true of American portraiture in the eighteenth century is also true of English paintings at this time, there is one dramatic difference, perceivable in this pair. In the American painting—and this is almost universally the case—the space pictured is shallow and the setting vague; the figures are pressed close to the picture plane. In the English work Mr. and Mrs. Andrews share their canvas with a generous expanse of countryside, a distinct and enveloping setting. This seems to be a consistent pattern even when both images represent mercantile rather than landed gentry, and it may suggest that the English family retained a firmer grasp on the concept of family line (the extended family in time and space) while the Americans preferred the image of an independent unitary household vaguely located in an unancestral, unspecific space. But in most other matters, there is a close and not surprising similarity between the products of the English painters and those of the Americans.[7]

After about 1760, when a husband and his wife are pictured together in one

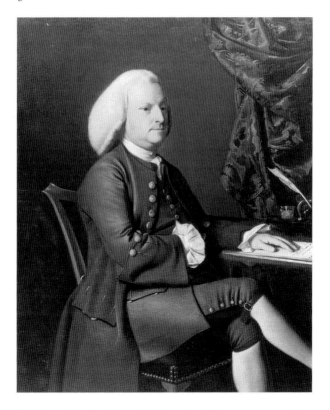

FIG. 55. John Singleton Copley, *Isaac Smith*, 1769. Oil on canvas. 50⅛ × 40⅛ in. (127.3 × 101.8 cm). Yale University Art Gallery, Gift of Maitland Fuller Griggs, B.A., 1896.

composition they usually assume the *same* posture: they both sit or they both stand, as in the case of Copley's portrait of the Winslows (fig. 59). There is an evenness in the relationship implied. They seem equal partners in a joint enterprise with perhaps a slight hint of dominance in the husband's hand and arm gestures, and a modest deference in her recession behind the furniture.[8]

In the last two decades of the eighteenth century these dual-figure portraits underwent a further modification. In such works as Charles Willson Peale's *Benjamin and Eleanor Ridgely Laming* (fig. 60) and Henry Benbridge's *Captain John Purves and His Wife* (fig. 61), the figures touch and lean on each other in postures and with gestures that suggest the popularity of love matches and a new acceptability of visible demonstrations of private affection. Stone—reading theorists and anecdotal accounts—chronicled the arrival of the "companionate marriage" at the heart of the modern family, an institution characterized by an "intensified affective bonding of the nuclear core" and "a weakening of the association of sexual pleasure with sin and guilt."[9] We need only to read Benjamin Laming's telescope and Eleanor's peaches as anatomical analogues

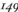

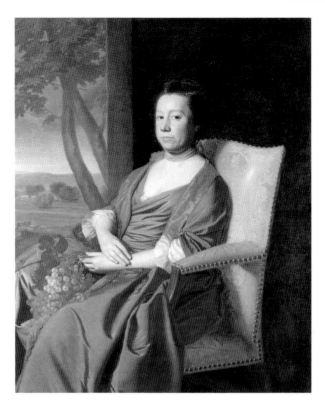

FIG. 56. John Singleton Copley, *Mrs. Isaac Smith (Elizabeth Storer)*, 1769. Oil on canvas. 50⅛ × 40⅛ in. (127.3 × 101.8 cm). Yale University Art Gallery, Gift of Maitland Fuller Griggs, B.A. 1896.

(as the artist seems to suggest) to see the intensity of this new social and personal vision.

DOMESTIC REVOLUTIONS

As we have seen, images of pictorially childless couples change from the early eighteenth century when active, vertical, akimbo male figures were balanced by passive, horizontal female figures (see figs. 57 and 58) to more companionate, parallel couples sitting or standing together in close harmony (see figs 59–61). The shift is significant and seems to occur about 1760. Turning to multifigure groups, we find that the family-portrait tradition exhibits an even more dramatic change at the same time. The early eighteenth-century multifigure works—such as Feke's *Isaac Royall and Family* (see fig. 53)—include standing, akimbo dominant males contrasted with clustered female figures and secondary male associates. The compositions include a dizzying variety of hand gestures, neck turnings, and direct gazes, but the principal male figure coolly ignores the household and gazes intently

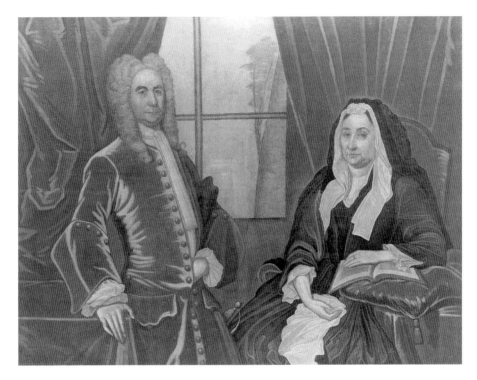

FIG. 57. Attributed to John Watson, *Captain Johannes Schuyler and His Wife, Elizabeth Staats*, c. 1725–1730. Oil on canvas. 54 × 71 in. (137.2 × 180.4 cm). Collection of The New-York Historical Society.

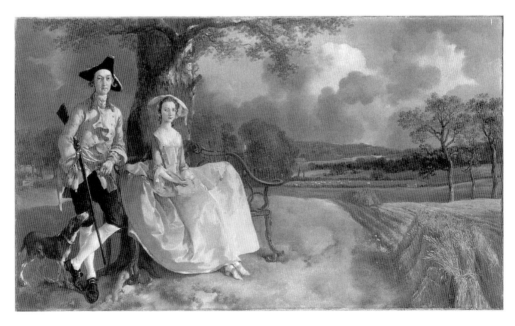

FIG. 58. Thomas Gainsborough, *Robert Andrews and His Wife*, ca. 1750. Oil on canvas. 27½ × 47 in. (70 × 119.5 cm). National Gallery, London.

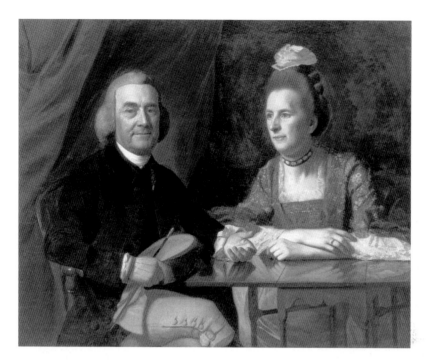

FIG. 59. John Singleton Copley, *Mr. and Mrs. Isaac Winslow (Jemima Debuke)*, 1773. Oil on canvas. 40 × 48¾ in. (101.6 × 123.82 cm). Museum of Fine Arts, Boston, M. and M. Karolik Collection of Eighteenth-Century American Arts; 39.250. Photograph © 2003 Museum of Fine Arts, Boston.

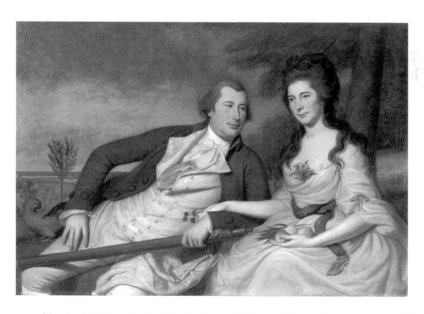

FIG. 60 Charles Willson Peale, *Benjamin and Eleanor Ridgely Laming*, 1788. Oil on canvas. 42 × 60 in. (106 × 152.5 cm). National Gallery of Art, Washington, D.C., Gift of Morris Schapiro, Image © 2004 Board of Trustees, National Gallery of Art, Washington.

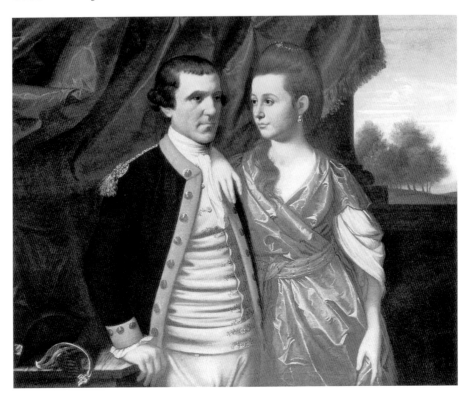

FIG. 61. Henry Benbridge, *Captain John Purves and His Wife (Anne Pritchard)*, 1775–1777. Oil on canvas. 39½ × 50 in. (100.4 × 127 cm). Winterthur Museum.

at the spectator or, as in the case of philosopher-theologian Berkeley in Smibert's *Bermuda Group*, at the heavens (see plate VIII). Most of the attributes and props that accompany sitters in single-figure portraiture disappear in the group context where gender confirmation and relationships depend on subtler clues. We can get a fairly clear sense of the social ideals and realities mapped here if we read these paintings with the interrogatives suggested by Ronald Paulson in a related context: "who is next to whom, who is how far from or inclining toward or away from or touching whom; whose eyes turn, whose eyes meet, and who is standing or sitting next to what."[10] The location of the males in *The Bermuda Group* is marked and punctuated by three stout columns (fictional columns, as Berkeley's house, still extant, in Newport, Rhode Island, has no such embellishment, a topic we will pick up in Chapter 6), while the women in both this and the Feke images are associated with the emphatic horizontality of the foreground table. The early eighteenth-century households pictured by Smibert and Feke are characterized in pictorial terms by the balancing of opposite elements: male and female, dark and light, vertical and horizontal. The patriarch in these images remains aloof and freestanding—he neither touches nor looks at his kinfolk. The children in these early eighteenth-century paintings pose

stiffly in their mothers' arms; they are still, composed, obedient, attentive, and easily overlooked minor actors in the complex tableaux. The women sit in quiet horizontal groups and direct their attention to the spectator and their gestures to their companions. In Stone's terms, these pre-1760 images record families characterized by "distance, deference, and patriarchy."[11]

In paintings of families (that is, husband, wife, and one or more children) by American artists after 1760, much changes. Numerically, although single-figure canvases still greatly outnumber family groups, there are many more family portraits than in the first half of the century. This increase may partly be explained by the growing technical expertise of American artists willing to take on more complex pictorial problems, but it appears to reflect primarily a social fact: a greater interest in, enthusiasm for, and celebration of the family.

CHILDREN

Taking the cast of characters one at a time, the most dramatic shift occurred in the figure of the child. The infants and toddlers in such early eighteenth-century works as Feke's *Royall Family* (see fig. 53) and Smibert's *Bermuda Group* (see plate VIII) are as still and as vertical in the upper body as their parents. Karin Calvert has argued that "upright" was, in seventeenth- and early eighteenth-century British America, not just a moral descriptor, it had a visible dimension in human posture. Infants, for instance, were actively prevented by swaddling, holding, and wheeled apparatuses from crawling or otherwise assuming nonupright "beastial" postures.[12] Their bodies were governed in an effort to enlist their minds and souls in an ethical and theological project. Vertical immobility was the outward sign of inward potential for humanity, self-governance, and even grace. If geometry and ideology rhyme in the bodies of portraited early colonial children, what can we make of the gamboling infants in post-1760 family portraits?

Characteristic of children in family portraits from the second half of the eighteenth century, the youngsters in Copley's *Sir William Pepperrell and His Family* (see plate IV) and in *The Copley Family* (fig. 62) play games, twist in space, cavort, and even lie down with a freedom and spontaneity in their gestures foreign to their pictorial predecessors. They were treated differently by the artist, and we sense that they are treated differently by their parents. Concerning this revolutionary shift in attitude toward the young, John Witherspoon wrote in 1797: "In the former age, both public and private, learned and religious education was carried on by mere dint of authority. This to be sure, was a savage and barbarous method. . . . Now . . . persuasion, and every soft and gentle method is recommended."[13] The behavior of the Pepperrell and Copley children suggests that theirs has been a "gentle" rather than an authoritative upbringing, one consistent with emerging attitudes toward the young. In the seventeenth and early eighteenth centuries, most parents felt compelled to apply strict adult controls to counter a deeply rooted natural depravity in youngsters, to "beat down" and "break"

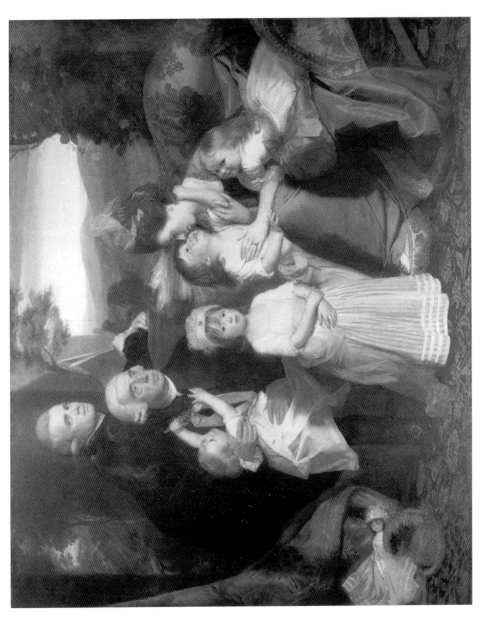

FIG. 62. John Singleton Copley, *The Copley Family*, 1776–1777. Oil on canvas. 72½ × 90¼ in. (184.1 × 229.2 cm). National Gallery of Art, Washington, D.C., Andrew W. Mellon Fund, Image © 2003 Board of Trustees, National Gallery of Art, Washington.

the inherently "diabolical" will with which children were born, a sentiment memorably captured in Anne Bradstreet's "Stain'd from Birth with Adams sin-full fact / Thence I began to sin as soon as act."[14] By the 1760s, however, a more hopeful sense of human nature prevailed, and the theories of John Locke and Jean-Jacques Rousseau concerning the impact of early experience on mature personality were becoming broadly known and endorsed. As a result, certain families—Philip Greven calls them "genteel"—developed permissive child-rearing practices, practices that shaped, in his opinion, adults with a sense of "self-worth, self-love, and self-confidence."[15] While Greven associates these fortunately nurtured children with distinct religious allegiances, the evidence of the portraits suggests that the introduction of new attitudes toward the young crossed sectarian boundaries and, to some degree, class boundaries, becoming almost universal among family portrait purchasers from 1760 on.

After 1760, these reaching, clamoring, grinning youngsters become the focus of the action in family portraits and threaten to break the elegant tone set by their parents. But these children are different from their predecessors in more than their freedom of movement, as Calvert has made eloquently clear; they are equipped with toys (such as the discarded doll in the lower left and the coral-and-bells on a pink sash, which the baby shows to her grandfather in Copley's portrait of his own family (see fig. 62). Moreover, Calvert has found that the boys among these children went through a complex, many-staged series of costumes before donning adult garb, suggesting that, in their parents' eyes, they changed as persons in more identifiable stages than their predecessors had.[16]

While the painters of the Revolutionary generation were clearly more talented than their predecessors, the changes that occur in the "body rhetoric" of both children and adults in portraits about 1760 are not attributable to this alone. The "stiffness" of Feke's *General Waldo* or the figures in Smibert's *Bermuda Group* compared with the "naturalness" of West's or Copley's figures suggests a shift in adult models of self-imagery and deportment, away from the formality prescribed by early eighteenth-century etiquette and advice books as much as an increased artistic fluency. Similarly, as argued above, the shift from the image of the infant or very young child who boldly, motionlessly observes the spectator to that of the clamoring youngster whose attention is completely absorbed by objects and persons within the tableau represents a change in society's understanding of the child as well as a greater mastery of anatomy and perspective on the artist's part. The characteristics that mark images of family members are widespread and more period-specific than artist-specific. Individual artists whose careers spanned the eighteenth century changed the body rhetoric and relative positions of their figures as the conventions of self-presentation shifted about 1760. The English artist Gainsborough, for instance, altered his interpretation of the couple from that of the early contrasting standing, vertical male and horizontal, seated woman in 1750 (see *Robert Andrews and His Wife*, fig. 58) to that of the parallel visibly affectionate couple who walk arm in arm in his 1785

Mr. and Mrs. Hallett (National Gallery, London). His interpretation of the family group changed from the classic early eighteenth-century format of *Mr. and Mrs. John Gravenor and Their Daughters* (Yale Center for British Art) to the matricentric *Baillie Family* of about 1784 (Tate Gallery). The pictorial evidence taken as a whole concerning the "unleashing" of children and the reorganization of pictorial focus from male dominance to female prominence points away from issues of individual talent and toward issues of social consensus.

FATHERS

While the shift in the social and pictorial role of the child in Anglo-American portraiture is clearly the most significant difference between early and late eighteenth-century images, alterations in the portrayal of other family members change the look, impact, and meaning of these paintings. The child's new centrality involves a corollary shift in the father's role: he cedes visual dominance and, turning sideways to the picture plane, leans toward, plays with, looks at, and touches the child as he never did in early eighteenth-century portraits. While in such early images as Feke's *Royall Family* (see fig. 53) the father anchored the composition and riveted the spectator with his authoritarian gaze, in such later works as West's *Arthur Middleton, His Wife, Mary (née Izard) and Their Son, Henry* (see fig. 15) and Charles Willson Peale's *John and Elizabeth Cadwalader, and Their Daughter, Anne* (fig. 63) his presence is reduced, softened, and contingent. This new status is often emphasized by his recession from the picture plane and his presentation to the beholder with a marginalizing profile physiognomy (see also plate VII and fig. 62). In such portraits as West's *Artist's Family,* the father's position, his posture, and often his attention encourage us to focus on his progeny and not on him. Clearly the (seeming) withdrawal from a posture of authority involved an admiration for, perhaps even a nostalgia for, the special state of childhood, as it was newly perceived. No longer seen as inherently sinful, these youngest members of the human community were understood as naturally good, uncorrupted, and even, on a theoretical level, admirable models for adult ways of being in and comprehending the world.

Fathers, however, do not just indulge in a new interest in observing their gamboling, frequently now non-"upright" heirs, they themselves abjure the muscular tautness of their predecessors for a more relaxed self. One hesitates to call "natural" the somatic self-presentation we see in West's depiction of his own paternal body (see plate VII) or Copley's of Sir William Pepperrell (see plate IV), although that is the specific term endorsed by contemporary etiquette texts. There are other ways the body could relax, could be depicted as relaxed, as we saw in West's image of a drayman, for instance (see fig. 24). The specific somatic self-presentation we see here conjures images of antique ideal male bodies, ideal male beings, excavated, displayed, copied, and published with increasing momentum in distant Italy over the course of the sixteenth and seventeenth

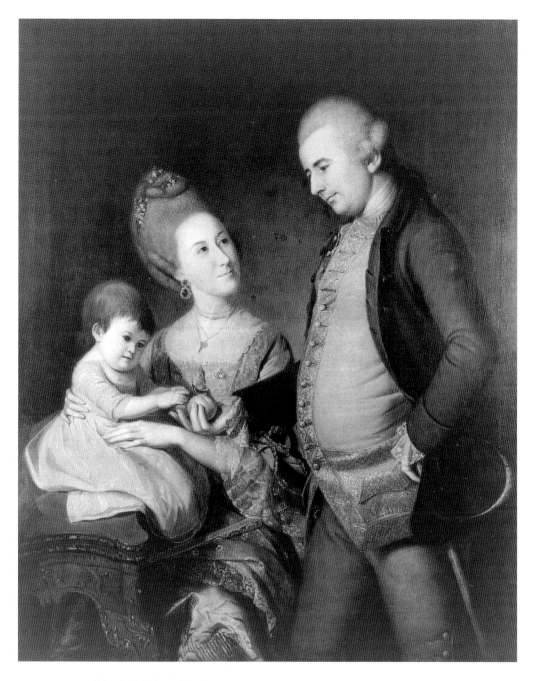

FIG. 63. Charles Willson Peale, *John and Elizabeth Cadwalader, and Their Daughter, Anne*, 1772. Oil on canvas. 51½ × 41¼ in. (130.5 × 104.7 cm). Philadelphia Museum of Art: purchased from the Cadwalader Collection with funds contributed by the Myrin Trust and the gift of an anonymous donor.

centuries, reaching a crescendo in the eighteenth. We saw in the last chapter hints that Copley and his patron, probably learning from Hogarth, embraced the sinuous leaning Belvedere Antinous (aka Hercules, Meleager, Mercury, and Theseus) to express modern civic masculinity (see plate VI and fig. 52). The sweeping linked S and C scrolls of these marble bodies were evident in the cyma and ovolo curves eighteenth-century aestheticians singled out for admiration in the forms of nature and ceramics of Asia as well as in these human forms extracted from the earth and installed with universal applause in Papal collections (and the collections of collateral Papal families). Copley—like most colonials—did not have a classical education and would have known little of Greece or Rome, but he signed his canvases with the Latinate "pinx" and added an Italianate portico to his house as well as embarking on the interesting ventures into visual quotation we see here and will take up shortly and again in Chapter 6. His literacy in things antique was thin, but it was important; and, for West, catch-up in this arena was even more important to his career in London than improving his painting technique.

Exactly what characteristics of these painted fathers conjure those distant gods and heroes? Primarily they lean. Rather than supporting an erect trunk on the firmly planted legs and perpendicular feet formal protocol endorsed in the first half of the eighteenth century as we heard in Nivelon's advice about straight backs and weight distribution and see paradigmatically in Feke's *General Waldo* (see fig. 54), West and Pepperrell, for instance, allow their bodies to be contingent, the supporting hip to swing out, and the unoperative leg to cross its fellow in graceful nonengagement (see plates VII and IV). This is the male body as we see it in the right figure of the much admired and much published Castor and Pollux pair (aka The Decii, two Genii, Orestes and Plyades; in Rome until 1724 and subsequently the Prado) and the Marble Faun (Rome, Capitoline Museum from 1753) as well as the Belvedere Antinous recorded by Hogarth.[17] The figure is stable but fixed; to move it must gather itself and radically readjust the weight burden. Moreover, the air of heroic self-sufficiency we see in all these icons of antiquity, in which the viewer's subjectivity is *not* constructed and acknowledged in a returned gaze, this air is evoked in the non-address of painted fathers to their viewers. Above all, the tone evoked by, for instance, Belvedere Antinous (see fig. 52) is what one commentator called a *morbidezza*, that is, a prevailing softness, smoothness, mellowness, and delicacy.[18] To adopt this "softened" posture, this averted gaze, is to visually cede dominion, to appear to not insist on paternal privilege or priority, and yet, in a cynosure of grace, to indirectly, "naturally," recover the viewer's riveted regard and admiration.

The enthusiasm generated in the eighteenth century for this particular group of "smooth" languid male postures was not sustained. As the select canon of greatest models of human form and expression was revised, Antinous, once consulted by Bernini "as an oracle," "sunk almost without trace from the general consciousness."[19] Inherent in this subsequent nineteenth- and twentieth-century

demotion was not only a revised view of antiquity but also a revised view of model masculinity. For West and Copley and their patrons, these were matters and models of importance, foregrounded particularly in the imagery for men in their roles as custodians of children. In images lacking children we see an absence of the extreme "softness" evident here, and yet echoes of these god-heroes lurk as resonant paradigms in the bodies of many colonial men as we saw in *Joshua Henshaw* (see plate VI). Distant in time and space from colonial America and even from London, these marble gods prompt us to ask Hamlet's question: "What's Hecuba to him or he to Hecuba?"[20] Our answer is argued in the paintings—Castor and Pollux, Antinous, various fauns in marble, bronze, plaster, and engraved simulacra—these mattered. They provided models of how men might be in the world, or at least how men—invested in law and custom with near-absolute authority over their households—might appear to be in a domestic circle that included young innocents: benevolent, attentive, unthreatening guardians and mentors, ready to try Witherspoon's "persuasion and every soft and gentle method" to bring their heirs to obedience and domestic harmony.

MOTHERS

Similarly, when a young child is included in the family portrait, the position of the mother vis-à-vis her infant and her husband is markedly different from the relationship perceived in family portraits executed in the first half of the eighteenth century, and different from the spousal relationships evident in contemporaneous paintings in which children are not present. The child-dependent paradigm shift realigned all the players. Reading such images as West's family groups (see fig. 15, plate VII), Copley's paintings of his own family (see fig. 62) and that of William Pepperrell (see plate IV), and Peale's portrait of the Cadwalader family (see fig. 63) in terms of Adam Smith's *Theory of Moral Sentiments* (1759) is instructive on this point. While both fathers and mothers display newfound feeling for and visual absorption in their progeny, Smith argues for the superiority of what could be called the triangulated sympathy of the father figure, alert not only to the self of the child but also to a subjunctive third-party self within (prompting him to generosity, self-restraint, and sacrifice).[21] In Smith's terms, male participation in self-theatricality signals the potential for virtue and makes empathy (the capacity to understand the experience of another) a basis for a practical modern morality. In other words, what Edmund Burke described as the feminine "softer," "amiable virtues" of "easiness of temper, compassion, kindness and liberality" are masculinized and elevated by their association with will, a sense of justice, and action aligned with "wisdom" as judged by—in Smith's terms—an "impartial [imaginative third-party] spectator."[22] We, as external observers of these paintings can imagine (and stand in for) this internal governor, and see in these fathers a Christianized ethically oriented hard-

ening of the "softness" of those pagan "Antinous" leaning bodies. Their softness is an alternative avenue to male virtue.

For women, "sympathy" and sentiment were understood to be socially useful, but, ungoverned by the "ideal man within the breast," unproductive of civic virtue.[23] Nevertheless, as these images make clear, women-as-mothers radiate a novel sanctity. Where formerly (as in Feke's *Royall Family*, see fig. 53) she presented a quiet undistinguished foil to the assertive figure of her husband, in such late eighteenth-century works as we saw in West's *Artist's Family* (see plate VII) the mother commands the primary attention of the viewer and of the family members pictured. The husband retreats visually and, although he usually maintains his standing posture, his gaze, coloration, gesture, and orientation subordinate his figure to that of his brightly lit, seraphic wife, absorbed in her identity as mother. Her centrality, however, is not assertive; rather, it is unself-conscious and modest. The curious mid-eighteenth-century reversal of time-honored stereotypes of women as the sinful, deceptive, and disobedient weaker vessel to the chaste, honest guardian of domestic harmony and republican virtue has been interestingly analyzed by numerous historians, including Nancy Cott, Mary Beth Norton, and Anthony Fletcher.[24] That this new role was in a sense artificial was rather cynically granted by such influential writers as Jean-Jacques Rousseau: "If the timidity, chastity, and modesty which are proper to [women] are social inventions, it is in society's interest that women acquire these qualities."[25] The celebration of these personal virtues and ideals is well known from the verbal documents, but the concurrent seeming retreat of the husband from centrality in the domestic sphere is nowhere as emphatic in the documents as it is in these paintings. Legal realities and written sources assure us that Stone is correct when he says: "As a social system, the nuclear family has two castes—male and female—and two classes—adult and child. The male caste always dominates the female, and the adult class the child. . . . In the Early Modern Period, a female adult took precedence over a male child, but only up to the age of about seven." The *Commentaries* (1765–1769) of noted English jurist William Blackstone make clear that property (and the dignity and power attendant on possessing property) remained unequivocally a male prerogative. Its movement within the family was patrilinear (fathers to sons), patricentric (control of a wife's property brought into a marriage was vested in the husband: *femme couvert*), and only conditionally and temporarily bestowed on widows, reverting on their death or remarriage to sons.[27] When we look at both English and American pictures, however, precedence is uniformly granted to the maternal figure; she glows and looms over the family like a triumphant Madonna—a fact that has puzzled some.[28] It is clear, however, that in the mime show of the family portrait (as in the newly popular medium of the novel) certain fictions and ideals are being asserted that helped the early modern family adjust to the strains of new economic and social relationships. Where some historians point to this moment as the beginning of a dramatic decline and a disabling sentimentalization

of womanhood the paintings give us some sense of the apparent privileging of woman in her role as mother. As we have seen, portraits of childless couples, even those from the late eighteenth century (figs. 57, 58, 59, 60, and 61) give her no such precedence as we find in the West, Copley, and Peale images that include children, or in such incongruously titled paintings as Sir Joshua Reynolds's *Duke of Marlborough and His Family* (fig. 64). Clearly it is the altered role of the child in the ideology of the day that is responsible for the mother's seeming elevation as custodian. And in America—as John Adams makes clear—there was a political as well as a moral goal at stake in the Madonna-fiction of mothers: "I say . . . that national Morality never was and never can be preserved without the utmost purity and chastity in women; and without national Morality, a Republican Government cannot be maintained."[29]

It is no coincidence that during this late eighteenth-century period we find

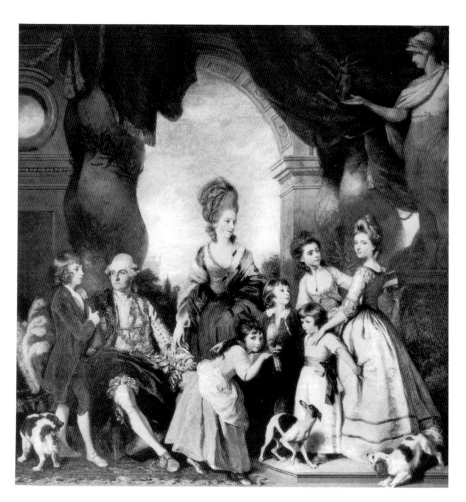

FIG. 64. Sir Joshua Reynolds, *The Duke of Marlborough and His Family*, 1778. Oil on canvas. 126 × 113 in. (320.1 × 287.1 cm). By permission of His Grace the Duke of Marlborough, Blenheim Palace.

a rare interest among American artists in religious painting, especially in images of the Nativity, Holy Family, and Madonna. In part, of course, this interest was sparked by the ambitious goals of some of these artists to compete and establish themselves on a par with first-rank European artists at a time when taste favored history painting (and its subgenre, religious painting). There was little market for religious subjects in Protestant colonial British America, but the general secularization of American life during the later eighteenth century permitted the experimentation, especially by American artists resident in England, in these formerly untried subjects. The degree to which these images were *secularized*—that is, liberated from their historic religious context and incorporated into a context of modern domestic life—is suggested by the literal conflation of the two spheres in such paintings as Copley's *Nativity* (fig. 65) and West's *Mrs. West and Her Son Raphael* (fig. 66). In the former, Copley has used his wife as a model for the Madonna, and her head and upper body appear in a pose almost identical to that in *The Copley Family* (see fig. 62). Similarly, West has incorporated his wife and elder son in a composition that consciously quotes the well-known tondo by Raphael known as *The Madonna of the Chair* (Uffizi, Florence). The intersection of the domestic and religious spheres in these images, and the

FIG. 65. John Singleton Copley, *The Nativity*, c. 1776. Oil on canvas. 24½ × 30 in. (62.23 × 76.2 cm). Museum of Fine Arts, Boston, Ernest Wadsworth Longfellow Fund; 1972.981. Photograph © 2003 Museum of Fine Arts, Boston.

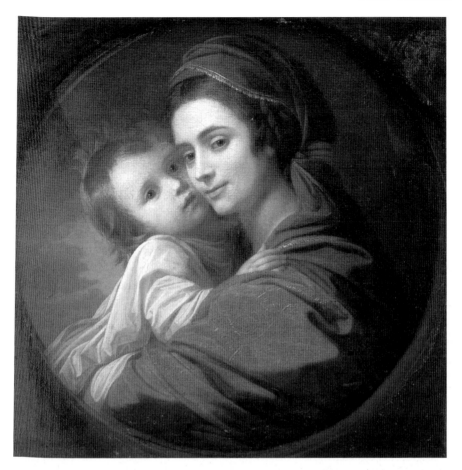

FIG. 66. Benjamin West, *Mrs. West with Raphael West*, ca. 1770. Oil on canvas.
26 × 25⅞ in. (66.5 × 66.3 cm). © Cleveland Museum of Art, Charles W. Harkness
Gift, 1927.393.

move by these artists to reinterpret and quote the Renaissance masters in
numerous other related images, suggests not only their personal artistic ambi-
tion but also their consciousness of an identity between the Holy Family and
an idealized version of the modern domestic sphere.[30] They have appropriated
for their wives—in their role as mother—the supreme example of female virtue.

ELSEWHERE

As noted, visually childless couples in the second half of the eighteenth century
exhibit an evenness of emphasis between the figures with a slight element of dom-
inance on the part of the husband (see figs. 59, 60, 61), the portraits from British
America in which there are infants and young children are dominated by the mater-
nal group.[31] There is one interesting exception: folk, or naïve, family portraits from
the late eighteenth century. Here, in such works as *Family Portrait* by Ralph E.

W. Earl (fig. 67), as in the contemporary childless couples painted by Copley, Trumbull, Peale, and others, there is an evenness of emphasis: the wife is pointedly not visually dominant.[32] At this point it is impossible to determine whether we are looking at evidence of different, older, child-rearing patterns in nonurban areas, at *retardataire* painterly conventions, or at certain habits of mind characteristic of the folk painter (by and large, the folk painter organized his composition for overall two-dimensional pattern rather than interlocking dominant and subordinate elements). These folk or vernacular pictures are uniformly even in their tone and in their attention to family members; they present us with an interesting example of nonemulation as these artists knew the work of their urban contemporaries and declined to imitate the compositions and family relationships they saw there. The social gulf between the urban mercantile elite (represented by most of the portraits included here) and the rural gentry (pictured in Earl's family portraits, for instance) was probably greater than we imagine—great enough to give us this evidence of distinctly different pictorial conventions, social ideologies, and, probably, child-rearing practices.

While much has been written on the nature of folk art and on its relation to urban art, little consensus exists on its boundaries or even on proper nomenclature. Some maintain that it is *the* locus of creativity in America, privileging

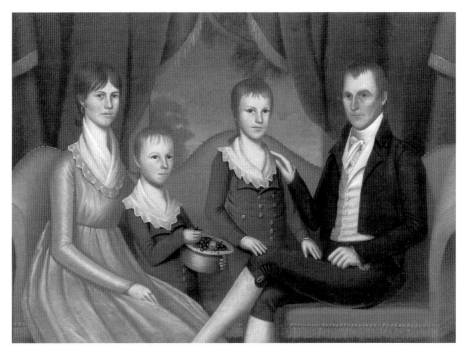

FIG. 67. Ralph E. W. Earl, *Family Portrait*, 1804. Oil on canvas. 46⅝ × 63½ in. (118.5 × 161.3 cm). National Gallery of Art, Washington, D.C., Gift of Edgar William and Bernice Chrysler Garbish. Image © 2004 Board of Trustees, National Gallery of Art, Washington.

it and valuing it beyond mainstream developments and European-oriented art forms, while others assert that it is simply a poorly understood, poorly executed version of its urban cousin.[33] In looking at this narrow group of family portraits— images that share certain characteristics of technique (and, I believe, of market, although it is difficult to find a body of conclusive research on the patrons of these elusive, often anonymous, works of often unknown sitters)—it is clear that the "rules" by which they are composed differ from those common in the urban centers of Boston, Philadelphia, and London. While the absolute number of naïve family portraits in nonurban areas rises as dramatically during this period as in the urban centers, the execution differs markedly, which supports the complex "reception theory" of cultural change in which novel forms are selectively adopted rather than poorly mimicked.

PRIVATE FAMILIES: PUBLIC IMAGES

This discussion has only touched parenthetically on the *uses* of family portraits in eighteenth-century British America. As one might expect, the commissioned works appear to have hung in the homes of the patrons who bought those paintings, and they descended through children to more distant heirs over time as we saw in Chapter 4 and will see in the investigation of another such work shortly. The portraits that artists painted of their own families arose from different circumstances and appear to have had a somewhat more public life. As noted, they did not yield a direct profit but, rather, cost the artist and his family time and materials. They gave him an opportunity, however, to experiment, using himself and his family members as fee-less models. Consulting the mirror and the bodies of his kin, he was able to study at leisure and depict "attitudes, expressions," and relationships useful in working out other multifigure groups including commissioned family portraits and, in a few cases, history paintings.[34] Once completed, these group portraits of the artist and his family appear to have been hung (as Smibert's had been early in the eighteenth century) where potential sitters and visitors to the artist's studio could view them. John Adams, for instance, recorded in his Philadelphia report to Abigail that he had seen and admired Charles Willson Peale's *Family Group* in the artist's studio, not as a potential patron but as a man generally interested in "these elegant and ingenious arts of painting, sculpture, statuary, architecture, and music" (see plate III).[35]

With a broader potential audience, access to public institutions, and greater ambition than Peale, Copley, upon establishing himself professionally in London, offered for exhibition at the Royal Academy during his first year in residence his *Copley Family,* using it as a kind of polite signboard soliciting patronage (see fig. 62). This was an unusual move and an unusual genre (as noted, few eighteenth-century English artists executed self-portraits within the context of a family group) and it was a very private genre to present in that very public venue. Copley was probably motivated by several conjoined circumstances.

First, he had had little call to learn or practice the skills of portraying multiple figures convincingly on a single canvas during his career in Boston. There is evidence, as touched on in Chapter 3, that he was conscious of a want of skill in this area. As he aspired to be a history painter, this project afforded him a no-fault opportunity for mastering the much more difficult spatial problem of a multifigure composition while at the same time developing, practicing, and displaying the remarkably free brushwork that we see hints of in his colonial portraits and that eventually came to characterize his London oeuvre. Second, it gave him an opportunity to rehearse a large family group in specific preparation for executing a long-standing commission to paint the Pepperrell family, as we will see. Moreover, West's small, jewel-like picture of his own family (see plate VII)—painted a few years earlier—was also exhibited at the Royal Academy in 1777 and it is probable that these friends, compatriots, and competitors knowingly offered answering visual texts. Last, the Smibert *Bermuda Group* (see plate VIII), executed some fifty years earlier and continuously available to students and artists in Boston during the second half of the eighteenth century, had familiarized British Americans with this genre, naturalizing it as a type of image one would expect to find on exhibition in an artist's studio. For them, then, it was no large leap to present this type of private image of a domestic ideal for public exhibition. In sum, the family portrait and the family portrait of the artist's family, were familiar genres to American audiences and artists, useful for describing the family to itself as a gathering of specific individuals and as an ideological text, and also useful as a sampler of the artist's skills, an instrument for proffering those skills to potential patrons. These are, in general, the uses for which these images were created and to which they were put in the years immediately following their creation.

Before we conclude too quickly that these are the only possible uses and audiences for painted family groups in colonial America, we might usefully turn briefly and comparatively to a genre of family images created in Spanish America for very different purposes at the same time, used in what is now Mexico but also, no doubt, used in what is now California and the Southwest. Characteristic is Miguel Cabrera, *De Espanol y de India, Mestiza* of 1763 (fig. 68). This is one of a set of family groups painted by this gifted artist in 1763, recording, in this case, a family composed of a Spanish shoemaker father, a "Mestiz" (that is, half Spanish, half Indian) mother, and their child, categorized and identified as a "Castiza." The figures and faces are highly individuated, appearing to be not only racial "types" but also portraits. Several dozen sets of Mexican "las castas" paintings survive, recording the fifty-three racial classifications (documenting and displaying specific terminology, characteristic features, skin color, costume, and occupations, based on quantity and mixture of Spanish, Spanish-born-in-the-New-World, Indian, Negro, and other "blood"), which were laminated onto individual identity by civil and religious authorities in sev-

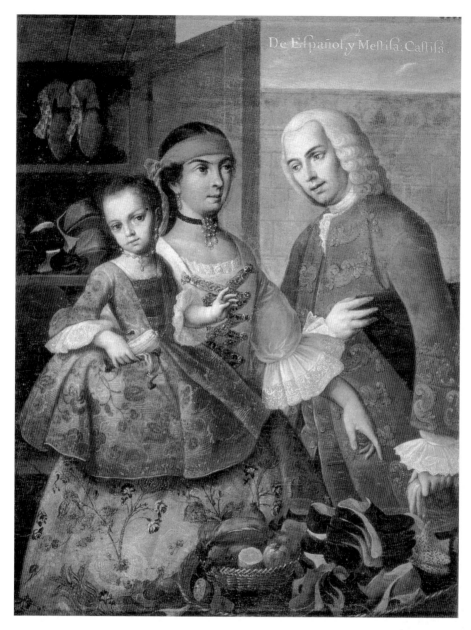

FIG. 68. Miguel Cabrera, *De Espanol y de India, Mestiza,* 1763. Oil on canvas. 52 ×
40 in. (132 × 101 cm). Museo de America, Madrid.

enteenth- and eighteenth-century Spanish America. Apparently painted for the
benefit of parish priests in their role as demographers, establishing identity in
the recording of parishioners' marriages, births, and burials, these family images
classified identity in a culture in which racial mixing was a fact of life, but priv-
ileges and prohibitions concerning the trades open to (or forbidden to) each

caste and the costumes permitted (or prescribed or proscribed) to each caste were highly regulated.[36] As unlike as these images are in patronage and purpose to those produced in the British colonies, the Spanish "castas" images executed in the second half of the eighteenth century nevertheless are quite consistent in describing the mothers, fathers, and youngsters they picture as affectionate child-centered families. My intent in bringing in these images is not to disrupt or derail the discussion at hand but rather to point to a comparative situation where a rather different European culture imported similar artforms and genres to the New World and even some of the evolving ideas of the bonds unifying the family unit but then used this pictorial language to very different, very public ends, to establish very different ideas of identity.

By reading eighteenth-century family portraits in British America in terms of the relationship of the figures, their attributes, and their activities and by finding consistent patterns in the portrayal of these elements, we can gain some insight into the larger questions of changing (and class-distinct) family manners, ideologies, and attitudes toward authority and virtue. The hyperbole concerning family roles we read in family portraits by West, Copley, Peale, and others, is particularly telling. In the post-1760 urban pictures, the children are more unleashed, the fathers more reticent, and the mothers more central than the verbal documents lead us to expect. Indeed, the pictorial record suggests that the watershed shift to a novel ideology governing modern family relationships occurred considerably earlier than social historians have generally believed.[37] In this breach between "reality" as social historians have come to understand it and the fiction the artists have described, we can locate the articulation of a new way of understanding the self—whether man, woman, or child—as a social being invested with feeling as well as dignity, individuality, and identity within the social unit of the family.

PROFESSIONAL AMBITION AND PRIVATE RECONSTRUCTION

Thus far, I have treated this genre, family portraiture, holistically, extracting from shared characteristics, shared attitudes. Exactly how did the individual family portrait relate to and express the family it fixed on canvas? A sustained look at one of these family portraits, Copley's *Sir William Pepperrell and His Family* (see plate IV), will help clarify how one of these ambitious paintings recorded, projected, and participated in the life of a specific family and in the professional identity of one notable painter as well as in the general reconstruction of the idea of family among late eighteenth-century British Americans.

In August 1774, two months after he had left his native Boston and scarcely a month after arriving in London, the city that would be his home for the second half of his remarkable career, John Singleton Copley wrote to his younger half-brother, an aspiring artist, "you must be conspecuous in the Croud if you

would be happy and great."[38] We sense that the astute Copley—who had pondered for many years the risks and potential rewards of challenging the English art establishment on its own ground—was recording his own intended plan of action as much as advising the provincial novice. A few days later, Copley left London for a year's sojourn on the Continent, returning in the autumn of 1775. Almost immediately, he moved into a house and studio on Leicester Square, "conspicuously" two doors up from that occupied by William Hogarth's widow and across the square from the home of Sir Joshua Reynolds, then president of the Royal Academy.[39]

Even in distant Boston, Copley had been aware of the Royal Academy (founded in 1768) and its important role in the education and professionalization of artists as well as in the opportunities its annual exhibitions afforded for public exposure and patronage development. He sent paintings to the Royal Academy's spring exhibitions in 1776 and 1777 but received little notice until the spring of 1778, when he sent two canvases of decidedly conspicuous size (as well as a third single-figure work of the type for which he was well known in the colonies). Both of the large 1778 canvases (one six by seven feet, the other seven by nine feet) were composed of multiple-figure groups and represented a decided departure for an artist who, until his emigration to England three years earlier, had virtually no experience in handling compositions of such size and complexity. Copley's anxiety concerning the management of multifigure groups is apparent in the relief he confided to his half-brother after his first reconnoiter of English studios: "I find the practice of Painting [groups] or rather the means by which the composition is attained easyer than I thought it had been. The sketches are made from the life, and not only from figures singly, but often from groups. This you remember was [what I] have often talked of, and by this a great difficulty is removed that lay on my mind."[40] The rendering of multiple figures, disposed convincingly in space and enacting a mime that was coherent, original, and dynamic was new to Copley, but it was, he knew, the essential characteristic of group portraiture (the genre he anticipated would sustain his livelihood) and history painting (the genre he hoped would bring him fame).

Copley's offerings at the 1778 Royal Academy represented only his second family group, *Sir William Pepperrell and His Family* (see plate IV) and his fourth attempt at history painting, *Watson and the Shark* (fig. 69).[41] Considering his novice status, it is remarkable that he should achieve so swiftly such competence, indeed such excellence, especially given the legendary slowness with which he labored at his craft. While *The Pepperrell Family* received brief and generally disparaging notice by the critics, *Watson and the Shark* was praised as "among the first performances in this exhibition" and launched Copley's reputation. As Jules D. Prown pointed out, the figure of Watson alludes to a classical sculpture, the Borghese Warrior—well known in eighteenth-century Europe through

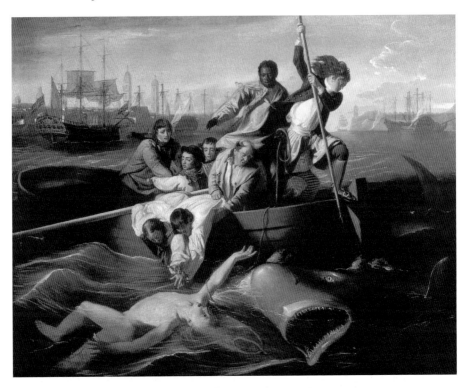

FIG. 69. John Singleton Copley, *Watson and the Shark*, 1778. Oil on canvas. 72¼ × 90⅜ in. (183.51 × 229.55 cm). Museum of Fine Arts, Boston, Gift of Mrs. George von Lengerke Meyer; 89.481. Photograph © 2003 Museum of Fine Arts, Boston.

copies and engravings—tipped "sideways" in Copley's composition to morph into a swimmer (fig. 70).[42]

Overshadowed by the more prominent genre and public acclaim of *Watson*, the Pepperrell family portrait is nevertheless a key work in Copley's career, one that points to both the artist's and the patron's strategy for positioning themselves in a novel environment and, simultaneously, but less consciously, serves as an index to broader issues of social history including eighteenth-century Anglo-American narratives of family, childhood, time, and death.

While for Copley the exhibition of his *Pepperrell Family* functioned as a kind of advertisement of his competence and availability in the genre that the English gentry were most wont to patronize, for William Pepperrell III the public presentation of his familial image served his own long-range purposes. Commissioned shortly after both Copley and the Pepperrells had emigrated from Boston to London, the painting preserves—or rather asserts—an image of the Pepperrell family that had scarcely ever existed and that certainly had altered irretrievably by the time the work was executed and exhibited in 1778.[43] That both artist and patron found it suitable to fictionalize the situation, to gloss over certain realities and hyperbolize others, not only suggests their willingness to ignore

FIG. 70. Borghese Gladiator or Warrior, plate 27, François Perrier, *Segmenta
Nobilium Signorum et Statuarum que Temporis Dentem Invidium Evase* (Rome and
Paris, 1638). Engraving. Research Library, the Getty Research Institute, Los Angeles.
(Turned sideways as it is in Copley's quotation of it in fig. 69.)

facts or to follow portrait conventions, but also points dramatically to the extraor-
dinary power of the underlying family-structuring function of portraiture in the
Anglo-American world. Not merely an idle public expression of pride or a dis-
play of personal beauty and worldly acquisitiveness, the eighteenth-century por-
trait was (as discussed earlier) addressed primarily to family members, and it
codified in an orderly manner horizontal relationships of power as well as ver-
tical relationships of descent. For this reason, most eighteenth-century Ameri-
can and English portraits were commissioned at the point of marriage, the birth
of an heir, the attainment of majority, or a moment of singular achievement, mark-
ing these notable and potentially disruptive or contested changes in the family
line, family name, and family wealth among those families fortunate enough to
have inheritable substance.[44] Copley's *Pepperrell Family* is no exception; it is
about the birth of an heir and the reachievement of a title. Pepperrell's family
was wealthy and prominent in New England. His maternal grandfather William
Pepperrell II (1696–1759) was a successful merchant in lumber and fish, and he

was a soldier whose command at Louisbourg was rewarded with a baronetcy (a unique distinction for a colonial family). The son of this war hero, Andrew, died childless. Sir William, therefore, made provision in his will that his daughter's son, William Pepperrell Sparhawk (1746–1816) could succeed to his estates, provided he assume his grandfather's name; he thereafter is known as William Pepperrell III, and figures in the title of Copley's painting as Sir William Pepperrell. His father—Col. Nathaniel Sparhawk—was the subject of one of Copley's most impressive full-length canvases (see fig. 4). William Pepperrell III, who succeeded to his grandfather's fortune as well as his name in 1759, attended Harvard, did the Grand Tour, and consolidated the family fortunes by marrying the daughter of Isaac Royall, a member of the King's Council at Massachusetts, a rum merchant, one of the wealthiest men in New England, and one of Copley's earliest patrons.

William Pepperrell III commissioned the Copley portrait after the birth of his heir (the cherubic figure whose umbilicus marks the center of the canvas), and, shortly after, in 1774, the Crown granted his petition to revive the baronetcy awarded his grandfather, the hero of Louisbourg, and to succeed to the title himself.[45] The image, then, is of a buoyant, stable, aristocratic, American household, presided over by a statuesque maternal figure and an admiring, urbane baronet, a family in which the line has just been re-elevated in status and ensured of perpetuation by the birth of an heir. In reality, the child, William Pepperrell IV, was born in the turbulence and privation of Boston in July 1775, when British troops occupied the city, keeping an uneasy peace between Loyalists and revolutionaries.[46] The young mother, Elizabeth Royall Pepperrell, died three weeks after his birth. The prosperity and calm, the exuberant health and confidence with which Copley has endowed the family masks the grim reality of Elizabeth's death, Sir William's censure as a Loyalist by the York, Maine, County Congress; the family's loss of its considerable fortune and revenues from the rents and profits of the confiscated Pepperrell lands, shipping, and lumber mills in New England; the anxiety of life in the rioting and bitterness of Boston before the Pepperrell family emigrated in February 1776; and the uncertainty of exile in the unknown environment of London.[47]

Copley's is a portrait in the subjunctive mode. It posits a "what if . . ." scenario, imaging the family as it might have been a year or so after young William's birth had war and financial loss, public animosity, and death not robbed the Pepperrells of halcyon prospects on their Roxbury, Massachusetts, estate, funded by the immense wealth and landholdings amassed by Sir William's grandfather and great-grandfather in Maine.[48] For Sir William, the portrait functioned as an assertion of the salvageability of dignity, confidence, prosperity, normalcy, and familial wholeness in an uncertain exile that offered the widower and his family only limited prospects. As it happened, Sir William was predeceased by his heir, and the family fortunes (and Copley's portrait) devolved on Harriot, here imaged as a tot seated on a table and busily engaged in a game of skittles, later Lady Palmer, dowager-matriarch of Wanlip in Leicestershire. There the painting hung until

1933, a graphic assertion of rules obeyed, conventions embraced, and continuity asserted in the teeth of rupture and loss, and a reminder to her descendants of the Pepperrells and their four-generation interlude as colonial Americans.[49] Seemingly stable and coherent, the narrative of the painting was inscribed by its author and patron within this unstable conjunction of modes and tenses, a wistful pantomime of history as it "will not have been."

Copley's portrait includes six life-size figures and two dogs in a spatially ambiguous but stately setting. Bracketed by such standard portrait conventions—one might call them visual clichés—as the drawn-back taffeta curtain and the glimpsed pastoral landscape, the baronet and his daughters gather on a colorful "turkey work" carpet around Lady Pepperrell and young William. Although Lady Pepperrell is a seated, still form, anchored in space by the white, insistently vertical column that silhouettes her head and marks her presence with permanence and resonance, all the other figures lean and stretch, their emphatic contingency and activity emphasizing her stability and calm. Yet this centrality and gravity of deportment are not simply tributes to her as a cherished and dignified memory nor are they characteristics resulting solely from the exigencies of an artist working from stand-in models, miniature portraits, and working drawings.[50] The mother-as-cynosure, as discussed, was a well-established, socially significant visual conceit during this late eighteenth-century period, one pointing to a new seriousness, even sacredness, in the maternal role as custodian of the moral well-being of impressionable children. Similarly, Sir William's leaning posture, his crossed legs, his gentle touching of the baby's arm, and his focus of attention on his family are characteristic of father figures in Anglo-American family portraits of the period.

As noted, the treatment of paternal figures and children in family portraits differed markedly between the first and second halves of the eighteenth century. A brief comparative glance at the portrait of Elizabeth's parents, *Isaac Royall and Family* by Robert Feke (see fig. 53), painted almost forty years earlier, clarifies the dramatic character of this change. Where early in the century the child was stiff, the father dominant in his posture and address to the spectator, and the mother a quiet secondary figure, by the 1770s the infant twists and gambols, the father leans, touches, and looks at his brood, and the mother is given centrality, a self-involved seriousness, and visual dominance.

Central to this portrait's composition and to its meaning is young William, pictured here as a robust toddler, standing on his mother's lap, reaching and looking toward his father's face. His mother, father, and eldest sister touch, hold, and embrace him, encircling his young frame with security and affection. That his status in the picture and in the family is different from that of his sisters is indicated not only by his central position in the composition and the attention lavished on him by his kin but also by his nudity. He is the only figure not wearing eighteenth-century age-specific and gender-specific clothing. A loose drapery suffices for modesty, but his otherwise rosy pink body provides a stark contrast to the tailored fabrics worn by the older members of the family. It is improbable that young William

spent much time unclothed, and uncostumed infants are not common in eighteenth-century portraits.[51] We can attribute Copley's presentation of young William then, to painterly allusion, recalling both the long tradition of the decorative classically inspired *putto* and the specific tradition of the Christ Child with the Madonna.

The most telling allusion in William's figure might be even more immediate. It is curious that while the surviving preparatory studies for this painting show variant positions for each of the other figures, the baby's outstretched

FIG. 71. John Singleton Copley, *Mother and Two Children (Study for Sir William Pepperrell and His Family),* 1777–1778. Black and white chalk on pinkish-buff paper. 17¼ × 13¼ in. (43.8 × 33.7 cm). Museum of Fine Arts, Boston, M. and M. Karolik Collection of Eighteenth-Century American Arts; 39.272. Photograph © 2003 Museum of Fine Arts, Boston.

right arm and upward gaze were established early and remained unchanging as the artist developed ideas about the composition (fig. 71).[52] Thus, though Copley struggled with the placement of the girls and the stance and gaze of the father, his concept of young William remained virtually fixed from the start. He had tried earlier, in *The Copley Family* (see fig. 62), to link youngsters to adults by their upward-reaching arms and gazes, but William's pose—more open and dynamic—is different. Indeed, it mimics quite precisely the outstretched right arm and raised left knee of the nude Watson in *Watson and the Shark* (see fig. 69), Copley's companion-piece for the *Pepperrell Family* portrait at the 1778 Royal Academy exhibition.

As Watson's pose and nudity reflect Copley's deployment of the principles of visual quotation, deliberately evoking the Hellenistic figure known as the Borghese Gladiator or Warrior, William's pose mimics and quotes Copley's own heroic Watson, subtly endowing his young frame with consequence and resonance (fig. 72).[53] The two paintings—the *Pepperrell Family* and *Watson*—radically different in their genre, tone, and impact, are, in a sense, subtly answering texts. While Watson hyperbolizes the agony and strain of a dramatic rescue at sea in the face of a savage attack, the *Pepperrell Family* images a more abstract triumph of continuity and life over loss, diminution, and death. Both canvases focus on a dramatically posed, male nude protagonist, whose reaching posture is answered by the leaning, straining, twisting forms of companions in contemporary costume. In both images the centrality and stability of a single calm figure—Lady Pepperrell in the *Pepperrell Family* and the black seaman in *Watson*—provides a telling foil for the contingency and turbulence of the other figures. These poised, thoughtful-rather-than-active figures seem repositories not only of physical calm but also of knowledge and perhaps empathy—they seem equipped to interpret as well as experience the lesson of the picture's event and thus, in seeing "beyond," act as models for the viewer.[54]

The infant William Pepperrell and the fourteen-year-old Brook Watson are Copley's first, and virtually only, publicly exhibited nude figures.[55] As we have seen, in such portraits as *Joshua Henshaw* (see plate VI), Copley had learned back in Boston to allude (with the assistance of William Hogarth and prints after antique sculpture) to ideal bodies and expressive postures or "attitudes." Benjamin West had written to him in 1773 urging him to travel to Italy to see, in particular, "Antient Statuarys [as they] are the great original whare in the various charectors of nature are finely represented."[56] Reverence for antiquity and its identity as the fountainhead of nature as well as of knowledge and authority was deeply ingrained in Copley's Boston. He would not have been among the select handful of boys drilled in the Grammar School curriculum ("Esop . . . Eutropius, Ovid's Metamorphosis, Virgil's Georgics, Aeneid, Caesar, Cicero" then the Greeks) from age seven to fourteen, as that was an expensive education reserved for the ministerial and mercantile elite.[57] Nevertheless, he would have known the resonance of that litany of names even if he could not parse the texts; indeed, everyone

FIG. 72. Borghese Gladiator or Warrior, plate 27, François Perrier, *Segmenta Nobilium Signorum et Statuarum que Temporis Dentem Invidium Evase* (Rome and Paris, 1638). Engraving. Research Library, the Getty Research Institute, Los Angeles.

did. Among the property listed in the probate inventories discussed in Chapter 1, we find an entry for "Will, Scipio, Ben, Caesar and Mimbo"—collapsing into one short list wildly disparate naming patterns and ancestral roots. Caesar and Scipio were named for an emperor and a general notable in narratives as remote in time and culture as their native Africa was in space, and yet these names were also quotidian and vernacular.[58] While Copley did not need to be instructed in the value of the classics, and he would have been familiar with the reputation of such sculpture as the Borghese Warrior as "the most famous statue of all that Antiquity hath left," nevertheless he would have been almost as illiterate in real knowledge of these forms as he was in Greek grammar.[59] No wonder, then, after a remedial year in Italy, his opening gambit in London was a witty double declaration of his newfound visual literacy.

In his months in Italy, Copley had seen and studied sculptural and painterly expressive heroic nudity on a scale and in an amplitude of examples that would have been deeply impressive to his New England eyes. Prepared as he may have been by Smibert's and Pelham's plaster casts, painted copies, and mezzotints, and the verbal discussions in such theory texts as Hogarth's and Reynolds's, nevertheless, the impact of seeing the model bodies that had become primary vehicles of expression for European art can be measured in this pair of canvases. In these two revised, modernized references to the Borghese Warrior Copley consciously and publicly aspired, as Leo Steinberg put it, "to become part of a chain, to join and prolong the historic relay from Antiquity. . . . [He was] suing for membership in that glorious company" of renowned European artists, quoting and requoting, to each other and to posterity, the language of torsos and limbs and expressive heroic gestures.[60] In employing "performed images" Copley was not displaying dependence or pretension but exuberant visual wit. A quick study, Copley absorbed and renovated the tradition in one leap, importing this "inherited" marble body into two very different narratives, in both of which the nude figure is simultaneously plausibly modern and resonantly antique. Copley's "relay" here is an instrument to enlarge the traumatic experience of Watson to that of Everyman, and to enlarge the fact of an heir to the only American baronetcy to suggest the possibility of reconciliation and reunion beyond revolution.[61] Young Watson, signals endurance and triumph over adversity; William, naked as a newborn, signals pure potential.

The viewer's attention is drawn into the Pepperrell family group by young Elizabeth, who, leaning on a footstool at her mother's knee, embraces her baby brother and casts a smiling glance directly at the spectator. Her gray-blue eyes solicit our attention, and her posture indicates where we should direct our gaze. Elizabeth (b. 1769), characterized as a toddler by her mother as "a very frolicsome body," is an ideal intermediary; her winsome smile does much to draw in the viewer and temper the sobriety of her parents.[62] Her dress—like those of her sisters—is white, of a thin, gauzy fabric. An abstract figure of a white, three-leafed sprig marks the surface, echoing the more substantial white, green, and

pink floral buds that ornament her elaborate headdress. The hue of the translucent salmon-colored sash edged with gold, which trails from her waist, is picked up in an ostrich plume that tops off her elaborate cap, its pinkish hue repeated in both her mother's and her sister's less exotic headdresses.

None of the figures wears jewelry (beyond the gold buckles on Sir William's shoes and knees, and the single strand of pearls in Lady Pepperrell's hair), but a tone of understated opulence is evident in the rich variety of textiles used throughout the composition. Indeed, the painting includes a veritable lexicon of eighteenth-century textiles of English and foreign manufacture, including the elaborate "turkey work" carpet, a lush velvet tablecloth edged in a wide gold fringe, satin-weave silks (in Lady Pepperrell's dress, the drawn-back curtain, and Sir William's waistcoat), the delicate figured cottons of the girls' dresses, the handsomely finished wools of Sir William's coat, and the elaborate embroidered collar on young Elizabeth's dress.

In his American portraits, Copley had included masterfully portrayed still-life elements, but rarely did his range in tactile variety reach the demonstration-piece level of *The Pepperrell Family*. Here he not only has incorporated an unusual multitude of fabric types but also has devised novel techniques for their portrayal, notably the heavy impasto with which he picks out the gold fringe of the tablecloth and the rich lace of Elizabeth's elaborate collar. The impasto renders these passages in high relief and interrupts the smooth fiction of the paint surface; it insists on our attentive reading of these costly trims as sculpturally, physically present. Touch, thematized repeatedly in the image as each figure touches skin, costume, or inanimate object, is presented synthetically in the richly tactile passages of these lush textile trims.

Unlike young William, whose centrality is marked by his difference from the others in the family, Elizabeth's role as intermediary is marked by reiteration. She initiates us into the picture and introduces each character in the family drama. She is linked to her mother by proximity and by the repetition of a transparent, violet, gold-figured cloth in the fichu at the elder woman's neck and in her young namesake's cap. She is linked to her brother by touch, her sisters by dress, and her father by a parallel, inward-leaning posture. Elizabeth's gaze breaks the genre-fiction of the tableau and reminds us that the image is a performance, an enactment completed only by the presence of an audience. This audience is both the general one of the commissioning Pepperrell family over time and the specific one of the 1778 Royal Academy viewers. The tertiary audience that we constitute—as strangers two centuries later who find the painting both legible and obscure—is necessarily distanced. Yet Elizabeth breaks through that distance and implores our attention to the facts and fictions of the tableau she eagerly presents.

In a photograph of the image, Elizabeth's role is central. Standing before the towering painting itself, one is equally aware of a competing gaze—that of the dignified springer spaniel on the far left. The spaniel's attention is riveted

on the viewer, and his eye level is only slightly below the viewer's own, which hovers about the tabletop even when the enormous canvas is hung as low as possible. In the eighteenth century, the painting was almost certainly hung higher, and the presence of the two dogs was even more emphatic. Our attention is drawn to this corner of the canvas and away from the central action by the bright shiny lock that closes the larger dog's collar and by the black King Charles spaniel who gazes alertly away from the family and toward his canine companion.

Copley had used pets in earlier portraits to help characterize sitters—indeed, he included a small King Charles spaniel in his portrait of Lady Pep-

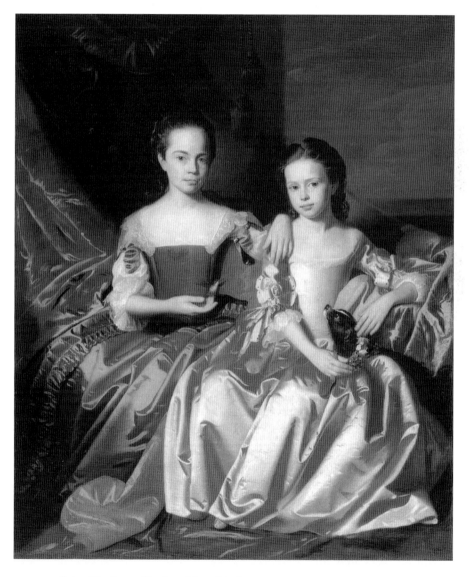

FIG. 73. John Singleton Copley, *Mary MacIntosh Royall and Elizabeth Royall*, c. 1758. Oil on canvas. 57⅜ × 48⅛ in. (145.73 × 122.24 cm). Museum of Fine Arts, Boston, Julia Knight Fox Fund; 25.49. Photograph © 2003 Museum of Fine Arts, Boston.

perrell and her sister, done when they were girls twenty years earlier (fig. 73). In most such images, the pets help direct our gaze toward the sitters' faces or hands; in the *Pepperrell Family* they draw our attention to a peripheral corner. But this is strategy and not accident or error, for it is here, just to the left of the precisely and brightly delineated collar padlock—one of the brightest spots on the canvas—that we find Copley's oversized signature. In his campaign to be "conspecuous" at the Royal Academy exhibition of 1778, Copley, who had signed fewer than a quarter of his American portraits, took care to sign prominently both this and the *Watson* paintings, announcing his authorship and availability. Guarding the "J S. Copley P[inxit] / 1778" inscription, the larger spaniel with his steady, dignified gaze plays the role of the artist's intermediary, while Elizabeth is the family's. They look out at us and solicit our attention and regard; they ask us to collaborate in constructing the archetypal domestic fiction and in acknowledging its authorship.

Balancing the spaniels on the opposite side of the family group (and marking the third angle of a carefully structured triangle whose other corners are marked by the heads of Sir William and his stately brown-and-white spaniel), Mary ("Polly," b. 1771) and Harriot (b. 1773) concentrate on a game of table skittles. Mary stands on a footstool similar to that on which her mother's foot rests. It is upholstered in a green velvet, matching the fabric used in the opulent gold-fringed cloth that tumbles in disorderly elegance from the mahogany table on which young Harriot sits and which is the site of the girls' game. The table and footstools are unusual in their sharply tapering legs, and their matte surface suggests that Copley—who made much of gleaming polished mahogany in his American portraits but avoided this effect, beyond the table corner evident here, in his English pictures—had already internalized the British dictum to suppress furniture in the interest of textiles. Indeed, the disarray of the tablecloth—caused, we presume, within the fiction of the image, by the children's activities—gives the artist an opportunity to display a virtuoso passage of drapery painting and gives the Pepperells an opportunity to suggest the financial power evident in its deeply piled surface and extravagant gold edge. The disorder into which this cloth has tumbled is negligible in the sphere of domestic concerns to which it refers. It is easily put to rights. Yet the deeper disorder at the heart of this domestic circle—the absence of the dead mother—is seamed over, denied. A chaos of cloth is permissible because manageable, a chaos in human relations is unimaginable and unpicturable.

Within the fiction of the image, the tablecloth, pulled so negligently from its place, preserves yet one small island of smooth, horizontal, geometrically precise surface, and it is here that the girls assert order and pattern over disorder as they place their neatly turned vertical pieces. By the late eighteenth century, the game of skittles, ninepins, or kayles, as it was variantly called, already had had a long history. The modern game of bowling suggests the scale on which the pieces were usually made, but miniature sets, such as the one in use here, were also popular.[63] In Mary and Harriot's game, one piece stands, two are being placed, and

two lie fallen on the velvet. The other four pieces are perhaps covered by the girls' skirts. That the pieces must be placed with care in an understood pattern is evident from the girls' concentration. That the object of the game is to obliterate the pattern with an artfully thrown ball (here dormant and innocent on a fold of cloth near Mary) we know from common cultural experience. The game suggests cyclical rounds of pattern and chaos, order and disorder. Like the disorder of the cloth, disorder among the skittles pins is permissible, controllable, diagrammable, and paintable, unlike the infinitely more open-ended and threatening disorder of domestic upheaval, loss of patrimony, and loss—in the painting's metaphoric language—of its pillar of stability. The game is included here not only because eighteenth-century children had more games and playthings than ever before and Copley is diligent in including them in his family portraits but also because, for the Pepperrells, an alternative universe in which action is predictable and chaos mendable was important.[64] The portrait itself performs this function on a large scale, positing rules of inheritance, domestic normalcy, and financial security for a family unsure of all three. Copley sets his figures as Mary and Harriot set their humanoid-shaped pins into a culturally understood, stable pattern of relationships, asserting and freezing them on canvas as though the bowler Fate had not already obliterated the pattern by death and revolution.

That Copley's painting is a fiction, a halcyon vision of a time that never was, is emphasized by its spatial ambiguities. Most eighteenth-century American portraits place the figures in a furnished room the wall of which opens with an unglazed window onto a landscape. Eighteenth-century English portraits, however, often place sitters out-of-doors, and here we see Copley partially accommodating this custom by positioning the Pepperrells in a liminal zone, on an imagined piazza or portico, its massive scale indicated by the central anchoring pillar. While the "indoor" architectural space is articulated on the right of the image and underfoot by massive draperies, a grand carpet, and drawing-room furniture, the exterior space described on the left side of the image presents—seemingly on the same level—an "outdoor" tapestry of picturesque trees and dappled lawn. The picture space on the right is shallow; that on the left is deep. The primary character of the space on the right is marked by a white, geometrically precise marble column, that on the left by a dark, irregular curving tree as congruent with Sir William's leaning posture as the column is with Lady Pepperrell's alert verticality. The fictive nature of this pictorial space is underscored by a discontinuity in the light between foreground-interior and background-exterior. A strong, midday, semidiffused light washes the foreground figures, its source high over the painter or viewer's left shoulder. Yet the deep recession of the distant landscape displays the long shadows of late afternoon. Indeed, the sky above the most distant copse is already tinged by the violet hues of a setting sun. Just below this softly chromatic sky a single tree displays yellow foliage, suggesting an autumnal season and an early frost within the yet-green lushness of the loosely brushed middleground landscape. Here in the pastel sunset and the distant autum-

nal tree Copley has interjected a quietly elegiac note within the context of an image that otherwise asserts normalcy, hope, and promise.

For both Copley and Pepperrell, this portrait signaled the hopeful repatriation to Great Britain of their re-emigrating families with more skills, greater financial power, and a more gentrified social position than their emigrating parents (in the case of Copley) and great–grandparents (in the case of Pepperrell). The movement of both families was from the periphery (the Singletons and the Copleys from western Ireland, and the Pepperrells from Revelstoke on the Devonshire coast) to the center, London, by way of the colonies.[65] And this point of arrival that was in fact a re-arrival is an integral part of the creation and our understanding of this portrait. Pepperrell, whose great-grandfather William Pepperrell I had left England an illiterate orphaned fisherman's apprentice, was returning with a baronetcy, a potential fortune, an heir, and a bevy of soon-to-be-marriageable daughters.[66] It was, at the time, unclear which side would win the war, and the enormous fortune amassed by Sir William's predecessors was still potentially recoverable.[67] But his bid for an established social and financial status for his family line and for his nuclear family was eclipsed by the failure of Britain to win the war and of the United States to reimburse Loyalists afterward, by the paucity of the Crown's reparation of Loyalist claims, and by the death of his only son (long an invalid) without issue in 1809.[68] The moment of hope, of possibility in the teeth of death and revolution, captured by the painting soon faded to a bitter memory, and Sir William spent his final years in the self-imposed isolation of a misanthropic exile, withdrawn even from the eager gestures of his less defeated daughters.[69]

Copley's hope for the painting—the expectation that it would win approval and bring him further commissions—was similarly dashed when the work received disparaging notice in the press as "a mere daubing," a response, perhaps to his determined inclusion of virtuoso passages of every conceivable type of textile: satin, velvet, sheer cottons, *couleur changeante* silks, embroidered figures, and tassels of gold thread.[70] Although he received significant subsequent commissions for single-figure portraits, it was almost a decade before he undertook another family group. However, the praise lavished on *Watson and the Shark*, his other 1778 Royal Academy offering, served, no doubt, to reinforce his ambition to earn fame and fortune in the more complex, more highly valued, more innovative, and more "conspecuous" genre of modern history painting.

Although it failed to establish Copley's reputation as a group portraitist, *Sir William Pepperrell and His Family* gave Copley valuable practice in composing multifigure canvases, practice he would utilize in his history paintings, especially when he began to include portraits of participants in his distinctive modernization of the genre. Copley's hybrid historical works, incorporating recognizable physiognomies within pantomimes describing topical momentous events, engaged a large portion of his English career and won him the acclaim he so purposefully pursued. To this success, the *Pepperrell Family* made a certain—if indirect—contribution.

From the point of view of the Pepperrells, the portrait no doubt functioned as a useful fiction, a document of confidence and wholeness in the face of calamitous upheaval. Both to the surviving figures—Sir William, young Elizabeth, Mary, and Harriot—and to Harriot's descendants, who observed it in the background of their quotidian lives among the squirearchy in Leicestershire at Wanlip—it diagrammed a cohesive family unit. It documented a longed-for memory of a moment that never was, but which gave order, pattern, and identity to a tumultuous chapter in their shared history.

For the contemporary viewer, reading the painting's surface, decoding its patterns, and deriving pleasure from its success as an artfully constructed composition, *Sir William Pepperrell and His Family* documents norms of behavior and of relationship that belong to a specific era and a specific concept of the unitary family. It suggests—with the basic motif of the game—that rules and conventions are shared and operational. Yet the tumbled tablecloth and the stretching contingent figure of the infant heir in his heroic nudity incorporate a countermetaphor of disorder, imbalance, and vulnerability. This tension between basic metaphoric systems is as important and as telling in the image as its well-seamed junctures between fiction and verisimilitude. Although the painting might have proved a failure for Copley in his bid for family portraiture commissions and for Pepperrell as an appropriate announcement of his family's second coming to ancestral turf, it is clearly—from the perspective of two centuries—a successful encoding of central cultural, as well as personal, preoccupations, desires, and memories.

The Pepperrell Family and the other family portraits painted by American artists over the course of the eighteenth century exhibit a culture of family-centered community and an artistic practice increasingly ambitious to play on a European stage. Complex and witty, these works exhibit on the part of the sitters a shifting ideology of familial relations. On the part of the artists they exhibit elaborate planning, technical accomplishment, and classical learning—an absorption of not only the new values governing familial roles but also new values attached to antique form imported northward and westward from Italy. In the next chapter, we investigate the broad implications of this migration of cultural models and their adoption in distant New England.

The Drawing in the Painting

John Smibert's magisterial *Dean Berkeley and His Entourage (The Bermuda Group)* of 1729, considered in Chapter 5 in the context of family portraits and social history, also prompts questions about the importation to the British colonies of theories and concepts of art, architecture, and design developed and codified in distant Italy a century and a half earlier (see plate VIII). The composition is bracketed on its left-hand margin by a self-portrait of the artist holding a partially furled drawing, a "drawing" that quietly points toward relationships between paper and knowledge, instruction and professional identity, that underlay eighteenth-century revolutions in thinking about and practicing art in British America (fig. 74). Much else is going on in this image. A group of seven adults and a baby, anchored by the considerable mass and dignity of the philosopher on the right, gather around a small carpet-clad table. They glance, point, and lean in tight proximity in front of a screen of columns overlooking a deep vista into a riparian landscape. In this busy depiction of a richly three-dimensional world the half-obscured paper in the artist's hand does not immediately draw the viewer's attention. Indeed, commentary on this milestone work—referred to characteristically as "the most sophisticated group portrait painted in the colonies during the first half of the eighteenth century, . . . a source of inspiration to numerous artists during the succeeding eighty years"—has little to say about this particular element in the composition.[1] One scholar proposed that it suggests that Smibert "drew as a matter of course"; another that, in the now-lost corpus of his landscape paintings, "he painted in the classical landscape style of Claude";[2] most deduce nothing from its inclusion.

In fact, Smibert probably drew very little during his decades as New England's most prominent artist, and his one surviving landscape painting is much closer in manner to Wenzel Hollar and the Dutch topographers than to Claude. In what other ways might this drawing be key to Smibert's project and to the project of art in the colonies? First, I propose to explore this "drawing" as, in fact, central to Smibert's understanding of his role as soon-to-be director of the "Academy of Painting, Sculpture and Architecture" attached to Berkeley's ambitious plans for a colonial university, and pointedly prophetic of a professionalization and "Italianization" of the arts in the English colonies that would not be fully accomplished until the Revolutionary decades of the eighteenth century. We will consider this "drawing," then, in both its seemingly literal and its more abstract dimensions, as a thing, a commentary, and a question referencing not only Smibert's identity as an artist (as *this* artist) but art as a certain kind of practice with history, theory, and cultural authority, planted, here, in this painting, in the New World. I

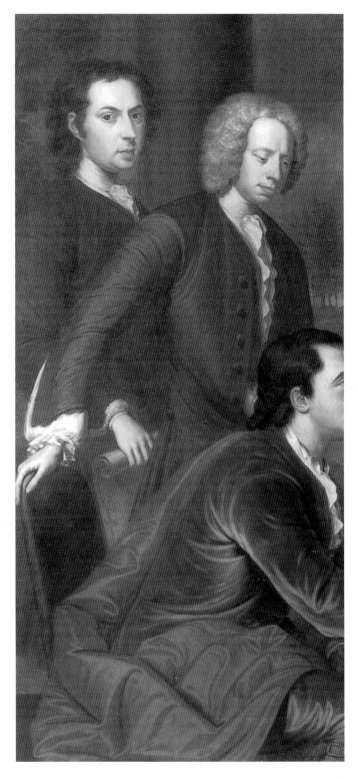

FIG. 74. Detail, John Smibert, *Dean Berkeley and His Entourage (The Bermuda Group)*, 1729.
Oil on canvas. Yale University Art Gallery.

wish, in other words, not just to parse it as an accessory or attribute within this painting but to see how it resonates backward and forward within larger cultural contexts, aesthetic projects, and social practices. Second, I propose that—unlike the curious paintings-within-portraits considered in Chapter 2 in which American artists theorize themselves as painters rivaling and simulating tactile concrete reality—in this little drawing-within-a-painting Smibert is aligning himself with a very different, more cerebral concept of art. Often credited with importing "sophisticated" painterly baroque plasticity to the colonies, that is, an au courant style, Smibert here is making different and more important claims, he is aligning his identity not with how art was practiced but how it was *thought*.[3]

On the surface, of course, this red chalk drawing presents itself as a common trope of artistic vocation, evidence of the artist's identity in the assembled company, and of his authorship of the canvas, a cypher in the hand to be read in conjunction with the face in the upper left, and the signature on the book edge at the center of the canvas—name, face, and deed in a redundancy of signs, pointing firmly to the artist's self. Perhaps we could also see in the presence of this drawing the hint of a narrative: the artist has been engaged in sketching the trees visible in the distance, and, interrupted by our arrival, turns 180 degrees to face the viewer who is, of course, also Smibert himself outside the picture. But that reading runs counter to contemporary habits of mind about the play involved in *thinking* a painting. The early eighteenth-century portrait usually captured not one telling moment of arrested time but the distilled essence of many moments deliberately extracted *out* of time.

Smibert's "chalk drawing" is different in subject, scale, and medium from the larger work in which it is presented, and in these differences it complicates and *marks as artificial* our experience of it and of the painting as a whole. Its rolled top points to its two dimensionality; its monochromatic "wrong" coloration points to its schematic nature. Within the language of a painting in which life-sized textiles, stone, flesh, and foliage are described as "real," the drawing pulls us in the direction of concept, schema, and knowledge already known. A tree can be red—leaf and branch—and tiny (rather than distant) because we know about trees, about red chalk, and about miniaturization. More important, this furled drawing points to a practice not involved, in fact, in the creation of eighteenth-century portraits, the genre from which Smibert and his compatriots on both sides of the Atlantic gained their livelihoods. Few British artists drew on paper in the process of painting portraits—they usually began directly in oils on the prepared canvas.[4] In the case of an exceptional multifigure composition like this one, they sometimes made preparatory drawings as we saw in the case of Copley's *Pepperrell Family* (see fig. 71 and Chapter 5 note 52) or they executed a small oil on canvas to work out the format, poses, and relationships between figures.[5] In general, for eighteenth-century portraitists, their "drawing" was done with a brush in much-diluted oil-based paint (or sometimes a charcoal stick) directly on the stretched and prepared final canvas (as we see in the infra-red photograph

detail of Pratt's *American School*, plate II, fig. 11), and subsequently covered with successive layers of more opaque pigments. The absence of surviving drawings by Smibert and the general paucity of drawings related to eighteenth-century Anglo-American portraits reflect this practice. As the helpful unknown British author of "The Art of Limning" of 1747 puts it, having explained how to prepare the canvas, "Place the party [subject] in a due position, on a seat rather higher than your own . . . at the first sitting you only *dead colour* the face. . . . to be done the roughest and boldest of all; having drawn your face with lake and white. . . . The second setting . . . [work] the grey and bluish under the eyes" and so forth.[6] So, Smibert's chalk drawing does not point to a stage in the development of this particular work but to more general principles involved in the production of art.

The primary arts practiced in British America before the Revolution were portrait painting, architecture, and extraordinary utilitarian craftwares, one genre of which we will pick up in Chapter 7. Nevertheless, there are indications that arts based on skill in *drawing* were also valued, used, and, to a degree, theorized in the colonies. Here I pick up the evidence of *disegno* as a practice and as an idea in this colonial venue, investigating those glimpses we find in the record of American artists practicing and valorizing branches of art based on draftsmanship and Florentine ideas concerning distinctions between craft and art and between the vernacular and Art. Looking at military topographic draftsmanship, gentry accomplishment drawing, the role of antiquity in understanding the human form, and the introduction of the Orders into a system of building innocent of such ornaments for the first busy century of construction, this chapter inquires into the nature of this drawing-based renovation of the class, training, outlook, and products of the "Italianized" colonial artist-designer.

ACADEMY AND UNIVERSITY

Twenty-seven years before he painted the *Bermuda Group* in colonial New England, Smibert had begun his professional life as an apprentice to a Scottish house painter, eventually making his way to London where he worked as a coach painter. He then found employment there copying paintings for dealers, achieving some success and recognition, "yet never" having, as one contemporary recorded, "copyd any thing from ye life, till he came to ye Accademy [and] haveing never drawn from plaister [casts of antique sculpture]."[7] The "Accademy" reference here is to one of the early artist's clubs or informal academies that professional artists arranged for mutual support—very different from the much more formal Royal Academy that was to follow the French model later in the century, both more hierarchical and authoritarian institutions with a broader, more national scope than these small ad hoc, democratic associations. But all of these academies were patterned, at least in some degree, after the original Academy in Florence, itself incorporating a memory of Plato's Academy in the olive groves of ancient Greece.

At a tavern called "the Piazza" in Covent Garden, Smibert learned to draw and all that that implied. The group called itself the Rose and Crown. It was comprised of practicing artists, sculptors, engravers, designers, and artisans—the architect James Gibbs and French painter Antoine Watteau among them.[8] The "Rosa Coronian Groupe" was founded in 1711; Smibert joined in 1713. The subscribers met on Saturday evenings to exchange information, to eat, to enjoy music, and to draw. We have some sense of what went on at these meetings from poems and contemporary accounts, especially those by fellow artist George Vertue and from Vertue's sketch after a large portrait Smibert painted of the assembled group about 1724 (now unlocated).[9] These meetings always took place in the evenings and involved the study of plaster casts or nude models by lamplight as their members were all working professionals and unavailable during daylight hours.

In Vertue's comment about Smibert's initiation into this group of professionals there is a telling association between copying "from ye life" and drawing "from plaister." Both these activities took place and they were distinct activities. However, in another sense, we can glimpse in Vertue's collapsing of "life" and "plaister," something we also see in the curious animation of antique sculptures in seventeenth- and eighteenth-century engravings (as well as in the frequent verbal conflation of "nature" and "the antique" in eighteenth-century texts)—to us a profound eliding of terms and meanings (see figs. 70 and 72). What drawings from "life" and "plaister" have in common is the human figure as object and drawing as the recording mechanism. Vertue was not alone in his yoking of "life" and "plaister"; in fact, he is echoing the thoughts and practices of many others in this comment. Drawing is not just drawing; it is the understanding, translation, and miniaturization by hand and mind of a complex form (whether body or sculpture) onto paper.

By the time Smibert, Gibbs, Vertue, and Watteau were spending their Saturday evenings drawing from nude models and plaster casts of antique sculpture in Covent Garden, the Italian concept of *disegno* had been imported, translated, domesticated, theorized, and conflated with the indigenous "draught" by English painters, poets, and architects for over a century. Its meaning in England was generally toward "disambiguation of a term whose functioning depended precisely on equivocation."[10] For our purposes the issue is not whether the British were "correct" in their usage or whether the ambiguities in the English language between "drawing" as a noun or a verb and between "designer" as a term of approbation or one of censure (an inventor or a schemer) reflected the ambiguities of Florentine usage but rather what the term meant in common usage in the vernacular in London and in Boston in the early and middle decades of the eighteenth century.

The chapter "Of Design or Drawing" in Jonathan Richardson's *Essay on the Theory of Painting* (1715) begins, "By these terms [design and drawing] is sometimes understood the expressing our thoughts upon paper, more commonly, the giving the just form, and dimension of visible objects as they appear to the eye." His compatriot John Evelyn had, in the late seventeenth century, also defined

drawing, and, in doing so, pointed to a distinction and a hierarchy of practices that would become naturalized in the eighteenth century: "For *Design* (say they) is of things not yet appearing; being but the picture of *Ideas* only; whereas *Drawing*, relates more to Copies, and things already extant."[11] Let us reserve the issue of "Copies" for the moment and focus on Richardson's definition of drawing ("the expressing our thoughts upon paper"), and Evelyn's definition of design ("the picture of *Ideas*"). The hand—rendering imagined forms and analyzing three-dimensional bodies in linear strokes on paper—is expressive of thinking, analysis, and creativity. It is also an instrument of subjectivity. As John Gwyn reiterates in his *Essay on Design* of 1749: "I have made use of the Word Design in this Essay, to express the supreme inventive Art of the Painter, Sculptor or Architect abstractly considered. . . . The great organ or instrument of this art is *draught* or *drawing*Without this neither the Genius nor Learning of the Designer, Painter or Sculptor can be displayed to advantage. It is the *sine qua non*."[12] To draw is to think: *disegno ergo cogito* (or *designo ergo cogito* to put it all in Latin). Drawing displays both "genius" (that is, invention) and also "learning" (that is, received wisdom). To draw is, therefore, to think and invent but also to express and externalize learning and knowledge of the unseen. As Richardson puts it, "in order to follow nature exactly, a man must be well acquainted with . . . geometry, proportion . . . anatomy, osteology. . . . the works of the best painters and sculptors, ancient and modern. . . . That this maxim is true, will appear by an academy figure drawn by one ignorant in the structure, and knitting of the bones, and anatomy, compared with another who understands these thoroughly."[13] Drawing, therefore, is not just a matter of manual and visual skill, a handmaiden of other more finished, more sellable artworks; rather, it is evidence of the mind thinking and of a lifetime of millennia-ripened knowledge mustered to the service of that thinking. Smibert, in the *Bermuda Group* is not just holding a drawing, he is holding an idea.

Drawing embodied the *intellectual* aspect of the painter's and the designer's craft; it was the medium in which the artist's literacy in perspective, human anatomy, and the classical world was expressed. It was the medium in which the artist expressed his own consciousness. In the early modern effort to remove the practice of painting from the realm of the artisan and to establish it on a footing with poetry, drawing (an activity rarely practiced by the artisan) became defined as evocative of professional and gentry power. It became a class issue. Smibert's education in this understanding of art occurred not just among the drawing fellowship at the Rose and Crown but also during his years in Italy (1719–1722) where he copied Old Master paintings, studied antiquities, and, among other items, bought—for himself and others—250 drawings.[14] In Italy, equally important, he met George Berkeley.

Vertue described Smibert as "a good ingenious man [who] paints & draws well."[15] By associating a chalk drawing with his self-portrait in the *Bermuda Group* Smibert reiterates and underlines these terms—that he is "ingenious" as well as

proficient. The drawing half-revealed to us is of a tree, not of an "academy figure." Perhaps, we might conclude, "nature" in the sense of flora and fauna, may have seemed more suitable to the New England environment depicted. More likely and more wittily, Smibert pictures himself on one edge of his enormous canvas holding a drawing of "nature" in its literal sense while he closes the composition on the other side with a visual quotation of "the antique," a re-animated "academy figure" in Dean Berkeley posed as the Farnese Hercules.[16] Along the back of the composition three giant orders speak of literacy in a third desiderata: classical architecture. Smibert is stating that he had the necessary knowledge and skills to design, to paint, and, foundational to both, to draw. Most important, he could not only replicate sight, he could "ingeniously" *create*, synthesizing recognizable beings, abstract concepts, as well as canonical antique orders and sculptural figures in the production of novel forms.

When Smibert painted the *Bermuda Group* (1729), he believed that Parliament would fund Berkeley's project and it would go forward. In Vertue's description, this was "a Scheme propos'd by Dean Barclay to lay the foundation of a College . . . to Instruct the Indian children in the Christian faith, & other necessary educations."[17] Berkeley himself explained the project in a pamphlet written about the time he met Smibert, entitled "A Proposal for the better supplying of Churches in our Foreign Plantations and for Converting the Savage Americans to Christianity, by a College to be erected in the Summer Islands, otherwise called the Isles of Bermuda."[18] The project was a utopic but real-life enactment of a belief, most memorably recorded in Berkeley's poetic formulation:

> Westward the Course of Empire takes its Way,
> The four first Acts already past.
> A fifth shall close the Drama with the Day;
> The world's great Effort [*variously* Time's noblest Offspring] is the last.[19]

More concrete, the venture acted on the belief many Britons shared that Native American Protestantism in that "West" would be a bulwark against French colonialism and other politico-theological threats. Berkeley designed a grand urban settlement for Bermuda and nearby, a distinguished university (fig. 75). He saw his college and the clergy trained there as "Rivulets perpetually issuing forth from a Fountain, or Reservoir, of Learning and Religion, and streaming through all Parts of America, ["rivulets" that] must in due time have a great Effect, in purging away the ill Manners and Irreligion of our Colonies."[20]

To teach these "rivulets" of colonial outreach, Berkeley enlisted a core faculty for his university. Next to his own contribution in Natural Philosophy and Theology, he desired nine fellows, including a professor of fine arts. The basic curriculum Berkeley proposed for his "Universal College of Science and Arts in the Bermudas" was not unusual for colleges at the time. Like Harvard (established

The City of
B E R M U D A
Metropolis of the
Summer Islands.

FIG. 75. George Berkeley, *The City of Bermuda, Metropolis of the Summer Isles*, engraving, Berkeley, *The Works of George Berkeley, D.D.* (Dublin, 1784), vol. 2, p. 419. Huntington Library, San Marino, California.

in 1636) it primarily was to have trained ministers. However, the inclusion of instruction in art and architecture—either at the College itself or at an ancillary "Academy of Painting, Sculpture, and Architecture"—was unusual. This novelty was probably the result of his belief, expressed in 1721, that the "noble arts of architecture, sculpture and painting do not only adorn the public but have also an influence on the minds and manners of men, filling them with great ideas, and spiriting them up to an emulation of worthy actions."[21] Art and architecture, then, for Berkeley, were on a par with rhetoric, not passive ornaments to life but important instruments capable of leading people toward ethical behavior and "worthy actions." While many contemporaries would have concurred with Berkeley concerning the potential public good to be effected by encouraging the arts— indeed the practice of history painting was underwritten by such assumptions— not all agreed. A half century later, John Adams, for instance, opined in a letter to his wife: "Is it possible to enlist the *fine arts* on the side of truth, or virtue, or piety, or even honor? From the dawn of history they have been prostituted to the service of superstition and despotism."[22] Adams, however, was in the minority; most in the eighteenth century on either side of the Atlantic, would have understood art to be an instrument of public betterment and uplift, although not necessarily an appropriate subject for college teaching and learning.

Most would have also seen Berkeley's grand and dignified design for a radial metropolis on Bermuda with "The Church" (C) at its point of focus, as entirely appropriate. The College was to have been somewhat retired from this hub on a peninsula with its own "circus" linked to the town center by a radial avenue terminating in the vicinity of the "Academy of Musick" (M) and the "Academy of Painting, Sculpture and Architecture" (N). Berkeley's is an ideal, orderly city with houses, parks, and food markets but without a plurality of religious sects, serious mercantile activity, or a visible civil authority. Moreover, given Bermuda's evolving role as the third leg of Britain's naval dominance of the Atlantic—the other two being Gibraltar and Halifax—the invisibility of the harbor and naval authority is curious. Nevertheless, as a design evocative of Berkeley's thinking it has two interesting features, the first being a picturesque zone sheltered by cypress groves (at the upper edge of the design) in which the dead and their impressive monuments would offer a contemplative and aesthetic precinct, removed—a century before the Rural Cemetery Movement effected this shift generally—from the churchyard and the center of town (P). More important for our purposes, the most dignified structure in Berkeley's very Londonesque city is the temple-fronted church, raised on a platform above a stately square and flanked by an extensive open colonnade—a structure that looks backward to Inigo Jones but also forward to developments in the New World to which we will return.

Based on the model in which the prosperous French and English West Indian colonies were supplied with foodstuffs from mainland North America or perhaps on knowledge that Bermuda is a coral island and therefore lacks the soil and water for substantial agriculture, Berkeley decided to link his projected

college and city to New England. As William Byrd described to a correspondent when Berkeley stopped in Virginia en route, visiting one of the two institutions of higher learning already established in the British colonies, the College of William and Mary, "Dean Berkeley put into this country, on his way to Rhode Island where he is gone to purchase some lands that may supply his intended College at Bermudas with provisions."[23] On arriving in Newport, Rhode Island, Berkeley reported, "I have purchased a pleasant farm of about one hundred acres with two fine groves and a winding rivulet upon it," and, "I live here upon land I have purchased in a farm-house I have built in this island. It is fit for cows and sheep and may be of good use for supplying our college in Bermuda."[24] Berkeley saw himself in this setting (and in his projected future in Bermuda) as living in quiet provincial retirement. Using the textile terms of his culture, he had praised his wife at the outset of this sojourn: "She goes with great cheerfulness to live a plain farmer's life, and wear stuff of her own spinning wheel, and for her encouragement [I] have assured her that from henceforth there shall never be one yard of silk bought for the use of myself, herself, or any of our family."[25] Suitably, then, the house in which he and his patient wife passed the three years waiting for Parliament's promised funding for the project (£20,000), was not grand. "Whitehall" has none of the architectural authority of the Palace complex for which it is named. The five-bay, not-quite-symmetrical façade of this clapboarded frame structure has a nodding acquaintance with patternbook Georgian architecture, but its center-chimney plan and long lean-to roof in the back are pure vernacular and, in fact, played a key role in the invention of a nostalgic neocolonial nativist shingle style in the late nineteenth century (fig. 76).[26] The columns that represent "architecture" in Smibert's *Bermuda Group*, in other words, are much more closely aligned with the portico of Berkeley's grand central church in his ideal Bermuda metropolis or the designs of Smibert's fellow "Rosacorosian" James Gibbs, than with the reality of Berkeley's home in the New World. Nevertheless, it would be a mistake to see Berkeley's adoption of homespun clothing and a "catslide" roof with retirement from the central theories and practices of English art and English colonialism. Beyond purchasing the farm, Berkeley purchased three slaves. Attending to their souls, he made sure they were baptized, bestowing on them new identities as Christians and as "his": Philip Berkeley, Anthony Berkeley, and Agnes Berkeley.[27] Their labor was of immediate use and was intended to evolve, no doubt, with the project to provision his offshore institution for Anglican Indian missionaries-in-training.

If the *Bermuda Group* was painted at Whitehall, just north of Newport, it neither depicted the structure nor would its unframed 5' × 8' dimensions fit comfortably in any of the philosopher's rooms. It is probable that it was, in part, painted there and, in part, at Smibert's studio in Boston. But it was intended, I propose, for the college in Bermuda—both its undomestic size and the language of its architectural forms point to a setting congruent with the scale and architectural vocabulary visible in public buildings on the order of "The Church"

FIG. 76. Thomas Worthington Whittredge, *Bishop Berkeley's House, Newport, Rhode Island*, 1877. Graphite pencil on paper, 15¹/₁₆ × 22³/₁₆ in. (38.3 × 56.4 cm). Museum of Fine Arts, Boston, M. and M. Karolik Collection of Eighteenth-Century American Arts; 39.272. Photograph © 2003 Museum of Fine Arts, Boston.

in Berkeley's ideal metropolis. While Berkeley's second drawing which depicted the academic building for his university has been lost, we know it was to be situated at the center of a large "academical circus" with fellows' houses, gentlemen's houses, and artisans' houses arranged in graduated concentric circles around the College, a structure that certainly was to be embellished with the antique language of columns, echoing the grandeur of "The Church" and the classicism of the College's "circus" format.[28] The man who paid for the painting, John Wainwright, seen acting as intent "scribe" within the fiction of the image in a characteristic donor profile pose, was not one of the party, remaining in England. He paid for it in full—£10 on the commission and £30 on completion—yet Smibert did not send it to him, an action, or rather, a lack of action, consistent with a commission intended for a third-party institution.[29] When Parliament withheld the funding, the Bermuda project aborted and the painting became foundational to another, more informal institution: the "school" evolving out of the objects in Smibert's Boston studio, an assemblage that remained intact until many years after the painter's death, and in active service to generations of American artists.[30]

Smibert never became a professor of fine arts, but through this painting (and the plaster casts after antique sculpture, Italian prints and drawings, and copies of Old and Modern Master paintings gathered and imported to the New

World for that appointment) he gave lessons in mime to his contemporaries and to his successors. One of the very few spaces in eighteenth-century America devoted to art that was accessible—if not exactly open—to many with a strong interest in art, Smibert's studio was key in the development of painters and painting and the *idea* of art in New England. The largest object in that space, this canvas exhorted each generation to "follow nature," to "follow the antique," and to draw.

"COPIES"

We have begun by looking at New World *disegno*/drawing/design in its most Italianate, most theorized, most history-laden mode, associating it with Smibert's rendering of "plaister" casts after antique sculpture with nature, and with Berkeley's design for an ideal intellectual metropolis. "Drawing" also meant, as Evelyn put it, making "Copies [of] things already extant," that is, using drawing as a vehicle more of description and replication than of idea and invention. While relatively few eighteenth-century drawings in Richardson's and Evelyn's first category ("expressing our thoughts upon paper" "pictures of *Ideas* only") survive from Smibert's hands or those of any others, quite a few in this descriptive mode do. These include the work of draftsmen recording specimens of Natural History, current events, and topographical information useful, for instance, to the military. These other, "lesser," more literal uses for drawing had use value, indeed had value, in direct proportion to their fidelity to facts. Their purview was not the imagination but truth. Characteristically, these drawings were not created as ends in themselves or as self-instruction, or as expressions of "our thoughts upon paper" (what we might think of as "thinking out loud on paper") but as vehicles of explicit communication, often to an engraver (and through him to a larger public) of "things already extant," that is, exact or replicated forms, and thus the hand and motion of the draftsman is suppressed in the interest of clarity and transparency, of information transfer. These uses of drawing to describe topographic, natural, and human-constructed forms with exactitude, nevertheless allowed, indeed required, the artist to omit elements, select expressive postures, format the sheet, and know and reference conventions and precedents. The process involved synthesis and expression, but, above all, it required mimicry, exactitude, and fidelity to preexisting realities.

Among the most vigorously descriptive and certainly one of the largest categories of drawings executed in eighteenth-century British America were the images of New World flora and fauna created by scientists and adventurers eager to document a "new"—that is, uncharted, un-Linnaean-ized—continent. From the earliest watercolors of John White in the late sixteenth century (at the British Museum) to the ebullient pen of William Bartram two hundred years later, this corpus of works on paper gives an animated and very descriptive specimen-by-specimen view of lifeforms both familiar and strange (fig. 77). Recording decon-

FIG. 77. William Bartram, *Sarracenia Purpurea (Purple Pitcherplant)*, c. 1803. Brown ink on paper. 10 × 7¾ in. (25.4 × 19.7 cm). Published as the frontispiece for Benjamin Smith Barton, *Elements of Botany* (Philadelphia, 1803). American Philosophical Society.

textualized, unique specimens, plucked out of ecological and pictorial three-dimensionality, these often beautiful works give us a sense of avid curiosity, a will to order, and, above all, an unambiguous "trustworthy" draftsmanship.[31]

Equally precise and "truth-telling" (in that summary of those aspects of the facts of the case that pertained to their interests) were the skilled military drafts-men (and civilian draftsmen in the employ of the military) whose drawings (often engraved) were instruments of war and defense. Berkeley's projected university for missionary Indians and other Anglican clerics may have been unusual in its inclusion of art in the curriculum, but that other arm of the British Empire—the military—included drawing, designing, and mapping in its curricula as a mat-ter of course from the early eighteenth century. Cadets at the Naval Academy at Portsmouth, founded in 1733, and at the Royal Military Academy at Woolwich, founded a decade later were taught to draw.[32] The United States Military Acad-emy at West Point followed suit, training its officer cohort in these skills from its founding in 1803.[33] The idea was that military officers had to be ready to record the landscape with accuracy and to design fortifications with efficacy.

One such officer, Thomas Davies, trained in drawing at the Royal Military Academy at Woolwich in the mid-eighteenth century, subsequently took on four tours of duty in the British colonies. He drew records of military engagements and strategic landscape sites, but by the 1760s he was using his skills to do something quite novel: making watercolors of waterfalls and specifically picturesque views. Some of Davies's drawings served explicit military purposes, others were circulated as engravings of notable battles or sites of particular grandeur and emotional impact as well as geological import.[34] Although his subject was the New World (from New York to Quebec), his practice and his audience were English. It would be the nineteenth century before home-grown New World artists and audiences began to record, exhibit, publish, and commend what could be termed a Gilpin-ized America, that is, landscapes seen through the models and precepts of William Gilpin, the most important British theorist of picturesque landscape drawing and painting. During the period we are addressing, this revolution in taste had not yet touched New World practice; what could be understood as the more topographical and more descriptive approach of military draftsmen—indeed all wielders of the pencil, pen, and crayon—prevailed.

Of the images included in this book in their role as descriptive of physical facts, contemporary nomenclature, and selective interpretation of those facts and those names, one is a print created from drawings with explicitly military motives: the extraordinary map engraved after a drawing by Henry Pelham (John Singleton Copley's half-brother), of the Boston region during the Revolution (fig. 78; see figs. 18 and 50). Pelham was not military but, in the shadow of war, he was unemployed ("my business is entir[e]ly ceased," he confided to his sister-in-law) and, sympathetic with the Loyalist cause, he engaged to make this document "sending Home [that is, to London, a place he had never visited] a Coppy to be engraved."[35] The record this map gives us of physical topography, roadways, and settlement patterns is both accurate and interpretive. It describes physical space, but it also describes human attitudes, actions, even drama and potential action. Pelham's map—an engraving that records a drawing now lost—includes a *trompe l'oeil* letter and a pair of architectural dividers in the upper left—the first attesting verbally to the eyewitness empirically viewed nature of the facts portrayed, and the other attesting to the painstakingly mechanically measured relationships drafted in miniature and displayed before us. In Pelham's map, the hills and waterways, streets and farms of the region are overlaid with military data. The "letter" in the upper left points to Pelham's authorship of the map and to the conditions under which it was crafted; its lines record whose troops controlled which batteries of how many cannon directed at whom. Pelham's detailed, grandly scaled project is both a deadpan description and a document expressive of extraordinary aggression and fear. This is a Boston in which pictures are not being painted, goods are not being made, children are not being educated, the sick and dying are not being attended to. In its clinical, precise,

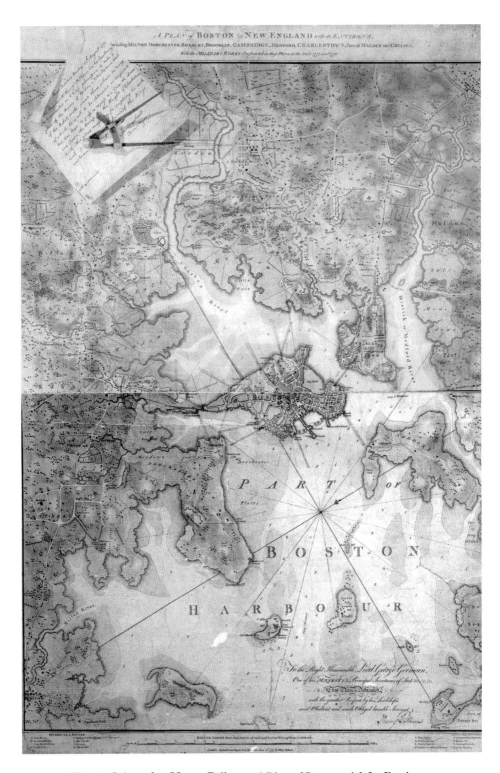

FIG. 78. Francis Jukes after Henry Pelham, *A Plan of Boston with Its Environs*, 1777.
Engraving. 43 × 28½ in. (109.2 × 72 cm). American Philosophical Society.

and seemingly neutral cartographic terms Pelham has drafted a portrait of a region whose considerable civil infrastructure is overstruck with military preemption, a region in which *seeing* means sighting, aiming, and gauging the trajectory of armaments.

The town's identity has shifted from that of a metropolis to that of a target; Pelham shows us, above all, a heavily fortified peninsula surrounded by animosity. The map is clear; the region is crisply depicted in seemingly neutral cartographic terms, but, in an epistolary mode, at the moment he describes beginning this map Pelham speaks of the region he is surveying as "This land of Ruin and Distress."[36] The distress he feels does not intrude on Pelham's commitment to "the giving the just form, and dimension of visible objects as they appear to the eye," for the authority of his depiction of the landscape—drawing at the service of military intelligence—lies in the precision and "justness" of that "form." Even when the orthogonal nature of the map renders its "copy" of the landscape incongruent with natural perspectival vision, it is a measured, miniaturized replica distillation of thousands of individual sightings to which he alludes in his legend.

In what Pelham termed the "desolation" of militarized Boston other, less skilled artists were eager to record with whatever clarity they could muster the events of the day, among them Christian Remick whose *Prospective View of Part of the Common* (1768, see fig. 17) we have discussed in Chapter 3 and will consider again later in this chapter. Unequal to the skilled precise draftsmanship of Pelham, Remick is, nevertheless, doing his best to give us a "copy"of "things already extant." His subject is Boston Common, sprinkled with cattle, travelers, courting couples, and family groups on one particular day, October 1, 1768, when the middleground of its pastoral and sylvan reaches was discordantly occupied by the tents, flags, and rigid marching formations of an occupying regiment of British troops, their bayonets silhouetted crisply against the greensward. Unlike academy drawing, ever conscious of inventing new ways to tell inspiring tales of antique heroics, Remick's drawing tries hard with its limited vocabulary of conventionalized trees and observed, enumerated windowpanes, to describe current events and "visible objects" before his eye. His skills are indifferent, his knowledge of botany and human anatomy downright poor, and yet, in terms of architectural observation, he is a trustworthy narrator. Remick is probably most comfortable in his drawings of ships, specifically his panorama of British men-of-war blockading Boston harbor and disembarking the expeditionary force sent to quell the rebellious colonists that year (now at the Peabody Essex Museum, Salem, Massachusetts). However, for our purposes, it is his visual curiosity about buildings that concerns us.

Remick's *Prospective View* is dedicated to John Hancock whose handsome three-story five-bay Georgian-style house is carefully delineated in the upper right, flanked by ornamental gardens on the Beacon Hill side and a service wing on the other (see fig. 14). Over the entrance to the house, as noted earlier, a lozenge-

shaped hatchment announces to the community a death in the family. Given the political circumstances, however, it seems possible that this arch–patriot, who eight years later would boldly scribe his name in defiance of royal authority on the Declaration of Independence, might have used this solemn indicator of personal mourning to also inscribe onto the communal face of Boston Common a sign of family identity and public mourning. The seizure of Hancock's sloop *Liberty* a few months before Remick's view was drawn, had resulted in outcry and public rioting from which the royal commissioner of customs had been forced to flee to the protection of the fort on Castle Island in the harbor (see fig. 50).[37] The *Prospective View* places Hancock's house and that other surrogate of Hancock identity, his coat of arms, toe to toe with the King's troops, sent to occupy the city, an intimidating vanguard of the vast expeditionary army that soon would arrive to enforce British law and prerogative. Remick advertised his readiness to draw "Perspective Views" (by which he presumably meant scenes of this sort that attempted to simulate vision) as well as "Coats of Arms" (which were, of course, nonperspectival).[38] The hatchment we see then, may well be one he crafted for Hancock, and thus, this modest watercolor probably records his handiwork figuring in a face-off of hemispheric proportions. Remick's *Prospectival View* records "visible objects as they appear to the eye;" it appears calmly factual, but, like Pelham's tidy map, it also points to personal turmoil and extraordinary public enmity.

The principal distinction that I have been making is that between the practice and meaning of drawing/*disegno* that Smibert learned at the Rose and Crown—drawing Richardson defined as invention and "expressing our thoughts on paper" (and its later progeny, the picturesque)—and another, more fact-driven kind of drawing practiced by scientists, military recognizance, and reporters of current events for whom communicating "visible objects as they appear to the eye" was paramount. This fact-driven kind of drawing is, of course, understood to be the lesser of the two, a skill wedded to fidelity to fact and things-as-they-look, while drawing/*disegno* is aligned with the authority of the Accademia delle Arti del Disegno (established in Florence in 1562), the ideal human form, an ethics of heroism, and the status of antiquity.[39] The various, somewhat different kinds of drawing practiced in the British colonies during the eighteenth century fall within a spectrum defined by this idea/fact polarity. Those I wish to turn to now can be termed, roughly, gentry "accomplishment," (which references issues of class and education), professional "grace" (which concerns a particular kind of professional drawing), and architectural design. I will suggest how one might begin to discuss these skills and practices at the threshold of their arrival and establishment in New England, and I will explain how the acquisition of these skills, membership in these practicing cohorts, became laminated to concepts of class, professional, and personal identity.

It is said that during the Atlantic crossing Smibert gave art instruction to Anne, George Berkeley's wife, and before long he was asking his friend and

supplier in London, Arthur Pond, to send fan paper to resell to an amateur fan-painters in Boston.[40] Drawing and watercolor painting on fans and on more traditional paper sheets was already an active practice among amateurs before Smibert's arrival, but certainly the color shop he established would have facilitated and encouraged this development. As Ann Bermingham has eloquently discussed, drawing and watercolor painting as gentry activities had taken hold in Britain in the seventeenth century and blossomed in the eighteenth, evolving out of theories and practices promoted in Castiglione's *Il libro del Cortegiano (The Book of the Courtier)* of 1518 and his English popularizers.[41] Nevertheless, it seems clear that—given the rather different social and political complexion of the colonies—amateur drawing was slow to arrive and taught and practiced in the New World on rather different terms. The enthusiasm with which their British counterparts took up drawing, especially the Claudian landscape rendering that Bermingham associates with "the landscape gardens of Capability Brown, the picturesque aesthetic of William Gilpin," the cult of sensibility, and a sense of "landscape and nationhood [that was] . . . collective and unified" had few reverberations in the British colonies before the nineteenth century.[42]

We know of few gentry draftsmen in eighteenth-century America. Edward Augustus Holyoke, son of the president of Harvard, took painting lessons while at the college, perhaps with Smibert. On graduation, in 1746, he situated himself in Salem where he practiced medicine indifferently, married well (twice), and continued drawing and painting throughout a life that stretched to a hundred years.[43] We can assume that Dr. Holyoke derived personal pleasure from his art activities and, although they may have been shared with few others in Massachusetts in his day, they connected him with long-standing British and continental practice. The acquisition of the skills of drawing and the associated skills of connoisseurship had been commended by theorist Jonathan Richardson as excellent occupations for a gentleman's leisure time, providing pleasure and instruction to those who might otherwise engage in "Criminal, Scandalous, and Mischievous" activities.[44] The acquisition and practice of skill and taste not only provided an expression of competence that might be acknowledged as social capital, it could also function as a preventative, deflecting destructive alternatives, and profiting not only the individual but also the community and nation. We feel here an echo of Dean Berkeley's praise for the arts as "improving." Leading men toward contemplation of heroic acts and the improvement of self, producing and studying art also filled hours that might otherwise be spent in antisocial dissipation and vice.

These are shadowy and rare figures and products, the colonial gentleman-amateurs and their drawings. That we know little about both suggests that the practice was limited and not subject to comment or filiopietistic conservation of portfolios. We do have one unusual and important late eighteenth-century record however, in the form of a portrait by Ralph Earl of Colonel William Taylor (see plate IX). A graduate of Yale College (1785), Taylor was a Connecticut

merchant who also pursued military advancement. A captain of cavalry in 1791, he became Major in 1796, and lieutenant-colonel in 1802.[45] Taylor presents himself to the viewer, not exhibiting his mastery of horsemanship, of a regimental cohort, or of business but combining the air, costume, and deportment of a gentleman with the tools of draftsmanship. His interest in drawing may have evolved out of his background in the military; as noted, skill in accurately rendering topographic features and effectively designing fortifications were desiderata for officers. Certainly the doubled image Earl gives us of a "real" landscape beyond the window frame simulated on the artist's tablet suggests an amateur artist as eager to capture the recognizable facts of the view (Evelyn's "Copies [of] ... things already extant") as the portraitist is in capturing the recognizable facts of the physiognomy before him. Taylor attends to the portraitist, the elegant gold-headed walking stick of a gentleman in one hand and, in the other, a *porte-crayon* charged with white chalk at one end and black at the other. This implement attests to his authorship of the "drawing" executed in black and white chalk on buff paper mounted on an easel before him. This artwork miniaturizes, describes, and summarizes hills, trees, clouds, and water in the *grisaille* palette of drawings of this type. More important, the artist within the image offers his work to those of us outside the image, against the "reality" of the lush summer landscape portrayed. We are invited to compare, match, and judge Taylor's skill. The object of the doubling is to attest to his fidelity—his skill in simulation, not invention—the fact that Taylor's drawing captures and recapitulates objects in nature "as they appear to the eye." Secondarily, of course, Earl the portraitist is making the same claim, but the truth of facial "likeness" cannot be affirmed, while this topographic "likeness" can.

Dr. Holyoke and Col. Taylor are rare examples of American eighteenth-century colonial men whose identity and memory intertwine drawing and artistic production with gentry social selves. These men worked for a living, certainly, but that production of livelihood fit into a category of economic pursuit separate from the production of artworks. Many other nonartists studied plastic form and practiced design (although they probably did not draw in the Rose and Crown sense; they designed directly in three-dimensional materials) but did so within a framework directly supporting and informing a livelihood. We know this not only because of the character and extremely high level of artisan production in colonial America (see, for instance Paul Revere's Liberty bowl [see fig. 43] described in Chapter 4, and the furniture examples discussed in Chapter 8) but because of the proliferation of specialty schools that offered this instruction.

A Silent Communication

The education that prepared eighteenth-century British Americans for productive lives took place primarily within the context of home and apprenticeship, although there were also schools. In Boston, for instance, two grammar schools,

supported by public funds, taught boys ages seven through fourteen (who already read English) Latin and Greek, preparing a minority of youngsters for Harvard and, until the mid-eighteenth century, largely for the ministry.[46] Three writing schools (some of which, after 1789 during the summer months, were available to girls) taught children "Reading, Writing [English] and Cyphering"; the curriculum also included prayer, scripture reading, catechism, and spelling.[47] Benjamin Franklin (born 1705/6) in his *Autobiography* records his "demotion" through this system as a child: "I was put to the grammar-school at eight years of age. . . . I continued, however . . . not quite one year . . . my father . . . took me from the grammar-school and sent me to a School for writing and arithmetic. . . . I acquired fair writing pretty soon but I failed in arithmetic, and made no progress in it. At ten years old I was taken home to assist my father in his business [making candles]."[48] He was subsequently apprenticed to his older brother, a project in education culminating equally in failure. Beyond these three basic institutions of learning—grammar school, writing school, and apprenticeship, other schools taught a host of practical skills, including some kinds of drawing and design. They were available for a fee and intended, apparently, for youngsters not formally apprenticed at age fourteen or for young adult journeymen as some were open in the evenings to accommodate "those that are employ'd in Affairs and Business in the Day Time."[49] The ads specify the curricula and frequently list the teaching of "Mathematical Sciences, viz Arithmetick, Geometry, Algebra, Fluxions, Trigonometry, Navigation, Dialing, Astronomy, Surveying, Gauging, Fortification, Gunnery; the Use of Globes, also other Mathematical Instruments, likewise the Projecting of the Sphere on any Circle."[50] Here mathematics paired with drawing to equip aspiring merchants, ship captains, military officers, shipbuilders, and land surveyors with the skills to measure, conceptualize, analyze, and record in drawings projectile trajectories, property lines, the optimum shape of barrels and hulls, and plans for forts resilient to attack. Drawing skills taught here were instruments of analysis and thought but in a much more pragmatic sense than Richardson's "expressing our thoughts upon paper."

A few drawing instructors embroidered their advertisements with extensive arguments for universal (male) instruction in their art; exemplary of these is that of James Smither of Philadelphia in 1769:

> Drawing is a most ingenious, interesting, and elegant art, and the study of it ought to be encouraged in every youth . . . its utility being so extensive, that there are few arts or professions in which it is not serviceable. All designs and models are executed by it—Engineers, architects, and a multitude of professions, have frequent occasion to practice it; in most stations it is useful, from the general who commands an army, to the mechanic who supports himself by handicraft. A young gentleman possessed of an accomplishment so exceedingly desirable, both for amusement and use, is qualified to take the sketch of a fine building—a beautiful prospect . . . or of any uncommon and striking appearance in nature . . . and enables

them to construct and improve plans [of property] to their own taste, and judge of designs, etc. with propriety.

Of all others this art has the greatest number of admirers, and no wonder, since in a kind of universal language . . . understood by all mankind, it . . . helps us to the knowledge of many of the works of nature and art, by a silent communication.[51]

The education offered to young women in colonial newspaper advertisements also stressed mechanical, pragmatic skills but these in the service of creating ornaments to the domestic environment rather than engaging the external world and the realm of economic exchange. Characteristic is an advertisement of 1753 in which a Mrs. Hiller informs "young Gentlewomen" that she teaches "Wax-work, Transparent and Filligree Painting upon glass, Japanning, Quill-work, Feather-work, and Embroidery with Gold and Silver"; she assures prospective students that they "may be supplied with Patterns and all sorts of Drawing, and materials for their work."[52] Note that the girls are supplied with patterns and drawings rather than instructed in producing designs. This omission is characteristic of eighteenth-century theories concerning the nature of women, creatures understood to excel in the manipulation of small materials, in exacting repetition, and copywork but deficient in originality and imagination. If they were understood to "draw" at all, it was decisively in Evelyn's second, copyist, sense of the word. By embroidering the patterns of others, young women effected the same ornamentation of the domestic they were encouraged to achieve in dancing (patterns choreographed by others) and in playing (music composed by others) on the harpsichord. They added value to themselves in proportion to their capacity to fulfill with grace and exactitude patterns created by professional men.[53] Unlike the drawing and other skills imparted to young men, those taught to young women did not include problem-solving, or utterance of new "sentences" in a common syntax of forms. Of course, a few colonial women drew inventively, some even became paid professionals, but this was not the intent of their education or the expectation of their parents; rather, it was the expediency of widows, deserted wives, or others forced by circumstance into a new relationship with their skills and their community.[54] As one proprietress of a girls' school put it, a student proficient in art might "find it a useful resource against great reverses of fortune."[55] Such a rescue function actually upended the object of female gentry education as that education, above all, labored to disassociate artfulness from money and the marketplace. This was not just a matter of decorum but an aspect of broader cultural theorizing of the female that positioned her face and body (her relative beauty), her deportment, and her accomplishments as aesthetic projects performed for a domestic audience of men—fathers, prospective bridegrooms, husbands, and impressionable children. As one anxious parent put it, "Much depends on your being improved."[56] What "depended," of course, was a "good" marriage, and this "improvement" referenced

not an eventual role as actor, initiator, or creator of expression on the stage of life but on a female's marketability as an object (and as a producer of embroideries and dances) for the aesthetic gaze of others. By such admonitions girls were socialized into what W. E. B. Du Bois called, in another context, a "double consciousness," that is, a sense of the self, primarily as an object *seen* and only secondarily as a subjective sentient self. So, while we might at first be surprised to read in the journal of a young Princeton-educated tutor in the Carter family of Virginia that "[this] evening, at Miss Prissy's Request I drew for her some Flowers on Linen which she is going to imbroider, for a various Counterpane," the concept of male and female competence and "sphere" incorporated into this arrangement was normative.[57] He drew the flowers—because doing so was an act of invention—and Miss Prissy would exactingly follow the tutor's lines on the linen as she would the figures of the dancing master who came the following week. It was only in the early years of the nineteenth century that, with the advent of the cult of sentiment that American women were taught drawing and artmaking in a more active sense. In the eighteenth century, the point of female education was, as capsulized by Yale president Timothy Dwight, "to excite . . . admiration and applause" on the narrow stage of familial (and prospective bridegroom) observation.[58]

In the three paintings of three Massachusetts kinswomen that Copley modeled exactly after Thomas Hudson's portrait of Mary Finch, Viscountess of Andover (by way of John Farber's engraving) discussed in Chapter 3, he individuated the sitters in three ways: their faces, their sleeve lace, and their implied relationship to drawing (see figs. 2, 3, 32, 33, and 34). In the Hudson portrait, the "original" sitter in this sequence holds a *porte-crayon*, and blank sheets of paper rest under her arm on a plinth ornamented with a *putto* displaying a painted "sculpted" sheet with a "drawing" of a tree. This assemblage of accoutrements and the redundancy in references to drawing intertwine Mary Finch's identity with her facility as an amateur artist (a talent confirmed by George Vertue who had an opportunity to view her drawings in 1747 and opined that they were executed "mighty well.")[59] None of the American women hold a drawing implement. One leans on a plinth with the *putto* and tree-drawing; another is accompanied by sheets of paper on one of which a floral border has been drawn, perhaps an embroidery pattern.[60] The third deletes all reference to patterns and drawing. We should assume that these distinctions mattered to Copley and to his sitters. While identical to their English counterpart and to each other in point of dress and posture, the colonial women are depicted as *not* draftwomen. One may have been an accomplished needlewoman, and all were sensitive to fine discriminations in the figures in lace, but they did not inhabit the "drawing" identity of their prototype. Englishwomen in the 1770s were well initiated into this "accomplishment"; their colonial counterparts (with rare exceptions such as Charles Willson Peale's sister in his portrait of the family [see plate III]) were not.

CASTIGLIONE

Castiglione, two centuries earlier, had made the case for drawing as a liberal art, an activity worthy of the serious attention of gentlemen, an activity different in quality and nature from art production by artisans. This view was by no means an established "truth" even in Italy. Well into the seventeenth century, even in important urban centers, guilds litigated this encroachment into the purview and prerogatives of their craft and resisted the book-learnable nature of this new concept of art that inclusion among the "liberal arts" implied.[61] As we have seen, drawing in the colonies was understood to be a useful skill for some professional men and mechanics, and it had not yet been identified with those "accomplishments" many gentry women would master in the nineteenth century, but subsequent to the settlement of Smibert in Boston and the immigration (or return from England) of other professional artists in the seaboard cities, the Castiglione concept of drawing and art-making among gentlemen and professional artists was making minor inroads. True, there were few amateur artists and virtually no commissions other than portraits but the importation of texts, treatises, and epistolary exchange hinted at change. When Copley complained to a sympathetic audience that in the colonies, "The people generally regard it [the craft and profession of "artist"] as no more than any other useful trade, as they sometimes term it, like that of Carpenter, tailor, or shew maker [shoemaker], not as one of the most noble Arts in the World," he was correct.[62] In saying so, he was voicing both annoyance with his context and allegiance with (or aspiration to) a concept of art that was not as self-evident, immutable, generally endorsed, or inevitable as he seemed to think. Indeed, in Genoa and Venice less than a century earlier, artists had made the same complaint with greater reason.[63] Castiglione's position concerning the amateur, and Leon Baptista Alberti's concerning the professional—that the artist was no longer a lowly craftsman, but, in the latter's phrase, *homo buono et doctor in buone lettere*—was not universally or immediately acknowledged.[64] In Venice, painters were yoked in a guild with textile designers, leatherworkers, mask makers, and the like, a guild that had, and used, the power of the law to exclude claimants trained and practicing outside guild apprenticeship and guild regulations from doing business. Courts in Genoa and Venice in the late seventeenth century were asked to adjudicate whether, in fact, painting was a liberal art, with mixed results.[65] At issue in the seventeenth century in Italy and the eighteenth century in Boston was not only the social status (and social mobility) of the artist but also the cultural valuation of "genius," that is, intellectual inventiveness above and beyond skill, proficiency, exactitude, and the workmanlike virtues fostered by guild training and affiliation. Corollary in the Castiglione plea for revaluation of "the artist" was the assumption that, unlike the product of the sign painter or the leatherworker, the painting could, as Berkeley put it, "influence . . . the minds and manners of men, filling them with great ideas, and spiriting them up to an emulation

of worthy actions," a precept that became integral to theorizing on this point from the sixteenth century forward.[66] As the drawing was understood to be the intellectual (and therefore the ethical) component in the production of art, the theory and practice of draftsmanship (of the sort aligned with the realm of ideas and antiquity practiced at the Rose and Crown) silently stood for much else.

As we have seen, John Smibert announced the arrival of painting as a liberal art in the New World in his self-presentation with a drawing in hand in the *Bermuda Group* (see plate VIII and fig. 74). But the sort of art he actually practiced in Boston, and the sort that others such as Copley after him practiced—portraiture—did not require drawing and did not, in fact, lead men to virtue. It did hold up, especially in public portraiture—such as the heroes of Louisbourg commissioned for Faneuil Hall—examples of achievement and perhaps even "character," but it would be hard to argue for the sort of ethical-problem-posed-and-answered-in-a-painterly solution that was fundamental to that theoretical position, that is, to history painting.[67] So when Copley complained that painting in the 1760s in the colonies was only valued as "any other useful trade" he certainly read the analysis of his audience correctly, and they read the products of his studio correctly: portraits were "useful" objects (see Chapters 1 and 3), judged on technique, skill, and likeness. Unlike his Italian predecessors, Copley was not hindered in practicing his craft by a controlling guild; he had not been stinted in earthly rewards nor socially stigmatized. Indeed his social rise had been astronomic and his fortune as great as all but a handful of his contemporaries. Yet he chaffed; he was "mortified." Being mortified was something he learned from books. What he coveted was not so much greater social distance from carpenters, tailors, and shoemakers as greater access to fame (available only where public art exhibitions existed) and commissions to paint "noble" subjects (available only where history painting was valued and patronized). It is logical, then, that on his eastward migration to London, he presented himself immediately to the public, the connoisseurs, the critics, potential patrons, and potential rivals with a multifigure canvas in which he, like Smibert fifty years earlier, on *his* arrival in a novel venue, brackets the group from the left, intently engages the viewer, and proffers as his attribute sheets of paper on which a drawing appears to be faintly discernable (see fig. 62).[68] Directly behind the artist's hands a bas relief classical nude figure adorns a large vase (modeled on the Medici Vase, first century C.E.), further underscoring his affiliation with the kind of drawing Richardson and Evelyn associated with "ideas" and that the Rose and Crown club associated with the authority of the antique. Even within the portrait genre, he is declaring here that his future work will be drawing-based and all that that implied. Indeed, he immediately began to practice—and revolutionize—history painting. It follows that, from his London career, which focused on large multi-figure groups, especially history painting with its emotional and ethical multifigure theatricality, numerable extraordinary drawings survive exemplary of which are the studies for the *Siege of Gibraltar* (fig. 79). It is beyond the scope

FIG. 79. John S. Copley, "Study for *The Siege of Gibraltar*, Sprawling Figures in Longboat," 1788–1789. Black, white, and red chalk on blue paper, squared for transfer. 13⅛ × 10 in. (33.4 × 25.4 cm). © Copyright British Museum.

of this chapter to pursue Copley into his London career except to note that with *The Copley Family* and with the double portrait of Mr. and Mrs. Ralph Izard (fig. 80) he brought full circle the project initiated by Smibert a half century earlier, declaring himself literate in the difficult languages of classical bodies, classical buildings, and the skill of drawing, which records and reimagines both.

One further dimension to the idea and practice of drawing needs to concern us briefly and that is the notion of the line as gesture. One reason drawing is associated with subjectivity and thought is that frequently the artist's stroke conveys to the viewer not only the "just form" of the object depicted or the realization of

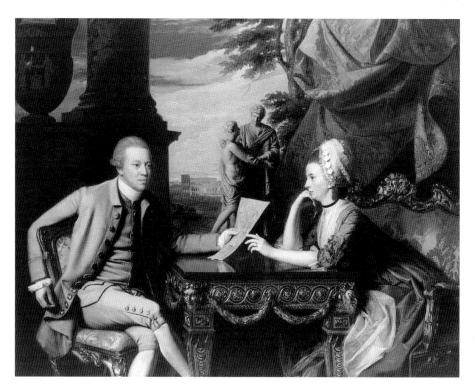

FIG. 80. John S. Copley, *Mr. and Mrs. Ralph Izard (Alice Delancey)*, 1775. Oil on canvas. 68¾ × 88½ in. (174.62 × 223.52 cm). Museum of Fine Arts, Boston, Edward Ingersoll Brown fund; 03.1033. Photograph © 2003 Museum of Fine Arts, Boston.

the artist's invention but also a trace of the artist's gesture in describing that form. An intimacy and immediacy in this visible trace of the thinking hand encourages the viewer to recapitulate the stroke mentally: the eye believes it can "feel" the direction, motion, and even speed of a stroke. While few colonial artists drew in the academic sense, some used the loaded brush to "draw" with paint in the final stages of creating a picture. Look, for instance, at the strokes of white pigment that Copley used to describe ("draw" in paint) the right wrist ruffle of Joshua Henshaw (fig. 81; see plate VI). Painting "fat over thin," in oil-rich white lead pigment with a loaded brush, Copley floated a fluent line defining textile edge in one of the last touches he made to the canvas, leaving a single stroke of opaque relief impasto on the surface. The fluidity and confidence of this gesture becomes much more characteristic of Copley's "London style"; art historians often describe these passages as "rapidly executed," as exhibiting "dynamic spontaneity," introducing in this language a concept of temporality as well as movement into an object that has no temporal or somatic dimensions.[69] But these frozen liquid gestures in which we see, or think we can see, the artist draw (in the sense of "pull," as draw a sword or draw a wagon) pigment into descriptive form, were not spontaneous or rapid even if they were gestural. As Sir Joshua Reynolds said of similar seemingly accidental or rapid

strokes in the work of a contemporary, this is "diligence under the appearance of chance and hasty negligence."[70] Copley's working method remained as "tedious," to use Gilbert Stuart's term, in Britain as it had been in Boston (see Chapter 3). In fact, we can see in the *pentimento* of Henshaw's right shirt cuff the ghost of two other, apparently unsatisfactory, ripples of ruffle. But we cannot resist seeing in these impasto strokes *mind*—in Norman Bryson's terms, "intention and decision"—that elsewhere in the painting hides itself but here rises to a doubleness in which image as image and "image as a trace of performance" coincide.[71] These passages of drawn pigment are rare in eighteenth-century American work. They concern us here as evidence of a wedding of drawing and painting, not in the initial stages of plotting a complex narrative picture, but in the final touches that animated a portrait's surface in the hands of a few masters. In Copley's English pictures, he increasingly privileged this "drawn" visible fluid brushstroke and associated it both with capturing stop-action temporality (the split second a ball has been thrown for a leaping dog, for instance) and with drawing in *The Western Brothers* (fig. 82). Such developments, though, were only prospective glimmers in Copley's American oeuvre and absent altogether in the work of other colonials. They represent Copley's comprehension and practice with his brush of a painterly version of that quality of grace and naturalness privileged in all gentry behaviors, commended explicitly by Castiglione: one must "practice in all things a certain nonchalance (*sprezzatura*) which conceals all artistry and makes whatever one says or does seem uncontrived and effortless," offering as exemplary "a single line which is not labored, a single brushstroke made with ease in such a way that it seems the hand is completing the line itself without any effort or guidance."[72] That Copley's painted line has been interpreted as "free and graceful," "rapidly executed," and signaling a "dynamic spontaneity" is a tribute to his capacity to cover his tracks, to his mastery of Castiglione's dicta but not to a literally rapid, spontaneous, or effortless execution.[73]

That Copley, without benefit of apprenticeship, academy, or "gentle" breeding was able to master this concept and all the truisms that went with it is a tribute to his capacity to read, for the potent instrument of instruction transmitting social and aesthetic values concerning drawing, the liberal arts, and antiquity was the illustrated book. It was the illustrated anatomy book that he copied as a youngster (see fig. 51), the "book of antique statues" of which he writes to his brother, the handbooks of drawing, the architectural patternbooks, and the periodic journals of useful knowledge that supplied the deficit in his education.[74] Indeed, we can almost hear in his often quoted comment about painting "as no more than any other useful trade . . . like that of Carpenter, tailor or shew maker" an echo of the tone and biases inherited from the Italian sixteenth-century theorists and inscribed into the work of such contemporaries as John Gwyn whose popular mid-eighteenth-century *Essay on Design* rehearsed the tussle between an older artisan system of knowledge transmission and classically laden book learning in seventeenth-century France:

FIG. 81. Detail, John Singleton Copley, *Joshua Henshaw,* c. 1770. Oil on canvas. Fine Arts Museums of San Francisco, Mildred Anna Williams Collection, 1943.4.

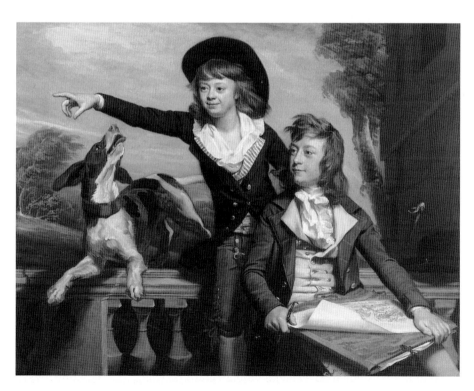

FIG. 82. John S. Copley, *Charles Callis Western, later Baron Western of Rivenhall, and His Brother Shirley Western: The Western Brothers*, 1783. Oil on canvas. 49½ × 61¾ in. (125.73 × 156.84 cm). Henry Huntington Library, Art Collections, and Botanical Gardens.

> Ignorance has always been the Enemy of Art: . . . The Gentlemen and Artists, who exercised themselves in Design, with a View to revive the antient Taste, and initiate the antient Performances in Painting, Sculpture, and Architecture, had not yet any Distinction from the common Class of Mechanics. When they came to put the Skill they had acquired into Practice, they raised the Envy of the Sign-Post-Daubers, Stonecutters, and Bricklayers. Some of our Artists were Men of Liberal education, who had not gone through the Drudgery of five or seven Years Servitude [artisan apprenticeship]. . . . [with the intervention of the King, the lawsuits were dropped and] art had an honourable Distinction given it from mere Labour, and those who could design a Picture, a Bas-Relief, a Statue, or a Public Edifice, had a Right to practice without Molestation from the Brush-men and Masons.[75]

This little morality tale between the "ignorant" "Sign-Post-Daubers, Stonecutters, and Bricklayers" and the "Men of Liberal education" summarizes an antipathy (one we have also seen in the Italian situation) more appropriate in Europe where class lines were firmer and the competition for work was far stiffer and more jealously guarded than in the colonies where, with only a little exaggeration a Philadelphian could ask: "Is not one half the property in the city [Philadelphia] owned by men who wear *Leather Aprons*? Does not the other half belong to men whose fathers or grandfathers wore *Leather Aprons*?"[76] At issue was not just protectionism but also a growing cleavage between master and journeyman, thinker and worker, brains and brawn, management and labor, and an invidious hierarchy asserted between them that has continued to the present.[77]

 The indigenous late medieval system in which the master workman was a designer who thought with the materials of his craft (and not with a pencil), who transmitted and received his knowledge in face-to-face encounters (and not in books), and whose knowledge was of the present and of the local, yielded to the values, forms, and authority of "antient" Italy late in the New World. When Smibert set up the *Bermuda Group* in his studio in Boston with its validation of drawing, its Berkeley-as-Hercules sculptural quotation, and its trio of enormous classical columns, this was news. He and Berkeley had brought in their luggage books, prints, drawings, plaster casts, and *ideas* that Copley would, thirty years later, take as axiomatic. When he complained of living among "people entirely destitute of all just ideas of the arts," Copley was bemoaning the incomplete transition of his fellow New Englanders to an Italianate way of seeing things.[78] Bostonians had long accepted the "necessity" for certain elites to be taught Latin and Greek texts at public expense to prepare them for the public-speaking roles that gave ministers civic power, but those other forms of quotidian reenactment of antiquity-without-togas—namely architecture, painting, and sculpture—were unfamiliar. The three key ingredients in this Latinization of America were (1) language (fluency in the ancient languages remained the criteria for admission to colonial colleges even after those institutions began, in the mid-eighteenth century, to train ordinary elite men, not just proto-ministers), (2) familiarity with those

antique sculptures understood to exemplify perfection of form and deportment (specifically, the Apollo Belvedere, the Borghese Gladiator/Warrior, the Belvedere Antinous, Farnese Hercules, and the Venus de Medici, a concept discussed in Chapters 4 and 5), and (3) knowledge of the five orders of Roman architecture.[79] Each of these three classical "grammars" stood for whole worlds of theory, meaning, and communication. They also stood for and effected an eclipse of the local.

THE BUILDING IN THE PAINTING; THE BUILDING BY THE PAINTER

Behind the figures in the *Bermuda Group*, three precise cylindrical forms punctuate the middleground. They are equidistant and equal in diameter. To one unfamiliar with classical forms—that is, to most in Boston in 1729—they would be faintly mysterious; *cognoscenti*, however, could quickly generate in their mind's eye the unseen moldings at the base of these columns (and perhaps a plinth) below the line of sight and the invisible capitals, entablature (and perhaps a pediment) above. Moreover, because the five orders of architecture that were understood to be the "grammar" of antique form each had a fixed ratio of diameter to height (as well as a fixed vocabulary of moldings, base, and capital), a knowledgeable viewer could, without blinking, estimate the height of the columns in question (in this case, not less than fourteen feet). Not just an ornament to enrich a façade, these orders, through a system of calibrated established proportion, determined the scale and dimension of the building to which they were frontispiece—that is, they generated volume and form itself. For this reason, all the design books that distributed patterns for exemplary Italianate buildings around the world (as well as the later design books intended for cabinetmakers, pewterers, and so forth) began with a plate of the five orders. As the eighteenth century advanced, the size and expense of the books with this type of Italianizing information diminished as their volume and number vastly increased, that is, they penetrated an ever wider and deeper pool of the literate population. While few would have been in the know in 1729, a few decades after Smibert unveiled this canvas many Bostonians would have become familiar with images of classical columns, moldings, and porticos, and they would have some actual examples within their townscape. Typical of the published examples available to a journal-reading audience (that is, an educated but not a specialized audience) by mid century is the London-published *Universal Magazine of Knowledge and Pleasure* (fig. 83). This journal actually set as its goal a certain universality, being titled in full *The Universal Magazine of Knowledge and Pleasure Containing News, Letters, Debates, Poetry, Music, Biography, History, Geography, Voyages, Criticism, Translations, Philosophy, Mathematics, Husbandry, Gardening, Cookery, Chemistry, Mechanicks, Trade, Navigation, Architecture, and Other Arts and Sciences which may render it Instructive and Entertaining to Gentry, Merchants, Farmers, and Tradesmen*. This ambitious title suggests exactly how fluid and

embracing (and how public) knowledge contained in book form was. One gets a sense paging through its monthly numbers (and those of similar journals and encyclopedias) of trade secrets and regional practices falling like flies before its powerful portability. One also gets the sense that in the eighteenth century the modest paper sheet, especially one on which engraved images supplemented verbal text, was a force multiplier akin to the modestly scaled silicon chip of today. In the particular numbers in question, an unknown author, "Architector" patiently explains (in a multipart installment lesson) architectural orders as his peers explain "The Art of Grinding and Polishing Plate-Glass," "Practical Chemistry," "The Art of Making Clocks and Watches," how to build a brewhouse, and why the Transit of Venus is interesting. "Architector" explicates the system of modules and ratios involved in building with columns, mentions their use by the "Antiens" and the King of France, clarifies that Architecture is a Liberal Art "worthy of a Gentleman's study and recreation," and makes it clear that his intent is "to enable young beginners to form a just idea of [the orders]" and all that that implies, in great detail.[80] When Smibert and Berkeley arrived in New England, however, few of these popularizing efforts had been undertaken or thought necessary. In the colonies regional vernaculars based on ancestral English building traditions were comfortably ensconced.

The *Bermuda Group* triumvirate of columns is not, therefore, a throw-away nicety lending abstract dignity to Smibert's scene. As we have seen, Berkeley did not take a casual view of architecture. He had a reputation in the eighteenth century as "an excellent architect," and both he and Smibert had a point of view about classicism.[81] The centerpiece of Berkeley's plan for the City of Bermuda was, as noted earlier, an Anglican church, its façade flattened in his engraving against the plane of the map so that its elevation is legible (see fig. 75). This mixing of plan and elevation was a convention used in some eighteenth-century maps that violated the logic of both city plan and architectural elevation, but it is a violation permitted here as an index of the importance of the architectural facade of this structure to Berkeley. It and the colonnade that flanks and enlarges its impact, as well as the monumental single column that prefaces it (a *memento Roma*), are all in the Ionic order. Berkeley may not have verbally spelled out the *classicism* implied in his belief that architecture could be an instrument of instruction leading men toward virtue, but it is clear that he privileged not only the orders but the literal temple form that embodied antiquity's most conspicuous and most recognizable building type. Vernacular building, master craftsman-type building, the kind of building he in fact inhabited in Rhode Island (and that would be seen by later generations as indexical of rustic virtue), was not what he had in mind (see fig. 76).[82] To him the modules of the orders had the same grammatical authority as the declensions and conjugations of Latin nouns and verbs, and were equally the appropriate agents in civilizing (that is, making British, Protestant, and Classical, all in one breath and all to one purpose) the New World.

In hindsight we can see the arrival of architectural classicism in the British colonies as the first of several book-based "international" styles to wash over and

FIG. 83. "The First Plate of Architecture Containing Plans and Elevations of the Five Orders of Architecture . . ." *Universal Magazine of Knowledge and Pleasure* 1 (1747), supplement, p. 375. Huntington Library, San Marino, California.

subsume coherent local traditions based on generation-to-generation, face-to-face transmission. That is, it represented loss as well as change. But to Smibert, Berkeley, and several in their circle, modest sproutings of this new patternbook Italianate vocabulary of design was a sign of progress and a harbinger of the triumph of Anglicanism as well as Britishism in the "savage" western continent.

When the group of Bermuda educator-adventurers landed in New England, a few domestic structures already existed on the landscape that were equipped with some of the earmarks of the type of building they came to promote, including Francis Brinley's Datchet House in Roxbury.[83] Its prominent hilltop site is noted in Henry Pelham's map of the Boston area, and a view of the not-yet-classicized city across Brinley's eighty-eight acres from that knoll is recorded in Smibert's portrait of the owner (fig. 84; see fig. 78). Built in 1723 on a symmetrical H-plan, its lofty central reception room—a space that measured 44 by 22 feet—was prefaced by a five-column "piazza," and flanked by two-story wings cornered with giant pilasters (fig. 85).[84] It also sported the clapboarding and gambrel rooflines of more modest building traditions, but its struggle to affiliate with Renaissance Italianate ideas of "antient" forms is clear (fig. 86). It is not surprising, then, that Brinley was one of Smibert's first customers, George Berkeley's host when the philosopher's family came to Boston en route back to Britain and a generous contributor to King's Chapel, built ten years later in downtown Boston with the full vocabulary of an ionic masonry portico. Brinley's house survived more than 150 years, a harbinger that came to see its Italianate columns, pilasters, symmetrical and hierarchical plan become fixed and common features on the landscape.[85]

FIG. 84. Detail, John Smibert, *Francis Brinley*, 1729. Oil on canvas. 50 × 39¼ in. (127 × 99.7 cm). Metropolitan Museum of Art, Rogers Fund, 1962. (62.79.1). Photograph © Metropolitan Museum.

FIG. 85. Unknown artist, *Brinley Place (Datchet House), Roxbury, MA* [1723], from Francis S. Drake, *The Town of Roxbury*, 1878. Wood engraving. 2⅜ × 3¾ in. (6 × 9.5 cm). Huntington Library, San Marino, California.

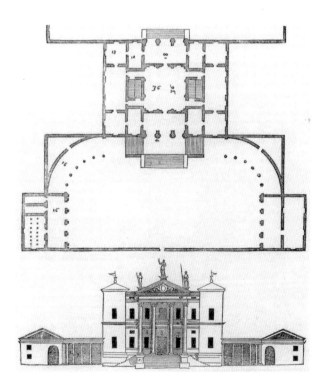

FIG. 86. Andrea Palladio, Plan and Elevation of Villa Thiene, Cigogna, 1554–1556, from *The Four Books of Architecture*, first published 1570, trans. Isaac Ware. (London, 1736). Book 2, plate XLV. Avery Architectural and Fine Arts Library, Columbia University.

Since the reign of Charles I, Renaissance Italianate buildings had dotted the London cityscape and made incursions into design projects among the nobility and gentry in the English countryside and, in the wake of the great fire of London of 1666, much of the rebuilding was done in this taste. Even with the dissemination of patternbooks, however, these forms continued into the early eighteenth century to be a novelty among most of the population in Britain and virtually the whole of the colonies. Brinley's house would have looked "different" to his neighbors, and an even grander version, using the same plan, built in the 1730s by another Smibert sitter, William Browne, was so odd it was locally spoken of as "Folly Hill." A vignette of the eighty-foot-long façade is included in Smibert's portrait of Browne's wife (fig. 87).[86] Six years later, in 1744, it was described as "not yet quite finished. It is built in the form of an H with a middle body and two wings. The porch is supported by pillars of the Ionick order about 15 foot high, and betwixt the windows of the front are pilasters of the same. The great hall or parlour is about 40 feet long and 25 wide with a gallery over the first row of windows, and there are two large rooms upon a floor in each of the wings, about 25 foot square. . . . In the hall I saw a piece of tapestry, or arras of scripture history, done by Vanderbank a Dutch artist."[87] Such a house had few peers in the colonies in the 1730s and 1740s, but its emphasized, raised, column-defined portico or porch; its ornamental surface pilasters, its symmet-

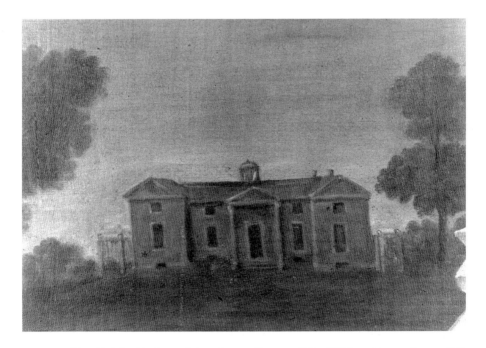

FIG. 87. Detail, John Smibert, *Mary Burnet Browne (Mrs. William Browne)*, 1738. Oil on canvas. 92½ × 57 in. (234.9 × 144.8 cm). Alan Mason Chesney Medical Archives of the Johns Hopkins Medical Institutions. Photography courtesy of the Baltimore Museum of Art.

rical, regular volumes exhibiting both vertical and horizontal hierarchy with an emphasized central section and central story would all become aspects of the Italianate "Georgian" building that would become so successful in America in the last five decades of the eighteenth century and that persists as "colonial" in suburban and institutional building today.

Smibert had clearly always had an interest in architecture and the built environment—the unusual inclusion of topographical cityscapes and house portraits in his canvases makes that clear. Perhaps drawing at the Rose and Crown in the company of James Gibbs had excited his idea of that other use for drawing— design. Like painting, architectural design was also (in England in the seventeenth century, and in the colonies in the eighteenth), moving from the province, expertise, and monopoly of apprentice-trained materials-oriented master builders to that of book-trained, drawing-oriented gentlemen. As in the case of painters, both the "grammar" of their practice (in antique sculpture and the five orders) and their authority as practitioners of the Liberal Arts were based on knowledge of antiquity, the claims of imagination, and the power of paper—that is, books and drawing. As among painters, there is a class tone in the commentary describing this shift: "Architector" in the mid-century *Universal Magazine* put it this way: "Amongst all the Arts which are properly stiled Liberal in Opposition to such as are merely Mechanic, I have always given preference to Architecture as well on Account of its Antiquity, as Usefulness."[88] The brusk "merely Mechanic" suggests rote learning and local horizons, while "Liberal" suggests book learning, international horizons, and the possibility of creativity. This polarity archetypically played itself out between a materials-knowledgeable candidate and the book-knowledgeable Smibert when in 1740 the painter's design for a market hall for Boston was accepted over one submitted by a master mason, Jason Blanchard.[89] This was a huge commission for a novice and it must have proved galling to a mason who knew how to engineer a 130-foot long 40-foot wide structure to see "paper" knowledge take precedence over "brick" knowledge (fig. 88).

Neither Smibert nor his contemporaries would have seen his practice of architecture as discontinuous with his mission as an artist—it was just one branch of a larger practice in which education in proportion, knowledge of classical prototypes, and artistic imagination guided the designer's hand. True to his allegiance to antiquity and the centrality of the orders in displaying that knowledge and affiliation, Smibert parades two stories of appropriately proportioned and appropriately detailed Doric pilasters (doubled at the corners) around the entire envelope of the market. The first purpose-built public market in the colonies, Faneuil Hall was quickly followed in Smibert's oeuvre by a commission to design the first college chapel in the New World—Holden Hall at Harvard. Still extant, this gem of a 32-by-40-foot building has a handsomely proportioned interior with a coved ceiling and repeats on its exterior the brick pilasters (with sandstone capitals and bases, which are doubled at the corners),

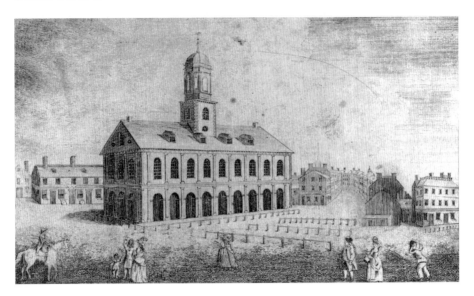

FIG. 88. Samuel Hill, engraver, *View of Faneuil Hall [designed by John Smibert] in Boston, Massachusetts*, in *Massachusetts Magazine* 1, no. 3 (March 1789). Winterthur Library: Printed Book and Periodical Collection.

round-headed windows, and a patternbook wooden entablature that were the signature "modernisms" of Faneuil Hall. It is shown, crowded to the left edge in Paul Revere's 1767 engraving of Harvard (fig. 89). In company with the two older, more gangly college buildings and even the two overscaled newer structures with their "gathering" central pediments and up-to-date hipped roofs—Smibert's chapel has the air, in its classical proportions and shadowed pilasters, of a poised Athenian temple dropped into a boisterous northern climate.[90]

Smibert had not been trained as an architect, but he had personal memory of ancient and Renaissance structures in Italy and Italianate buildings in London. He also had access to books. That books alone appeared sufficient to launch a novice into design we can see in the efforts of Copley thirty years later. In the wake of his marriage and with the assistance of his wealthy father-in-law, Copley had acquired a large piece of property (noted as "Copley's Hill" in the Jukes/Pelham map of 1777, see fig. 18), and in 1771 began renovations on the central of three extant structures (fig. 90; see fig. 17). He laid plans to transform this single-pile gambrel-roofed structure into an elegant double-pile, hipped-roof, Georgian house with a central passage and two flanking piazzas or porches—in this last feature outdoing his neighbor John Hancock. A summary plan and elevation the artist-architect enclosed in a letter survives (fig. 91). These piazzas or porches were unusual at this early date and suggest Copley's interest in literalizing the liminal indoor-outdoor space painted by Smibert in the *Bermuda Group* and subsequent portraits but unusual in the actual built environment.

An exchange between Copley (away on a painting tour in New York) and

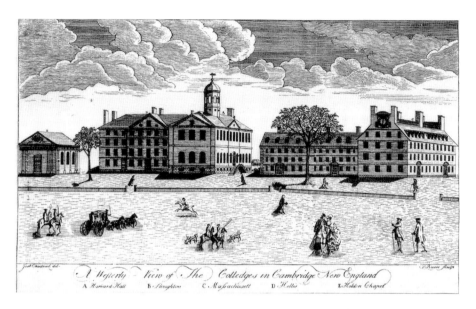

FIG. 89. Paul Revere, *A Westerly View of the Colledges at Cambridge New England*, 1767 engraving. American Antiquarian Society. Holden Chapel, designed by John Smibert, is on the extreme left.

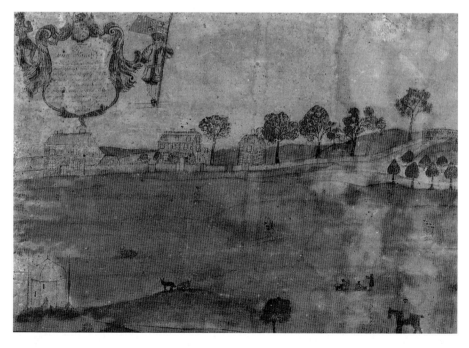

FIG. 90. Detail, Christian Remick, *A Prospective View of Part of the [Boston] Commons*, 1768. Watercolor drawing on paper. Concord Museum P1409, Gift of John Brown, 1889, Photograph by David Bohl.

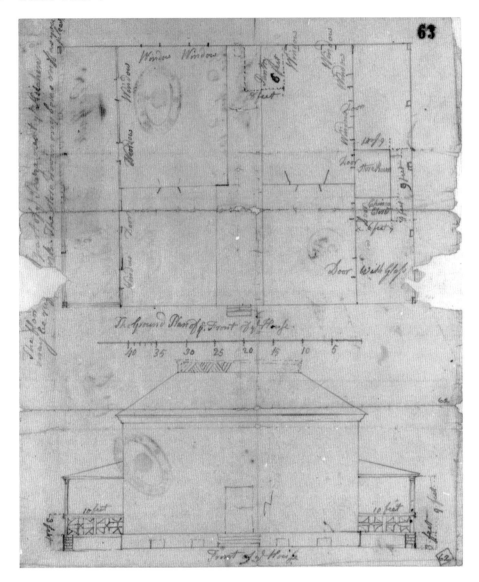

FIG. 91. John Singleton Copley, *Ground Plan and Front of the House*, 1771. Graphite on paper. 8⅝ × 7 ¼ in. (21.9 × 18.4 cm). National Archives, Kew, London.

Pelham concerning the "Peazers" is instructive as Copley translates this architectural form—derived ultimately from the porticos of Palladian villas and ancient temples but most readily available to Copley in such design books as that by James Gibbs—into the local vernacular.[91] In response to Copley's first mention of these spaces, the baffled Pelham writes, "I dont comprehend what you mean by a Peazer. explain that in your next [letter]." The artist replies with the drawing illustrated in figure 91 and writes: "A Peaza. . . . is exactly such a thing as the cover over the pump in your Yard, suppose no enclosure for Poultry their., and 3 or 4 Posts aded to support the front of the Roof, a good floor at bottum, and from

post to post a Chinese enclosure [railing] of about three feet high. . . . some have Collums but very few."[92] A roofed, floored, balustraded, columned, or post-supported structure, the piazza is a room without walls, partaking equally in the domestic (rectangular, orthogonally defined volume) and the unbounded natural (open to the view and to the uncontrolled accidents of shifting atmosphere). Copley had been familiar with such a space as an artistic trope before his visit in 1771 to New York (indeed, he had painted a plan for a piazza-portico furled in the hand of Nathaniel Sparhawk in 1764, which he had wittily signed as painter and "architect"; see fig. 4), but it was apparently not until the 1770s that he saw such a structure in a domestic building and, enabled by the profits of this distant painting tour, decided to realize the concept in bricks, mortar, and wood. Copley and other New Englanders would have seen fully realized classical porticos on Peter Harrison's King's Chapel (1749) in Boston and on the Redwood Library (1748) in Newport, Rhode Island, and some would have seen simulacra in paintings and prints, but such appendages on domestic structures remained rare even after the Brinley and Browne houses set precedents in the 1720s and 1730s. Pelham clearly was puzzled by the concept.

In Copley's instructions to his half-brother, we see a literalizing of the concept of paper transmission of design concepts. We also see the ways in which classical rules and vocabulary also lent themselves to the utterance of new architectural "sentences"; in this case, defined in terms of a vernacular pump-cover, Renaissance "collums," and, rather incongruously, a "Chinese," that is, an exotic rather than antique, balustrade and parapet.

By the 1770s, a provincial tyro like Copley would sign his paintings "pinx," reference "antient" sculpture in his poses, add "peazers" to his house, and consider himself "mortified" by association with artisans. In his words, paintings, and designs we can see the eclipse, even the stigmatization of artisanal knowledge, and the embrace of systems of knowledge that moved on paper. Even though he had none of the classical education of a European gentleman or even of provincial gentry, he had learned and internalized the cultural authority and values inherent in Montaigne's comment about the precedence of ancient Rome over the visible, local, experience-able present: "I was familiar with the affairs of Rome long before I was with those of my own house. I knew the Capitol and its position before I knew the Louvre, and the Tiber before the Seine. I have meditated more on the conditions and fortunes of Lucullus, Metellus and Scipio than I have about many of our own men."[93] By the mid-eighteenth century, the potency, immediacy, and "naturalness" of antiquity transcended time and geography, even among the scantily educated in the provinces. What Smibert and Berkeley had been harbingers of in the 1720s had become established consensus by the Revolution. The sweep of Italianate ideas and forms may have been inevitable, but it was not "progress" or inherently "good," for with it came the loss of the local, the vernacular, and the social dignity of the master craftsmen. The next chapter will explore artisanal creativity before the Revolution. In the

succeeding decades, the novel principle of interchangeable parts finished off what Italian theories, books, and practices had begun.

What had happened between 1720 and 1776 was not just a shift in "taste" or "style" or the arrival of new powerful systems of metaphor but rather a shift in what was understood to be the locus of thinking and creativity. Formerly it had been understood to be in the hands of the experienced artisan, his knowledge of materials and the "mysteries" of their manipulation. What arrived in the colonies in the 1720s was not just a mix-and-match patternbook of authoritative columns and sculptural bodies to be respectfully or wittily drawn, mimicked, and quoted but a powerful corollary axiom—that drawing was the instrument of thinking. Drawing, and all it stood for, was not just about visual literacy in antique proto-types (about knowing), it was also about seeing and thinking, and imagining within the syntax of a powerful international timeless, spaceless language of form and allusion. Once having seized professional (and economic) control of design and production in the Revolutionary decades, those with "paper" knowledge are only just now in the early twenty-first century beginning to relinquish it to new models of authority and a new order of information transmission.

Money, Art, Family, and the Cabinetmakers of Newport

The philosopher George Berkeley whose "westward the course of empire" project for a college in the New World was discussed in Chapter 6, settled in Rhode Island just outside of the city of Newport from 1729 to 1732. He had anticipated that it would be a rustic place in which, of necessity, his gentle-born wife would spin and the household would be clad in her homespun cloth. That was not the case. Berkeley brought with him in his entourage the painter John Smibert, anticipating correctly that such an importation would revolutionize the arts in the colonies, but he would by no means be introducing art and internationalism into New England. Established systems of apprenticeship, ingenious designers, active investment markets, and global patterns of trade had already established Newport as a place where imported goods and, more important, finely made aesthetically conscious local goods could be acquired. Not yet having learned to make invidious distinctions between art and craft, Newporters focused their art (as well as economic and social) energy on household objects. In this chapter I turn to an investigation of the economic and social circumstances of artmaking in that context, and especially to the craft of cabinetmaking as an important ingredient in the prosperity and identity of that wealthy center of trade. Like the portraits considered in the previous chapters, mahogany desks, tables, and other cabinetwares contributed to the interior landscape of colonial homes, enabling and marking family activities and relationships. Just as close analysis of family portraits as a group in Chapter 5 suggested ways of understanding family relationships, so focused attention on these objects points to what could be termed the domestic values of specialization, compartmentalization, hierarchy, and lockability.

Unlike portraits, mahogany furniture could be readymade and it retained value after purchase. If well made with distinctive, desirable, and predictable characteristics, it could be a highly marketable commodity in an international marketplace. This chapter traces how the best-known Newport craftsmen organized, over multiple generations, their production and marketing of these wares (including style consistency for product recognition, products adapted for portability, and labeling). It also describes two competing types of shops—the master-family unit and the master-wage-labor unit. Both the older and the newer types of artisanal organization provided bespoke and readymade goods for both local and export markets. This chapter offers a case study in an art product at the center of complex economic networks and interdependent social

organisms oriented—unlike the colonial portrait trade—toward an intercolonial and international marketplace.

In mid-eighteenth-century Newport, witchcraft was a felony punishable by death, and rowdy Indian dances in town were a matter of public concern.[1] Yet at the same time that these frontier tensions and medieval mental structures were still evident in the city, a recognizable modern market economy with international horizons was rapidly developing. This occurred despite New England's substantial obstacle to prosperous trade—a relative scarcity of the kind of agricultural and mineral resources on which most contemporary expectations of riches were based. As visiting Englishman Robert Honyman observed during his journey from Newport to Boston in 1775, "I never saw a Country so full of rocks and stones" and yet the "houses are neat and substantial," which "does so much honour the incomparable industry of the inhabitants."[2] That prosperity, a palpable something, could spring from apparent nothing was an alchemical trick with which New Englanders were thoroughly familiar. Basic to the practical economy of eighteenth-century America was the regard with which people held the industry, and the application of the "art and mystery" of craft—as the apprenticeship indentures invariably phrased it—by which a husbandman or an artisan could turn a bushel of seed or a pile of planks into a plentiful harvest or a sturdy, weatherproof structure. The farmer and the artificer *made* something valuable out of something almost valueless. He contributed to the economy by creating a new commodity that could be used, enjoyed, or exchanged. The merchant, on the other hand was somewhat suspect. He did not make something; he merely moved goods from one place (where they were plentiful) to another (where they were scarce). He took risks and he needed skill and cunning to judge markets, weather, and civil disturbances, but he was essentially profiting from the labor of others. And his profit, because he dealt in bulk, was usually much higher than that of the maker of the commodity. The farmer and the artisan could make a living; the merchant could make a fortune.

"Comforts"

The disparity between the role of the merchant and that of the farmer and artificer in the economy appears to have set up a sort of tension—a tension expressed as a wished-for memory of a golden age in which the economy was in balance, in which people had and supplied "simple" needs, and no one lusted for foreign (i.e., nonlocal) goods. And this vision of a mythic balance (a recurrent and potent conceit at least since Virgil wrote his *Eclogue IV*) seemed to increase in strength in America as the visibility and prosperity of the merchant sector increased until, from the perspective of the nineteenth century, the entire eighteenth century took on a comfortable but artificial glow of economic harmony; in the words of one orator in 1800, recollecting the pre-Revolutionary era: "The temperance, the economy, the simplicity, the industry of those times, would render our country

independent of every nation on earth; and each individual of us entirely independent of all the influences of his neighbours, and perfectly master of his own resolves."[3]

An eighteenth-century observer, however, embedded in that era and closer to the moment of initial settlement, had a clearer view of the frankly non-self-sustaining nature of the Rhode Island economy from the outset: "We have reason to think the very first settlers did not come here empty handed," and, when this supply of things was exhausted, "the produce of wild Lands was able to go but little way in purchasing a new Supply of many Comforts of Life."[4] Even at the moment of settlement the quest for a means of acquiring the barter power—or even better because more versatile, hard coin—with which to buy "a new Supply of many Comforts of Life" began in earnest. Indeed, the definition, scope, and range of those "comforts" changed dramatically as the seventeenth century gave way to the eighteenth, but the basic felt perception of a *need* to acquire nonlocal goods and therefore to develop a surplus product, desirable abroad, pressed Rhode Islanders toward industry and ingenuity. From the outset, they were moving toward the creation and exhibition of that prosperity-on-barren-ground of which Honyman was so admiring.

Recognizing the scarcity of their natural resources and accepting as a natural condition their appetite for a complex range of "comforts," Rhode Islanders looked beyond their own immediate precinct for barter goods and enabling trading opportunities. Our best evidence is the well-documented commercial career of Rhode Island merchant Peleg Sanford, a grandson of religious leader Anne Hutchinson (and cousin of the poet John Dryden), who was born in 1639, the year after the initial schismatic settlement of the colony. Overlooking doctrinal differences, he established close business relations with his Hutchinson kin in Boston and engaged in wide-ranging international trade, involving principally the importation of such natural produce into Rhode Island as sugar, molasses, and cotton from Barbados, and the exportation to the West Indies of such agricultural commodities as a grazing economy on rocky soil could produce: pork, beef, butter, cheese, and a sturdy breed of horses.[5] Profitable as these exchanges were, the object of the exercise was not this profit but the establishment of economic leverage to purchase manufactured goods from England, principally dry goods, luxury goods, and hardware, which he sold retail in Newport. The fundamental problem was that Rhode Islanders were extremely anxious for these goods, but they produced nothing that the English wanted in exchange—hence the triangulation of their trade. Rhode Island's commerce followed the basic lines established by Sanford and others of his generation for two centuries with the significant and profitable additions early in the eighteenth century of slaving and large-scale privateering.

Of the exchange goods that originated in Rhode Island, few gained a distinctive reputation. Its country produce and the rum distilled from West Indian sugar were usually considered, in the Atlantic marketplace, as generic North

American produce, but its horses were spoken of as "New England" or, more particularly, "Rhode Island" or "Narragansett," with special desirable and identifiable characteristics. One Scottish observer remarked in 1776 of her new acquaintances in Antigua, "their carriages are light and airy; this of Mr. Halliday's was drawn by English horses, which is a very needless piece of expense, as they have strong horses from New England, and most beautiful creatures from the Spanish Main."[6] Horses were, to Janet Schaw and her hosts, both useful and aesthetic objects—they were judged and valued on strength, swiftness, and beauty. Acknowledged internationally for its preeminence, the newly developed English Thoroughbred had the greatest appeal for those bent on speed or 'show' in their transportation, but it was notoriously delicate of diet and prone to injury and hence, a "needless expense." Narragansett horses were judged to be comfortable to ride and, above all, well boned (or strong) and resistant to illness and injury. They were the practical purchase, but they never would have gained popularity had they not been also regarded as handsome; the issue was what they could do, how they could to it, and how they looked doing it. When Rhode Islanders sought other, more shippable commodities (the risks and difficulties involved in transporting this equine cargo on a heeling sailing ship are graphically described in contemporary letters and accounts), they developed a distinctive local furniture product with the same qualities: the utility, strength, and serviceability of "good bones" (or careful construction) wedded to the aesthetic pleasure of proportionate design. Like their horses, these handsome, useful objects became important specialty commodities in the urgent arena of intercolonial trade.

In 1761, when the town had about 7,500 inhabitants and had not quite reached its eighteenth-century peak of population and prosperity, Ezra Stiles— a Newport clergyman who later became president of Yale College and an inveterate statistician—estimated that Newport contained 888 dwelling houses, 439 warehouses and other service buildings, ninety shops with merchandise worth £1,000, twenty stores with merchandise worth £2,000, and sixteen distilleries.[7] Altogether, he estimated the total value of "the Town including Buildings, Furniture, Plate [silver], Goods, Navigation [ships], etc., at about 9 or 10 millions Old Tenor."[8] Furniture figures prominently in Stiles's list, and clearly it loomed large in his consciousness of the town and its wealth. That it was a significant factor in the local visual landscape and the local economy for any observer we can learn simply by noting the disproportionate number of furniture craftsmen in the city. During the eighteenth century at least ninety-nine cabinetmakers, seventeen chairmakers, and two upholsterers worked in Newport. An additional four carvers, one turner, and sixteen joiners may have worked on furniture projects as well as on vessels and buildings.[9] This means that at least one in every hundred men earned his livelihood at this craft, almost a third again more than worked as shipbuilders and boatbuilders or housewrights.[10]

These objects and the craftsmen who produced them were, by 1761, a significant

presence in the city's economy and complex social organism, but it had not always been so. They and their products signaled a significant shift in consumer behavior and consumer desire. While Peleg Sanford's mid-seventeenth-century commercial activities can be taken as a model and type of the exchange to be developed by Newport merchants in the succeeding century, his physical world was not. Certainly he had a substantial house, chairs, and tables, beds and chests, and possibly a court cupboard for the display and storage of silver, ceramics, and pewter—but his objects and house would not have exhibited a fraction of the differentiation, specialization, and compartmentalization that came to characterize eighteenth-century objects and structures. He would have eaten his meals, written his accounts, taken afternoon refreshment, even shaved and sorted small merchandise at tables that were more alike than different from one another. He would have had no desk, no clock, probably no drawers. This is not to say that the objects of his world were simple, rustic, or provincial. In all probability they were highly ornamental (carved and polished oak, elaborately turned maple and ash, or brightly painted pine) and they would have been cushioned and draped with costly imported textiles in deeply saturated hues and bold patterns; in the development of design, utility does not precede aesthetic expression, it is integral to it.[11] So while rich in aesthetic energy, the needs and "comforts" embodied in seventeenth-century design were expressed in a narrow range of objects and spaces. Even sixteenth- and seventeenth-century palaces in their proliferation of rooms did not offer their inhabitants the multiplicity of room size, shape, and function that characterized eighteenth-century (and, even more, nineteenth-century) structures.[12] The radical shift in the interior landscape, then, from the seventeenth to the eighteenth century cannot be understood as simply a function of new technologies, an increase in wealth, or a growing aesthetic sophistication; it reflects new *ideas* about things themselves and it reflects different social behaviors.[13]

When we look at the surviving account books of the eighteenth-century Newport cabinetmakers and at the surviving objects, we are struck by the large number of desks and chests of drawers produced and sold. Yet only a generation or two before, drawers were a curious novelty and desks were unknown. The desire to have specialized furniture (as a desk for correspondence) and compartmentalized furniture (as a chest of drawers, which enabled the user to segregate and categorize multiples of stored objects) reflects not only a larger *quantity* of ledgers, letters, maps, and accounts on the one hand, and linens and clothing on the other, but also a desire to discriminate finely *among* many different kinds of information and objects (figs. 92, 93, 94, and 95). The need for containers occurs simultaneously as the need for things contained and organized expands. The primary desires being expressed are for precise visual order and for separation. In his interpretation of eighteenth-century architecture, Henry Glassie sees this pressure toward symmetrical order as the dominant characteristic of structures of this period, and the primary physical, psychological, and social element that sets the eighteenth-century world off from the previous era.[14]

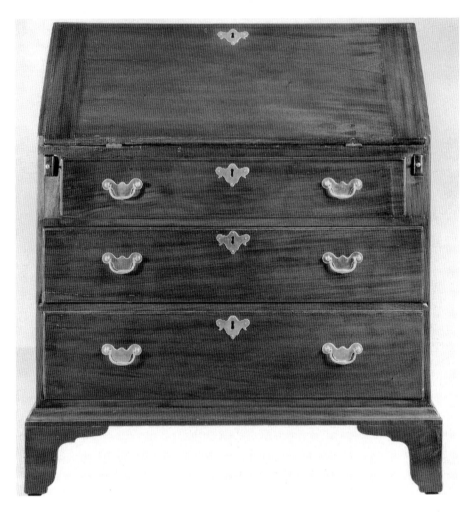

FIG. 92. John Goddard, Desk, Newport, R.I., 1745. Mahogany, white pine. 42 × 35½ × 19 in. (106.6 × 90.1 × 48.2 cm). Chipstone Foundation, photograph by Gavin Ashworth.

FIG. 93. Label pasted on inner back of top drawer of desk in fig. 92: "Made by John Goddard of Newport on Rhoadisland in New England in the year of our Lord 1745."

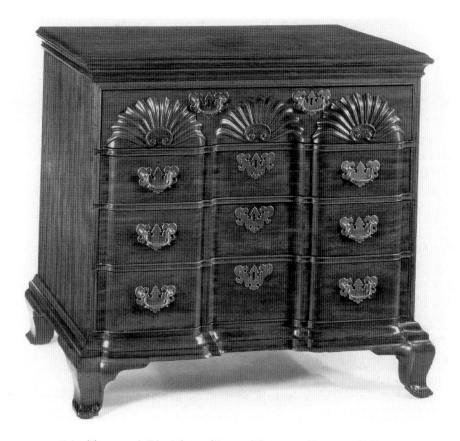

FIG. 94. John Townsend, Blockfront Chest of Drawers, Newport, R.I., 1765. Mahogany, white pine, chestnut, and poplar. 34½ × 36¾ × 19 in. (86.4 × 93.3 × 48.3 cm). Metropolitan Museum of Art, Rogers Fund, 1927 (27.57.1). Photograph © Metropolitan Museum of Art.

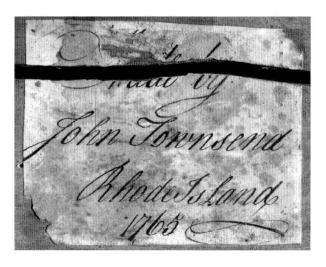

FIG. 95. Label passed inside top drawer of chest of drawers in figure 94: "Made by John Townsend, Rhode Island, 1765."

Approaching the subject from a different perspective, Neil McKendrick has explained the desire for a new range of specialized goods as the result of a manipulation of a growing consumer consciousness of "needs" and "comforts" by enterprising entrepreneurs who placed the object within a complex psychosocial web of envy, emulation, and ambition.[15] This argument is suggestive and compelling, especially in explaining the meteoric careers of such British artisan-merchants as Josiah Wedgwood and Mathew Boulton, but it does not sufficiently emphasize the explicitly *aesthetic* terms in which the psycho-economic drama played itself out. In McKendrick's view, the new interior landscape was designed not only to be more functional and more complex, it was also designed to evoke a strong and covetous response in the visiting onlooker. The object functioned as a kind of triangulating mirror at which the visitor would look, but, in fact, in which the visitor would see the person of his host. One's objects functioned as an extension of one's self and spurred the visitor to furnish himself with similar (and here McKendrick would insert the terms novel and fashionable) display. Probably equally powerful and insufficiently appreciated by McKendrick, however, is the straightforward aesthetic and sensual pleasure that the well-conceived and well-designed object evoked in both owner and onlooker. The eighteenth century not only saw the development of new furniture forms for new uses—tea tables (fig. 96), bureau tables (figs. 97 and 98), dressing tables, high chests (fig. 99), chest-on-chests, tall-case clocks, desks, and desk-and-bookcases (fig. 100; see plate X) to name a few—it also saw the extensive use of new surface textures—shiny where, in the seventeenth century, surfaces had been matte—and new materials—dramatically grained mahogany, walnut, cherry, and brightly contrasting brasses. The overall effect is rich and sensuous; the objects were designed to excite admiration in both senses—straightforward pleasure (visual and tactile), and covetous desire. In the competitive world of Newport's 122 furniture makers the pressure toward excellence in design and elegant sleekness in materials must have been considerable. Curiously, the aesthetic route taken by Newport designers was not that predicted by McKendrick's analysis, namely, direct emulation of London's fashionable rococo forms (as was the case with their Philadelphia rivals, for instance), even though imported examples and design books were available in the city. Nor did they develop everchanging novelties to stimulate patronage, but rather repeated, polished, and perfected a fairly narrow range of designs and motifs. They were creating a predictable commodity with known virtues—strength, meticulous craftsmanship, and sleek sensuous beauty.

Newport's aesthetic energy was not to be found in easel painting in the eighteenth century—the city produced only one notable artist, Gilbert Stuart, and sustained but a single print dealer.[16] In nearby Boston, as we have seen, portraiture, that most utilitarian of genres, flourished, but in few other locales did easel painting gain a firm foothold in the colonies before the Revolution. We find in Newport, however, considerable aesthetic energy invested in three-dimensional design: architecture, landscape design, and furniture.[17] Of these, only cabinet-

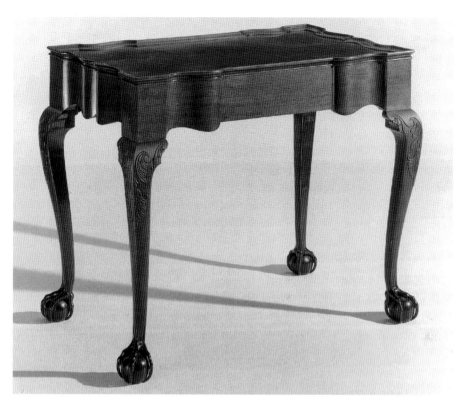

FIG. 96. Tea table, attributed to John Goddard, Newport, R.I., 1763. Mahogany. 26⅞ × 33½ × 20⅝ in. (68.3 × 85.2 × 52.4 cm). Winterthur Museum.

wares had the potential for commodification, which we usually identify with most genres of easel painting. Unlike the physically fixed and frequently altered arts of architecture and garden design, furniture was portable and easily exchangeable. It had two separate values, one locally and another one, higher in certain other markets; it could be made in surplus quantities and marketed to advantage. In dramatic confirmation of this fact, these objects have retained their value (against the cost of a median-level house, for instance) and, in the instance of blockfront case pieces (see figs. 94, 97, 100, plate X), exceed in value today even a very luxurious home. While strong arguments have been made by Clifford Geertz and others concerning aesthetic localism, aesthetic relativism, and the vicissitudes of taste, the intimate relationship among aesthetic achievement, portability, permanence, and market value was as evident in the eighteenth century as it is today.[18] Scholars have tended to see the relationship between cabinetmakers and merchants as that of artist and patron—the role of the artisan in the cycle of desire being to design and supply singular objects for wealthy clients. Yet surviving account books, receipts, and inventories suggest that they supplied an enormous range of products to an extremely wide spectrum of the populace and that they were active in seeking out and developing specific ready-

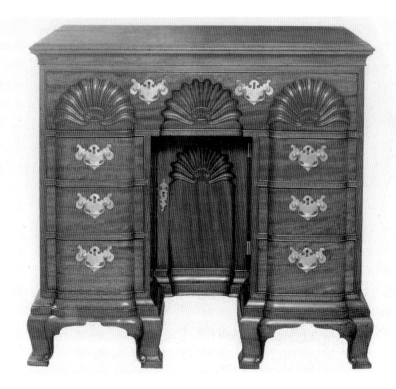

FIG. 97. Edmund Townsend, Bureau Dressing Table, Newport, R.I., c. 1765–1785.
San Domingo mahogany, Cuban mahogany, whitewood, and chestnut. 33⅝ × 34½
× 18⅞ in. (85.41 × 87.63 × 47.94 cm). Museum of Fine Arts, Boston, M. and M.
Karolik Collection of Eighteenth-Century American Arts; 41.579. Photograph ©
2003 Museum of Fine Arts, Boston.

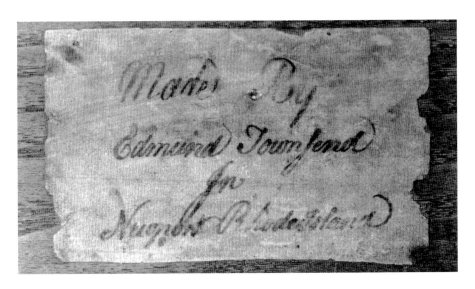

FIG. 98. Label pasted on inner bottom of top drawer of bureau table in figure 97:
"Made By Edmund Townsend In Newport RhodeIsland."

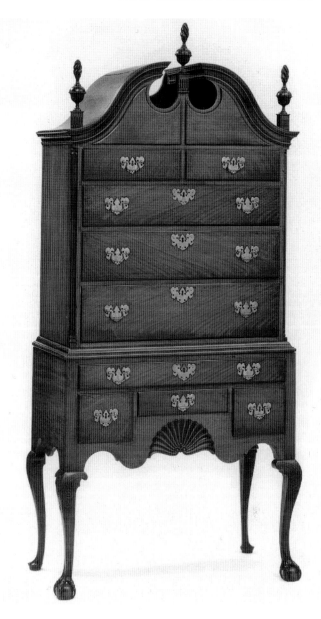

FIG. 99. High chest of drawers, Newport, R.I., c. 1760. Mahogany and white pine.
87¼ × 39 × 20⅜ in. (221.61 × 99.06 × 51.75 cm). Museum of Fine Arts, Boston,
M. and M. Karolik Collection of Eighteenth-Century American Arts; 41.579.
Photograph © 2003 Museum of Fine Arts, Boston.

made markets as well as eagerly providing bespoke goods.[19] Stiles estimates that
in 1761 there were one thousand families worth £2,000, two hundred families
worth £40,000, twenty worth £100,000, and two worth £500,000 (all figures,
Old Tenor—Rhode Island specie) in Newport.[20] Practical experience would have
quickly taught the craftsmen that their primary market was the many (those two

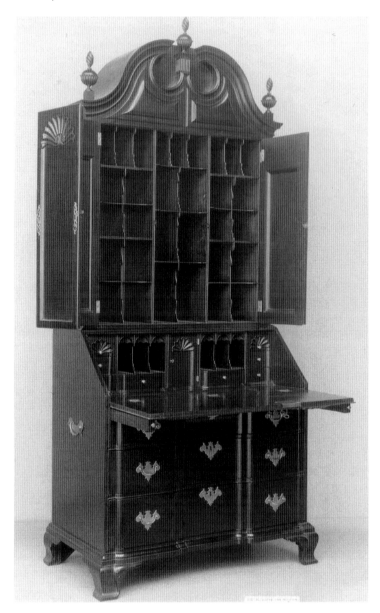

FIG. 100. Desk and Bookcase, Newport, R. I., 1760–1790. Mahogany, chestnut, white pine, yellow pine, poplar, and cedar. 99⅛ × 44⅛ × 25¾ in. (251.9 × 112.1 × 65.3 cm). Metropolitan Museum of Art, Rogers Fund, 1915 (15.21.2). Photograph © Metropolitan Museum of Art.

hundred families worth £40,000 and those of lesser means) and not the narrow tip of the pyramid although currency with the former was often, of course, achieved through access to the latter. Beyond these patrons lay the potentially huge and lucrative markets abroad. Here the cabinetmakers and the merchant-captains became collaborators, even models for one another. Sea captains—who

spoke of themselves as "mariners" but used the address "Captain"—were not just sailing professionals, they were also merchant-traders who exercised creativity and expertise in locating markets and exchanging the cargo (usually a mixed lot of goods belonging to a number of owners, including the captain himself) in as many as a dozen ports at incremental profits, before returning home.[21] After several years at sea, many became land-based merchants and continued to capitalize on their knowledge by trading abroad and establishing retail shops in town. Some even became manufacturers (of such commodities as spermaceti candles) and distillers of rum, entering the production as well as the transport phases of commerce to maximize profits and assure their supply of vendable items. Merchants were reluctant to become producers, however, as manufacturing was never as profitable as transport. As one Newporter put it, "an Aethiopian could as soon change his skin, as a merchant could be induced to exchange so lucrative a trade as that is for the slow profits of any manufactory."[22]

From time to time in quest of the hard currency to purchase English goods, the colony even entered the trade arena, offering bounties and tax benefits for artisans and manufacturers who produced commodities thought to be desirable abroad (as the generous but bizarre encouragement in 1750 to those who, in the teeth of English law, superior technology, and cheaper labor, produced linen and woolen cloth; the act was repealed the next year).[23] By the 1760s, a note of urgency can be detected in the proposal "encouraging Industry, Frugality, and our own Manufactures": "whereas the excessive use of foreign superfluities is the Chief Cause of the present distressed State of this Town [Newport], as it is thereby drained of its money . . . this Town will take all prudent and legal Measures to encourage the Produce and Manufacture of this Colony."[24] Furniture makers needed no such encouragement. Since early in the century they had shipped objects as venture cargo (to be disposed of at the best price at the captain's discretion, the proceeds to be reinvested throughout the voyage) and by mid-century Newport artisans were going to sea themselves (often as captain), or chartering whole vessels to vend their wares in ports from New York to Surinam. So when we attempt to map the relationships between cabinetmakers and merchant-captains, the situation is more complex than one might at first think. Makers traded and traders made. The patron group was also complex, simultaneously including people of great wealth, the hatter next door, and the unknown shopkeeper in distant Charleston in need of a desk. The parts of the economic network and the social organism were highly interdependent, woven together by a credit exchange of goods and services that was only finally reconciled at death.

The one constant was the Newporters' unquestioned enthusiasm for trade. By 1775, the city was home to 200 vessels, and 400 coasters, all making the most of each opportunity. Newporters were notoriously eager to trade, even with the enemy such as the French during the French and Indian War and the British on the eve of the Revolution.[25] And in times of peace, it seems most Newporters were willing to break the law if it was profitable. We learn of this,

of course, indirectly, as in the diary entry of a young Newport minister: "A sloop commanded by Mr. William Gardner with whom were Stephen and David Mumford, Peter Ayrault, and two negros, was lost as is supposed by a sudden storm of snow that arose. They went to receive prohibited goods brought from Holland."[26] The Ayraults, Mumfords, and Gardners were not sleazy smugglers but respectable businessmen, members of Newport's early eighteenth-century elite. Francis Malbone, one of Newport's wealthiest and most distinguished merchants, reputedly equipped his new mansion (built about 1758 and still extant) with an underground passage leading directly to the shore. These men were in good company in their evasion of customs. According to Ezra Stiles, "Mr. William Vernon, merchant tells me he knows the Collector [of Customs whose official annual salary was £100] makes Six Thousand Dollars a year [under the table] and that the other officers of the Customs make Three Thousand Dollars [£1,350] per annum and that the merchants would gladly compound for [agree to pay] Seventy Thousand O[ld] T[enor] per annum with the custom house."[27] It seems that the establishment collaborated in a universal evasion of tax duties and then shared in the profits. The difficulty this presents for a historian, of course, compounds the paucity and untrustworthiness of extant records. Deliberate vagueness, manipulation of data, artful misinformation all disguise both outbound journeys to taboo destinations and inbound voyages with dutiable cargo. On the eve of the Revolution, a single voyage of a moderately sized vessel carrying largely legal cargo could be anticipated to net for the owners £729 in Rhode Island money (or £547 sterling), inspiration enough to encourage the swift, even illegal movement of goods and the collaboration of the whole manufacturing and transporting community in the effort.[28]

Generally, then, a complex and constant movement of goods and credit characterized eighteenth-century Newport. Desire for distant goods or the means to pay for distant goods set off a chain of activity that was bewildering in its complexity. The quest was not an end in itself, however; it had as its goal certain *things*—whether locally acquired or imported at great cost and difficulty—that were possibly novel, probably useful, and certainly pleasing in their designs.

Such scholarship as has been undertaken to date isolates the investigation of objects from an understanding of their context. Decorative-arts historians tend to minimize social context while they heroicize the artisans and their objects and certain elite patrons. They focus on the product, on connoisseurship, and on attribution, and they take little interest in what Clifford Geertz characterizes as "the chief problem presented by the sheer phenomenon of aesthetic force . . . [namely,] how to place it within the other modes of social activity"—they generally ignore the social and cultural processes that enabled the cabinetmakers to make and market the objects they so justly admire.[29] However, social and economic historians neglect both the artisan group and the surviving material culture in their mapping of eighteenth-century urban America. Lynn Withey, for example, attributes Newport's prosperity solely to the ingenuity and enterprise

of merchants and traders, treating artisans as pawns rather than initiators and actors in the enterprise, and she ignores the aesthetic dimension of trade values. She also sees elites (she identifies three: merchants, politicians, and old families) as social isolates and constants although the founding members of many elite families were artisans themselves, and their merchant-politician children and grandchildren continued to intermarry, socialize, and construct economic ties with master craftsmen throughout the eighteenth century. Her focus on the very rich and politically powerful (who appear by name) is only partly balanced by her interest in the very poor (who appear statistically). Arguably, the true center of the economy was the producer-entrepreneur—the farmer or artisan whose energy, expertise, inventiveness, and capital outlay in tools and materials employed the propertyless, created a vendable something out of apparent nothingness, and provided the merchant with commodities to exchange. Focus on this group and on what eighteenth-century theorists termed the ingredients of "art" and "ingenious labour" in social prosperity can reintegrate our knowledge of enabling economic and social structures with our understanding of the craftsmen and their remarkable efforts.[30]

COMMUNITY

Eighteenth-century Newport was composed of individuals moving through a series of intersecting circles of civic, religious, fraternal, trade, and familial groups. Each of these communal structures also functioned, to a degree, as an economic unit, enabling and encouraging the exchange of goods, information, and services. Primary was the town itself. One did not simply move in, one joined—with permission—only if it were clear that the prospective townsman and his family would never become a "charge on the town," that is, would never be in need of relief.[31] Only eldest sons of Freemen, median-level (and wealthy) property owners, and median-level renters could become Freemen. What was at stake was the power to vote (or sell one's vote) and to hold public office (and possibly, through that office, profit personally).[32] The majority of people in town—women, nonwhites (both free and slave), and the poor—could not become Freemen, but they were members of the community nevertheless, attached by kinship, ownership, or employment to Freemen. In some cases, large political factions were based on familial loyalties (as in the rivalry between the Ward and Wanton families for the governorship) or on religious affiliation (as in the mid-century shifts in the balance of power between Quaker and Church of England merchants in the Assembly), but by and large political interests coincided with geographic locale and common economic base.[33]

Beyond membership in the larger social unit, an individual's most public affiliation was religious. Newport was more polyglot in this respect than other colonies. As one contemporary put it, "Road Island is a chaos of all Religions. . . . So that the body of the people are an Heterogeneous Lump," and another,

"here is a medley of most Perswasians."[34] Baptist, Sabbatarian, Moravian, Jewish, Congregational, Church of England, and Quaker congregations of various sizes made up this crazy quilt of faiths and constituted microcommunities of support for their members. The strength of religious affiliation was reinforced by familial ties—usually marriage partners were found within the same sect. Because the congregation and the kinship units were so closely and powerfully linked, this was often the strongest factor in a Newporter's economic as well as social and religious life. For two religious groups—the Jews and the Quakers—strong ties (reinforced by frequent journeys and correspondence) with their coreligionists in other colonies, in England, on the Continent, and in the Caribbean were particularly powerful, giving them intercolonial kinship ties and an international perspective on issues of trade.[35]

Sometimes closely allied to religious, trade, or military membership, fraternal social clubs reinforced financial, familial and gender bonds. Significant among these was the Artillery Company (organized in 1741 and restricted to 100 members), which was both social and military in nature, and the Jewish Club (organized in 1761), which was designed to give merchant members the opportunity to meet, eat, play cards, and discuss affairs together weekly.[36] Perhaps the largest and most influential club of all was the Fellowship Club, founded in 1752 and renamed the Marine Society in 1785. It was established "with the intent and design to promote the interest of each [member and his] . . . family," specifically, to communicate useful navigational knowledge and to establish a sort of life-insurance fund for the families of experienced captains ("mariners") whose profession put the support of their dependents at risk. For another social class but equally important to their participants were certain houses where slaves and free nonwhites congregated in the evenings to drink, dance, and game.[37] These gatherings were, of course, more informal than the organizations noted above and, unlike the fraternal groups, they may have included women. They were discouraged—and illegal after 9 p.m.—but they vigorously persisted in the face of repeated prohibitive ordinances passed by the colonial assembly, an indication of their importance within the minority community. This population was never large (Rhode Island as a whole was 6 percent African American and 2 percent Native American in 1774, and just over 6 percent nonwhite in 1790), but it was relatively independent (79 free nonwhite households out of a total of 1,243 in Newport were counted in the 1790 census).[38] Whatever its overt purpose, each fraternal and social group repeatedly reconstituted itself, confirming and reconfirming the viability, usefulness, and perhaps priority of the subcommunity it represented. This formal convergence of members in itself (beyond the specific friendships and financial arrangements that arose from the meetings) functioned to endow the group with self-recognition and even an enabling power.

Beyond these more public circles of relationships lay the family, the community's basic social and economic unit. Although a woman could practice a trade under her own name in eighteenth-century Rhode Island—as did Widow

Franklin and Sarah Goddard, printers, who managed their high-profile businesses under their imprints—men were typically the primary wage earners and providers for the family group, which usually numbered about six to eight. As elsewhere in the eighteenth century, marriage in Rhode Island was for life. It is useful to inspect the patterns of Newport marriages, for they seemed to function critically in the economy as well as in the social realm. While divorce was legally possible and did occur, it was rare.[39] Marriages moved toward identity and convergence rather than toward variety and divergence. First, marriage partners tended to come from the same religious group—which, in Newport's heterogeneous community immediately and radically narrowed possible marriage choices. Second, the partners were usually, in first marriages, of a like age. Third, they tended to marry within closely allied trades, that is, the bride's kin would work in the same trade as her husband. Twelve members of the cabinetmaking Townsend family, for instance, married into seven families in which there were joiners or furnituremakers (charts 2–5).[40] This was logical as an occasional occurrence because apprentices lived in the household of their masters (and their masters' daughters), but as a consistent practice it represents a selectivity that suggests purpose. Last, there was a tendency for pairs of brothers to marry pairs of sisters—for instance, Hannah and Susannah Townsend, sisters of cabinetmakers, married cabinetmakers John and James Goddard—or, even more dramatically, the great-great-grandfather of these sisters, John Townsend (d. 1669), the immigrant, was one of three brothers who married three Cole sisters.[41] These multiple sibling yokings were surprisingly common. What was served by this insistent tendency toward convergence? Most obviously, the business interests of the men.

Eighteenth-century Newport business partnerships—whether of merchants or of craftsmen—were family affairs. Men who were unrelated occasionally engaged in short joint ventures, but real partnerships were based on kinship. Many were partnerships of brothers (Stephan and Thomas Townsend, and the Champlin brothers, for instance) or father and son (Joseph Wanton and his sons), but equally frequent were business alliances based on marriage alliances. William Ellery was in partnership with his son-in-law, William Channing, and Aaron Lopez established a partnership with his brother, Moses, until the latter's death when he embarked on an extraordinary career with his new father-in-law, Jacob Rodriguez Rivera.[42] While we are assured by historian Lawrence Stone that by the latter half of the eighteenth century love matches were beginning to achieve some popularity, the profile of Newport marriages suggests in many cases an alliance between men in the same trade who could be helpful to one another—alliances in which the women performed the function of permanent adhesive.[43]

While this marriage pattern suggests that women were made a convenience of, it also suggests that women exerted a kind of power in the realm of their husbands' careers that historians have overlooked. In some cases, even when the new husband did not become the bride's father's business partner, he did relocate from

Chart 2
Townsend Family Tree

Henry Townsend
miller, Quaker
Norfolk, Eng., to Flushing, N.Y.,
pre 1645, to Warwick, R.I.,
pre 1645, to Oyster Bay, L.I., c. 1656, to
Oyster Bay, L.I., c. 1656,
m. Ann Cole (of R.I.)

John Townsend
(d. 1669)
Norfolk, Eng., to Flushing, N.Y., pre 1645,
to Warwick, R.I., by 1649, to Monmouth Co.,
N.J., pre 1669, to Norwick, L.I.
m. [1] Elizabeth Cole (of R.I.)
m. [2] Elizabeth Montgomery

Richard Townsend
(d. 1671)
Norfolk, Eng., to Warwick, R.I., to
Oyster Bay, L.I., to Warwick by 1663
m. [1] Deliverance Cole (of R.I.)
m. [2] Elizabeth Wickes

John
(see chart 3)

Elizabeth
L.I.
m. Gideon Wright

James
Jerico, L.I.

Rose
L.I. to Newport
m. [1] John Wickes
m. [2] Samuel Haydon,
blacksmith

Ann

Sarah

George
(1661–97)
Oyster Bay, L.I.,
and Norwich, Conn.
m. Mary Hawxhurts

Daniel

Thomas
(d. post 1712)
captain, Quaker
L.I. to Portsmouth,
R.I., c. 1686, to L.I.
to Tiverton and Bristol,
R.I., to Newport pre 1696,
m [1]?
m [2] Mary Unthank Almy
(d. ca. 1710)

Freelove
m. Thomas Jones
1692

Justice John
(d. 1709)
Newport to L.I.
ca. 1694
m. Rebecca Almy
1692

John Wright
L.I. to Newport
1707
m. Abigail Barker

Nathaniel
(1698–post 1726)

George
(b. 1687)

Richard

Samuel

Thomas
(b. 1693)
Church of England
L.I. to Newport
c. 1700
m. Abigal Wilson

Silvanus
(b. 1696)
L.I. to Newport
ca. 1700

Sarah
(b. 1698)
L.I. to Newport
ca. 1700

Philena
(b. 1699)
L.I. to Newport
c. 1700

Jacob
(1725–45)
d. at Jamaica

John
(1729–63)
d. at Guadeloupe

Chart 3

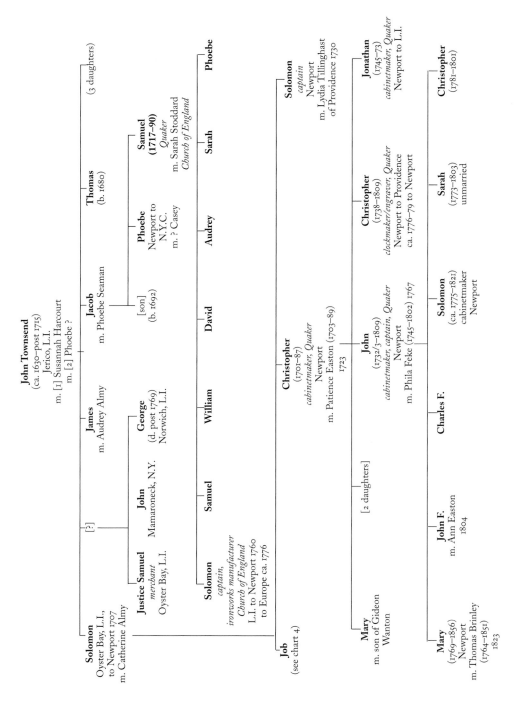

John Townsend
(ca. 1630–post 1715)
Jerico, L.I.
m. [1] Susannah Harcourt
m. [2] Phoebe ?

Solomon
Oyster Bay, L.I.,
to Newport 1707
m. Catherine Almy

[?]

James
m. Audrey Almy

Justice Samuel
merchant
Oyster Bay, L.I.

John
Mamaroneck, N.Y.

George
(d. post 1769)
Norwich, L.I.

Solomon
*captain,
ironworks manufacturer*
Church of England
L.I. to Newport 1760
to Europe ca. 1776

Samuel

William

Jacob
m. Phoebe Seaman

[son]
(b. 1692)

Phoebe
Newport to
N.Y.C.
m. ? Casey

David

Audrey

Thomas
(b. 1680)

Samuel
(1717–90)
Quaker
m. Sarah Stoddard
Church of England

Sarah

Phoebe

(3 daughters)

Job
(see chart 4)

Christopher
(1701–87)
cabinetmaker, Quaker
Newport
m. Patience Easton (1703–89)
1723

Mary
m. son of Gideon
Wanton

[2 daughters]

John
(1732/3–1809)
cabinetmaker, captain, Quaker
Newport
m. Phila Feke (1745–1802) 1767

Christopher
(1738–1809)
clockmaker/engraver, Quaker
Newport to Providence
ca. 1776–79 to Newport

Solomon
captain
Newport
m. Lydia Tillinghast
of Providence 1730

Jonathan
(1745–73)
cabinetmaker, Quaker
Newport to L.I.

Charles F.

John F.
m. Ann Easton
1804

Solomon
(ca. 1775–1821)
cabinetmaker
Newport

Sarah
(1773–1803)
unmarried

Christopher
(1781–1801)

Mary
(1769–1856)
Newport
m. Thomas Brinley
(1764–1851)
1823

Chart 4

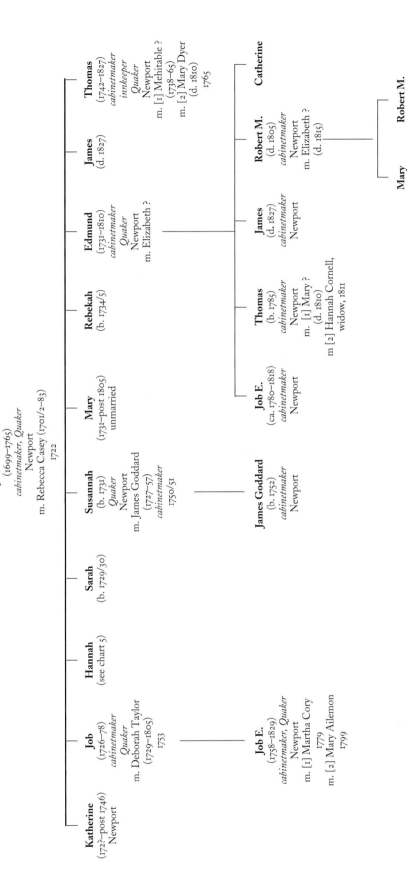

Job Townsend
(1699–1765)
cabinetmaker, Quaker
Newport
m. Rebecca Casey (1701/2–83)
1722

Katherine
(1722?–post 1746)
Newport

Job
(1726–78)
cabinetmaker
Quaker
Newport
m. Deborah Taylor
(1729–1805)
1753

Hannah
(see chart 5)

Sarah
(b. 1729/30)

Susannah
(b. 1731)
Quaker
Newport
m. James Goddard
(1727–57)
cabinetmaker
1750/51

Mary
(1731–post 1805)
unmarried

Rebekah
(b. 1734/5)

Edmund
(1731–1810)
cabinetmaker
Quaker
Newport
m. Elizabeth ?

James
(d. 1827)

Thomas
(1742–1827)
cabinetmaker
innkeeper
Quaker
Newport
m. [1] Mehitable ?
(1738–65)
m. [2] Mary Dyer
(d. 1810)
1765

Job E.
(1758–1829)
cabinetmaker, Quaker
Newport
m. [1] Martha Cory
1779
m. [2] Mary Ailemon
1799

James Goddard
(b. 1752)
cabinetmaker
Newport

Job E.
(ca. 1780–1818)
cabinetmaker
Newport

Thomas
(b. 1785)
cabinetmaker
Newport
m. [1] Mary ?
(d. 1810)
m [2] Hannah Cornell,
widow, 1811

James
(d. 1827)
cabinetmaker
Newport

Robert M.
(d. 1805)
cabinetmaker
Newport
m. Elizabeth ?
(d. 1815)

Catherine

Mary

Robert M.

Chart 5

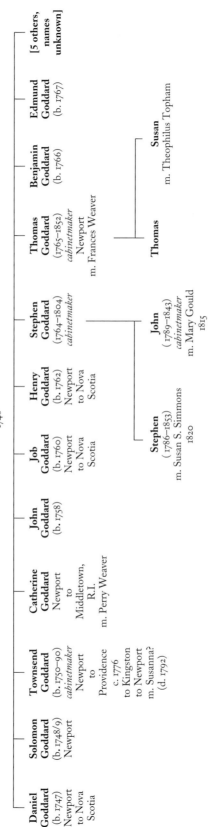

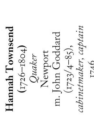

Hannah Townsend
(1726–1804)
Quaker
Newport
m. John Goddard
(1723/4–85),
cabinetmaker, captain
1746

Daniel Goddard
(b. 1747)
Newport to Nova Scotia

Solomon Goddard
(b. 1748/9)
Newport

Townsend Goddard
(b. 1750–90)
cabinetmaker
Newport
to
Providence
c. 1776
to Kingston
to Newport
m. Susanna?
(d. 1792)

Catherine Goddard
Newport
to
Middletown,
R.I.
m. Perry Weaver

John Goddard
(b. 1758)

Job Goddard
(b. 1760)
Newport to Nova Scotia

Henry Goddard
(b. 1762)
Newport to Nova Scotia

Stephen Goddard
(1764–1804)
cabinetmaker

Thomas Goddard
(1765–1852)
cabinetmaker
Newport
m. Frances Weaver

Benjamin Goddard
(b. 1766)

Edmund Goddard
(b. 1767)

[5 others, names unknown]

Stephen
(1786–1853)
m. Susan S. Simmons
1820

John
(1789–1843)
cabinetmaker
m. Mary Gould
1815

Thomas

Susan
m. Theophilus Topham

Sources: John Osborne Austin, *The Genealogical Dictionary of Rhode Island; Comprising Three Generations of Settlers Who Came Before 1690* (Albany, N.Y.: J. Munsell's Sons, 1887); Waldron Phoenix Belknap Jr., *American Colonial Painting: Materials for a History* (Cambridge, Mass.: Harvard University Press, Belknap Press, 1959); Wendell Garrett, "The Goddard and Townsend Joiners of Newport: Random Biographical and Bibliographical Notes," *Antiques 121,* no. 5 (May 1982): 1153–55; C. A. Townsend, *A Memorial of John, Henry, and Richard Townsend* (New York, 1865); extant gravestones and census records.

a distant place of origin to plant himself in his wife's and father-in-law's locale and orbit.[44] Thomas Davenport, for instance, a long-lived cabinetmaker born in Dorchester, Massachusetts, settled and worked in Little Compton, Rhode Island, where he buried his first wife in 1729. He then married Mary Pitman of Newport in 1737 and moved to her city where her kinsmen, John, Jr., and James Pitman, made chairs and case pieces.[45] The role of the woman is also suggested in the decision to send a son to a maternal uncle for apprenticeship (as in the case of young cabinetmaker James Goddard (b. 1752), who apprenticed not with his father's brother, John Goddard, but rather with his mother's brother, Edmund Townsend) (see figs. 92 and 97).[46] Overall, although the marriage pattern is complex it is not random and not uncalculated. It enabled and encouraged economic relationships among men, permitting them access to information, materials, labor, and perhaps tools even when it did not result in formal partnerships. In its fully realized state, it created a tightly bonded community of support in which there was a dramatic and insistent convergence of family, religious, and trade interests.

Familial-artisanal links of this sort are perhaps the most obvious fact about the Goddard and Townsend school of cabinetmakers; at least twenty of these craftsmen were linked by birth or marriage (see family tree).[47] That this astonishing family network represents an older structure of craft relationships in comparison with emerging craft practices is less obvious. The difficulty with the marriage or sibling link is that relatively few links could be made, and these were permanent; they were based on loyalty of like to like as much as on interest. In comparison, by the mid eighteenth century new patterns of association were emerging for craftsmen, one evidenced in nascent form in the account book of the Newport rival cabinetmaking concern of John Cahoone. While we do not know whether the Goddards and Townsends hired journeymen from outside of their families, we suspect that they did not as there is little evidence to support their presence in the shops. Cahoone's artisanal relationships seem in contrast, to be strictly economic. He retained the flexibility to hire a number of workmen with an eye only on the specific piece of work needed. This newer mentality, which banked on crisply financial convenience relationships, is also evidenced in the journeymen's price books and mechanics' associations springing up elsewhere (as in nearby Providence) but nowhere in evidence in Newport in the eighteenth century.[48]

Throughout the seventeenth and most of the eighteenth centuries an artisan moved from boyhood apprenticeship (in which he was bound in order to learn a trade, usually for a period of five to seven years, with a master), through a period of employment as a journeyman, when as a young adult he worked for wages, to (with the acquisition or accumulation of personal capital and tools through earnings, inheritance, or marriage) the status of master when he managed a shop on his own. By the second half of the eighteenth century, however, the crafts were becoming so competitive and the capital investment needed to

start a shop so considerable that many artisans felt themselves locked into permanent journeyman status.[49] Labor was identifying itself as a separate sector. In some urban centers the men banded together as a citywide interest group, published price lists stating the sum they felt was appropriate for each piece of work, and, when all else failed in their struggle with the masters, went on strike (as the Philadelphia cabinetmakers did in 1796 and those in New York did in 1802).[50] These price lists were often illustrated and constituted a kind of proto-union contract. The masters, for their part, sometimes banded together and agreed on retail prices within a city to minimize competitive bitterness.[51] The most interesting aspect of these developments in Newport is their nonoccurence. It is possible that the British occupation during the Revolution—which decimated Newport's economy as a whole—prevented the establishment of oppositional artisanal politics. However, it is more likely that the preeminent cabinetmakers, anchored firmly in the familial system, may have exerted a kind of neutralizing influence on the development of these price books and the adversarial labor-management relationships they imply.

These self-conscious communities of labor, of trade, of family, of religion and of the body politic constituted the map through which Newporters made their way. The system seemed to work (it was operational in Newport long after it had begun to dissolve elsewhere); the population confirmed and replicated these relationships with every meeting and with every succeeding generation. The realms of public and private meshed intricately and usefully as individuals etched the trajectory of their individual lives on the bedrock of family and work.

CRAFT

Scholars in the field of American decorative arts seem confident in their knowledge of the Newport furniture craft, especially in terms of regional characteristics and the personal idiosyncrasies of individual craftsmen. In fact, though, we know very little, and much of what we know could profitably be questioned. Of the 122 furniture makers we know worked in the city over the course of the eighteenth century, we have documented objects by only a dozen. Most of these men are represented by a single—perhaps eccentric—object, and less than half the dozen are artisans outside the Townsend-Goddard circle. So for at least 90 percent of the makers, we are wholly ignorant of their work. Even so, because of the connoisseurship focus of the field, enormous energy has been invested into producing Berensonian lists of authenticated-documented objects associated with the hand of a master, of objects attributed to the "Townsend-Goddard" school in general, and even of objects considered "workshop of" quality.[52] Yet the assumptions behind this activity are that the most aesthetically complex and successful objects are the most important (as well as the most expensive in the marketplace) and that those artisans whose names have not yet been associated with masterworks were not involved in the production

of these "best" objects. That John Cahoone—for whom we have located no authenticated objects—was able to sell a "mahogany OG Case of Drawers" to Samuel Goldthwait in 1759 for £250 when both he and Job Townsend were selling a maple desk for £30 and a mahogany desk for £66 to £95 (figs. 101, 102), and when a median house price in Newport was in the £500–£600 range, suggests that Cahoone was possibly making blockfronts and that his command of the carriage trade rivaled that of the Townsends and Goddards.[53] It might also encourage us to take a greater interest in these lesser known makers, and to direct our energies to asking other questions altogether. What, for instance, was the backbone of the trade? Was it these extravagant objects or was an artisan's livelihood guaranteed by his £15–£30 items? Did the efficient production of the less expensive objects give the cabinetmaker the capital and leisure to produce his best, most spectacular efforts? Or did the singularly magnificent object draw customers for the routine work that in turn formed the basis of his prosperity as McKendrick suggests was the case with the decorative arts producers he has studied? Whichever group of objects was the enabling one, the relationship between them was important to the cabinetmaker and might usefully be to us. "Consumption," Adam Smith reminds us, "is the sole end and purpose of all production," pointing us to the study of the dynamics of consumption and the development of specific markets.[54]

One reason scholarship has focused on attributions is that the Townsends, especially John, seem to have labelled and signed more of their products than other eighteenth-century cabinetmakers (see figs. 94, 95, 97, 98, 101, 102). Silversmiths whose wares were closely identified with and frequently substituted for currency invariably marked their products with their initials as a guarantee of the percentage of silver in the alloy. Similarly, pewterers, whose wares were valued and sold by weight and were therefore subject to dangerous adulteration with lead, also marked their wares. Clockmakers systematically inscribed the dials of their clocks, assuring purchasers and users of the accuracy of these chronometers on which owners depended in calculating longitude at sea, in judging tides, and in transacting daily business. In the eighteenth century, only these three types of goods—critical in the realms of money, health, and time—were consistently marked as guarantees of quality on objects whose outward appearance might belie hidden and fatal flaws. No other types of goods consistently bore their maker's mark in eighteenth-century America, and very few cabinetwares bear labels. When the issue of "why" is broached, the explanation usually offered is that the tendency to inscribe one's identity on one's product was a matter of pride.[55] But the labels themselves point to another motive. As an act of communication—and we can guess that John Townsend did not paste labels inside his coffins; he had a receptive perceiver in mind—it is probable that the maker's primary audience was not us although we instinctively, but probably erroneously feel that posterity must surely have been the intended recipient of the message. The distinction is important—if we think of such a label as a note in a bottle, it has a

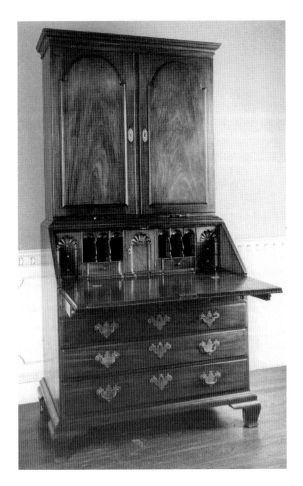

FIG. 101. Job Townsend, Desk and Bookcase, Newport, R.I., 1740–1760. Mahogany, chestnut, poplar, white pine, and cherry. 82⅛ × 40 × 24½ in. (208.6 × 101.5 × 62.2 cm). Museum of Art, Rhode Island School of Design, Gift of Mrs. Murray S. Danforth.

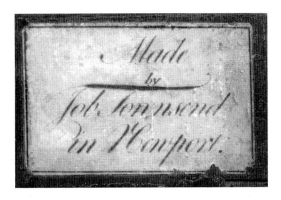

FIG. 102. Label pasted inside prospect door of desk-and-bookcase in figure 101: "Made by Job Townsend in Newport."

very different meaning to the sender and receiver than if we think of it as an obelisk erected with the future's memory in mind. Temporality is certainly one of the elements recorded on those slips; most cabinetmakers (like most painters) who noted their name on a work, also noted the date of completion. John Townsend and Edmund Townsend (and a few other Newport cabinetmakers such as John Goddard and Constant Bailey) inscribed—or pasted a label imprinted with—not only their name and date but also their location (see figs. 93, 95, 98, 102). They add "Newport," or "Rhode Island," or "Newport Rhode Island" on the final line. None of this information was news to a local customer. He knew who he had ordered it from and when and where, but to a distant purchaser this label in the top drawer might substitute, in the anonymity of an exchange in which a ship captain intermediary is the vendor, for the face-to-face acquaintance of a local exchange. Even more significant, it would give the purchaser a source if he or she should desire another item. In fact, "Edmund Townsend / in / Newport Rhode Island" or "John Goddard of / Newport on Rhoadisland in New England" is exactly how eighteenth-century letters were addressed, as we see in the letter on the table in Smibert's portrait of a Boston merchant, identifying the sitter: "Mr. Richard Bill Esq / in Boston" (see fig. 46). Such a label might have been of great interest to the distant purchasers of such trans-shipped items as those recorded in a receipt signed by Capt. Peleg Bunker: "Received of John Townsend two Red Cedar Desks in cases at one hundred and seventy pounds old Tenor each & one Maple Desk in case at fifty pounds also four Maple Tea Tables at Twenty three pounds old Tenor in Cases which I promise to carry to the West Indies their to dispose of to the best Advantage the Danger of the Seas only excepted and remit the neat proceed in Molasses, Coffee or Cotton Wool & thereof unto said Townsend he allowing me one half of the profits."[56] Given the pressure for trade goods in the city and the evident willingness, even eagerness, of the furniture artisans to oblige, it is logical to view these labels as active agents of trade. While alike in many respects (strong, well built, and handsomely proportioned), one important difference between the Narragansett horse and the Newport desk is that the latter could carry a subtle, semi-permanent advertisement for its supplier in a convenient, eye-level drawer.

It is not only the labels that suggest that Newport cabinetmakers were focused as much on foreign trade as on local consumption; this market orientation is also evidenced in construction techniques. Unlike comparable cabinetwares made in Britain and in the other North American colonies, Newport high chests (a major form) and some other forms were routinely made with detachable legs for safer, more compact shipment (see fig. 99). These innovations, these departures from the norm, indicating an export, business mentality, corroborate evidence in surviving account books and point toward economic shrewdness on the part of those usually credited only with aesthetic and craft achievement.

Just as the cabinetmaker's label presumes an audience and special con-

struction techniques suggest trade-enabling innovations, the look of the object itself instructs us in the cultural perspective of the makers and consumers. We can assume that the startling and consistent differences in style, form, construction techniques, and even materials that are known as regional preferences were as recognizable in the eighteenth century as they are today. We feel at this point quite confident about our ability to identify an object's region—this has been the focus of most research in the field, and most of these maps of localized design characteristics have been charted, using as signposts secondary woods and construction techniques as well as provenance and design elements in documented examples.[57] While an awareness of the large-scale intercolonial shipment of lumber (which includes secondary wood usually presumed to be local) should teach us some caution in this area, the outlines of the regional styles are probably pretty accurately understood now.[58] Exactly how and *why* these distinctive schools developed in the major seaports is unclear. It has been suggested that these furniture regions are congruent with dialect regions and reflect major differences in settlement populations—a thought-provoking thesis.[59] But it is usually assumed that the cause of strong regional style is primarily the dynamic of an influential teacher on numerous apprentices (supplemented by local dependence on specialty craftsmen supplying single items like decorative veneer banding or table legs) affecting a whole craft region.[60] One of the problems with this thesis is the primacy it gives to the concept of mimicry—the concept that apprentices learn one craft manner and style, which they repeat throughout their careers and pass on intact. The polarities of convention and invention are not so much explained or investigated as merely identified after the fact. And both are caused by influence, that is, the artisan seeing something and using it as a point of departure or of imitation, depending on his talents. Perhaps it would be more useful to ask why—if emulation is the engine that drives a consumer market—there were regional styles in furniture but not in dress or, in other words, why London fashion was followed quickly and precisely in the design of costume, but broadly interpreted or cavalierly ignored (as in the case of Newport) in the design of furniture. Also, why does style travel (the how is the relatively easy part)? What is the rule in operation when, of a hundred visual facts introduced, one or two will be adopted or adapted? Is it whim, or are there deep guiding aesthetic and marketing principles that enact themselves in single, seemingly random instances of selection? Are these principles (or opportunities) only in the mind of the maker who instructs his patron group with the novelty, or must the principle also be shared, must it tap into a common denominator in the culture to become established—that is, to become desirable on the one hand and profitable on the other?

Certainly a tempting model in art historical thinking is the diffusion model in which a radical, aesthetically (and economically) successful development strikes a culture like a pebble in a pond and then rings of what is usually termed influence spread out as the novelty is naturalized and imitated (usually in lesser forms). Immigrant craftsmen, traveling craftsmen, pattern books, and

imported objects are usually credited with the introduction of new concepts and new designs. But perhaps as interesting as the migration of style per se is its non-migration, or rather, the process of selectivity by which certain elements are appropriated or exaggerated and certain other elements are ignored. Equally unexplored is the apparently swift naturalization of a novel form into the physical argot of a region; invention moves to convention in a single step. Newport cabinetmakers, for instance, did not begin by mimicking Boston blockfront case furniture and then gradually devise a local variant; they saw, appropriated, adapted, and naturalized the forms in a single act, laying the new concept onto the existing map of local design principles. Clearly it is easier and most economical to rethink a problem thoroughly, but only once.

The Newport aesthetic common to its furniture and its architecture by 1760 is one that we can capsulize as capitalizing on highly polished, light colored, vibrantly variegated mahogany; generous proportions based on the golden section, rich S-curves and ogee curves in repeated patterns; generous, meticulous, architecturally precise classical moldings based on the five orders (fig. 83); an eschewal of floral, whimsical, vine-based rococo ornament in favor of more abstract architectural and geometricized shell forms; and a careful adherence to the baroque principals of symmetry, hierarchy, and proportion (see plate X). This homogeneous eighteenth-century design vocabulary was successful in both local and distant markets where the purchasing population was unusually heterogeneous. The basic elements of this design vocabulary were articulated by William Hogarth in his *Analysis of Beauty* (1753), a work notable both for its codification of theory and its reiteration of extant design practice. For Hogarth, the appropriately proportioned S-curve exhibited and contained elements which aroused in the beholder an apprehension of "Beauty"—not as a taught appreciation or taste but as a natural (we might say, hard-wired) cerebral response (fig. 103 and see fig. 52).[61] What the Newport cabinetmakers effected was the wedding of Hogarth's unarchitectonic line of beauty (in many variants) onto classical Italiante architectural forms creating a vocabulary to which many eighteenth-century (and many subsequent) observers responded with natural admiration, and—more important—desire. The artisans discovered that—beyond exquisite craftsmanship, precious materials, and prompt attention to orders—the most powerful ingredient in their continued success was aesthetic power. People would (and will) pay for Hogarthian Beauty. The aesthetic ingredient in the consumer revolution is unquantifiable but extraordinarily powerful and has been curiously uninspected by scholars.

For those who have considered the operation of design on desire, the presumption has been that change and novelty, imitation and emulation, are the best indices of an entrepreneurial spirit and a consumer behavior at work.[62] But in Newport it appears that cabinetmakers displayed an entrepreneurial spirit by avoiding emulation of the obvious model and by maintaining style constancy. Having developed a highly polished, idiosyncratic idiom congruent with contemporary theoretical concepts of Beauty, they also appear to have determined

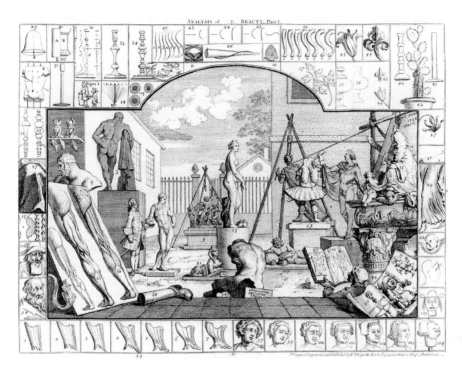

FIG. 103. Plate I, *The Sculptor's Yard*, from William Hogarth, *The Analysis of Beauty: Written with a View of Fixing the Fluctuating Ideas of Taste* (London: J. Reeve, 1753). Etching and engraving. 15⅛ × 19⅝ in. (38.5 × 49.8 cm). Lewis Walpole Library, Yale University.

to test the presumed universality of those principles. Not only Hogarth but also other midcentury theoreticians as David Hume hypothesized the existence of "beauties which are naturally fitted to excite agreeable sentiments, [which] immediately display their energy; and while the world endures, they maintain their authority over the minds of men."[63] Were this true, these objects could and would appeal to a culturally diverse population over an extended period of time. They could be marketed throughout the colonial and Caribbean marketplace, and both the natural admiration of heterogeneous potential customers and, on a more practical level, widespread product recognition would develop from style constancy. Yet the cabinetmakers were not trading on S-curves alone. Their wares were extremely functional and appealed to the pragmatic man-of-the-world who valued solidity, painstaking craftsmanship, and compartmentalized, specialized surfaces and containers to equip his physical world with the separation of functions and spaces and the codified order that he valued at least as highly as he valued Beauty.

Having developed a recognizable, pragmatic, desirable language of design, a veritable industry of more than a hundred known craftsmen labored for half a century to produce objects that are—Berensonian lists of attribution notwith-

standing—more alike than different. So much is clear. What is ambiguous is how the shops worked profitably in such tight competition with one another, using the same basic regional language of forms and techniques.

Little as we know about the actual dynamics of style migration, development, and innovation, we are equally ignorant of craft practices and shop organization. The shop was an economic, physical, and social unit. The workforce usually consisted of the master, possibly kin associates, journeymen, apprentices, and laborers. Except for journeymen, whose labor and wages were entirely related to production, the allocation of human resources between shop and household is difficult to ascertain because these adjoining structures constituted a single economic unit. There were ten individuals in John Townsend's household in 1774, for instance, when he was forty-one years old and a productive and preeminent craftsman. The family consisted of himself, his wife, and three children under the age of seven. There were also two males over sixteen living in the household (apprentice Jonathan Sheldon, a grand-nephew, and a second apprentice, also probably kin), as did three African Americans of undesignated gender (whether slave or free is unspecified); in 1790, one slave, at least one apprentice, and two grown sons are noted.[64] Journeymen, if any, usually did not board with their employer so it is difficult to know of their presence.

Physically, the shops we know about abutted the craftsman's dwelling and consisted of a single medium-sized room with street access and oversized windows (fig. 104).[65] It is unclear, however, whether this was primarily a ware room in which completed objects were exhibited and others, perhaps, were finished, or whether it was—as is usually supposed—the primary locus of production. If the latter, it certainly was not the only location in which objects were worked on, as it would be impossible to varnish (a procedure that takes several days and multiple coats in a dust-free environment) and to saw, plane, or turn (all sawdust-creating procedures) in the same room.[66] At least one secondary site—a warehouse or outbuilding—is implied. That shop owners employed multiple workmen (perhaps one fabricating and another assembling parts) is suggested by the frequent (and very unusual within the spectrum of colonial cabinetmaking) instructional inscriptions: "Upper Left," "Frunte Top," that are penciled and chalked deep within many Newport case pieces.

Whatever the physical situation and the division of tasks, these shops were run in an efficient and businesslike manner. Surviving account books, daybooks, and ledgers indicate an awareness of up-to-date accounting techniques and an intimate knowledge of commodity values and fluctuations. That some of these cabinetmakers were excellent businessmen, acutely aware of the economic aspects of regional as well as familial and personal finances, is attested by the successive appointments of Job, John, and Edmund Townsend to the office of town treasurer. An office we might expect to be entrusted to merchants was in Newport, for more than five decades was the civic assignment of cabinetmakers, one apparently discharged with credit.

FIG. 104. Jonas Bergner, attrib., House and shop of Christopher Townsend, 74 Bridge Street, Newport, 1725–1740. Photograph, 1900–1920. Newport Historical Society, Newport, R.I.

Given the small scale of these shops, they were remarkably efficient, consistent, and productive. Judging from their turnaround time for those orders for which we have documentation and their purchases from such hardware retailers as Henry Ayrault (imported British brass handles, escutcheons, hinges, locks, and knobs seem to have been bought in sets for each case piece as needed), we can get a pretty good idea what these craftsmen were making on what kind of schedule. Samuel Easton made one major object every two months; he was also farming and hunting, judging from his purchases of farm tools, powder, and shot. By contrast, his brother-in-law Christopher Townsend made two large case pieces each month, and his brother-in-law Job Townsend produced three and even four major objects a month over the 1736–1737 period for which there is good documentation.[67] It is astonishing that objects made with such extraordinary craftsmanship and attention to detail were made with such rapidity. However, that these artisans were as attentive as any to the pressure to convert man-hours into money should not surprise us. John Goddard willed his tools and the use of his shop to his sons Stephen and Thomas "in consideration of their working up the Stock of Mahogany for their Mother in such Furniture as will be most profitable."[68] He directed his sons to design and plan their use of their time and the shop's resources with the market foremost in mind. Goddard's measure of success in the production of an object was, thus, profitability. Making it beautiful and making

it well were part of making the furniture desirable. Making it quickly and making it efficiently were part of making it profitable.

Customers and Markets

Ezra Stiles responded to an inquiry from a friend who sought advice on the possibility of establishing a medical practice in Newport: "About 6 years ago Dr. Danforth . . . of Cambridge [Massachusetts] came with a view of Settling in the medical practice; he was an agreeable young Gentleman and had a proper Share of Knowledge in the profession; he had good Recommendations—yet after a considerable Trial he was discouraged and returned to Cambridge. . . . Two others have failed in the attempt . . . Dr. Moffat was 10 or 15 years getting into practice before it was good for any thing. [Dr.] Hunter came about 1752 and did no thing to Effect in the first 10 years till he married Col. Malbons Daughter, an Shur Anchor is a Petticoat."[69] Stiles is clear: skill, talent, training, and pleasing personality are insufficient equipment for a newcomer who wants to make his way in Newport. The key to the patronage issue and to full integration into the community is not through recommendations or the excellent practice of one's profession but through "a petticoat." Marriage anchored the individual and permitted him access to his wife's male kin, their resources, and their allies in his formation of a stable customer or client group.

In the early eighteenth century, the Townsends (like Dr. Hunter) were outsiders and their trade, cabinetmaking, was a new one. (Before 1700, the primary furniture forms were chests and chairs made of oak and pine by shop joiners and turners who used mortice-and-tenon joints; after 1700, the primary furniture forms were a broad spectrum of specialized case pieces with drawers and carved chairs made of mahogany, maple, and walnut by cabinetmakers and chairmakers, using far more complex dovetail joints).[70] Tracing the Townsends' marriage patterns over the 1680–1770 period, two distinct patterns become evident: linkages with cabinetmaking families and linkages with the customer-patron group. The strategy was twofold—to concentrate capital, tools, and expertise in the specialized woodworking trades, and to ensure a rich pool of merchant kin-customers who would be inclined to make purchases for their own use and who would be positioned to make additional purchases for export.

About 1686, widower Thomas Townsend of Oyster Bay on Long Island emigrated to Rhode Island where his mother and two aunts (a trio of sisters who had married three Townsend brothers) had grown up half a century before (see family tree, charts 2–5).[71] In Newport he married Mary Unthank Almy, widow of a distinguished member of the community, Col. Job Almy, and within a few years his son John and nephew Solomon also immigrated to Newport and married Almy women.[72] This interweaving of families (a triple alliance between Long Island Townsend men and Newport Almy women) undoubtedly helped to establish the newcomers in their adoptive city.[73] The trades of these Townsends

have not been established, but kin and cousins are known to have been house-wrights and joiners.[74]

The sons of Solomon Townsend and Catherine Almy (and the earliest gen-eration of cabinetmakers for whom we have documented objects), Job (1699–1765) and Christopher Townsend (1701–1787), further consolidated the family's posi-tion and established a firm footing in the artisanal structure as well as the patronage structure of Newport when, in 1722, Job married Rebecca Casey and, the next year, Christopher married Patience Easton (see family tree, charts 3 and 4). The kin of both these women became customers of the Townsends—a pattern that was frequently repeated as the century progressed. The Caseys, like the Townsends, were Quakers, and they were a family of substance, able to give general support and specific patronage to the craftsmen. At least two of Rebecca's cousins, for instance, bought furniture from the Townsend work-shops—Silas Casey, a merchant, and Samuel Casey, the distinguished silversmith; the latter bought a mahogany desk, two mahogany tables, and a bed from his cousin's son in 1752.[75] Samuel was a wealthy man and evidently had a consider-able appetite for cabinetwares; twelve years later his house burned to the ground "with a great Quantity of rich Furniture" and one contemporary estimated that "the whole loss, 'tis said, amounts to near Five Thousand Pounds."[76] The sum is staggering even in Rhode Island's inflated currency and suggests a degree of mid-eighteenth-century consumerism wryly noted by moral and economic philosopher Adam Smith: "The desire for food is limited in every man by the narrow capacity of the human stomach, but the desire for the conveniences and ornaments of building, dress, equipage, and household furniture, seem to have no limits or certain boundary."[77]

Patience Easton, Christopher's "petticoat" anchor, was the granddaughter of Nicholas Easton, a wealthy English-born tanner who had immigrated to Boston and then followed Anne Hutchinson in the original settlement of the Newport region.[78] It was Patience's step-grandmother Ann Bull Easton who in her will of 1708, left to the Quakers Eastons Point, the area of the city that was to be quickly identified as not only the Quaker residential section but also the manufacturing heart of the city.[79] Of more immediate significance to Christopher, Patience's brothers were in the furniture and building trades—Samuel Easton was a shop joiner, Peter a glazier, and James a shipwright.[80] The family was also involved in international trade (at least four Eastons were ship captains; one of Patience's uncles died in Jamaica, and one of her nephews in Surinam) and hence were positioned to expand the market for their kinsmen's wares.[81] In his marriage to Patience Eas-ton, Christopher also allied his family with Easton in-laws, a distinguished group that before long included the immensely wealthy merchant Abraham Redwood, a nabob Christopher eagerly addressed as "cousin" and for whom he carefully executed furniture commissions.[82] The Townsend marriages were, from a strategic standpoint, excellent. Their prospects for success were, if Stiles is cor-rect about the enabling role of an anchoring "petticoat," infinitely enriched by these

liaisons to potential customers and distributors. The next generation contin-
ued this consolidation process, widening and deepening the patronage pool with
the marriage of Christopher's daughter Mary to the son of Governor Gideon
Wanton, a member of arguably the wealthiest and most powerful family in the
colony.

Mary's siblings and first cousins, however, made marriages that tied the
family to the community of artists and artisans. Her brother John (perhaps the
best known of the cabinetmakers because of his tendency to label his work)
married Phila Feke, daughter of the elusive portrait-painter-cum-sea captain
Robert Feke.[83] Her cousins Hannah and Susannah Townsend (sisters of three cab-
inetmakers, Job, Jr., Edmund, and Thomas) made a double marriage with two tal-
ented Goddard cabinetmaking brothers, John and James in 1746 and 1750 (see charts
4 and 5). This interweaving of furniture makers and their sisters created an inter-
locking network of interests and know-how that undoubtedly led to the aesthetic
achievements and the consistency of style for which especially this mid-century
generation of these artisans is well known. Equally significant, the mid-century
weddings, which marked the joining of the Townsend and Goddard artisanal dynas-
ties, were attended by literally dozens of their customers, including a former
Governor of Rhode Island, the current Governor, and a future Governor of the
colony.[84] The efficacy of Stiles's "petticoat anchor" in the formation of a customer
group is suggested by the relationships evident in these wedding witness lists—
a tight overlap among kinship, business, religious, social, and familial ties.

Surviving bills, receipts, letters, and two account books and a day book pro-
vide the names of many individuals who made purchases from the Townsend and
Goddard cabinetmakers between 1737 and 1808. An analysis of one account
book listing the debit and credit accounts of Job Townsend (1726–1778) for the
decade 1750–1759 clarifies these relationships in terms of patterns of patronage
on the one hand and marketing on the other.[85] Job's account book for these years
lists fifty purchasers of furniture (plus six who requested only repairs or purchased
non-furniture goods). Of these, eighteen—fully a third—were kin, and eleven
had attended the weddings of Hannah, Susannah, and Job Townsend in 1746, 1750,
and 1753, respectively. Of those whose religious affiliation is known, twenty, the
largest group of Job's purchasers during this decade were, like the Townsends and
Goddards, Quakers; three were Jewish, and one was a Baptist. Patronage, like mar-
riage, along religious lines seems to have been common in the eighteenth cen-
tury. Stiles, for instance, in his letter concerning the state of the medical profession
in Newport, stated "Dr. Eyres has a considerable share [of the medical business]
and the Baptists are endevoring to throw all their custom into his Hands as he
is a Baptist."[86] Concerning the trades of Job Townsend's patrons, among those
whose trade has been identified, the largest group, nineteen, were merchants and
merchant-captains, including many Marine Society members; but the group also
included two shoemakers, two women (a widow and a wealthy spinster), a sil-
versmith, a barber-wigmaker, a boat builder, a butcher, a ferryman, a schoolmaster,

and the local apothecary. The profile, then, of Job Townsend's mid-century patron suggests that he was likely to be a merchant or a captain, probably a Quaker, and he might well be kin. From what is known of the significance of family connections, religious ties, and Newport trade, this is not a surprising pattern except perhaps in the very strong representation of family patronage.

Most of Job Townsend's customers bought several items covering a wide variety of merchandise, but mainly they bought mahogany chests of drawers, desks, and tables. Many paid in imported goods (such as sugar, rum, molasses, or fine fabric), which functioned almost as currency and which Townsend then exchanged for other goods. In a very few instances he bartered his furniture directly for goods or services needed by his household, as his exchange with the barber of a wig and a year's worth of shaving for three tables and a corner cupboard. The most frequent credit entry (for seventeen purchasers) is payment in boards—mahogany, maple, cedar, poplar, and chestnut. As we might expect, the captains and merchants who were in a position to provide this desirable method of payment frequently did so. Moreover, it was the merchants (five) and sea captains (six) who also most frequently settled their accounts in whole or in part with the most desirable from of payment of all, cash. Nevertheless, it is important to note that it is not just the mariners and merchants who were in a position to pay in cash or in imported raw materials. Even those exchanges we might expect to be characterized by a "village barter" system partake in the larger system of exchange in which imported (and some native) commodities circulated *as cash* even among those who did not produce, consume, or craft them as when the hatter William Cozzens purchased a mahogany table, tea table, stand, pine desk, and several repairs in exchange for £11 worth of sugar, £10 worth of mahogany, and £10 in cash.

Job Townsend's customers during this decade spent on the average of £67/5/0 for three objects (repair orders aside). Most appear to be purchases for the customers' personal use, but such entries as "To a Red Seader [cedar] Desk and Ruff case [rough or shipping crate] £82" for his brother Capt. Solomon Townsend suggest venture cargo for export to the West Indies where the insect-resistant character of cedar drawers was particularly prized. Townsend seems to have worked personally on each object he sold (although he almost certainly had apprentices and the ledger indicates he bought mahogany from his brother-in-law, the cabinetmaker, John Goddard, and bought a set of maple legs from the cabinetmaker Constant Bailey).

During the 1750s Job Townsend's total recorded sales amount to £3,498/15/0. He produced a wide variety of items, from a bird cage for £5 to a mahogany desk for £100, and he sold to a broad spectrum of Newport's populace. The overall pattern of his trade, however, was the production of single mahogany cabinetwares for merchant-mariners who were frequently kin and coreligionists, in a small shop that probably included one or two kin apprentices and a laborer (the 1774 census noted that his household included at that time himself, his wife, one male under sixteen years, and one African American).

It is instructive to compare Job Townsend's business practices and his customer group with that of his contemporary, John Cahoone (1725–1795). Both men were in their prime (aged twenty-five to thirty five) during the 1750–1760 period covered in their respective account books, and both sold similar products to similar customers, but there are important differences. The record we have for Cahoone (a ledger of credit sales 1749–1760) indicates that Cahoone was acquiring furniture—he appears to have specialized in case pieces, principally desks and chests of drawers—from at least five journeymen cabinetmakers and then directly exporting these objects himself or selling them in lots of one to twenty-seven pieces (with an average being five pieces at a cost of approximately £180) to investors for export, or for local use.[87] His cabinetmaker suppliers, Job Clark, James Searl, Benjamin Tayre, Jonathan Brier, Moses Norman, Gideon Lawton, and Jonathan Swett were not kin, and his relationship to them in the ledger is meticulously financial. Nor were they relations to any of the broad circle of Newporters to whom the Townsends and Goddards were connected by marriage. According to Jeanne A. Vibert's analysis of this single ledger covering his credit transactions for one decade, Cahoone's local sales amounted to £2,739/17/10 while his export trade was almost double that figure at £4,778/16/8.[88] His was a considerable business, serving both consumer and investor needs.

The Cahoone ledger gives the names of 111 furniture customers from this mid-century decade. Those whose occupations have been identified include twenty-five merchants and mariner-captains, two doctors, two glaziers, two housewrights, two chairmakers, a barber, a hatter, a gunsmith, a cooper, a mason, a clerk, a rigger, and a braizer. Of these artisans, only the rigger requested a packing case for his purchase, suggesting not only that local craftsmen looked to Cahoone as well as to Job Townsend to supply their personal furniture needs but also that, by the mid-eighteenth century, a hatter, a glazier, and a cooper were sufficiently *businessmen* as well as artisans to need a desk to do their accounts and their correspondence. They saw themselves as management as much as craftsmen, with complex record-keeping tasks requiring specialized locus and equipment. As to the rigger, he represented one end of a broad spectrum of investors; his modest "3½' table and casing [@] £17" (1756) represented a move to turn savings from wages into capital with its own potential for growth by merely moving a commodity from one site to another (presumably on the ship on which he was employed).[89] While his wages would remain basically constant throughout his life and his labor was worth basically the same throughout the Atlantic marketplace, the table could magically double in value and earnings by a mere shift in locale, giving him an opportunity for profit, even (with repeated investments) prosperity that his job could not.

While Cahoone supplied the desk for the hatter, a table for the scrivener, and a potentially profitable commodity for the modest investor, he also supplied elegant mahogany desks and bookcases to the colony's wealthiest citizens who maintained showpiece estates.[90] In fact, there are as many major landowners and

eminent public officials in Cahoone's customer list as in Job Townsend's. For three of these—Henry Overing, William Redwood, and Metcalf Bowler—the purchases seem to be for their own personal use; for three others—John Jepson, John Collins, and Captain Godfrey Malbone—these objects were business investments, bought with care for export.[91] Malbone was Cahoone's biggest customer, acquiring twenty-seven objects (cedar desks and tables, maple desks and tables and cases of drawers, mahogany desks and walnut tables) between 1751 and 1760.[92] Rival landowner and merchant Metcalf Bowler acquired only a few objects—an expensive mahogany desk and bookcase, a mahogany table, a bedstead, and a dressing table over the same period—probably to furnish his villa situated in the middle of the island on which Newport is located.[93] The range of goods made by the journeymen cabinetmakers in Cahoone's employ was quite broad, but clearly for these customers (who were in a position to be selective) they rivaled in price and quality those of the Townsends and Goddards.[94]

Of Cahoone's 111 customers, at least seventeen were sea captains, six others were shopkeepers and merchants; eight of these captains and seven men whose profession has not been determined requested crates for their objects (other mariners could have reused cases made earlier). As in the case of Job Townsend's customers, the traffic with captains suggests the commodity value of these objects for the median-level investor with on-site advantages. This kind of investment was also clearly as attractive to the five-item captain-purchaser as to the minor league one-item player (William Rider, the Rigger), and the big investor (Godfrey Malbone).

Religious affiliation was less a factor for Cahoone's customers than for those of the Townsends and Goddards. For those whose congregation is known, thirty were fellow Congregationalists (Cahoone was a member of the first Congregational Church), fifty-four belonged to the Church of England, eight were Quakers, three were Baptist, and one Jewish.[95] This represents a distribution closer to the general population than Job Townsend's customer group with its much higher proportion of Quakers. More important for Cahoone, it seems, was political persuasion. While only one of Job Townsend's customers shows up on Ezra Stiles's list of Tories, Cahoone and six of his customers were, in Stiles's opinion, by 1776, too closely allied with the interests of Great Britain.[96]

Generally, the Cahoone group of cabinetmakers and customers seems a loose collection of Newporters for whom their primary relationship was a depersonalized financial transaction. The artisans were tied to Cahoone only by wage and piecework labor; the investors (if we judge by the gross value of exports against personal local use as analyzed by Jeanne Vibert) patronized his business with an eye primarily on resale and profit. Only the pressure of political opinion seems a factor in customer loyalty. While an artisan and craftsman himself, Cahoone applied to his trade the principles and concepts of a modern, eighteenth-century merchant. By contrast, Job and his kin in the Townsend-Goddard group relied on strong kinship and religious ties within both the artisan and the customer

groups. These older foundations for trade served them well during most of the century. The innovative strategy of labeling goods for export added a note of modernity, of "advertising," that improved trade without disrupting the basic, family oriented, structures on which their art and prosperity were based.

Curiously, the circles of craftsmen and patrons for the two groups scarcely intersect. No known kinship or apprenticeship ties link the two groups of makers, and very few links are discernible in the customer group.[97] The records do not suggest that they were making different kinds or qualities of furniture or were focusing on a single style or design. Because of the labels and signatures, we know a good deal about particular Townsend-Goddard surviving objects but almost nothing about those of their competition. Yet there is every reason to believe they were comparable in craftsmanship and design. Both Cahoone and the Townsend group sold to a wide range of customers at roughly equal prices, and both serviced local needs as well as export demands. Each exhibited some (although different) modern business practices—practices that were to become characteristic of nineteenth-century production—in shop organization and marketing approach, and each prospered in the middle decades of the eighteenth century.

While it is sometimes difficult to tell whether the purchased object was for personal use, in some instances it clearly was a commodity for exchange, venture, or gift. One of the most notable characteristics of both the Townsend-Goddard and the Cahoone circles of craftsmen and their customers is their enthusiasm for exporting furniture products. This was a matter of recognized public policy as well as private ambition. As early as 1734, the Report of the Council of Trade and Plantations to the House of Lords commented: "The people of New England being obliged to apply themselves to manufactures more than other of the plantations [colonies], who have the benefit of better soil, [and] warmer climate, such improvements have been made there in all sorts of mechanic arts, that not only escritoires [desks], chairs, and other wooden manufactures, but hoes, axes, and other iron utensils, are now exported from thence to the other plantations."[98] In some instances we know of specific export commissions—such as a desk-and-bookcase sent by Christopher Townsend to Abraham Redwood in Antigua on behalf of a third party, and a large and varied group of objects bought by Aaron Lopez from John Goddard and Edmund Townsend as well as a group of other furniture makers for trade.[99] Characteristically, many of the export links of the Townsend-Goddard cabinetmakers appear to be based on kinship ties. The delicacy with which one embarked on business with one's wealthy in-law kin is suggested by Christopher's letter of January 4, 1738, to Redwood, concerning an expensive desk and bookcase:

Cousin Abraham Redwood

[I] indevoured to finish a Desk and Book Case Agreeable to thy Directions. . . . understanding it was not for thee But a friend of thine. . . . And having an oper-

tunity to Send it by Brother Solomon [a sea captain], I shipped it by him and
ordered him to Deliver it to thee or thy order, thou paying him one Moydore
freight. The Desk and Book Case amounts to Sixty Pounds, this [Rhode Island]
currency; including the Ruf [packing] Cases—which is equal to fourteen heavy
Pistoles @£4/5/8 or forty four ounces and a half of silver, which I Desire thou
would Pay or Cause to be paid to Brother Solomon. I may let thee know that I
sold, Such a Desk and Book Case as this without any Ruf Cases for £58 Cash in
hand this winter. Brother Job, also sold one to our Collector [of Customs] for £59—
I mention this that thou may know that I have not Impossed on thee. I now let
thee know that our Relations are Generally well and thy Wife and Children in
Perticular.[100]

Clearly this Townsend craftsman goes to some lengths to assure his patron/
in-law that the price is fair, even a bit of a bargain. Equally characteristically,
John Cahoone's exports involved investment transactions with nonkin associ-
ates, and the bulk merchandizing of furniturewares. In 1749, for instance, he and
two other cabinetmakers, Constant Bailey and Benjamin Peabody, rented a
sloop to ship furniture as venture cargo to North Carolina.[101]

Purchases by Aaron Lopez for export and exchange were a rather differ-
ent matter and suggest the scale on which furniture was traded by some eager
merchants with considerably more capital to invest than even collaborating
furniture makers could command. He dealt in bulk, purchasing from at least ten
cabinetmakers during the 1760s and 1770s.[102] It is possible that some of these
objects were for personal or local use, but in several instances Lopez ordered the
objects with packing cases, clearly for shipment. A truly diversified trader with
a fleet of thirty wholly or partly owned vessels, Lopez was using furniture to sup-
plement his much larger cargos of agricultural goods (rum, sugar, tea, Madeira
wine, chocolate, coffee, indigo, lumber, fruit, grain), English manufactured
products (such as dry goods) and slaves, in a complex international trade char-
acterized by "tramping"—that is, not trading between fixed ports but rather mov-
ing from place to place in search of cargoes and markets on an opportunistic
basis—as much as by triangulation.[103] The purchase of finished goods like cab-
inetry in Newport for exchange abroad became, by the 1760s and 1770s an
important feature of his global trading pattern. He became a manufacturer and
industrialist as well as a shipper, making spermaceti candles (from 1756), mak-
ing rum (from 1772), and building ships (from 1765) while contracting for tex-
tiles, bottles, and clothing as well as furniture for export.[104] By entering the less
profitable realm of production as well as transport, Lopez was better able to con-
trol supply, and the perennial problem of finding a tradeable Rhode Island prod-
uct was minimized. While it is possible that some furniture purchases were
incidental, opportunistic acquisitions of goods on hand to fill up a partially laden
ship, others were clearly bespoke goods, acquired with a deliberate sense of pur-
pose as evidenced by such a notation as:

October 2, 1771

Memorandum that I have this day engaged a Cedar Bookcase from Edmund Townsend for which am to allow him £340 and he is to deliver it completed and cased in 12 days from the above date. Payable in goods.

Accomplished.[105]

If all his dealings were executed with this precision and attention to detail, it is no wonder that he was so remarkably successful and as universally admired as Stiles suggests: "He perfectly understood Trade and Commerce" and was held in high "esteem in Europe, and with the whole commercial Interest in America."[106] Lopez signaled the wave of the future for the commercially ambitious; his interests were widely diversified, included production as well as transport, and his relationships were crisply financial.

On a smaller scale, other traders also patronized a variety of cabinetmakers, including Capt. Archimedes George who bought from John Townsend, Thomas Townsend, Samuel Vinson, and James Pitman; similarly, the merchant John Banister ordered furniture from John Goddard, Thomas Townsend, John Townsend, John Hookey, Clement Packcom, and James Pitman.[107] While some of these purchases may have furnished the rural showplaces that these merchants maintained (both Banister's and Lopez's were a matter of some interest and comment in the eighteenth century), the overall pattern seems to have been purchase for export.[108]

The scale of this export enterprise can only be estimated, but it seems to have been considerable. Advertisements in such newspapers as the *South Carolina Gazette* record sizable shipments from Newport, and Vibert's review of shipping records in Annapolis and Charleston indicate that in a sample three-year period 492 chairs, 71 case pieces, and 30 tables entered Annapolis from Rhode Island, and 133 Newport chairs, 70 case pieces, and 33 tables arrived in Charleston (1764–1767).[109] Shipments to other important markets, such as New York and the West Indies, were probably much higher.[110]

At the same time that merchants were beginning to purchase vigorously in such commodities as furniture and actively enter the production side of trade with the establishment of manufactures, some Newport cabinetmakers were becoming active traders, competing with the merchants and captains. Furniture craftsmen John Townsend, John Goddard, Robert Lawton, Caleb Gardner, Caleb Coggeshall, Thomas Davenport, James Taylor, John Thurston, John Tillinghast, and John and Stephen Cahoone all became sea captains, and, while most of their wares were probably the same commodities carried by other traders, they certainly did not ignore the products of their primary profession.[111] In fact, in some instances, the cargo was entirely venture cargo of furniture.[112] Perhaps it was mere youthful zest that sent these talented, well-trained artisans (as we know at least some of them to have been) to such a radically different occupation as that of sea

captain, but it is more likely that they and their mentors saw the opportunities and advantages of trade as something to be pressed in the present and cultivated for the future; what better vendor or on-site evaluator of the markets and the competition (or purchaser of Caribbean mahogany) than a cabinetmaker himself. As meager as the archives are, documents connect at least 31 of the 122 chairmakers and cabinetmakers working in eighteenth-century Newport to export activities. It is probable that a much higher percentage were focused on this trade.

While New York was a handy market with an underdeveloped native cabinetmaking industry and strong prices for handsome, serviceable wares, the distant West Indies offered a market with virtually no native artisanal competition and a cosmopolitan sense of culture and exchange.[113] As one visitor said of St. Eustatia, a Dutch island, "never did I meet with such variety; here was a merchant vending his goods in Dutch, another in French, a third in Spanish, etc. They all wear the habit of their country.... From one end of the town of Eustatia to the other is a continued mart, where goods of the most different uses and qualities are displayed before the shop-doors. Here hang rich embroideries, painted silks.... most exquisite silver plate, the most beautiful indeed I ever saw, and close by these iron-pots, kettles and shovels."[114] Into this cosmopolitan variegated mart where trade was brisk and profitable, we can imaginatively insert the Newport cabinetmaker. Joseph Ott calculates that after the Revolution when records are available (but also when Newport was in a significantly reduced state of financial health) a quarter of the vessels carried woodwares as a least part of their cargos.[115] If this percentage represents a continuity with the busy mid-century period when, for instance, 519 vessels departed from the city in a single year (1764) then furniture export was a significant element of the economy.

While Cahoone's sons, John and Stephen were able to continue along the trajectory set by their father, making and exporting furniture in the closing years of the eighteenth century, and the third (and last) generation of Townsend-Goddard craftsmen (Solomon Townsend [1775?– 1821], Job E. Townsend, son of Job [1758–1829], Job E. Townsend, son of Edmund [c. 1780–1818], Thomas Townsend [1785– ?], James Townsend [?–1827], Robert M. Townsend [?–1805], Stephen Goddard [1764–1804], Thomas Goddard [1765–1858], James Goddard [1752–?], and John Goddard, son of Stephen [1789–1843]) made an apparently sound living at their craft, the exuberant, creative mid-century generation whose designs are enthusiastically sought in the marketplace today came to an unrecoverable standstill with the Revolution.[116] John Goddard died insolvent in 1785, and John Cahoone was worth only £65/18/8 at the time of his death in 1792.[117] The agent of devastation was the three-year occupation of the city from December 8, 1776, to October 25, 1779, during which 6,000 British soldiers were billeted on a populace of Newporters shrunk to 5,299 from 9,209 overnight.[118] It was not the bombardment of the city by the French fleet in support of the Continental army in July and August 1778, nor the despoliation of all the city's churches (those central symbols and frameworks of social community), except Trinity, nor

even the destruction by the British soldiers of all the fences, orchards, warehouses, wharfs, and half the houses in town that ruined Newport; it was the mere fact of economic isolation.[119] Newport was a city built on rocky ground—it could not feed itself or provide fuel for itself. For a century and a half it had built a social economy based on "needs" and "comforts" unobtainable at home, and a complex interdependent web of credit exchanges that touched at every point the intercolonial and international marketplace. Not just the merchants but every artisan and laborer was pitched into the nightmare of autarcky for three long years. The Virgilian dream of a self-contained, self-sustained pastoral economy became the reality of desperately misfit relations between people, place, and things.

Once established, the modern, outward-looking, outward-reaching economy of eighteenth-century Newport with its focus on *things* obtainable by the most profitable (and often, therefore, distant) sale of other things could not retrench or retool for narrower horizons. Eighteenth-century Newporters were born and bred consumers as well as producers and traders; they were intensely aware of the manmade physical world through which they moved. Their habits of thinking in terms of merchandise and physical objects were as deeply entrenched as their habits of social interaction. When Reverend Joshua Bradley, in his funeral sermon for Paul Mumford, a merchant whose career spanned the second half of the eighteenth-century, sought to remind his listeners of their brief physical presence in the world, he did so in terms of their man-made possessions—merchandise, furniture, buildings—and this last is the metaphor by which he even conceived the hereafter: "reflect that within a few years to come, not one of this large assembly will be living: That in a little time; in a few days, in a few hours, a few moments, comparatively speaking, all must leave their seats, their houses, their farms, their merchandize, this world, and enter the mansions either of everlasting happiness, or misery and punishment."[120] "All must leave their seats": has death ever been so imaged? Bradley's *memento mori* is not the traditional vacant skull (tangible evidence of the death of the body and mind if not the spirit) but an empty chair in an empty house. He and his listeners thought and responded in terms of their constructed environments, environments of things that are, we could add, desirable not just because they are useful or exotic, or novel, or stylish, or imported, or expensive, or big, but because they had (and have) aesthetic power, and therefore financial value. While, as one artisan said in an address to the Mechanics of Providence in 1800, "theory teaches the artist what to do; practice guides him in the performance," he might well have added that the social and economic circumstances of his career, contemporary attitudes toward *things*, condition the parameters of his performance, his prosperity, and his sense of community on which both are based.[121]

Conclusion

The objects discussed in this book are unusual because they have survived. But surviving, they necessarily have found themselves displaced wanderers in the foreign land of an unexpected future. Inhabiting that succession of necessarily strange contexts they have pleaded in the mime of their unfamiliarity for interpretation. Interpreters have obliged. A century and a half ago, these artworks were often valued for their associations, their evocation of a projected golden past, and their proximity to "Washington slept here" at the celebrity end of the scale and to the Centennial "New England Kitchen" at the homey anonymous domestic end. Sometimes they were gathered into period rooms where the assemblage cast the viewer as a participant, reenacting humanness at a different time. They were harnessed to the ideology of quaint "colonialness," and, in the early twentieth century to filiopietistic posturing. By the mid-twentieth century, that narrative aura of a simpler, more virtuous era had faded, and "Americana" objects were evacuated of history; they were valued, understood, and analyzed for their formal qualities as aesthetic achievements extracted from time and space. They were also gradually extracted from the domestic settings in which they were indigenous, and permanently institutionalized. They were gathered into genre-cohorts and exhibited in whitened galleries as coherent complex products of singular creative minds, just as John Donne's poems were subjected to and burnished by the hard acuity of New Criticism. In art galleries and historical societies, they have been, and continue to be, admired, analyzed, and installed as vehicles of ideology, as the end products of technology, as exemplars of creativity, as coup-counting trophies. Increasingly, in the past two decades, scholars have sought to understand the circumstances surrounding the creation of these artworks, the economic patterns that precipitated and facilitated their creation, turning the spotlight a little off the artist as hero and on to the patrons—understood largely along generic class lines.

This book has explored the question of how one might begin to find ways to look at historic objects a little differently than have most investigations of late eighteenth-century American paintings, decorative arts, drawings, and architecture. The objective of this study is not to add one more sedimentary layer to the tales that have been told about these individual objects on museum labels, in textbooks, in monographs reverencing the achievements of their extraordinary makers or their original patrons. Instead, selecting a handful of examples, I have tried to begin to discover how we might learn *from* them what they can tell us about visuality in the larger social ecology out of which they have been so decisively extracted. I have attempted to understand art and material culture as the residue

of the intentions and collaborations of dozens, even hundreds of people making individual decisions, making them in an enormous network of intended and unintended actions and consequences that are legible both in the objects themselves and in the archives of historical factoids laid down by census takers, accountants, diarists, mapmakers, and letter writers, while attending to other matters. In trying to model this larger map of aesthetic activity framed within quotidian facts of daily use, I do not belittle or underestimate the extraordinary achievement of singular designers, artists, theorists, or patrons; rather, I have tried to position that "genius" factor within a complex model of social interdependence. And I have tried to position the self-portraits, family portraits, drawings, and chests of drawers within living social landscapes of exchange and use. My second objective is to find strategies to recover the "eyes" by which they were created to be seen, that is, to move toward understanding the social axioms, the physical and economic conditions, and the aesthetic and personal mnemonics that were their unspoken coordinates. In Charles Harrison's terms, my question has been "who are they *for*, that is, whose eyes [were] equipped" to perceive and understand their nuanced meanings, and what were those meanings?[1]

These objects and object sets were not picked for attention here because they were the "best," that is, aesthetically "better" than others of their kind (although many are highly praised), nor were they picked because they had long bibliographies (although some do), rather, they were picked because they puzzled me. They puzzled me individually and together as an assemblage of disparate types. They prompted questions about motives and unforeseen consequences, about making and using, and about everyday seeing. How did Copley learn the aesthetic value system that spurred him? Why did Newporters (and their neighbors in Boston and Connecticut) spend extra money, design effort, and precious mahogany to undulate their furniture surfaces? What are the artists who paint themselves painting their spouses into "life" up to? And who drew to what purpose? Who would "get" a visual quotation? What was the patron's share in creativity? How did artworks come out of communities of craftsmen, and how did they descend in families of patrons? Some of these questions seem so basic, so preliminary, and yet the one thing this close look at these objects consistently tells me is that nothing is simple; everything ramifies and prompts further questions. A three-dimensional model that keeps many elements on the table has value: it offers richer readings and a more complicated, more interesting, more useful past.

My basic inquiry has to do with visuality, simply seeing, and, in the end, what I have offered is also a set of "readings." They attempt to situate that *seeing* in languages (and "luggages") common to speaker-artisan and user-purchaser, to the community at large. These readings have been not just a literal matter of finding equivalences but finding oblique reference, tone, innuendo—finding the "argot" of a native in the dead language of the social past. Most history is done with words and it is done *about* words, but history happens (when it is the present, before it is history) in a densely packed object-world where a hatchment

above a door, a lock on a desk, the cut of a coat, the turn of a leg, the lip of a bowl all generated meaning and communities of communication. When George Berkeley—as utopianist-draftsman-urban planner—proposed the construction of a porticoed Roman temple-church at the heart of his ideal city, hub of a new empire in Bermuda, what he sought was a sign of continuity with antiquity, domesticated, adopted, and modernized to signal both Rome and Britain, displaced even further west. His aim was to make visually familiar and to make historically resonant and historically relevant a continent that was, to him, unfamiliar and without history. That architecture was not just a container for institutions and concepts, a bricks and mortar mnemonic of valued ideologies, it was itself to be an agent of instruction, and so it can be to us.

Some dismiss objects as mute or trivial, relentlessly laconic vehicles of value measured on the auction block and little else. But objects are, to those who make and "read" or use them, give them to others, or pass them to progeny, important matters, legible documents as full of metaphor and rhetoric, pun and complication, as primary sources of the literary sort. Objects are about memory, virtue, defiance, disappointment, order, and exhortation. They are about family wholeness in the wake of fracture (as in the case of the Pepperrell family portrait); they are about deliberate affronts (as in the case of Hancock's hatchment silently casting the "face" of his house in mourning to behold encamped Redcoats on Boston Common); they are about communities of solidarity (as in the case of the itinerant blue dress). Objects can tell us about important matters on which the written record is silent, or they can tell us about matters (such as the effects of the shift in the "theory" of the child on mothers and fathers we see in family portraits) that had become visible by 1760, but that would not reach the horizon of audibility in the written record for another two decades.

The objects considered here are primary sources, remnants of a past known otherwise only indirectly, eyewitnesses surviving into the present. Even when they are fictions and constructs (such as Copley's *Pepperrell Family*) that record not specific authoritative reality but longed-for artificial moments of wholeness, they nevertheless carry the weight of truth. For the moment they envision is authentic to deeply felt desire and guiding ideology, and if one's quarry is ideology, such objects provide a window on long-dead dreams. In their role as primary documents, these works are both true to the past and present in the present: they coexisted with *them* and they coexist with us. "The past is never dead," as William Faulkner put it, "it's not even past."[2]

Beyond my probing into the potential of these objects to yield significant readings, my curiosity has also focused on investigating the ways in which artists and craftsmen have made their way in the world, how they have defined themselves in the act of defining their patrons. In designing, marketing, and producing their goods they had an audience in mind, an individual, a group, or a vaguely understood hope of a not-yet embodied need. In any case, they had in mind the eyes (and pocketbooks) of others with whom they shared cultural

niceties and nuances. How they have defined themselves in their products, gives us a window through which we can peer or "eavesdrop" on issues large and small at the heart of their ways of understanding family, civic wholeness, and humanness itself. I have also been curious about how objects have made their way in the world, for every object becomes an actor on the stage of the lives that are lived around it. The strategy for this "eavesdropping" has been to be attentive simultaneously to the macrocosm and the microcosm, not only to see the individual object event but also to see it staged and restaged within both local and vast interdependent social networks.

The objects and object sets addressed here were made in a colonial context, on the edge of a world only faintly known and understood by British Americans. They were made with reference to and in response to habits of mind, technologies, genres, materials, and institutions those colonies imported from the British islands and exported to other reaches of the Atlantic marketplace. They were instrumental in defining personal identity, family identity, and group identity as both aligned with Britain and as separate and separable from that nation. They echo English arts but are recognizably different, expressive of cultural difference as well as geographic distance. The Galapagos effect was apparent in the New World almost immediately. My subject here has not been the transmutations attendant on the migration of people, ideas, and objects, on new forms generated out of similar-but-different contexts. Rather, it uses explanatory models that take larger British origins as a given and focuses on the operation of localized systems of usage, patronage, and design. The transatlantic dimension (selection, mutation, exclusion, adaptation) is a rich, virtually untapped arena of inquiry that awaits thoughtful investigation. Beyond a center-periphery model privileging uniqueness, origination, and the financial power of the center with its inherent hierarchies and diminutions, beyond the worn concept of influence that rides on a hair-thin model of the human mind, lies a universe of visual and aesthetic decision-making and cultural expression that begs to be explored. A fine-grained, deeply-theorized analysis of the aesthetic continuities and disjunctions between parent culture and (rebellious) progeny is a project only just begun.

The Revolution, from the perspective of these objects and their narratives, occurs offstage. Nevertheless, that war and the unsettled decades leading to July 1776 are critical players here. The political upheaval that goes on in the background of all these chapters was—we have been told since childhood—the founding moment of national heroism, the birth of modern democracy, the cradle of modern capitalism, when (a fraction of) the population evolved upwardly "from subject to citizen" (as the unit in high-school texts tended to put it). But in the context of the objects investigated here, the Revolution was the event that shredded an enabling status quo, that affected social wholeness and aesthetic productivity in less positive ways. While it caused individuals, including Joshua Henshaw, William Pepperrell, and the Sons of Liberty to commission extraordinary

objects of memory, commemoration, unity, identity, and exhortation, it also occasioned the decimation of the flourishing Newport cabinetmaking industry, and the emigration of America's most talented painter, John Singleton Copley. It fractured families as it fractured an economic and aesthetic florescence sheltered and fostered by the *pax Britannia*.

NOTES

Introduction

1. See, for example, Wayne Craven, *Colonial American Portraiture: The Economic, Religious, Social, Cultural, Philosophical, Scientific, and Aesthetic Foundations* (Cambridge: Cambridge University Press, 1986); Richard H. Saunders and Ellen G. Miles, *American Colonial Portraits, 1700–1776* (Washington, D.C.: Smithsonian Institution Press, 1987); Ellen G. Miles, ed., *The Portrait in Eighteenth-Century America* (Newark: University of Delaware Press, 1993); see also M. M. Lovell, "The Terre Inconnue of the Colonial Face," *Winterthur Portfolio* 24, no. 1 (Spring 1989), pp. 69–76.

2. See, for instance, David Solkin, *Painting for Money: The Visual Arts and the Public Sphere in Eighteenth-Century England* (New Haven: Yale University Press, 1993), pp. 1–26; and Marcia Pointon, *Hanging the Head: Portraiture and Social Formation in Eighteenth-Century England* (New Haven: Yale University Press, 1993); Ann Bermingham, *Learning to Draw: Studies in the Cultural History of a Polite and Useful Art* (New Haven: Yale University Press, 2000).

3. Charles F. Montgomery, "Price Books," in *American Furniture: The Federal Period in the Henry Francis du Pont Winterthur Museum* (New York: Viking Press, 1966), pp. 19–26.

4. Pointon appropriately argues that "all portraiture is public." It is, of course, in the sense that a family and an intimate circle wider than the protagonists' immediate kin would view it, and, over time, it would be visible to, indeed owned by, descendants whose intimacy with the figure imaged was genetic rather than social. However, in America, gentry houses were not generally open to nonfamily nonintimates, and these images circulated in a much more circumscribed sphere than in Great Britain (*Hanging*, p. 164).

5. Studies based on Thorsten Veblen's *Theory of the Leisure Class*, of 1899 (a classic text but one far more useful in analysis of the late nineteenth century from which its models of behavior were drawn), include T. H. Breen, "The Meaning of 'Likeness': American Portrait-Painting in an Eighteenth-Century Consumer Society," in Miles, *The Portrait*, pp. 37–60; Paul Staiti, "Character and Class," in *John Singleton Copley in America* (exhib. cat.), ed. Carrie Rebora et al. (New York: Metropolitan Museum of Art, 1995), pp. 53–77.

6. George Kubler, *The Shape of Time: Remarks on the History of Things* (New Haven: Yale University Press, 1962).

7. Richard L. Bushman, "American High-Style and Vernacular Cultures," in *Colonial British America: Essays in the New History of the Early Modern Era*, ed. Jack P. Greene and J. R. Pole (Baltimore: Johns Hopkins University Press, 1985); Breen, "Likeness'"; Philip Zea, *Useful Improvements, Innumerable Temptations: Pursuing Refinement in Rural New England, 1750–1850* (Deerfield, Mass.: Historic Deerfield, 1998); Stati, "Character and Class"; Edward S. Cooke, Jr., *Making Furniture in Preindustrial America: The Social Economy of Newtown and Woodbury, Connecticut* (Baltimore: Johns Hopkins University Press, 1996).

8. Robert Filmer, *Patriarcha: A Defence of the Natural Power of Kings Against the Unnatural Liberty of the People* (1635–40), ed. Peter Laslett (Oxford: Basil Blackwell, 1949).

9. Michael Baxandall, *The Limewood Sculptors of Renaissance Germany* (New Haven: Yale University Press, 1980), p. 142.

10. Michael Baxandall, "Pictures and Ideas: Chardin's *A Lady Taking Tea*," *Patterns of Intention: On the Historical Explanation of Pictures* (New Haven: Yale University Press, 1985), p. 74.

11. Laurel Thatcher Ulrich, *The Age of Homespun: Objects and Stories in the Creation of an American Myth* (New York: Knopf, 2001), p. 25.

12. Ulrich, *Homespun*, p. 414.

13. *Boston Weekly Newsletter*, November 28–December 5 and December 5–12, 1728; *New England Weekly Journal*, November–December 1728; see also Anne Allison "Peter Pelham—Engraver in Mezzotinto," *Antiques* 52, no. 6 (December 1947), pp. 441–43.

Chapter 1. Painters and Their Customers

An earlier version of this chapter was published in *Of Consuming Interests: The Style of Life in the Eighteenth Century*, ed. Cary Carson, Ronald Hoffman, Peter J. Albert (Charlottesville: University Press of Virginia, 1994), pp. 284–306.

1. Jonathan Richardson, *Two Discourses* (London: Churchill, 1719), pt. 2, pp. 41–52.

2. Richardson, *Two Discourses*, p. 47; see also Louise Lippincott, *Selling Art in Georgian London: The Rise of Arthur Pond* (New Haven: Yale University Press, 1983), pp. 95–125.

3. Cary Carson, "The Consumer Revolution in Colonial British America: Why Demand?" in *Of Consuming Interests: The Style of Life in the Eighteenth Century*, ed. Cary Carson, Ronald Hoffman, Peter J. Albert (Charlottesville: University Press of Virginia, 1994); Neil McKendrick et al., *The Birth of a Consumer Society: The Commercialization of Eighteenth-Century England*, pp. 9–94 (Bloomington: Indiana University Press, 1982), p. 10 and passim.

4. Georges Duby, *The Knight, the Lady, and the Priest: The Making of Modern Marriage in Medieval France*, trans. Barbara Bray (New York: Pantheon, 1983), pp. 92–95, 235–40; see also Lippincott, *Selling Art*, pp. 64–66. Prown estimates that 39 percent of Copley's customers had an annual income between £100 and £500, 31 percent an income between £500 and £1,000, and 22 percent an income over £1,000 (Jules David Prown, *John Singleton Copley*, 2 vols. [Cambridge, Mass., 1966], vol. 1, p. 127).

5. Wayne Craven, *Colonial American Portraiture: The Economic, Religious, Social, Cultural, Philosophical, Scientific and Aesthetic Foundations* (Cambridge: Cambridge University Press, 1986), pp. 183, 167 (a reference to family portraits inventoried explicitly in pairs); Prown reports that 45 percent of Copley's business was for portraits ordered in pairs *(Copley*, vol. 1, p. 135).

6. Jonathan Richardson, *An Essay on the Theory of Painting*, 2nd ed. (1725; reprint ed., Manston, Yorkshire, 1971), pp. 13–14, cited in Richard H. Saunders and Ellen G. Miles, *American Colonial Portraits: 1700–1776* (exhib. cat.) (Washington, D.C.: Smithsonian Institution, 1987), p. 45.

7. See, for instance, Ellen G. Miles, "Portraits of the Heroes of Louisbourg, 1745–1751," *American Art Journal* 15, no. 1 (Winter 1983), pp. 48–66.

8. Henry Wilder Foote, *John Smibert, Painter* (Cambridge, Mass.: Harvard University Press, 1950), p. 13.

9. Foote, *John Smibert*, pp. 106–7; George Vertue, *Note Books*, 7 vols. (Oxford: Walpole Society, 1930–55). vol. 3, pp. 36, 161, cited in Richard H. Saunders, *John Smib-*

ert: Colonial America's First Portrait Painter (New Haven: Yale University Press, 1995), p. 254.

10. *The Notebook of John Smibert* (Boston: Massachusetts Historical Society, 1969), pp. 73–99; Prown, *Copley*, vol. 1, pp. 36 n.2, 128–29.

11. Lippincott, *Selling Art*, pp. 32–34, 108.

12. Anne Allison, "Peter Pelham—Engraver in Mezzotinto," *Antiques* 59, no. 6 (December 1947), pp. 441–43.

13. George Vertue speaks of Smibert's wife, whom Smibert had married within months of his arrival in Boston, as "a woman of considerable fortune" (cited in Saunders, *John Smibert*, p. 240); Saunders, *Smibert*, p. 254; Prown, *Copley*, pp. 62–65 (figs. 224 and 225).

14. *Notebook of Smibert*, p. 77; Saunders, *Smibert*, p. 88.

15. Prown, *Copley*, p. 137.

16. Portraits of Isaac Winslow, for instance, by both Joseph Blackburn and Copley are preserved in the collection of the Museum of Fine Arts, Boston; see also Lippincott, *Selling Art*, pp. 64–65, 69.

17. For a discussion of some American portraitists who did advertise, see Saunders and Miles, *American Colonial Portraits*, pp. 12, 58–61.

18. Prown, *Copley*, p. 139.

19. Saunders, *Smibert*, p. 100; M. A. Flory, *A Book About Fans* (1895; reprint ed., Detroit, 1974), pp. 37–38, cited in Craven, *Colonial American Portraiture*, pp. 286, 428 n. 9.

20. Lippincott, *Selling Art*, pp. 30, 38.

21. Saunders, *Smibert*, pp. 110–13; Prown, *Copley*, pp. 79–82; Lippincott, *Selling Art*, pp. 36–38; *Letters and Papers of John Singleton Copley and Henry Pelham, 1739–1776*, ed. Charles F. Adams, Guernsey Jones, Worthington C. Ford (Boston: Massachusetts Historical Society Collections, 1914), vol. 71, pp. 117–28.

22. An instance of the "pride" thesis is found in Saunders and Miles, *American Colonial Portraits*, p. 43.

23. *Notebook of Smibert*, p. 95.

24. Saunders, *Smibert*, p. 121.

25. Wendy J. Shadwell, *American Printmaking: The First 150 Years* (New York Museum of Graphic Art, 1969), pp. 16–21; Saunders and Miles, *American Colonial Portraits*, pp. 80, 90, 134–43, 151–52.

26. Saunders and Miles, *American Colonial Portraits*, pp. 140–41.

27. Wendy J. Shadwell, "The Portrait Engravings of Charles Willson Peale," pp. 123–44, in *Eighteenth-Century Prints in Colonial America: To Educate and Decorate*, ed. Joan D. Dolmetsch (Williamsburg, Va.: Colonial Williamsburg, 1979), pp. 125–28.

28. Shadwell, *American Printmaking*, figs. 33–35.

29. Adams et al., *Copley-Pelham Letters*, p. 83.

30. Theodore E. Stebbins, Jr., *American Master Drawings and Watercolors: A History of Works on Paper from Colonial Times to the Present* (New York: Harper & Row, 1976), p. 34.

31. Ann Bermingham, *Learning to Draw: Studies in the Cultural History of a Polite and Useful Art* (New Haven: Yale University Press, 2000), p. xii.

32. See Lippincott, *Selling Art*, pp. 126–59.

33. For classic examples see Craven, *Colonial American Portraiture,* figs. 112 and 113, 123 and 124, 145 and 146; Saunders and Miles, *American Colonial Portraits,* figs. 75 and 79.

34. Saunders and Miles, *American Colonial Portraits,* pp. 237–38, 247.

35. Allison, "Pelham," p. 442.

36. The probate entries referenced here were gleaned from mid-eighteenth-century Suffolk County Probate Records (1740–1780, 1849) housed in the Boston courthouse (hereafter SCPR) by Robert Blair St. George to whom I am deeply grateful for providing me with this material.

37. SCPR vol. 63, p. 405, John Simpson, Boston merchant, 1764; SCPR vol. 73, p. 333, Mr. Robert Jenkins, December 1773.

38. SCPR vol. 42, p. 157, Mr. Nathaniel Cunningham, February 6, 1748/49, total estate £6,095/5/6; SCPR VOL. 73, p. 333, Mr. Robert Jenkins, December 1773. Jenkins was a dealer and he kept his stock of mezzotints in a chamber (an upstairs, usually secondary room).

39. SCPR vol. 35, p. 178, John Boydell, Boston merchant, September 25, 1740; SCPR vol. 55, pp. 128–33, Charles Apthorp, Boston merchant, January 1759.

40. SCPR vol. 46, pp. 356–57, Capt. John Chick, Boston mariner, June 12, 1752.

41. SCPR vol. 35, pp. 176–80, John Boydell, Boston merchant, September 25, 1740.

42. Saunders, *Smibert,* pp. 156–57, 158–60, 214, 218.

43. SCPR vol. 46, p. 552, Mr. John Smibert, painter, September 22, 1752.

44. SCPR vol. 72, pp. 73–76, list of rents in Boston due to estate of Samuel Bleigh from February 19, 1766, to July 16, 1772, Capt. Thomas Dade.

45. For discussion of signatures and labels see Chapters 2 (p. 40), 3 (p. 61), and 7 (pp. 248–250).

46. Allison, "Pelham," p. 443. Pelham also sought to instruct working adults as is evident from his advertisement in the *Boston Gazette* of September 20, 1748, announcing that his "School . . . (during the Winter Season) will be open from Candle-Light 'till nine in the Evening, as usual, for the benefit of those employ'd in Business all the Day"; see George Francis Dow, *The Arts and Crafts of New England, 1704–1775* (Topsfield, Mass.: Wayside Press, 1927), p. 12; see also Barbara N. Parker, "Portrait of John Barnard, attributed to Peter Pelham," *Antiques* 70, no. 3 (September 1956), p. 260 (now at Historic Deerfield). For a general discussion of the role of prints, especially mezzotints, in the reproduction of paintings and the dissemination of art see Richard T. Godfrey, *Printmaking in Britain* (New York: NYU Press, 1978), pp. 43–65.

47. Adams et al., *Copley-Pelham Letters,* p. 340.

Chapter 2. The Picture in the Painting

An earlier version of this chapter appeared under the title "Bodies of Illusion: Portraits, People, and the Construction of Memory" in *Possible Pasts: Becoming Colonial in Early America,* ed. Robert Blair St. George (Ithaca: Cornell University Press, 2000), pp. 270–301.

1. This painting, signed "B. West 1806," was given by the artist to his friend Robert Fulton (artist, cyclorama entrepreneur, and inventor of the steamboat and the submarine), who brought it to the United States in that year. Two years later it was listed among the works hanging in the newly established Pennsylvania Academy in Philadelphia. The location of the "original" portrait of Elizabeth Shewell West, if one in fact

existed independent of its inclusion within the 1806 *Self-Portrait*, is unknown (see Helmut von Erffa and Alan Staley, *The Paintings of Benjamin West* [New Haven: Yale University Press, 1986], pp. 453–56). For Robert Fulton as a collector (as well as producer) of art see Carrie Rebora, "Robert Fulton's Art Collection," *American Art Journal* 22, no. 3 (1990), pp. 40–63.

2. *Self-Portrait* is the title under which the painting is published in von Erffa and Staley, *Paintings of Benjamin West* (no. 530), and in Susan Danly, *Facing the Past: Nineteenth-Century Portraits from the Collection of The Pennsylvania Academy of the Fine Arts* (Philadelphia: Pennsylvania Academy of the Fine Arts and The American Federation of Arts, 1992), p. 40; in 1808, it was listed in an inventory of West's works published by the English journal *La Belle Assemblée or Bell's Court and Fashionable Magazine addressed particularly to the Ladies* as "Mr. West painting the portrait of Mrs. West, in one picture, half figures, large as life; in ditto [the Academy at Philadelphia]" (John Dillenberger, *Benjamin West: The Context of His Life's Work with Particular Attention to Paintings with Religious Subject Matter* [San Antonio: Trinity University Press, 1977], pp. 129, 187). For an account of West's self-portraits as a group see Ann C. Van Devanter, "Benjamin West and His Self-Portraits," *The Magazine Antiques* 103, no. 4 (April 1973), pp. 764–71.

3. John W. McCoubrey, *American Art, 1700–1960: Sources and Documents* (Englewood Cliffs, N.J.: Prentice-Hall, 1965), pp. 5–25, 35–43.

4. More appropriate to our understanding of West's position and his reputation among his peers is the portrait of him by Sir Thomas Lawrence of the same decade, which situates him in the robes of the President of the Royal Academy as a lecturer and as a history painter (1810, Yale Center for British Art, New Haven, Conn.).

5. Reynolds, in "Discourse III," insists that deception is not the "business of art" because "it is not the eye, it is the mind, which the painter of genius desires to address." In "Discourse XIII," he states, "Painting is not only not to be considered as an imitation, operating by deception, but . . . it is and ought to be . . . no imitation at all of external nature" (Sir Joshua Reynolds, *Discourses on Art*, ed. Robert R. Wark, [San Marino, Calif.: Huntington Library, 1959, based on the 1797 edition], pp. 50, 232).

6. Chester Harding, *My Egotistigraphy*, originally published in 1866, excerpted in Walter Teller, ed., *Twelve Works of Naive Genius*, pp. 81–103 (New York: Harcourt Brace Jovanovich, 1972), p. 92.

7. David Hume, "Of Personal Identity," in *A Treatise on Human Nature* (1739), ed. L. A. Selby-Bigge, 3 books in 1, pp. 251–63 (Oxford: Clarendon Press, 1978), vol. 1, 260–61.

8. For a discussion of the role of the myth of the origins of painting and drawing in the eighteenth century, see Ann Bermingham, "The Origin of Painting and the Ends of Art: Wright of Derby's *Corinthian Maid*," in *Painting and the Politics of Culture: New Essays on British Art, 1700–1850,* ed. John Barrell (Oxford: Oxford University Press, 1992), pp. 135–66.

9. Rembrandt Peale, "Reminiscences: The Person and Mien of Washington," *The Crayon* 3 (April 1856), p. 100. For a discussion of Peale's veristic "plain" style, see Brandon Brame Fortune, "Charles Willson Peale's Portrait Gallery: Persuasion and the Plain Style,"*Word and Image* 6, no. 4 (October–December 1990), pp. 308–24.

10. Charles Willson Peale, "Autobiography," typescript, p. 338, American Philosophical Society, Philadelphia, as cited in *Philadelphia: Three Centuries of American Art* (exhib. cat.) (Philadelphia: Philadelphia Museum of Art, 1976), p. 167.

11. Reynolds, "Discourse XIII," in *Discourses*, pp. 232–33.

12. Gilbert Stuart, quoted in Jules David Prown, *American Painting: From Its Beginnings to the Armory Show* (Geneva: Skira, [1969]), p. 47.

13. Models for Peale in this hand-play include William Hogarth's *David Garrick with His Wife*, 1757, Collection of HRM The Queen, Windsor Castle. Angelica Kauffmann Peale (b. 1775) was indeed taught by her father how to paint but discontinued painting after her marriage; see Charles C. Sellers, *Portraits and Miniatures by Charles Willson Peale* (Philadelphia: American Philosophical Society, 1952), p. 159, and Wilbur Harvey Hunter, *The Peale Family and Peale's Baltimore Museum, 1814–1830* (Baltimore: Peale Museum, 1965), n.p. For a discussion proposing that Angelica in this painting represents divine inspiration, see David Steinberg, "Charles Willson Peale: The Portraitist as Divine," in *New Perspectives on Charles Willson Peale*, ed. Lillian B. Miller and David C. Ward (Pittsburgh: University of Pittsburgh, 1991), pp. 131–43. The ambiguity concerning the dating of the work revolves around the age of Angelica—either she is aged seven to ten years in 1782–85 (and this seems most reasonable to me as her size, hairstyle, and manner all seem clearly marked as juvenile), or thirteen to fifteen years in 1788–90. In 1782 Rachel was thirty-eight; she died in 1790 when Angelica turned fifteen.

14. For an instance of a contemporary discussion of likeness see Stephen E. Patrick, "'I Have at Length Determined to Have My Picture Taken': An Eighteenth-Century Young Man's Thoughts About His Portrait by Henry Benbridge," *American Art Journal* 22, no. 4 (1990), pp. 68–81.

15. The mystique of the genius portrait painter who could read souls found contemporary expression and popularization in the writings of Johann Caspar Lavater in which he discussed "the talent of discovering the interior of Man by the exterior—of perceiving by certain natural signs what does not immediately strike the senses" (*Essays on Physiognomy Designed to Promote the Knowledge and the Love of Mankind* [1781], 3 vols. [London, 1810], vol. 1, 218). The question remains whether the outward signs of inward states are natural or cultural and how the reading of these signs is acquired. As the philosopher George Berkeley put it: "Without experience we should no more have taken blushing for a sign of shame than of gladness" (Berkeley, *An Essay Toward a New Theory of Vision* (1709), in *The Works of George Berkeley Bishop of Cloyne*, pp. 141–239, ed. A. A. Luce and T. E. Jessup, 9 vols. (London: Nelson, 1948–57), vol. 1, p.195. For a discussion of the origins and political and ideological uses of veristic (male) portraiture see Sheldon Nodelman, "How to Read a Roman Portrait," *Art in America* 63, no. 1 (January–February 1975), pp. 26–33. For a recent discussion of the portrait sitter's assumption of a pose that enacts the "air" of an inner consciousness (usually misread by art historians as the skill of the painter to "read" a passive subject), see Harry Berger, Jr., "Fictions of the Pose: Facing the Gaze of Early Modern Portraiture," *Representations* 46 (Spring 1994), pp. 87–120.

16. As William Hogarth put it, nature has "afforded us so many lines and shapes to indicate the deficiencies and blemishes of the mind, whilst there are none at all that point out the perfections of it beyond the appearance of common sense and placidity." The solution of the ancients—to indicate the gods' Olympian sagacity by "giv[ing] them features of beauty"—is, in his view, unsatisfactory (William Hogarth, *The Analysis of Beauty Written with a View to Fixing the Fluctuating Ideas of Taste* [London: J. Reeve, 1753], pp. 141, 142, as quoted in Richard Wendorf, *The Elements of Life: Biography and*

Portrait-Painting in Stuart and Georgian England [Oxford: Clarendon Press, 1990], pp. 175–76). Richard Brilliant aptly maintains that, of the constituent ingredients of personal identity (appearance, name, social function, and consciousness), only the first is directly picturable; see Brilliant, *Portraiture* (Cambridge: Cambridge University Press, 1991), p. 9.

17. The internal portrait of Archbishop Robert Drummond (d. December 1776) which West reproduces here, was executed by Sir Joshua Reynolds and is now in the St. Louis Art Museum. As the West *Drummond Family* was painted in 1776, the year West succeeded Reynolds in the presidency of the Royal Academy, this portrait may obliquely comment on professional as well as family succession.

18. Susan Rather, "A Painter's Progress: Matthew Pratt and *The American School*," *Metropolitan Museum Journal* 28 (1993), pp. 169–83. Berkeley's project is discussed in Chapter 6.

19. See also Trudy E. Bell, "Technology: Ultraviolet Detection," *Connoisseur* 210, no. 843 (May 1982), pp. 140–41.

20. Questions concerning the authorship of this pair of portraits and the identity of the sitters are addressed in the curatorial file, Fine Arts Museums of San Francisco. Here, as in the case of work on Peale's self-portrait with Rachel and Angelica and Pratt's *American School*, the impetus in recent scholarship has been to upgrade these portrait-projects into the more "elevated" realm of history painting. Benjamin West painted, in the 1760s, *Mrs. John Sawrey Morritt*, a portrait possibly related to Pratt's *American School*; the sitter's gesture is similar to that of the fugitive figure on Pratt's easel (private collection, illustrated in von Erffa and Staley, *Paintings of Benjamin West*, p. 27), although the Benbridge portrait (fig. 13) is closer.

21. McCoubrey, *American Art*, pp. 17–18. By the early nineteenth century, it was a standard trope of English artists to decry the bread-and-butter portraiture business. See Desmond Shawe-Taylor, "This Mill-Horse Business," in *The Georgians: Eighteenth-Century Portraiture and Society* (London: Barrie and Jenkins, 1990), pp. 7–20.

22. William Dunlap, *A History of the Rise and Progress of the Arts of Design in the United States,* 2 vols. in 3 books (New York, 1834; reprint, New York: Dover, 1969), vol. 1, p. 67. Concerning Peale's experience in West's London studio, see Jules D. Prown, "Charles Willson Peale in London," in *New Perspectives on Charles Willson Peale*, ed. Lillian B. Miller and David C. Ward (Pittsburgh: University of Pittsburgh Press for the Smithsonian Institution, 1991), pp. 29–50. For a discussion of the theory and patronage of these two genres in eighteenth-century Britain, see Louise Lippincott, "Expanding on Portraiture: The Market, the Public, and the Hierarchy of Genres in Eighteenth-Century Britain," in *Consumption of Culture: 1600–1800: Image, Object, Text*, ed. John Brewer and Ann Bermingham (London: Routledge, 1995), 3:75–88.

23. Benjamin West, *Self-Portrait*, 1806, exhibited 1807, Pennsylvania Academy of the Fine Arts; Matthew Pratt, *The American School*, 1765, exhibited 1766, Society of Artists of Great Britain; Charles Willson Peale, *Staircase Group*, 1795, exhibited 1795, the Columbianum or American Academy of the Fine Arts.

24. Of all of his paintings, Pratt signed only this, a for-exhibition painting; for more on signatures, see Chapters 3 and 7. Public exhibitions of artworks were extremely rare in the New World until well into the nineteenth century.

25. Robert Fulton, letter to Mary Smith, January 20, 1792, Semple Collection,

Historical Society of Western Pennsylvania, Pittsburgh, as cited in Rebora, "Robert Fulton," p. 41; see also Matthew Pratt's "Autobiographical Notes" in William Sawitzky, *Matthew Pratt* (New York: 1942), p. 22. In London, as Marcia Pointon wrote: "the successful portrait painter . . . employed the Royal Academy as his chief publicity agent" (*Hanging the Head: Portraiture and Social Formation in Eighteenth–Century England* [New Haven: Yale University Press, 1993], p. 41).

26. Charles C. Sellers, *Charles Willson Peale* (New York: Charles Scribner's Sons, 1969), pp. 80, 104, 122; Sellers, *Portraits and Miniatures*, p. 157. It was apparently executed in 1773 (some evidence suggests as early as 1770) and exhibited in his painting gallery. He returned to the canvas in 1808–1809, and alterations at this time include painting out a verbal legend, work on the background and on his self-portrait, and the addition of the dog and the palette with brushes.

27. Carole Shammas, "Anglo-American Government in Comparative Perspective," *William and Mary Quarterly*, 3rd ser., 52, no. 1 (January 1995), pp. 104–44. Shammas suggests that, surprisingly, patriarchal power did not wane or falter in the United States as a result of the Revolution (pp. 128–29, 132–34).

28. Gerda Lerner, *The Creation of Patriarchy* (Oxford: Oxford University Press, 1986), pp. 212–29; Robert Filmer, *Patriarcha*, 1680, ed. Peter Laslett (Oxford: Blackwell, 1949).

29. Edward P. Richardson, Brooke Hindle, and Lillian B. Miller, *Charles Willson Peale and His World* (New York: H. N. Abrams, 1983), p. 28.

30. Sellers, *Portraits and Miniatures*, p. 157; Charles Willson Peale evidently intended the canvas to be "emblematical of family concord;" see Charles C. Sellers, *Charles Willson Peale, Early Life* (Philadelphia: American Philosophical Society, 1947), p. 116. Not surprisingly, Peale's concept of nature also evidenced this enthusiasm for linkage, order, and harmony: species were linked by "the same chain. . . . manifesting the most perfect *order* in the works of a great *Creator*—who's [*sic*] ways are wisdom, her paths are peace, harmony and Love." Animals similarly provided Peale with "models of friendship, constancy, parental care, and every other social virtue" (quoted in Richardson, Hindle, and Miller, *Charles Willson Peale*, p. 196). While mythological figures are relatively rare in American art of this period, Henry Benbridge's similar tableau of *The Three Graces* survives from the West circle (Winterthur Museum).

31. Wayne Craven, *Colonial American Portraiture: The Economic, Religious, Social, Cultural, Philosophical, Scientific, and Aesthetic Foundations* (Cambridge: Cambridge University Press, 1986), p. 386; for another perspective on Peale's familial personality, see Phoebe Lloyd, "Philadelphia Story," *Art in America* 76 (November 1988), pp. 154–203.

32. John Barrell, "Sir Joshua Reynolds and the Political Theory of Painting," *Oxford Art Journal* 9, no. 2 (1986), p. 38, and John Barrell, *The Political Theory of Painting from Reynolds to Hazlitt: "The Body of the Public"* (New Haven: Yale University Press, 1986). See also Dell Upton, *Holy Things and Profane: Anglican Parish Churches in Colonial Virginia* (New York: Architectural History Foundation, 1986), pp. 199–232. Filmer, of course, famously and explicitly, links family government, political theory, and theological law, codifying popular (reactionary) ideology among his seventeenth-century contemporaries and eighteenth-century successors (*Patriarcha*).

33. Jonathan Richardson, *An Essay on the Theory of Painting* (London, 1725; reprint, Menston, England: Yorkshire Scolar Press, 1971), p. 13.

34. Julian Franklyn, *Shield and Crest: An Account of the Art and Science of Heraldry*

(London: Macgibbon & Kee, 1960), pp. 294–98; C. W. Scott-Giles, *Boutell's Heraldry* (London: Frederick Warne, 1958), pp. 146–49; Jonathan L. Fairbanks, "Portrait Painting in Seventeenth-Century Boston: Its History, Methods, and Materials," in *New England Begins: The Seventeenth Century*, ed. Jonathan L. Fairbanks and Robert F. Trent, 3 vols. exh. cat. (Boston: Museum of Fine Art, 1982), vol. 3, p. 413; and Abbot Lowell Cummings, "Decorative Painting in Early New England" in *American Painting to 1776: A Reappraisal*, ed. Ian M.G. Quimby (Charlottesville: University Press of Virginia, 1971), pp. 91–101.

35. David H. Solkin, "Great Pictures or Great Men? Reynolds, Male Portraiture, and the Power of Art," *Oxford Art Journal* 9, no. 2 (1986), pp. 42–49; see also Timothy H. Breen, "The Meaning of 'Likeness': American Portrait Painting in an Eighteenth-Century Consumer Society," *Word and Image* 6, no. 4 (October–December 1990), pp. 325–50.

36. Refused portraits had no residual value for the artist, as we note in such poignant evidences as the inventory of Sir Joshua Reynolds's closet on his death, "where there were a great number of portraits which had been rejected and were left upon his hands," cited in Pointon, *Hanging the Head*, p. 50, fn. 123.

37. For an insightful discussion of portraiture and legitimacy, "family pieces," and generational continuity see Pointon, *Hanging the Head*, pp. 61, 158–75; for a discussion concerning the tangential subject of naming in relation to progeny-substitutes in the eighteenth century, see the provocative essay by Gauri Viswanathan, "The Naming of Yale College: British Imperialism and American Higher Education," in *Cultures of United States Imperialism*, ed. Amy Kaplan and Donald E. Pease (Durham, N.C.: Duke University Press, 1993), pp. 85–108.

38. William Hazlitt, *The Complete Works of William Hazlitt*, ed. P. P. Howe, 21 vols. (London: J. M. Dent, 1933), 18:108–9, as cited in Nadia Tscherny, "Likeness in Early Romantic Portraiture," *Art Journal* (Fall 1987): pp. 193–99.

39. While the portrait-based history paintings of Copley, West, and Trumbull are well known, vernacular versions are less well known. Notable in this context is an account of an effort by Matthew Pratt in this line recorded by his son: "I think about 1785 the Fine arts, were very poorly encouraged in Philad[elphi]a and during which time, my Father, having little to do in that Line, was prevailed upon, by a number of his particular friends, to paint some signs, and he consented thereto. The first which he painted, was a very large one called 'The representation of the Constitution of 1788,' which contained excellent portraits of the Gentlemen, composing that convention. And which was hung up, at the South west corner of Chestnut & Fourth Sts where the Philadelphia Bank, was afterwards erected. Which attracted very great attention. Persons pointing out particular likenesses, such, as Washington, and others. At the bottom of which, the following lines were written by my Father. 'Those 38 great men have signed a powerful Deed / That better times to us, should very soon succeed'" (as cited in Sawitzky, *Matthew Pratt*, p. 23). The subgenre of portraiture (with which this chapter does not deal)—public portraits of worthies intended for specific sites of display to encourage emulation and regard—grew considerably in importance on both sides of the Atlantic at this period. The project in this case, of course, was to familiarize, heroicize, and individualize notables who were personal strangers to their audience. See also Pointon, *Hanging the Head*, pp. 52–104.

Chapter 3. The Empirical Eye

Parts of this chapter were published in "Copley and the Case of the Blue Dress," *Yale Journal of Criticism* 2, no.1 (Spring 1998), pp. 53–67, and an earlier version of this chapter appeared as "Mrs. Sargent, Mr. Copley, and the Empirical Eye," *Winterthur Portfolio* 33, no. 1 (Spring 1998), pp. 1–39.

1. Peter Pelham, mezzotint engraver, portrait painter, and widower, married John Singleton Copley's widowed mother in 1748 when Copley was ten, and died three years later in 1751; see Jules D. Prown, *John Singleton Copley*, 2 vols. (Cambridge, Mass.: Harvard University Press, 1966), vol. 1, pp. 8–10. He was born in London, according to the records of the church of St. Giles in the Fields, "son of Peter Pelham, Gent." in 1697 and was apprenticed in 1713 to John Simon, "engraver in metzotinto," emigrating to Boston in 1727; see Anne Allison, "Peter Pelham—Engraver in Mezzotinto," *Antiques* 52 (December 1947), pp. 441–43.

2. Jonathan Richardson, *An Essay on the Theory of Painting* (London, 1715), p. 25; Louise Lippincott, *Selling Art in Georgian London: The Rise of Arthur Pond* (New Haven: Yale University Press, 1983), pp. 31–54.

3. Remick's view is taken from "the grove" near the site indicated on Thomas Johnston's 1729 map of Boston (after William Burgis) as the "Governours House"; see also Prown, *Copley*, vol. 1, pp. 61–63, fig. 224; Clifford K. Shipton, *Sibley's Harvard Graduates: Biographical Sketches of Those Who Attended Harvard College*, 19 vols. (Boston: Massachusetts Historical Society, 1873–1999), vol. 8, pp. 550–60. See also fig. 90.

4. Concerning the necessity of maintaining an establishment of the sort one's sitters might visit socially, the London artist John Hoppner complained that a portraitist's rent is a "burthen, under which the demands of our profession compel us, quarterly, to groan" (Hoppner, in Prince Hoare, *The Artist*, 2 vols., 1810: 1, pp. 7–8, quoted in Desmond Shawe-Taylor, *The Georgians: Eighteenth-Century Portraiture and Society* (London: Barrie and Jenkins, 1990), p. 14.

5. In 1763–65 Copley was located "Near the Orange Tree" Tavern on Cambridge Street in Boston (Charles F. Adams, Guernsey Jones, Worthington C. Ford, eds., *Letters and Papers of John Singleton Copley and Henry Pelham, 1739–1776* (Boston: Massachusetts Historical Society, 1914), vol. 71, pp. 28, 32.

6. Wayne Craven, *Colonial American Portraiture: The Economic, Religious, Social, Cultural, Philosophical, Scientific and Aesthetic Foundations* (Cambridge: Cambridge University Press, 1986), pp. xvii, 9, 111, 126, 259, 304, 318–50; see also Barbara Novak, *American Painting of the Nineteenth Century: Realism, Idealism, and the American Experience* (New York: Harper and Row, 1979), pp. 10, 15–24.

7. Paul Staiti, "Accounting for Copley," in *John Singleton Copley in America*, exhib. cat., ed. Carrie Rebora et al., pp. 25–51 (New York: Metropolitan Museum of Art, 1996), pp. 25, 28, 29, 32, 33, 37, 40; T. H. Breen, "The Meaning of 'Likeness': American Portrait Painting in an Eighteenth-Century Consumer Society," *Word and Image* 6, no. 4 (October–December 1990), pp. 325–50.

8. Emma Worcester Sargent, *Epes Sargent of Gloucester and His Descendants* (Boston: Houghton Mifflin, 1923), p. 134; Sidney Perley, "Salem in 1700, No. 23," in *The Essex Antiquarian*, ed. Sidney Perley, 13 vols. (Salem, Mass., 1906), vol. 10, pp. 60–74.

9. Prown, *Copley*, vol. 1, pp. 180–81, 190–91.

10. For records concerning Daniel Sargent's ownership of schooners during this decade, their cargoes of molasses, sugar, salt, wheat, pork, flour, bread, and their ports of call in St. Eustasia, St. Martin, and Annapolis, see "Custom House Records of Annapolis Districk, Maryland, Relating to Shipping from the Ports of Essex County, Mass, 1756–75," in *Essex Institute Historical Collections,* pp. 256–82 (Salem, Mass.: Essex Institute, 1909), vol. 45, pp. 260, 274.

11. Steele as cited in Shawe-Taylor, *The Georgians,* p. 99. A few colonial gentry women defined themselves outside marriage and within the masculine realm of commerce, including one of Copley's sitters, the merchant Elizabeth Murray. However, these women were widows, moved by exceptional circumstances (like the artisan widows of printers), to take on a second public identity after the failure of the first (see Patricia Cleary, *Elizabeth Murray: A Woman's Pursuit of Independence in Eighteenth-Century America* [Amherst: University of Massachusetts Press, 2000], p. 46 and passim).

12. William Dunlap, *A History of the Rise and Progress of the Arts of Design in the United States,* 3 vols. (1834; reprint, Boston: C. E Goodspeed, 1918), vol. 1, p. 126; also Sargent, *Epes Sargent,* p. 137.

13. Sir Joshua Reynolds to Daniel Daulby, 9 September 1777, F. W. Hilles, ed., *The Letters of Sir Joshua Reynolds* (Cambridge: Cambridge University Press, 1929), p. 56.

14. James Northcote, *The Life of Sir Joshua Reynolds,* 2 vols. (London, 1818), vol. 1, p. 299.

15. "Pictor" in "The Art of Painting, Limning, Etc.," *Universal Magazine* (November 1748), p. 225–33; see also M. Kirby Talley, Jr., "'All Good Pictures Crack': Sir Joshua Reynolds's Practice and Studio," in *Reynolds,* ed. Nicholas Perry (New York: Harry N. Abrams, 1986), pp. 66–67.

16. Receipt, mss BR Box 257 no.27, Huntington Library, Art Galleries, and Botanical Gardens; Dunlap quoting Cunningham, *History,* vol. 1, p. 111; *Letters and Papers of John Singleton Copley and Henry Pelham, 1739–1776,* ed. Charles F. Adams, Guernsey Jones, Worthington C. Ford (Boston: Massachusetts Historical Society Collections, 1914), vol. 71, p. 112; Talley, "'All Good Pictures Crack,'" pp. 55–70. See also Shawe-Taylor, *The Georgians,* p. 10; Robin Simon, *The Portrait in Britain and America* (Boston: G. K. Hall, 1987), pp. 111–12; and Ellis Waterhouse, *Reynolds* (London: Phaidon, 1973), p. 39; *Boston Evening Post,* September 24, 1764, as cited in George Francis Dow, *The Arts and Crafts of New England, 1704–1775* (Topsfield, Mass.: Wayside Press, 1927), pp. 237–43.

17. Malcolm Cormack, transcriber, "The Ledgers of Sir Joshua Reynolds," *The Walpole Society,* vol. 42, 1970, pp. 105–70.

18. West, conversation with C. Robert Leslie recorded in Dunlap, *History,* vol. 1, p. 126. Gilbert Stuart also reiterated of Copley that "he was very tedious in his practice" (ibid.).

19. Concerning difficulties with male sitters see Chapter 4, and *Copley-Pelham Letters,* pp. 67, 70, 313.

20. *Copley-Pelham Letters,* p. 30.

21. Prown, *Copley,* vol. 1, p. 43; Staiti, "Accounting for Copley," p. 46. Although the vandalized portrait (a half length) is unlocated, a smaller Copley of the governor, *Sir Francis Bernard,* c. 1772, is at Christ Church [Oxford] College Library.

22. François Nivelon, *The Rudiments of Genteel Behavior* (London, 1737), "Dancing," n.p.

23. Lady Sarah Lennox, 1766, as cited in Aileen Ribeiro, *A Visual History of Costume: The Eighteenth Century* (London: B. T. Batsford, 1983), p. 89.

24. Henry Brooke *The Fool of Quality or The History of Henry Earl of Moreland,* 5 vols. (London: W. Johnston, 1767–70), vol. 2, pp. 274–75; vol. 3, pp. 103–4.

25. Parliamentary bill, cited in David Piper, *The English Face* (London: Thames and Hudson, 1957), p. 189; see also Fenja Gunn, *The Artificial Face: A History of Cosmetics* (London: Newton Abbot, 1973), p. 124.

26. Anne Buck, *Dress in Eighteenth-Century England* (New York: Holmes & Meier, 1979), pp. 26, 40. One commenter on Bath in 1761 noted that "The Ladies who intend to dance the minuet wear large hooped dresses, but others do not" (Count Frederick Kielmansegge, *Diary of a Journey to England in the Years 1761–62* [London: Longmans, Green, 1902], p. 125, as cited in Buck, *Dress,* p. 27. While obvious hoops rarely appear in colonial paintings, their presence in America is indicated by such protests as a pamphlet entitled "Hoop-Pettycoats Arraigned and Condemned by the Light of Nature and Law of God" advertised in the *New England Courant* in 1722, by correspondence (as that between Solomon Stoddard and Judge Sewell in 1701 about the dubious morality of hoops), and by recorded gifts of hooped petticoats (as that from William Pepperrell to his bride Mary Hirst in 1723), and by many advertisements for imported and Boston-made hoops throughout the eighteenth century (Alice Morse Earle, *Costume of Colonial Times* [New York: Charles Scribner's Sons, 1894], pp. 24, 135–38).

27. Mrs. Papendiek [Charlotte Louise Henrietta Papendiek], *Court and Private Life in the Time of Queen Charlotte,* ed. Mrs. V. D. Broughton, 2 vols. (London: R. Bentley and Son, 1887), vol. 1, p. 218, as cited in Buck, *Dress,* p. 28.

28. Frances Seymour, Duchess of Somerset, *Correspondence Between Frances Countess of Hartford (afterward Duchess of Somerset) and Henrietta Louisa, Countess of Pomfret, 1736–1741,* 3 vols. (London: R. Phillips, 1805), vol. 3, p. 292, as cited in Buck, *Dress,* p. 36.

29. "Satin: A kind of silken stuff, very smooth, and shining, the warp whereof is very fine, and stands out; the woof coarse, and lies underneath; on which depends that gloss, and beauty, which is its price" (Ephraim Chambers, *Cyclopedia; or An Universal Dictionary of Arts and Sciences,* 2 vols. [London: D. Midwinter, J. Senex et al., 1741], cited in Florence M. Montgomery, *Textiles in America, 1650–1870* [New York: W. W. Norton, 1987], pp. 314, 339–40, 350). "Paduasoy . . . the heaviest of dress silks" (Montgomery, *Textiles,* p. 314); "The Best Sort Dutch Paduasoys" were advertised in the *Boston News Letter* from as early as 1727 (Earle, *Costume,* p. 175). Alfred Frankenstein, apparently looking at a poor transparency of Copley's *Mrs. Daniel Sargent* or at the work itself, which had been discolored by old varnish, erroneously described this dress as "green" (*The World of Copley, 1738–1815* [New York: Time-Life Books, 1970], p. 79) and subsequent authors have repeated this mistake. Evidence of silk, gold lace, and silver thread in use among Native Americans includes an order by King Philip at Mount Hope in 1672 addressed to Colonel Hopestill Foster of Dorchester for "A pr of good Indian briches and silk & Buttons & 7 yards Gallownes [a strong, thick, gold lace trim woven on silk or worsted] for trimming" (Earle, *Costume* p. 64), and "galloon, yellow silk with twists of silver thread found at a Wampanoag archaeological site in Narragansett" (Laurel Thatcher Ulrich, *The Age of Homespun: Objects and Stories in the Creation of an American Myth* [New York: Knopf, 2001], p. 50).

30. Earle, *Costume,* p. 5; while England was encouraging the growth of the silk

weavers of Spitalfields, and Boston merchants (including Copley patron Isaac Smith, fig. 55) are known to have reviewed the works there in person, it is evident that most silk consumed in both England and the colonies was cultivated and woven outside the British Empire (Montgomery, *Textiles,* p. 350); Buck, *Dress,* p. 189; and Natalie Rothstein, "The Elegant Art of Woven Silk," pp. 61–87, in *An Elegant Art: Fashion and Fantasy in the Eighteenth Century,* exhib. cat. (New York: Harry Abrams for Los Angeles County Museum, 1983), p. 61.

31. Elizabeth M. Kornhauser, *Ralph Earl: The Face of the Young Republic,* exhib. cat. (New Haven: Yale University Press, 1991), p. 194.

32. Alicia M. Annas, "The Elegant Art of Movement," in *Elegant Art,* p. 48.

33. Dunlap, *History,* p. 110; see also Chapter 5.

34. Adam Petrie, *The Polite Academy,* 8th ed. (London, 1785), p. 60, as cited in Annas, "Elegant Art," p. 35. Nivelon's *Rudiments of Genteel Behaviour* begins with "an Introduction to the Method of attaining a graceful Attitude, an agreeable Motion, an easy Air, and a genteel Behaviour," n.p.

35. Annas, "Elegant Art," p. 45.

36. Arthur Murphy, *Gray's Inn Journal,* March 1752, cited in C. Willett and Phillis Cunnington, *Handbook of English Costume in the Eighteenth Century* (London: Faber and Faber, 1957), p. 267. On stays see Edward Maeder, "The Elegant Art of Dress," in *Elegant Art,* pp. 19, 38–39, 179–80; Dow, *Arts and Crafts,* p. 289; Earle, *Costume,* pp. 237–39; Aileen Riberio, *Dress and Morality* (New York: Holmes and Meier, 1986), p. 115; and David Kunzle, *Fashion and Fetishism: A Social History of the Corset, Tight-Lacing, and Other Forms of Body-Sculpture in the West* (Totowa, N.J.: Rowman and Littlefield, 1982), pp. 84–104.

37. Kurt Badt, *The Art of Cézanne,* trans. Sheila Ann Ogilvie (London: Faber and Faber, 1956; trans. 1965), pp. 58–72. According to *The Artist's Repository* (1784–86), ultramarine cost from three to ten guineas per ounce during the 1780s (less expensive but in some cases fugitive and usually less optically desirable blue pigments available in the eighteenth century included smalt, turchino, bice, and verditer); Talley, "'All Good Pictures Crack,'" p. 64. Although it is popularly believed that blue shadows are an invention of artists in the late nineteenth century, prescriptive texts (e.g., "Pictor," *Universal Magazine* 3 [November 1748], p. 228) and technical analysis (Rica Jones, "Artist Training and Techniques," in *Manners and Morals: Hogarth and British Painting 1700–60,* exhib. cat. [London: Tate Gallery, 1987], pp. 23, 26) make it clear that blue in the shadows was eighteenth-century practice among Anglo-American portraitists. The association of "blue" feelings with somber music is recorded from the late eighteenth century (Ulrich, *Homespun,* p. 346).

38. Sir Joshua Reynolds, *Discourses on Art,* ed. Robert R. Wark (New Haven: Yale University Press, 1981), p. 158. Concerning the tale that Sir Joshua Reynolds's rival, Thomas Gainsborough painted his celebrated *Blue Boy* (Huntington Library, Art Galleries, and Botanical Gardens) to refute Reynolds's dicta, see Robert R. Wark, *Ten British Pictures, 1740–1840* (San Marino, Calif.: Huntington Library, 1971), p. 35.

39. *Copley-Pelham Letters,* p. 240.

40. *Copley-Pelham Letters,* pp. 164, 182.

41. *Copley-Pelham Letters,* p. 297.

42. Prown, *Copley,* vol. 1, p. 16. The wall behind Mary Sargent is the same as that visible in the background of Sir Godfrey Kneller's *Earl of Ruglen* (private collection).

It is possible that Copley was using a print of the Kneller portrait or that they both drew on the same common source. Copley has "feminized" the wall by changing the pilasters from Doric to Ionic.

43. Staiti, "Accounting for Copley," pp. 32, 33, 39, 40; Paul Staiti, "Character and Class," in *John SingletonCopley in America*, ed. Carrie Rebora et al., exhib. cat. (Metropolitan Museum of Art: New York, 1995), pp. 53–78.

44. Sargent, *Epes Sargent*, p. 135. The house was purchased for £2,800 from Ellis Gray, whose brother John married the sister of Mercy Otis Warren (see fig. 36). Genealogical data in this chapter is based on that presented in Prown, *Copley*, vol. 1, pp.139–99, except where noted. Lucius Manlius describes the establishment in considerable detail, including the staff consisting of a Black man, a French cook, a chambermaid-nurse, a man "partly employed about my father's store," a cow, a horse, and a Newfoundland dog. In 1794 this house burnt and the family moved to grander quarters at the corner of Lincoln and Essex Streets (a property "accounted a palace" and purchased for £8,000) (Sargent, *Epes Sargent*, pp. 134–36).

45. Peter Kalm, *Independent Reflector*, 1753, quoted in Robert E. Cray, Jr., *Paupers and Poor Relief in New York City and Its Rural Environs, 1700–1830* (Philadelphia: Temple University Press, 1988), p. 69. Anthony Griffiths and Gabriela Kesnerova, *Wenceslaus Hollar: Prints and Drawings* (London: British Museum Publications, 1983), pp. 49, 83; Richard T. Godfrey, *Wenceslaus Hollar: A Bohemian Artist in England* (New Haven: Yale University Press, 1994), pp. 19–20, 128–30. S. Peter Dance, *Shell Collecting: An Illustrated History* (Berkeley: University of California Press, 1966), pp. 53–131; Lippincott, *Selling Art*, pp. 29, 120–21, 185; and Ian Cox, ed., *The Scallop* (London: Shell Transport, 1957); Keith Thomas, *Man and the Natural World: A History of the Modern Sensibility* (New York: Pantheon Books, 1983), p. 284.

46. *Abigail Allen (Mrs. Jonathan Belcher)*, 1756, is in the collection of the Beaverbrook Art Gallery, Fredericton, New Brunswick, Canada; *Alice Hooper (Mrs. Jacob Fowle, Mrs. Joseph Cutler)*, c. 1763, is in the collection of the U.S. Department of State; *Mrs. Epes Sargent II (Catherine Osborne)* (1764) is in a private collection.

47. Alison McNeil Kettering, *The Dutch Arcadia: Pastoral Art and Its Audience in the Golden Age* (Montclair, N.J.: Allanheld & Schram, 1983), pp. 101–7; figs. 148–55; Francis Haskell and Nicholas Penny, *Taste and the Antique* (New Haven: Yale University Press, 1981), pp. 280–81.

48. The Earl of Clarendon is cited in Richard Charlton-Jones, "Lely to Kneller: 1650–1723," pp. 74–127, in Brian Allen et al., *The British Portrait, 1660–1960* (London: Antique Collectors Club, 1991), p. 87. The issue may have been personal, but certainly it was political.

49. Earlier discussion of the uses of mezzotints by Copley includes the following essays: *Metropolitan Museum of Art Bulletin* 11, no. 3 (March 1916), p. 21; Frederick A. Sweet, "Mezzotint Sources of American Colonial Portraits," *Art Quarterly* (Detroit Institute of Arts) 14, no. 2 (1951), pp. 148–56; Waldron Phoenix Belknap, Jr., *American Colonial Paintings: Materials for a History* (Cambridge, Mass.: Harvard University Press, 1959), pp. 273–76; Trevor Fairbrother, "John Singleton Copley's Use of British Mezzotints for His American Portraits: A Reappraisal Prompted by New Discoveries," *Arts Magazine* 55, no. 7 (March 1981), pp. 122–30; Craven, *Colonial American Portraiture* p. 316; Jessie Poesch, "'In Just Lines to Trace': The Colonial Artist, 1700–76," in *The Portrait in Eighteenth-*

Century America, ed. Ellen G. Miles (Newark: University of Delaware Press, 1993), pp. 61–83. Copley was introduced, in at least one sense, to this practice by his stepfather, Peter Pelham, whose plate for the 1743 mezzotint of *Rev. William Cooper* became—with a reworked head, collar, and inscription—*Rev. William Welsteed* (1753), Copley's first artwork, a decade later; Prown, *Copley,* vol. 1, p. 15.

50. Breen, "The Meaning of 'Likeness,'" p. 346; Staiti, "Character and Class," p. 74.

51. James Northcote, *Life of Sir Joshua Reynolds,* 2 vols., vol. 1, pp. 55–56, 83, cited in Talley, "'All Good Pictures Crack,'" p. 61; Simon, *Portrait,* p. 129; Concerning the replication of costume and pose in British art see John Steegmann, "A Drapery Painter of the Eighteenth Century," *Connoisseur* 97, no. 418 (June 1936), pp. 309–15. It is notable, however, that while Thomas Hudson, for instance, copied prints literally, surviving works by Reynolds do not include exact duplicates on the Amory-Hubbard-Murray model (conversation with Shelley Bennett, February 1995).

52. Lippincott, *Selling Art,* p. 70; Simon, *Portrait,* pp. 97–100; Talley, "'All Good Pictures Crack,'" p. 57; Shawe-Taylor, *The Georgians,* pp. 11–12.

53. Talley, "'All Good Pictures Crack,'" pp. 57, 61; Hogarth openly satirized their use by other artists (Shawe-Taylor, *The Georgians,* pp. 12–13); Jones, "The Artist's Training," pp. 19–28; Oliver Millar, *Sir Peter Lely, 1618–1680,* exhib. cat. (London: National Portrait Gallery, 1978–79), p. 17, fn. 35, cited in Simon, *Portrait,* p. 98.

54. It is possible that Pelham's participation in Copley's painting practice was more extensive than we imagine, but until a body of Pelham's work in oil on canvas is located and investigated we have only the evidence of such remarks as: "Mr. Andrews would be greatly obliged if he [Pelham] could finish his picture. . . . [which had been held up] on account of some Alteration in the Landscape which Mr. Copley said Mr. Pelham was to make" (*Copley-Pelham Letters,* pp. 67, 152, 197, 373).

55. Mr. C. H., "lately Arrived from Great Britain," in *Boston Newsletter,* Feb. 18, 25, 1730/31, cited in Dow, *Arts and Crafts,* p. 19–20.

56. J. Ray, *The wisdom of God manifested in the Works of the Creation* (1691, 2nd ed. London, 1692), pp. 15–20, as cited in Marcia Pointon, *Hanging the Head: Portraiture and Social Formation in Eighteenth-Century England* (New Haven: Yale University Press), p. 81.

57. Abbé Le Blanc, *Letters on the English and French Nations* (1747), pp. 159–60, cited in Talley, "'All Good Pictures Crack,'" p. 61.

58. For Copley on the importance of "likeness" see *Copley-Pelham Letters,* p. 30, 31, 35, 65; and for Reynolds, see Reynolds, *Discourses,* pp. 72, 259; also see Nadia Tscherny, "Likeness in Early Romantic Portraiture," *Art Journal* 46, no. 3 (Fall 1987), pp. 193–99.

59. Reynolds, *Discourses,* Discourse 8, p. 107.

60. Peter Manigault (1751), as cited in A. W. Rutledge, "Portraits of American Interest in British Collections," *Connoisseur* 141, no. 570 (May 1958), pp. 266–70; and Simon, *Portrait,* p. 107.

61. T. H. Breen, "Narrative of Commercial Life: Consumption, Ideology, and Community on the Eve of the American Revolution," *William and Mary Quarterly,* 3rd ser., 50, no. 3 (July 1993), pp. 471–501; Breen, "Meaning of 'Likeness,'" p. 54.

62. Martha C. Codman, ed., *The Journal of Mrs. John Amory (Katharine Greene), 1775–1777 with Letters from her Father Rufus Greene, 1759–1777* (Boston: Privately printed,

1923), pp. 4, 5, 14, 20, 23–24. In her diary of two years in England she records the comings and going of many British individuals resident on both sides of the Atlantic but only once uses the category "Americans" (p. 35). It could be argued that far from "playing at being English," the Amorys, Hubbards, and Murrays were in every sense British (Thomas Murray, for instance, was born in Ireland), and all were Loyalists when politics forced absolute identity decisions in a cultural realm that had been both politically and culturally fluid up to that point (see *Divided Hearts: Massachusetts Loyalists, 1765–1790: A Biographical Directory,* ed. David E. Maas [Boston: Society of Colonial Wars, 1980], pp. 3, 83, 110).

63. Codman, *Journal of Mrs. John Amory,* pp. 4. 13, 17, 28–30.

64. Breen, "Meaning of 'Likeness,'" p. 346; Ellen Miles, introduction to *The Portrait in Eighteenth-Century America* (Newark: University of Delaware Press, 1993), p. 12; T. H. Breen, "Meaning of 'Likeness,'" pp. 37–60, in *The Portrait,* ed. Miles, p. 54.

65. Codman, *Journal of Mrs. John Amory,* pp. 4, 78, 82, 86.

66. Johnson, quoted in Simon, *Portrait,* p. 64.

67. *Copley-Pelham Letters,* pp. 117, 126, 132, 297–98, 339; on the general use of lay figures see Talley, "'All Good Pictures Crack,'" p. 57, 59; and Pointon, *Hanging the Head,* p. 41. Other surviving eighteenth-century lay figures include those of Louis-François Roubiliac at the Museum of London, and of Arthur Devis at the Harris Museum and Art Gallery in Preston. "Pictor," *Universal Magazine* (1748).

68. Simon, *Portrait,* p. 107.

69. Reynolds, *Discourses,* pp. 41, 140.

70. "The Dress of the Year, 1761," *The Ladies' Pocket Book* (1762), illustrated in Pat Earnshaw, *Lace in Fashion: From the Sixteenth to the Twentieth Centuries* (London: B. T. Batsford, 1985), p. 70.

71. Buck, *Dress,* pp. 75, 159–63; Rothstein, "Woven Silk," p. 61; Anne Ratzki-Kraatz, "The Elegant Art of Lace," in *Elegant Art,* pp. 119–20; Aileen Ribeiro, *Dress in Eighteenth-Century Europe, 1715–1789* (London: B. T. Batsford, 1984), p. 48; Frances Morris, *Notes on Laces of the American Colonists* (New York: William Helburn, 1926), p. 10. For a broad perspective on dress and eighteenth-century American portraiture, including the probability that dress rendered with detail and accuracy suggests costume "painted from life," see Aileen Ribeiro, "'The Whole Art of Dress': Costume in the Work of John Singleton Copley," in Rebora et al., *Copley,* pp. 102–15. There is an elaborate silk damask sack said to have been worn at the Mischianza Ball in Philadelphia 1778 in the collection of the Philadelphia Museum of Art (Montgomery, *Textiles,* p. 212). Characteristic remarks include those of the Abbé Robin who "hardly expected to find French fashion in the midst of American forests" (Morris, *Notes on Laces,* p. 12). Concerning the sumptuousness of colonial life and its interpretation by those both within and outside of colonial culture, see Breen, "Narrative," pp. 471–501.

72. See, for instance, the correspondence between Christian Russel and Edmond Williamson concerning the trimming of a new sack for Williamson's new wife, Mary, 1764, in Buck, *Dress,* pp. 72–75.

73. Marylynn Salmon, *Women and the Law of Property in Early America* (Chapel Hill: University of North Carolina Press, 1986), pp. 15, 54.

74. *Copley-Pelham Letters,* p. 32; Receipt, mss BR Box 257, no. 27, Huntington Library, 1762, for Harryson Gray, "To Painting a portrait of Miss Betsey at eight guineas & one

frame at four pounds £15/4/0" (the computation is irregular but also perhaps includes uninvoiced crating and shipping charges).

75. *Copley-Pelham Letters*, p. 68.

76. Earle, *Costume*, p. 14.

77. George Francis Dow, *The Diary and Letters of Benjamin Pickman (1740–1819) of Salem Massachusetts . . .* (Newport, R.I.: privately printed, 1928), pp. 15, 16, 17, 250.

78. Dow, *Pickman*, pp. 82, 92, 98.

79. Dow, *Pickman*, pp. 77–82; Mary Toppan Pickman, was the sole surviving child of Dr. Bezaleel Toppan (1704/5–1762), physician and ship owner; his estate was valued at £2,500 in 1762 (James Duncan Phillips, *Salem in the Eighteenth Century* [Boston: Houghton Mifflin, 1937], p. 247); *Sibley's Harvard Graduates*, vol. 7, pp. 127–28.

80. Phillips, *Salem*, pp. 117, 254, 462–63.

81. Sidney Perley, *The History of Salem Massachusetts*, 3 vols. (Salem, Mass.: privately printed, 1928), vol. 2, p. 37, 100, 135, vol. 3, pp. 37, 100; Phillips, *Salem*, pp. 17, 254, 259; Dow, *The Diary and Letters of Benjamin Pickman*, pp. 15, 16, 77–83, 107, 108, 110; *Sibley's Harvard Graduates*, vol. 5, pp. 645–46; vol. 8, pp. 118–24, 660; vol. 11, p. 566; vol. 12, pp. 30–40; vol. 13, pp. 551–60; vol. 14, pp. 485–88; Colonel Benjamin Pickman, "Some Account of Houses and Other Buildings in Salem" (1793), in *Historical Collections of the Essex Institute*, ed. George B. Loring 6, no. 3 (June 1864), pp. 93–109; *Essex County Court House Registry of Probate, Salem, Mass.*, vol. 325, pp. 448–55. The numbers in the text refer to houses indicated in Benjamin Pickman's essay of 1793 and on Phillips's map (see fig. 19).

82. Earle, *Costume*, pp. 159, 191; Willet and Cunnington, *Handbook*, p. 168; Ribeiro, *Visual History*, pp. 89, 144; Robert Francis Seybolt, *The Private Schools of Colonial Boston* (Cambridge, Mass.: Harvard University Press, 1935), pp. 32–33.

83. Oliver Greenleaf, advertisement, May 23, 1768, *Boston Evening Post*; ivory turner and mathematical instrument maker, Isaac Greenwood also advertised: "neat Persian umbrilloes compleat at £6 10s and in proportion for better Silk. Those Ladies whose Ingenuity Leisure and Oeconomy leads them to make their own may have them cut out by buying the sticks or Frames of him; and those Ladies that are better employed may have them made at 15s a Piece" (*Boston Evening Post*, June 6, 1768); umbrellas are advertised in Boston from 1753 (Dow, *Arts and Crafts*, p. 163); see also Jeremy Farrell, *Umbrellas and Parasols* (London: B. T. Batsford, 1985), pp. 7–11, 23–27. In these cases, as in virtually all eighteenth-century examples, married women are pictured without wedding rings (Willet and Cunnington, *Handbook* p. 179).

84. Mercy Otis Warren is best known as the author of *History of the Rise, Progress, and Termination of the American Revolution*, ed. Lester H. Cohen (1805; reprint, Indianapolis: Liberty Classics, 1988).

85. Cited in Alice Brown, *Mercy Warren* (New York: Charles Scribner's Sons, 1896), p. 24.

86. John Adams to William Wirt, 5 January 1818, in Charles Francis Adams, *The Works of John Adams*, 10 vols. (Boston: Little, Brown, 1856), vol. 1, p. 272. See Mary Beth Norton, *Liberty's Daughters: The Revolutionary Experience of American Women, 1750–1800* (Boston: Little, Brown, 1980), pp. 121–23.

87. *Sibley's Harvard Graduates*, vol.14, pp. 375, 471, 478. That Pickman and Otis remained lifelong friends based on their college years is evident from Pickman's notation

in his diary of 4 October 1803 that he "saw my classmate Secretary [of the U.S. Senate for twenty-five years] Otis" (Dow, *Pickman*, p. 170).

88. Phillips, *Salem*, p. 283; William Tudor, *The Life of James Otis* (Boston: Wells and Lilly, 1823), pp. 22, 52–88; Brown, *Mercy Warren*, pp. 19–43 (as an indication of the closeness of James Otis and Mercy Otis Warren, he wrote her in 1766: "This you may depend on, no man ever loved a sister better, & among all my conflicts I never forget yt I am endeavoring to serve you and yours" [p. 19]); *Sibley's Harvard Graduates*, vol. 11, pp. 251–53; Lawrence Henry Gipson, "Aspects of the Beginning of the American Revolution in Massachusetts Bay, 1760–1762," *Proceedings of the American Antiquarian Society*, new series, 67 (1957), pp. 11–32. James Otis was also Copley's lawyer (*Copley-Pelham Letters*, pp. 122,133, 151). While the names of the Salem merchants actively involved in the writs case is not known, the prominence of the Turners, Sargents, Pickmans and Toppans suggests their participation. M. H. Smith, *The Writs of Assistance Case* (Berkeley: University of California Press, 1978), pp. 193–203, 234–35.

89. There is a third instance in which the interaction of these families reaches the horizon of visibility in the public record: in 1778, Daniel Sargent bought a house in Boston from Ellis Gray, whose brother was married to Mercy Otis Warren's sister (Sargent, *Epes Sargent*, p. 133). A detailed description of this house, its grounds, and household members has been left to us by Mrs. Daniel Sargent's son Lucius (Sargent, *Epes Sargent*, pp. 134–37). For a discussion of the role of the Otis-Bourne families of Cape Cod and their political links to Boston see also Ulrich, *Homespun*, pp. 142–73.

90. Brown, *Mercy Warren*, p. 246; Emily Reigate, *An Illustrated Guide to Lace* (Woodbridge, Suffolk, England: Antique Collectors Club, 1986), pp. 90–92.

91. Maud Macdonald Hutcheson, "Mercy Warrren, 1782–1814," *William and Mary Quarterly*, 3rd ser., 10, no. 3 (July 1953), pp. 378–402, at 386, 390.

92. Copley paintings from the 1760s that display virtuosity in the painting of lace, beyond those illustrated and discussed here, include *Anne Fairchild Bowler (Mrs. Metcalf Bowler)*, c. 1763 (National Gallery of Art); *Mrs. Thomas Greene*, c. 1765 (Philadelphia Museum of Art), *Mrs. John Barrett*, c. 1758 (Prown, *Copley*, fig. 58); *Mrs. Thaddeus Burr*, 1758–1760 (City Art Museum, St. Louis). Some authors suggest that the lace-trimmed sleeve ruffles were attached to "the sleeves of the hidden chemise" (Earnshaw, *Lace*, p. 64), while other evidence points to these ruffles as integral to the dress. Some laces were made in America but the patterns were less elaborate and production much more meager than English or Continental sources. Ipswich, Massachusetts, the center of lace production in New England, apparently produced 4,200 yards of silk lace and edging in 1786, according to Tench Coxe in an address to the Pennsylvania Society for the Encouragement of Agriculture (Morris, *Notes on Laces*, p. 13). Buck's research indicates that laces in Britain cost as much as 25s a yard in the 1760s, a figure that would have been even higher after transatlantic transport (Buck, *Dress*, p. 191).

93. Lippincott, *Selling Art*, p. 73.

94. Earnshaw, *Lace*, p. 16.

95. Sir John Barnard, *A Present for an Apprentice*, 5th ed. (London, 1747), p. iii.

96. Adam Petrie, *Rules of Good Deportment, or of Good Breeding* (1720; reprint, Edinburgh, 1835), pp. 6–16; see for instance, such remarks as "to lay out Money in fine Cloaths . . . [may result in] The Wall in the Street [the relinquishing by another of the safer, area of honor and predecent away from the traffic], or some little Deference, where

you are not known, being all the Advantages attending it" (Barnard, *Present*, p. 9). See Karen Halttunen, *Confidence Men and Painted Women: A Study of Middle-Class Culture in America, 1830–1870* (New Haven: Yale University Press, 1982); and John Kasson, *Rudeness and Civility: Manners in Nineteenth-Century Urban America* (New York: Hill and Wang, 1990).

97. *Sibley's Harvard Graduates*, vol. 7, p. 127. On the verbal viciousness of art critics in the late eighteenth century, see, for instance, Robert C. Alberts, *Benjamin West: A Biography* (Boston: Houghton Mifflin, 1978), pp. 219–20.

98. N. E. H. Hull, *Female Felons: Women and Serious Crime in Colonial Massachusetts* (Urbana: University of Illinois Press, 1987), p. 111; John K. Alexander, *Render Them Submissive: Responses to Poverty in Philadelphia, 1760–1800* (Amherst: University of Massachusetts Press, 1980), p. 65; Cray, *Paupers and Poor*, pp. 57–63; David H. Flaherty, "Crime and Social Control in Provincial Massachusetts," pp. 105–26 in *The Colonies and Early Republic*, ed. Eric H. Monkkonen, vol. 1 of *Crime and Justice in American History*, 2 vols. (Westport, Conn.: Meckler, 1991), p. 115.

99. Craven, *Colonial American Portraits*, pp. xvii, 111, 121, 123, 126, 128, 138, 171, 268, 296, 309–52; Staiti, "Character and Class," pp. 54, 65, 67.

100. *Copley-Pelham Letters*, pp. 302–3.

101. Kenneth Garlick and Angus MacIntyre, eds., *The Diary of Joseph Farington*, 16 vols. (New Haven: Yale University Press, 1979), vol. 6, p. 2284.

102. Peter Pelham, Sr., was attached in some capacity to the household of Lady Isabella Scotts, and his two sisters were in service in other aristocratic households, of sufficient status to share in the dispersal of the wardrobe when a principal died, yet sufficiently poorly paid that one writes that to have a miniature portrait painted "would cost above half a year's income to have it done." *Copley-Pelham Letters*, pp. 6, 24, 27, 29; Dow, *Arts and Crafts*, pp. xviii, 10–11, 31; *Boston Gazette*, February 26, 1728; *Boston Weekly Newsletter*, April 5–11, 1734, *Boston Evening Post*, October 1, 1750; Allison, "Peter Pelham," p. 443.

103. *Copley-Pelham Letters*, pp. 8, 18, 20; Allison, "Peter Pelham," p. 441.

104. Breen, "Meaning of 'Likeness,'" pp. 40–48; for a critique of the emulative model, see Colin Campbell, *The Romantic Ethic and the Spirit of Modern Consumerism* (Oxford: Blackwell, 1987), pp. 17–58, 174–84.

Chapter 4. The Remembering Eye

1. Igor Kopytoff, "The Cultural Biography of Things: Commoditization as Process," in *The Social Life of Things*, ed. Arjun Appadurai (Cambridge: Cambridge University Press, 1986), pp. 64–91.

2. Jules D. Prown, *John Singleton Copley*, 2 vols. (Cambridge, Mass.: Harvard University Press, 1966), vol. 1, pp. 61–63, 77, 84; Marc Simpson, Sally Mills, and Jennifer Saville, *The American Canvas: Paintings from the Collection of the Fine Arts Museums of San Francisco* (New York: Hudson Hills Press, 1989), pp. 32–33. Most of the FAMSF curatorial file material cited in this essay was gathered by these authors.

3. Rev. Richard Townsend Henshaw, compiler, *Belcher-Henshaw and Other Ancestry of Richard Townsend Henshaw, 1882–1938 of Rye, New York with a Record of His Descendants* (New Orleans: Polyanthos, 1983), pp. 137; Albert Harrison Hoyt [and Andrew Henshaw Ward], "A Sketch of the Life of Hon. Joshua Henshaw, with Brief

Notices of Other Members of the Henshaw Family," *New England Historical and Genealogical Register* 22, no. 2 (April 1868), pp. 105–15 at 106; Ledyard Bill, *The Bill Genealogy* (New York, 1867), p. 112.

4. John W. Tyler, *Smugglers and Patriots: Boston Merchants and the Advent of the American Revolution* (Boston: Northeastern University Press, 1986), pp. 25–150.

5. Henshaw, *Belcher-Henshaw*, pp. 137–38; Hoyt, "Sketch," pp. 111–14.

6. See Prown, *Copley*, vol. 1, figs. 238, 306, 307, 308; the portrait of Henshaw's daughter Sarah (at Bayou Bend, Museum of Fine Arts, Houston) is similar in date and format to, but in medium and size not a pair with that of her husband (private collection).

7. Hoyt, "Sketch," p. 109. This painting is now unlocated.

8. Richard H. Saunders and Ellen G. Miles, *American Colonial Portraits: 1700–1776* (Washington, D.C.: Smithsonian Institution Press, 1987), p. 16; Prown, *Copley*, vol. 1, p. 129.

9. Louise Lippincott, *Selling Art in Georgian London: The Rise of Arthur Pond* (New Haven: Yale University Press, 1983), pp. 65–66.

10. See Chapter 2, pp. 43–44.

11. For standardization of portrait sizes, see Chapter 3, p. 13.

12. Karin Calvert, *Children in the House: The Material Culture of Early Childhood, 1600–1900* (Boston: Northeastern University Press, 1992), pp. 43–44.

13. See also Chapter 3, fns 26, 36; Calvert, *Children*, p. 44.

14. Aileen Ribeiro, "'The Whole Art of Dress': Costume in the Work of John Singleton Copley," pp. 103–15, in *John Singleton Copley in America*, ed. Carrie Rebora, Paul Staiti et al. (New York: Metropolitan Museum of Art, 1996), pp. 111–13; see also Copley, *James Gambier*, 1773, at the Museum of Fine Arts, Boston.

15. See discussion of Copley and perspective in Chapters 2 and 6.

16. This group includes *Thomas Boylston* (1767), *Rev. Thomas Cary* (1773), *Joseph Sherburne* (1767–70), *Thomas Hubbard* (c. 1767); several small heads of banyan-clad merchants and artisans might also be included here: *Nathaniel Hurd* (c. 1765), *Ebenezer Storer* (1767–1769), *Joseph Barrell* (1767–1769), *Joseph Green* (1767), and *Jonathan Jackson* (1767–1769).

17. Nicholas Boylston was a general merchant; his brother Thomas (also painted in a banyan by Copley) was a merchant, slaver, and smuggler (Tyler, *Smugglers*, pp. 260–61).

18. Ribeiro, "Dress," p. 113.

19. Concerning sentiment see John Mullen, *Sentiment and Sociability: The Language of Feeling in the Eighteenth Century* (Oxford: Clarendon Press, 1988); Adam Smith, *The Theory of Moral Sentiments* (London: Printed for A. Miller, A. Kincaid, and J. Bell, 1759); G. J. Barker-Benfield, *The Culture of Sensibility: Sex and Society in Eighteenth-Century Britain* (Chicago: University of Chicago Press, 1992).

20. See letter, John Bours, Portsmouth, Rhode Island, to Stephen Gould, Newport, September 5, 1814 (Redwood Library and Athenaeum); and George C. Mason, 1890, pp. 12, 34, 165, cited in http://www.worcesterart.org/collection/Early_American/Artists/copley/john—bours.

21. Unknown critic, The *Morning Chronicle and Morning Advertiser*, April 25, 1778, as cited in Emily B. Neff and William L. Pressly, *John Singleton Copley in England* (Houston: Museum of Fine Arts, 1995), p. 104; for a thoughtful summary of the readings of

this work, see Louis P. Masur, "Reading Watson and the Shark," *New England Quarterly.* 67, no. 3 (September 1994), pp. 427–54.

22. The one exception to the ruffled cuff rule for gentlemen in Copley's oeuvre is the odd *Eleazar Tyng* (National Gallery of Art) whose eccentric artisanal cuffs, black wool stockings, and unupholstered Windsor chair belie his great wealth. However, his identity was that of a farmer and not an urban gentleman (see Rebora et al., *John Singleton Copley* [New York: Metropolitan Museum of Art, 1996], pp. 307–9). For an extended comparison of Revere and General Thomas Gage, see David Hackett Fischer, *Paul Revere's Ride* [New York: Oxford University Press, 1994], pp. 30–64 and passim.

23. In terms of absolute wealth, Jules David Prown places Revere and Hurd in the "medium" income group of Copley patrons, positioning them with the general Thomas Gage and the merchant John Bours, discussed earlier, as well as with the sons of Joshua Henshaw and the renowned lawyer James Otis (Prown, *Copley*, vol. 1, p. 127).

24. Charles F. Adams, Guernsey Jones, and Worthington C. Ford, eds., *Letters and Papers of John Singleton Copley and Henry Pelham, 1739–1776* (Boston: Massachusetts Historical Society Collections, 1914) , vol. 71, pp. 8, 18, 20.

25. Kathryn Buhler, *American Silver, 1655–1825 in the Museum of Fine Arts, Boston*, 2 vols. (Boston: Museum of Fine Arts, 1972), vol. 1, pp. 48, 312; in 1819 this teapot was inventoried in Benjamin Pickman's effects as "1 teapot 22 oz at 1.20 $26.40"; see also Jonathan L. Fairbanks, *New England Begins: The Seventeenth Century*, 3 vols. (Boston: Museum of Fine Arts, 1982), vol. 2, p. 500.

26. Revere's portrait remained in the Revere family until given to the Museum of Fine Arts, Boston, in 1930; Hurd remained a bachelor so his painting descended in a collateral line (Rebora et al., *Copley*, pp. 208–11, 246–49).

27. Laurel Thatcher Ulrich, *The Age of Homespun: Objects and Stories in the Creation of an American Myth* (New York: Knopf, 2001), pp. 182–83; Buhler, *American Silver*, vol. 2, pp. 408–9.

28. Lord Chesterfield (Philip Dormer Stanhope), *The Elements of Polite Education* (1774; reprint, London: R. Phillips, 1800), p. 310.

29. See Calvin Martin, *Keepers of the Game: Indian-Animal Relationships and the Fur Trade* (Berkeley: University of California Press, 1978).

30. Marcia Pointon, *Hanging the Head: Portraiture and Social Formation in Eighteenth-Century England* (New Haven: Yale University Press, 1993), pp. 128–30.

31. Prown defines this paring down as an abstract style shift (*Copley*, vol. 1, pp. 73–78).

32. See Chapter 3, notes 12, 18 and pp. 54–58.

33. *Copley-Pelham Letters*, pp. 67, 70.

34. *Copley-Pelham Letters*, p. 313 (a letter of April 7, 1775, from Joshua Wentworth in Portsmouth, N.H., to Henry Pelham as Copley's agent).

35. See, for instance, *Isaac Smith*, 1769 (fig. 55), *John Hancock*, 1765 (Museum of Fine Arts on deposit from the City of Boston), *John Erving*, c. 1772 (private collection), and *Eleazer Tyng*, c. 1772 (National Gallery of Art); see also *Copley-Pelham Letters*, p. 74.

36. Tyler, *Smugglers*, pp. 50, 254, 258, 266.

37. Tyler, *Smugglers*, pp. 29, 260, 266.

38. Hoyt, "Sketch," p. 11; *A Report of the Record Commissioners of the City of Boston Containing the Records of the Boston Selectmen* (Boston, 1900), vol. 4, p. 655.

39. Hoyt, "Sketch," p. 12.

40. Tyler, *Smugglers*, pp. 105, 254, 266.

41. Nonimportation agreement, March 1, 1768 (Massachusetts Historical Society); documents concerning seizure of Mr. Hancock's sloop, 1768–69 (Massachusetts Historical Society); Tyler, *Smugglers*, pp. 255, 266–67.

42. Dorchester Antiquarian and Historical Society, *History of the Town of Dorchester, Massachusetts* (Boston: Dorchester Antiquarian and Historical Society, 1859), p. 321.

43. Hoyt, "Sketch," p. 12; Massachusetts Historical Society *Proceedings* 11 (1869), pp. 140–42; Tyler, *Smugglers*, pp. 255, 266–67.

44. Hoyt, "Sketch," p. 13.

45. Tyler, *Smugglers*, pp. 253, 258–77; Prown places him in the "high" income group among Copley's (all wealthy) patrons (*Copley*, vol. 1, p. 127).

46. Hoyt, "Sketch," pp. 106, 109.

47. Hoyt, "Sketch," p. 106; Bill, *Bill Genealogy*, p. 112; Tyler, *Smugglers*, p. 266.

48. In an unusual move, Richard Bill's probate inventory includes this portrait, valuing at £15 a work Bill had commissioned for £50 two decades earlier (Richard Saunders, *John Smibert: Colonial America's First Portrait Painter* [New Haven: Yale University Press, 1995], p. 179).

49. Ledyard Bill indicates that the Smibert portraits of Richard Bill and his daughter Elizabeth were in the possession of Andrew Henshaw Ward (of Newton, Massachusetts) when he visited Ward in the summer of 1862, and that both paintings had passed into the possession of Ward's granddaughter, Mrs. Miles Washburn of Newton Corner, by 1867 (Bill, *Bill Genealogy*, pp. iv, 110, 111); Hoyt, "Sketch," p. 109. Smibert's Notebook records the commission for the half-length Richard Bill portrait (for the largest sum Smibert had charged to date for a single-figure half-length canvas) in March 1733. No commission for Elizabeth's portrait is noted; it is possible that her image was painted by another artist, but it is more likely that hers is the portrait Smibert recorded as "A Lady 3/4 [canvas] 25/0/0" in July 1733 (Andrew Oliver, *The Notebook of John Smibert* [Boston: Massachusetts Historical Society, 1969], p. 89).

50. Marc Simpson (curator), memo of record of visit of Jules Prown, February 12, 1985; Elizabeth Cornu (conservator), conservation report, March 19, 1993, Fine Arts Museums of San Francisco curatorial file.

51. Morrison H. Heckscher, "Copley's Picture Frames," in *John Singleton Copley in America*, exhib. cat., ed. Carrie Rebora et al. (New York: Metropolitan Museum of Art, 1996), pp. 143–59.

52. Heckscher cites records in which Copley charged Ezekiel Goldthwait, for instance, £19/12/0 for each of a pair of half-length portraits, and £18/0/0 for their matching frames (Heckscher, "Frames," p. 154, figs. 143, 144); see also Barbara M. Ward and Gerald W. R. Ward, "The Makers of Copley's Picture Frames: A Clue," *Old-Time New England* 47 (Summer–Fall 1976), pp. 16–20.

53. Heckscher, whose project is to categorize styles, establish chronologies, and propose carver attributions for these frames, finds the Joshua Henshaw frame "puzzling" in that its vocabulary of ornament falls outside those of the two workshop clusters he has identified. However, on the basis of material (white pine), general character, and structure (spline-less corners) he groups it with frames in the "Boston manner" and agrees that it is of local manufacture and original with this painting, as does Jules Prown.

(Heckscher, "Frames," pp. 143, 148, 150, 157; Simpson, memo of record, Prown visit February 11, 12, 1985).

54. Other Copley portrait frames with coats of arms include those for *Thomas Hollis*, 1754–56 (Harvard University), *Nathaniel Sparhawk* (escutcheon now missing, 1764, Museum of Fine Arts, Boston, see fig. 4), and *Richard Dana*, c. 1770 (private collection).

55. Fairbanks, *New England Begins*, vol. 2, pp. 402, 471.

56. A rare embroidered example survives by an unknown Boston needlewoman of the Carpenter family arms, c. 1750–77, Milwaukee Art Museum. Others are carved of wood, but most were painted on canvas. See Georges Duby, *The Knight, the Lady, and the Priest: The Making of Modern Marriage in Medieval France* (New York: Pantheon, 1983).

57. Robert Dale, mss 1701, Herald's Office, London, as cited in Hoyt, "Sketch," p. 114. B. Pendley for H. E. Paston-Bedingfeld of the College of Arms reports a slight variant in a letter of 14 October 1988, concerning "Grants 2-657. This grant to Thomas Henshaw . . . 26 June 1611: 'Arms: Argent a chevron Ermine between three Moore cocks Sable beaked and legged Gules./ Crest: A falcon seasing on a wing Gold with a crown about the neck Gules beak and legs Sable with bells of the first'" (www.blueneptune.com/~hinshaw/coa—rpt.htm).

58. This account is based on Hoyt, "Sketch," pp. 112, 114–15; Henshaw, *Belcher-Henshaw*, p. 135; the geneology of 1701 was drawn up by Robert Dale, genealogist, and entered into Joshua Henshaw's suit in Court of Chancery (Hoyt, "Sketch," p. 115). The Chancery Court documents and Herald's College documents were inspected and copied in 1844 by John Henshaw of Boston and in 1892 by William Griffith Henshaw of California (Sarah Edwards Henshaw, *Our Family* [Oakland, Calif., 1894], pp. 6–7).

59. In 1843, the city of Liverpool purchased Wavertree, then understood to be "an old fashioned mansion" and its park, "demolished [the building and divided the] grounds . . . between City Park and [the] Botanical Gardens" (J. A. Picton, *Memorials of Liverpool: Historical and Topographical*, 2 vols. [London: Longmans, Green, 1875], vol. 1, pp. 79, 83, vol. 2, pp. 152, 335–36, 439–40; Edward Baines, *History of the County Palatine and Duchy of Lancaster*, 4 vols. [London, 1836], vol. 4, p. 177; S. E. Henshaw, *Family*, p. 12). Katherine Houghton's grandmother was Margaret Stanley (descendant of John of Gaunt and daughter of the Earl of Derby) and it was through the Stanleys that she came into possession of Wartree Hall, Penketh Hall, and ten other properties including lands in the city of Liverpool (Baines, *Lancaster*, vol. 3, p. 759; S. E. Henshaw, *Family*, pp. 14–15, 19.

60. Hoyt, "Sketch," p. 112; Thomas Henshaw had a brother John who removed to Ireland, married, and produced a line of Henshaw/Hinshaws, some of whom emigrated separately to America (to the Southern states) in the eighteenth century (http://freepages.genealogy.rootsweb.com/~summer/Hinshaw.htm).

61. Hoyt, "Sketch," p. 112. The marriage settlement of Margaret Stanley and Richard Houghton (1585), the great-grandparents of these boys, provided that, should issue fail, property would revert to "right heirs" of respective families. Ambrose's tenuous claim to the property, then, was contingent on the death/disappearance of the boys (Henry Oswals Aspinall, *The Aspinwall and Aspinall Families of Lancashire, A.D. 1189–1923* [Exeter: William Pollard, 1923], pp. 21, 46; S. E. Henshaw, *Family*, pp. 15–17). The Ambrose kin were in the neighborhood and knowledgeable concerning the legal and real estate affairs of this family (J. Brownbill, *A Calendar of That Part of the Collection*

of Deeds and Papers of the Moore Family of Bankhall, Co. Lancashire Now in the Liverpool Public Library [Liverpool: Records Society, 1913], p. 161).

62. Hoyt, "Sketch," p. 112; S. E. Henshaw, *Family*, p. 20.

63. Barry Richard Burg, *Richard Mather of Dorchester* (Lexington: University of Kentucky Press, 1976), p. 6; Baines, *Lancaster*, vol. 4, p. 195; Increase Mather, *The Life and Death of That Reverend Man of God, Mr. Richard Mather, Teacher of the Church in Dorchester in New England* (1670; reprint, Boston: David Clapp, 1874), pp. 44–46. For an account of the Puritans of Toxteth Park see Ramsay Muir, *A History of Liverpool* (London: Williams and Norgate, 1907), pp. 112–15; and Picton, *Memorial*, vol. 2, pp. 450–61.

64. Burg, *Mather*, pp. 7, 10; Baines, *Lancaster*, vol. 4, p. 196; Barry A. Cotton, "Aspinwall & Mather 1600s Lancashire, UK" at *genforum.genealogy.com*; I. Mather, *Richard Mather*, pp. 47–53.

65. Aspinall, *Aspinall Families*, pp. 15, 21; George Chandler, *Liverpool Under Charles I* (Liverpool: Brown, Picton, and Hornby Libraries, 1965), p. 182.

66. Robert Middlekauff, *The Mathers: Three Generations of Puritan Intellectuals, 1596–1728* (Oxford, Oxford University Press, 1971), pp. 44–45, 59; I. Mather, *Richard Mather*, pp. 55–66.

67. Burg, *Mather*, p. 19; Increase Mather, ed., *Journal of Richard Mather* (1635), reprint, Dorchester, Mass.: *Collections of the Dorchester Antiquarian and Historical Society*, no. 3, 1874, pp. 5–32.

68. Richard Mather published two pamphlets in New England addressed as "Exhortation[s] to our Countreymen of Lancashire" in 1645 and 1650 (Huntington Library).

69. The Chetham Society, *The Historical and Literary Remains Connected with the Palatine Counties of Lancaster and Chester* (114 vols. in the series, 1843–1886), vol. 9, pp. 13–15; vol. 12, p. xlii; vol. 22, p. 535; vol. 47, pp. 94–95; vol. 105, pp. 154–76; *Die Veneris*, October 20, 1646 (www.covenanter.org, the home page of the Reformed Presbyterian Church).

70. Chandler, *Liverpool*, pp. 189, 169; Chetham Society, *Historical and Literary Remains*, vol. 105, p. 176.

71. Clifton K. Shipton, *Sibley's Harvard Graduates: Biographical Sketches of Those Who Attended Harvard College*, 19 vols. (Boston: Massachusetts Historical Society, 1873–1999), vol. 1, pp. 381–82, 554.

72. Dorchester Antiquarian and Historical Society, *History of the Town of Dorchester, Massachusetts* (Boston, 1859), pp. 27, 53, 181 (hereafter *History of Dorchester*); Joshua Ambrose graduated from Harvard College in 1653 and subsequently went "home," becoming a conforming minister at Darley in Lancaster County; Nathanial Ambrose also graduated from Harvard College in 1653, became a fellow of the College, and then went home to England becoming minister at Kirkby in Lancaster County; he was a nonconformist (James Savage, *A Genealogical Dictionary of the First Settlers of New England Before Showing Three Generations of Those Who Came Before May 1692 on the Basis of Farmer's Register*, 4 vols. [Boston: Little Brown, 1860–62], vol. 1, pp. 44–53).

73. Quoted in unknown, Hinshaw Family Association: www.blueneptune.com. To give a sense of the value of this £30: in 1659, Liverpool Castle was demolished and the salvaged materials (notably the lead roofs) were valued at £35; a substantial house on the site was valued at £100 (Baines, *Lancaster*, vol. 4, p. 187). See also Aspinall, *Aspinall Families*, p. 15.

74. Josselyn, quoted in *History of Dorchester*, p. 29.

75. *History of Dorchester*, pp. 181, 186.

76. *History of Dorchester*, p. 186.

77. Ordinance dated 1659, *History of Dorchester*, p. 188.

78. *History of Dorchester*, p. 181.

79. I. Mather, *Richard Mather*, p. 42.

80. 1655, *History of Dorchester*, p. 184.

81. The petition was designed to ensure local governance in the "making and executing [of] all laws for the government of this people not repugnant to the laws of England," *History of Dorchester*, p. 196.

82. *History of Dorchester*, p. 211.

83. *History of Dorchester*, pp. 255–57.

84. Hoyt, "Sketch," p. 112; see also S. E. Henshaw, *Family*, pp. 24–29; Chetham Society, *Historical and Literary Remains*, vol. 21, p. 169; vol. 105, p. 176.

85. G. A. Chinnery, *Records of the Borough of Leicester*, vol. 6: *The Chamberlain's Accounts, 1688–1838* (Leicester: Leicester University Press, 1967), pp. 16, 21, 31, 138, 183, 231, 281, 337.

86. Hoyt, "Sketch," pp. 112, 113.

87. S. E. Henshaw, *Family*, pp. 44–45; Hoyt, "Sketch," p. 111.

88. Probate Inventory of Daniel Henshaw, Leicester, Worcester County, Massachusetts (curatorial file, FAMSF; many of the probate and gravestone transcription records in the FAMSF files were assembled by Helen Fitch Emery of Wayland, Mass., for whose labors both the staff of the Fine Arts Museums of San Francisco and this author are deeply grateful) (hereafter Probate Daniel Henshaw); S. E. Henshaw, *Family*, p. 9; Hoyt, "Sketch," p. 111; *Sibley's Harvard Graduates*, vol. 15, p. 400.

89. Dec. 14, 1773, mss Huntington Library HM1570.

90. Hoyt, "Sketch," p. 108. Copley's pastel portrait of Mrs. Joseph Henshaw (Sarah Henshaw) is at the Museum of Fine Arts, Houston.

91. Henshaw, *Belcher-Henshaw*, pp. 136–37; mss letter Daniel Henshaw of Boston and Winchendon, to Doct. Joshua Henshaw Hayward of Boston, August, 16, 1829, at American Antiquarian Society, Box 1, folder 2 (I am indebted to MaryKate McMaster for transcribing this letter).

92. Probate Daniel Henshaw; S. E. Henshaw, *Family*, p. 9; Hoyt, "Sketch," p. 111.

93. Hoyt, "Sketch," p. 108.

94. Hoyt, "Sketch," p. 108;

95. Hoyt, "Sketch," pp. 108–9.

96. William Hogarth, *The Analysis of Beauty Written with a View to Fixing the Fluctuating Ideas of Taste* (London: J. Reeve, 1753), pp. viii, 81–83; Francis Haskell and Nicholas Penny, *Taste and the Antique: The Lure of Classical Sculpture, 1500–1900* (New Haven: Yale University Press, 1981), pp. 6, 11, 17, 141–43. The "Antinous" enjoyed widespread admiration and familiarity—through copies, miniatures, printed engravings, and guide books—in the sixteenth, seventeenth, and eighteenth centuries, but has subsequently "sunk almost without trace from general consciousness" (Haskell and Penny, *Antique*, p. xiv).

97. Probate Daniel Henshaw.

98. Hoyt, "Sketch," p. 114.

99. Kopytoff, "Cultural Biography," pp. 64–91; objects in public collections are "decommodified" in the sense that they do not have commodity value; except when stolen, insured for transport, or deaccessioned values are generally not researched or assigned and then only by reference to "similar" objects exchanged between a willing seller and a willing buyer at auction.

100. Suffolk County Probate record 16376, 1777 (FAMSF curatorial file).

101. The genealogical material that follows was extracted from Hoyt, "Sketch"; Henshaw, *Belcher-Henshaw*; transcription of grave markers in Wayland, Mass.; Daniel Henshaw letter, 1829, American Antiquarian Society; http//:wwwblueneptune.com/cgi-bin/cgiwrap/hinshaw/id?; and *Sibley's Harvard Graduates*, vol. 12, pp. 268–71, 371; vol. 15, pp. 400–403, 439–40; vol. 17, pp. 32–36, 107, 580.

102. The two Smiberts descended in the line of either David (1744–1808), whose daughter was Sarah Henshaw Ward (1787–1863), or Elizabeth Bass Henshaw, whose grandson Andrew Henshaw Ward (1784–1864) of West Newton married his cousin, Sarah Henshaw Ward, as these paintings were in the possession of that couple in 1862 (Bill, *Bill Genealogy*, p. iv). Andrew Henshaw Ward had gathered the materials that were subsequently published by Hoyt, "Sketch." A Worcester-area grandniece of Joshua Henshaw, Ruth Henshaw Bascom, became a portraitist, perhaps in part in response to the importance of portraits within the family.

103. *Sibley's Harvard Undergraduates*, vol. 17, pp. 32–36.

104. Will of Sarah Henshaw Hayward, 1849, will 36417, Suffolk County, Mass., Probate Records, vol. 147 (second series), p. 236. She died at her Boston home (*Massachusetts Vital Records, Archives: Boston Deaths* [Boston: City Register, 1849], item 65, vol. 41, p. 217) (FAMSF curatorial files).

105. Bellows Genealogy; *Sibley's Harvard Graduates*, v. 17, pp. 32–34.

106. Exhibited as no. 202 and no. 12, respectively (FAMSF curatorial file).

107. Mabel Munson Swan, *The Athenaeum Gallery, 1827–1873: The Boston Athenaeum as an Early Patron of Art* (Boston: Boston Athenaeum, 1940), pp. 4–17, 20, 134.

108. Swan, *Athenaeum*, p. 18.

109. Swan, *Athenaeum*, pp. 21, 35.

110. Will of Sarah Henshaw Hayward, 1849.

111. Bellows Genealogy, pp. 191–92.

112. Will of Sarah Henshaw Hayward, 1849.

113. Hoyt, "Sketch."

114. Appraisal, March 29, 1886, Probate Court, Middlesex County, estate of J. McL. Henshaw, Probate No. 20239 (second series); Gravemarker, North Cemetery, Wayland (FAMSF curatorial file).

115. Letter, February 1962, Mary Binny Wakefield to T. Howe (FAMSF curatorial files); conversation M. B. Wakefield with the author April 12, 2002.

116. http://www.wayland.ma-us/town—summary—page.htm.

117. "It was loaned to the MFA by Sidney W. Hayward from Nov. 10, 1919 to Nov. 27, 1942," correspondence, G. Mott (MFA) to S. Mills (FAMSF) (FAMSF curatorial file).

118. FAMSF files. A similar perspective is evident in the announcement of the arrival of the painting in San Francisco. See Alfred Davidson, "Important Copley Goes West," *Art Digest* 17, no. 18 (July 1943), p. 10.

119. February 1962 letter, Wakefield; personal communication with author, April 2002.

120. Quoted in William Dunlap, *A History of the Rise and Progress of the Arts of Design in the United States*, 3 vols. (1834: reprint, Boston: C. E. Goodspeed, 1918), vol. 1, p. 110.

Chapter 5. The Family

Earlier versions of materials incorporated into this chapter appeared under the title "Reading Eighteenth-Century American Family Portraits: Social Images and Self-Images" in *Winterthur Portfolio* 22, no. 4 (Winter 1987), pp. 46–71, in *Critical Issues in American Art*, ed. Mary Ann Calo (New York: HarperCollins, 1998), pp. 35–45, and, published under the title "To Be 'Conspecuous in the Croud': John Singleton Copley's *Sir William Pepperrell and His Family*," *North Carolina Museum of Art Bulletin* 15 (1991), pp. 30–42.

1. See, for instance, John Mullan, *Sentiment and Sociability: The Language of Feeling in the Eighteenth Century* (Oxford: Clarendon Press, 1988).

2. George Kubler, *The Shape of Time: Remarks on the History of Things* (New Haven: Yale University Press, 1962).

3. Lawrence Stone, *The Family, Sex, and Marriage in England, 1500–1800* (London: Weidenfeld and Nicolson, 1977), pp. 12, 20; Neil McKendrick et al., *The Birth of a Consumer Society: The Commercialization of Eighteenth-Century England* (Bloomington: Indiana University Press, 1982), p. 10 and passim; John Demos, *Past, Present and Personal: the Family and the Life Course in American History* (Oxford: Oxford University Press, 1986), p. 60; see also G. J. Barker-Benfield, *The Culture of Sensibility: Sex and Society in Eighteenth-Century Britain* (Chicago: University of Chicago Press, 1992).

4. Henry Glassie, *Folk Housing in Middle Virginia* (Knoxville: University of Tennessee Press, 1975), pp. 66–193; for a rather different demand-side model of invention, production, and consumption, see Cary Carson, "The Consumer Revolution in Colonial British America: Why Demand?" in *Of Consuming Interests: The Style of Life in the Eighteenth Century*, ed. Cary Carson, Ronald Hoffman, and Peter J. Albert (Charlottesville: University Press of Virginia, 1994), pp. 483–697.

5. François Nivelon, *The Rudiments of Genteel Behaviour* (London, 1737), n.p. Concerning the standardization of canvases and formats, see Chapter 3, especially n 16.

6. That the portraits were intended to be hung facing one another is indicated by such contemporary documents as the parental pair on the wall in Johann Zoffany's *Prince George and Prince Frederick in an Interior in Buckingham House* (1765, Royal Collection); that the convention was commonly understood is suggested by William Hogarth's pointed and witty inflection of the betrothed couple *away* from each other in *Marriage a la Mode: The Marriage Contract* (1743–45, National Gallery, London).

7. Philippe Ariès, *Centuries of Childhood: A Social History of Family Life*, trans. Robert Baldick (New York: Random House, 1960), p. 353; Georges Duby, *The Knight, the Lady and the Priest: The Making of Modern Marriage in Medieval France*, trans. Barbara Bray (New York: Pantheon, 1983), pp. 228ff. Other English dual portraits from the first half of the eighteenth century include Arthur Devis's *William Atherton and His Wife, Lucy* (c. 1744, Walker Art Gallery, Liverpool), and *Mr. and Mrs. Hill* (1750, Yale Center of British Art).

8. Other examples include John Trumbull, *Governor Jonathan Trumbull and Mrs.*

Jonathan (Faith Robinson) Trumbull (1778, Connecticut Historical Society); and Ralph Earl, *Justice Oliver Ellsworth and His Wife* (1792, Wadsworth Atheneum).

9. Stone, *Family*, pp. 8, 325–404; English dual-figure portraits, such as Henry Raeburn's *Sir John and Lady Clark of Penicuik* (c. 1790, Sir Alfred Beit Collection) and Thomas Gainsborough's *Mr. and Mrs. Hallett* (1785, National Gallery, London), include similar instances of couples leaning on and touching one another.

10. Ronald Paulson, *Emblem and Expression: Meaning in English Art of the Eighteenth Century* (London: Thames and Hudson, 1975), p. 157.

11. Stone, *Family*, p. 4. Other pre-1760 family groups by American artists include John Greenwood's *Greenwood-Lee Family Group* (1747, private collection) and Joseph Blackburn's *Isaac Winslow and His Family* (1755, Museum of Fine Arts, Boston); English works exhibiting these characteristics include Gainsborough's *Mr. and Mrs. John Gravenor and Their Daughters* (c. 1748–50, Yale Center for British Art), William Hogarth's *William Ashley Cowper with His Wife and Daughter* (1731, Tate Gallery), Devis's *Robert Gwillym of Atherton and His Family* (c. 1749, Yale Center for British Art), and Francis Hayman's *Margaret Tyers and Her Husband* (c. 1750–52, Yale Center for British Art).

12. Karin Calvert, *Children in the House: The Material Culture of Early Childhood, 1600–1900* (Boston: Northeastern University Press, 1992), pp. 19–38.

13. John Witherspoon, "Letters on Education" (1797), quoted in Philip J. Greven, Jr., *Child-Rearing Concepts, 1628–1861: Historical Sources* (Itasca, Ill.: F. E. Peacock, 1973), p. 89.

14. Quoted in Demos, *Past, Present*, p. 14; Ross W. Beales, Jr., "In Search of the Historical Child: Miniature Adulthood and Youth in Colonial New England," in *Growing Up in America: Children in Historical Perspective*, ed. N. Ray Hiner and Joseph M. Hawes (Urbana: University of Illinois Press, 1985), pp. 7–24.

15. Philip J. Greven, Jr., *The Protestant Temperament: Patterns of Child-Rearing, Religious Experience and the Self in Early America* (New York: Knopf, 1977), pp. 29, 274; John Locke, *Some Thoughts Concerning Education* (first published 1693), ed. John W. Yolton and Jean S. Yolton (Oxford: Clarendon Press, 1989); Jean-Jacques Rousseau, *Emile* (first published 1762), trans. Barbara Foxley (London: Everyman, 1993).

16. Karin Calvert, "Children in American Family Portraiture, 1670–1810," *William and Mary Quarterly* 3rd ser., 39, no. 1 (January 1982), pp. 87–113. Surviving coral and bells include a remarkable gold example of c. 1760–70 by Daniel Christian Fueter of New York at the Yale University Art Gallery (1942.91).

17. Francis Haskell and Nicholas Penny, *Taste and the Antique: The Lure of Classical Sculpture, 1500–1900* (New Haven: Yale University Press, 1981), pp. 1–43, 173–75, 141–43, 146–47, 209–10. Copley—and, we can assume, other colonial Americans—had access to books of engravings of these canonical works as we learn from a letter of 1775 in which Copley encouraged his half-brother to consult "the Book of Antique Statues" that he had left in Massachusetts (*Letters and Papers of John Singleton Copley and Henry Pelham, 1739–1776*, ed. Charles F. Adams, Guernsey Jones, Worthington C. Ford [Boston: Massachusetts Historical Society Collections, 1914], vol. 71, p. 338). Conduct manuals continued to proscribe leaning in the second half of the eighteenth century yet we have this evidence that, at least among Americans, it was model deportment in certain familial circumstances (C. Dallett Hemphill, *Bowing to Necessities: A History of Manners in America, 1620–1860* [Oxford: Oxford University Press, 1999]), p. 76.

18. Haskell and Penny, *Antique*, p. 17.

19. Haskell and Penny, *Antique*, pp. xiv, 6, 31, 37, 141–43.

20. William Shakespeare, *Hamlet*, II: ii, 585–86.

21. Adam Smith, *The Theory of Moral Sentiments*, ed. D. D. Raphael and A. L. Macfie (Oxford: Clarendon Press, 1976); Maureen Harkin, "Smith's *The Theory of Moral Sentiments*: Sympathy, Women, and Emulation," in *Studies in Eighteenth-Century Culture*, ed. Carla H. Hay and Sydney M. Conger (Baltimore: Johns Hopkins University Press, 1995), pp. 175–90.

22. Edmund Burke, *Philosophical Enquiry into the Origin of Our Ideas of the Sublime and the Beautiful* (London: Printed for R. and J. Dodsley, 1757), pp. 110–11; Smith, *Theory*, p. 129n.

23. Smith, *Theory*, p. 148.

24. Nancy Falik Cott, *The Bonds of Womanhood: "Woman's Sphere" in New England, 1780–1835* (New Haven, Yale University Press, 1977); Marlene Le Gates, "The Cult of Womanhood in Eighteenth-Century Thought," *Eighteenth-Century Studies* 10, no. 1 (Fall, 1976), pp. 21–39; Mary Beth Norton, *Liberty's Daughters: The Revolutionary Experience of American Women, 1750–1800* (Boston: Little, Brown, 1980), pp. 228–55 and passim; Anthony Fletcher, *Gender, Sex, and Subordination in England, 1500–1800* (New Haven: Yale University Press, 1995).

25. Jean-Jacques Rousseau, *Lettre à M. D'Alembert sur les spectacles* (Amsterdam, 1758), p. 160 (my translation).

26. Stone, *Family, Sex and Marriage*, p. 22.

27. Carole Shammas, "Anglo-American Household Government in Comparative Perspective," *William and Mary Quarterly*, 3rd ser., 52, no. 1 (January 1995), pp. 104–44.

28. Stephen Brobeck, "Images of the Family: Portrait Paintings as Indices of American Family Culture, Structure and Behavior, 1730–1860," *Journal of Psychohistory* 5, no. 1 (Summer 1977), pp. 81–106.

29. John Adams to Benjamin Rush, as quoted in *The Spur of Fame: Dialogues of John Adams and Benjamin Rush, 1805–1813*, ed. John A. Schutz and Douglass Adair (San Marino, Calif.: Huntington Library, 1966), p. 76; see also an entry on this subject in Adams's diary as early as June 2, 1778, in Charles F. Adams, ed., *The Works of John Adams*, vol. 3 (Boston: Little, Brown, 1851), p. 171. In paintings that include only adolescent and grown children with their parents, the mother retreats from prominence. Examples include William Dunlap, *The Dunlap Family* (1788, New-York Historical Society), and Charles Willson Peale, *The Goldsborough Family* (1789, private collection).

30. Other examples include West's *The Holy Family* (c. 1760–63, Old St. Joseph's Church, Philadelphia), and *The Golden Age* (1776, Tate Gallery); and John Trumbull's *St. Jerome at Parma*, after West's copy of Corregio's painting of the subject (1780–81, Yale University Art Gallery), *The Holy Family* (c. 1804, Yale University Art Gallery), and *The Holy Family* (1802–6, Yale University Art Gallery). See also Jules D. Prown, "Benjamin West's Family Picture: A Nativity in Hammersmith," in *Essays in Honor of Paul Mellon*, ed. John Wilmerding (Washington, D.C.: National Gallery of Art, 1986), pp. 269–86. Among his copies of Italian Old Masters Smibert imported and hung in his studio a Holy Family by Raphael which Copley knew and studied in that context (*Copley-Pelham Letters*, p. 304).

31. Other American examples beyond those illustrated and discussed here include

The Peale Family Group (1770, 1809, see plate III), *The Edward Lloyd Family* (1771, Winterthur Museum), and *Gov. Thomas Johnson and Family* (1772, C. Burr Artz Library, Frederick, Md.) by Charles Willson Peale; *The Todd Family* (c. 1785, Detroit Institute of Arts) by an unknown artist; *Sir John Temple and Family* (1784, private collection) and *The Vernet Family* (1806, Yale University Art Gallery) by Trumbull; and West's *Portrait of Arthur Middleton, His Wife, and Their Son, Henry* (1770–71, fig. 15).

32. Other folk, or naïve, family portraits include Earl, *The Angus Nickerson Family* (c. 1790, Museum of Fine Arts, Springfield, Mass.), William Wilkie, *Nathan Hawley and Family* (1801, Albany Institute); unknown artist, *The Sargent Family* (1780, National Gallery of Art, Washington, D.C.); and William Williams, *The Denning Family* (1772, private collection).

33. See Henry Glassie, "Folk Art," in *Folklore and Folklife: An Introduction*, ed. Richard M. Dorson (Chicago: University of Chicago Press, 1972), pp. 253–80; Ian M. G. Quimby and Scott T. Swank, eds., *Perspectives on American Folk Art* (New York: W. W. Norton, 1980; and M. M. Lovell, "Folk Painting—An Oxymoron or a Threat to Folk Orthodoxy?" *American Quarterly* 42, no. 1 (March 1990), pp. 153–60.

34. *Copley-Pelham Letters*, pp. 294–308.

35. Quoted in David McCullough, *John Adams* (New York: Simon and Schuster, 2001), pp. 149–50; John Singleton Copley's *Copley Family* was displayed, according to the memory of his granddaughter, in the family dining room, although it might have been hung during the late eighteenth century in the artist's studio (Martha Babcock Amory, *The Domestic and Artistic Life of John Singleton Copley, R.A.* [Boston: Houghton Mifflin, 1882; reprint New York, 1969], p. 79).

36. Jaccques Lafaye, "Diferencias historicas: La sociedad de castas en La Nueva Espana" pp. 25–36, Margarita de Orellana, "Diferencias imaginadas: La fiebre de la imagen en la pintura de castas," pp. 51–59; Edward J. Sullivan, "Diferencias pintadas: Un fenomeno visual de America," pp. 60–72; Teresa Castello Yturbide, "Diferencias vestidas: La indumentaria en las castas del mestizaje," pp. 73–78, in Alberto Ruy Sanchez, ed., special volume of *Artes de Mexico no. 8: La Pintura de Castas* (Mexico City: Artes de Mexico y del Mundo, 1998), pp. 25–36, 51–88.

37. Demos, *Past, Present*, p. 30, 49, 57–58.

38. *Copley-Pelham Letters*, August 17, 1774, p. 241.

39. Jules David Prown, *John Singleton Copley*, 2 vols. (Cambridge, Mass.: Harvard University Press, 1966), vol. 2, p. 259.

40. *Copley-Pelham Letters*, July 15, 1774, p. 226.

41. The previous history paintings were *The Ascension* (1775, Museum of Fine Arts, Boston), *Priam Beseeching Achilles for the Body of Hector* (1776, unlocated), and *The Nativity* (1776–77, Museum of Fine Arts, Boston); the previous family portrait (by which I mean two parents and at least one child) was *The Copley Family* (1776–77, National Gallery of Art, Washington, D.C., see fig. 62). for an account of Copley as a history painter and as a painter of modern history see Emily Ballew Neff, *John Singleton Copley in England* (Houston: Museum of Fine Arts, 1996), and William L. Pressly, "The Challenge of New Horizons: Copley's 'Rough and Perilous Asent' 'of that Mighty Mountain Where Everlasting Lauriels Grow,'" in that same volume, pp. 23–59.

42. *Morning Post* [London] April 25, 1778, quoted in Prown, *Copley*, vol. 2, p. 267.

Prown, *Copley*, vol. 2, p. 273 and fig. 379 (Prown attributes the observation to Prof. Benjamin Rowland).

43. Virginia Browne-Wilkinson, *Pepperrell Posterity* (Florence, Italy: privately printed, 1982), p. 126.

44. See Chapters 1 and 3.

45. William Pepperrell II (1696–1759), merchant of Kittery, Maine, was created baronet in 1746. When his grandson died in 1816 the baronetcy became, once more, extinct (see G. E. Cokayne, ed., *Complete Baronetage*, vol. 5, 1707–1800 [Exeter: W. Pollard, 1906]).

46. Browne-Wilkinson, *Pepperrell*, pp. 113–15.

47. Browne-Wilkinson, *Pepperrell*, pp. 112–13, 116.

48. Browne-Wilkinson, *Pepperrell*, pp. 4–23.

49. Browne-Wilkinson, *Pepperrell*, pp. 134–203.

50. Anna Wells Rutledge, "American Loyalists: A Drawing for a Noted Copley Group," *Art Quarterly* 20 (Summer 1957), pp. 195–203; Prown, *Copley*, vol. 2, p. 265, figs. 357–60; Browne-Wilkinson, *Pepperrell*, p. 126.

51. Other examples of nude infants in family portraits include Benjamin West's *Arthur Middleton, His Wife Mary (née Izard), and Their Son Henry*, 1770–1771 (see fig. 15), and West, *The Sheridan Family* (c. 1775–76, Walker Art Gallery, Liverpool).

52. For studies for *Pepperrell Family*, see Prown, *Copley*, vol. 2, figs. 357–61.

53. Note that Perrier, like many seventeenth- and early eighteenth-century interpreters of the antique, reanimated the sculpture, conflating sculpted body with flesh-and-blood body in his mezzotint rendering of both at once.

54. See Chapter 4, discussion of *John Bours* (see fig. 39), and note 21 above.

55. The only other exhibited nude is *Abraham Offering Up His Son Isaac*, shown nearly two decades later, in 1796 (Prown, *Copley*, vol. 2, p. 350).

56. *Copley-Pelham Letters*, p. 194. For an account of West's own acquisition of knowledge of modern and ancient Italy, see Jules David Prown, "Benjamin West and the Use of Antiquity," in Jules D. Prown, *Art as Evidence: Writings on Art and Material Culture* (New Haven: Yale University Press, 2001), pp. 257–80.

57. Jonathan Homer, who attended Boston's South Grammar School from 1766 to 1773, as quoted in Robert Francis Seybolt, *The Public Schools of Colonial Boston, 1635–1775* (Cambridge, Mass.: Harvard University Press, 1935), p. 73.

58. Suffolk County Probate Records, vol. 55, p. 133, Mr. Charles Apthorp, Boston Merchant, January 1759.

59. Isaac de Caus, *Le Jardin de Vuillton, construit par très noble et très Puissant Seigneur Philippe Comte de Pembroke et Mongomeri* (n.p., n.d., between 1626–30), plate 20, quoted in Haskell and Penny, *Antique*, p. 35.

60. Leo Steinberg, "The Glorious Company," in *Art About Art*, ed. Jean Lipman and Richard Marshall (New York: Whitney Museum, c. 1978), pp. 8–31; Haskell and Penny, *Antique*.

61. Pressly, "Challenge," p. 36.

62. Browne-Wilkinson, *Pepperrell*, p. 95.

63. Mrs. F. Nevill Jackson, *Toys of Other Days* (New York: B. Blom, 1968), pp. 161–62; Claude Tchou and René Alleau, eds., *Dictionnaire des jeux* (n.p.: Musée de l'Histoire de l'Education, 1964), pp. 425–27.

64. See, for instance, *The Copley Family* (see fig. 62) and the *Knatchbull Family* (1800–1802, private collection).

65. Prown, *Copley*, vol. 1 p., 7; Browne-Wilkinson, *Pepperrell*, pp. 4–7, 10.

66. Browne-Wilkinson, *Pepperrell*, pp. 4–5.

67. Sir William was the president of the Loyalist Association and the Board of Agents, organizations of expatriate American loyalists designed to further the interests and prosecute the claims of members (Browne-Wilkinson, *Pepperrell*, pp. 122–24).

68. Brown-Wilkinson, pp. 124, 219–20. Pepperrell's total claim was for £35,702/3/8 for house, farms, mills, lands, furnishings, and unpaid notes.

69. Browne-Wilkinson, *Pepperrell*, pp. 155–56.

70. Unnamed critic writing in the *Morning Post*, April 25, 1778, in "Cuttings from English Newspapers on Matters of Artistic Interest, 1686–1835" (London, n.d.), vol. 1, p. 160, cited in Prown, *Copley*, vol. 2, pp. 267–68. A letter to the editor of the *General Advertiser* demurred, praising the "expressive meaning" in Copley's figures in this image and comparing it favorably with Reynolds's *Marlborough Family* (see fig. 64) also of 1778 (*Victoria and Albert Press Cuttings*, vol. 1, p. 160, cited in Neff, *Copley in England*, p. 100).

Chapter 6. The Drawing in the Painting

1. Richard Saunders, *John Smibert, Colonial America's First Portrait Painter* (New Haven: Yale University Press, 1995), p. 172.

2. Theodore E. Stebbins, Jr., *American Master Drawings and Watercolors: A History of Works on Paper from Colonial Times to the Present* (New York: Harper and Row, 1976), p. 14; R. Peter Mooz, "Smibert's Bermuda Group—A Reevaluation," *Art Quarterly*, 33, no. 2 (Summer, 1970), pp. 147–57, p. 148.

3. Characteristc of this "style"-centered interpretation is that found in John Wilmerding, *American Art* (New York: Penguin, 1976), pp. 29, 30; and Wayne Craven, *Colonial American Portraiture: The Economic, Religious, Social, Cultural, Philosophical, Scientific and Aesthetic Foundations* (Cambridge: Cambridge University Press, 1986), pp. 152–77.

4. Rica Jones, "The Artist's Training and Techniques: Changes in Techniques of Painting, 1700–1760," in *Manners and Morals, Hogarth and British Painting, 1700–1760* (London: Tate Gallery, 1987), pp. 23–28.

5. The *modello* (small-scale oil sketch) for this painting is in Dublin at the National Gallery of Ireland. A few drawings for English portraits survive from the seventeenth and eighteenth centuries including some by Lely, Hudson, Tuscher, and Richardson, brought to my attention by Louise Lippincott.

6. "Pictor," in "The Art of Painting, Limning, Etc.," *Universal Magazine* 3 (November 1748), pp. 225–33 at 230–32.

7. George Vertue, *Notebooks*, 7 vols. (original mss. British Museum) (this vol. 3 of Vertue's seven, 1723) (Walpole Society, Oxford), vol. 22 (1934), p. 14; see also Saunders, *Smibert*, pp. 7, 14.

8. Vertue, *Notebooks* (this vol. 3 of Vertue's 7), Walpole v. 22, p. 24; Vertue, *Notebooks* (this vol. 6 of Vertue's 7), Walpole v. 30, 1951–52, pp. 35, 168; Antoine Watteau drew with the Rose and Crown group in 1719–1720 during the period he had placed himself in the care of a London physician in a fruitless search for a cure for his tuberculosis. He must have been quite determined to draw, as doing so in the company of the

Rose and Crown habitués almost certainly threatened his already frail health; at least one other member, Vertue informs us, "excus'd himself being not well . . . [he] cou'd not bear the smoke of the lamp." Vertue, *Notebooks* (this vol. 6 of Vertue's seven), Walpole, v. 29, p. 169.

9. Vertue, *Notebooks* (this vol. 3 of Vertue's 7); (Walpole), vol. 22, p. 24.

10. Michael Baxandall, "English *Disegno*," in *England and the Continental Renaissance: Essays in Honor of J. B. Trapp,* ed. Edward Chaney and Peter Mack (London: Boydell Press, 1990), p. 211.

11. Jonathan Richardson, *An Essay on the Theory of Painting* (first published 1715), in *Works of Jonathan Richardson* (London, 1792), p. 60. I use Richardson here as a widely read popularizer. John Evelyn, *Sculptura or the History of Chalcography*, first published 1662 (1662; reprint, Oxford: C. F. Bell, 1906), pp. 105–6, as cited in Baxandall, *Disegno*, p. 212.

12. John Gwynn, *An Essay on Design* (London, 1749), pp. i–ii.

13. Richardson, *Theory*, pp. 61–62.

14. John Smibert, *The Notebook of John Smibert*, ed. Andrew Oliver (Boston: Massachusetts Historical Society, 1969), pp. 74–77, 99–102.

15. Vertue, *Notebooks* (this vol. 3 of Vertue's 7), Walpole, vol. 22, p. 11.

16. Berkeley as "Hercules" looks up to heaven rather than down at the ground because he is a Christian, not a pagan (observation of Charles F. Montgomery, c. 1978).

17. Vertue, *Notebooks* (this vol. 2 of Vertue's seven); (Walpole), vol. 22, p. 36.

18. First published 1725; George Berkeley, *The Works of George Berkeley, Bishop of Cloyne*, ed. A. A. Luce and T. E. Jessop, 9 vols. (London: Thomas Nelson & Sons, 1964), vol. 7, pp. 335–61.

19. "Verses on the Prospect of Planting Arts and Learning in America." First published in Berkeley's *Miscellany* of 1752 but circulated in manuscript from February 1726, *Works*, vol. 7, pp. 369–71.

20. Berkeley, *Foreign Plantations* in *Works*, vol. 7, p. 358; David Berman and Jill Berman, "The Fountain Portraits of Bishop Berkeley," *Apollo* 115, no. 240 (February 1982), pp. 76–79 at 77.

21. George Berkeley, "Essay Towards Preventing the Ruin of Great Britain," in *The Works of George Berkeley, Bishop of Cloyne*, ed. A. A. Luce and T. E. Jessop, 9 vols. (London: Thomas Nelson, 1964), vol. 6, p. 80.

22. John Adams to Abigail Adams, 1780, as cited in "The Artist Speaks: Part One," *Art in America* 53 (1965), p. 28.

23. Quoted in Benjamin Rand, ed., *Berkeley and Percival: The Correspondence of George Berkeley, Afterwards Bishop of Cloyne and Sir John Percival, Afterwards Earl of Egmont* (Cambridge, Mass.: [Harvard] University Press, 1914), p. 244; in his *Proposal* Berkeley catalogues foodstuffs available on Bermuda, but it is clear that by the time of his first landfall in the New World—and probably much earlier—he had a more realistic perspective concerning provisioning an island-bound university (*Works*, vol. 7, p. 351).

24. Quoted in Henry Foote, *John Smibert Painter* (Cambridge, Mass.: Harvard University Press, 1950), p. 40.

25. Rand, *Berkeley and Percival*, p. 236.

26. Vincent J. Scully, Jr., *The Shingle Style and the Stick Style: Architectural Theory and Design from Downing to the Origins of Wright* (New Haven: Yale University Press, 1955), p. 26.

27. Foote, *Smibert*, p. 42.

28. Annotations by Anne Berkeley of 1776 to Stock's *Account of Berkeley* (1776), cited in Raymond W. Houghton, David Berman, Maureen T. Lapan, *Images of Berkeley* (Dublin: National Gallery of Ireland, 1986), p. 45; see also *Biographia Britannia* (London, 1784), vol. 3, p. 10f, as cited in Saunders, *Smibert*, p. 131, n. 60.

29. Smibert, *Notebook*, pp. 85, 89, 108. See Saunders, *Smibert*, p. 86, for another explanation for the nondelivery of this painting to its purchaser.

30. For accounts of Smibert's studio from the time of his death in 1751 to its dispersal in 1795, see Saunders, *Smibert*, pp. 122–26, and Walter K. Watkins, "The New England Museum and Home of Art in Boston" (paper read 1910), *Bostonian Society Publications*, ser. 2 (1917), pp. 103–30.

31. See, for instance, Henrietta McBurney and Amy R. W. Meyers, *Mark Catesby's Natural History of America* (Houston: Museum of Fine Arts: 1997); and Amy R. W. Meyers, "Imposing Order on the Wilderness: Natural History Illustration and Landscape Portrayal" in *Views and Visions: American Landscape Before 1830,* ed. Edward J. Nygren and Bruce Robertson (Washington, D.C.: Corcoran Gallery, 1986), pp. 104–31.

32. Bruce Robertson, "Venit, Vidit, Depinxit: The Military Artist in America" in *Views and Visions: American Landscape Before 1830,* ed. Edward J. Nygren and Bruce Robertson (Washington, D.C.: Corcoran Gallery, 1986), pp. 83–103.

33. Joseph Ellis and Robert Moore, *School for Soldiers: West Point and the Profession of Arms* (New York: Oxford University Press, 1974), p. 37

34. Edward J. Nygren and Bruce Robertson, eds., *Views and Visions: American Landscape Before 1830* (Washington, D.C.: Corcoran Gallery, 1986), pp. 49, 52, 249–51.

35. The project began during the summer of 1775; its scope increasing considerably before its publication in the summer of 1777 (*Letters and Papers of John Singleton Copley and Henry Pelham, 1739–1776,* ed. Charles F. Adams, Guernsey Jones, Worthington C. Ford [Boston: Massachusetts Historical Society Collections, 1914], pp. 344–47).

36. *Copley-Pelham Letters,* pp. 344–47.

37. John W. Tyler, *Smugglers and Patriots: Boston Merchants and the Advent of the American Revolution* (Boston: Northeastern University Press, 1986), p. 61.

38. George Francis Dow, *The Arts and Crafts in New England, 1704–1775* (Topsfield, Mass.: Wayside Press, 1927), p. 2.

39. Francis Haskell and Nicholas Penny, *Taste and the Antique: The Lure of Classical Sculpture, 1500–1900* (New Haven: Yale University Press, 1981), p. 17.

40. Alice Brayton, *George Berkeley in Newport* (Newport, R.I., and Portland, Me.: Anthoensen Press, 1954), p. 14; Antoinette Downing and Vincent J. Scully, Jr., *The Architectural Heritage of Newport Rhode Island, 1640–1915* (New York: Bramhall House, 1967), p. 440; Saunders, *Smibert*, p. 257.

41. Ann Bermingham, *Learning to Draw: Studies in the Cultural History of a Polite and Useful Art* (New Haven, Yale University Press: 2000), pp. 3–105.

42. Bermingham, *Learning*, p. 90.

43. Clifford K. Shipton, *Sibley's Harvard Graduates: Biographical Sketches of Those Who Attended Harvard College,* 19 vols. (Boston: Massachusetts Historical Society, 1873–1999), vol. 12, pp. 30–32; Essex South District Medical Society, *Memoir of Edward*

A. Holyoke (Boston: Perkins and Marvin, 1829), p. 38; In Salem he boarded with, married, and lived next to the Turners, Pickmans, Sargents, and Brownes (see Chapter 3).

44. Jonathan Richardson, *Two Discourses* (London, 1719), part 2, pp. 41–52, quoted in Louise Lippincott, *Selling Art in Georgian London: The Rise of Arthur Pond* (New Haven, Yale University Press, 1983), p. 101.

45. Franklin Bowditch Dexter, *Biographical Sketches of the Graduates of Yale College,* 6 vols. (New York: H. Holt, 1907), vol. 4, p. 442; Elizabeth Mankin Kornhauser, *Ralph Earl: The Face of the Young Republic* (New Haven: Yale University Press, 1991), pp. 163–64.

46. Robert Francis Seybolt, *The Public Schools of Colonial Boston, 1635–1775* (Cambridge, Mass.: Harvard University Press, 1935), p. 73; Robert Middlekauf, *Ancients and Axioms: Secondary Education in Eighteenth-Century New England* (New Haven: Yale University Press, 1963; reprint, Salem, N.H.: Ayer, 1988), passim.

47. Seybolt, *Schools,* pp. 10, 67, 76; Finance Commission of the City of Boston, *A Chronology of the Boston Public Schools* (Boston: Printing Department, 1912), p. 6.

48. Benjamin Franklin, *The Life of Dr. Benjamin Franklin, Written by Himself* (Philadelphia, 1794), pp. 14–15.

49. Peter Pelham, *Boston Evening Post,* September 13, 27, October 4, 11, 1742, quoted in Seybolt, *Schools,* p. 29.

50. Samuel Scammell, *Boston Evening Post,* November 21, 28, December 5, 1737, quoted in Seybolt, *Schools,* p. 25.

51. Alfred Coxe Prime, *The Arts and Crafts in Philadelphia, Maryland, and South Carolina, 1721–1785* (Topsfield, Mass.: Walpole Society, 1929; reprint, New York: Da Capo Press, 1969), p. 28.

52. *Boston Evening Post,* February 1, 8, 15, 1747, as cited in Seybolt, *Schools,* p. 33.

53. The needlework patterns were created by men paid for that work, in London firms such as Bowles & Carver, or Laurie & Whittle, or Philadelphia firms such as that of John Walters and Thomas Bedwell; patterns were published in catalogues, magazines, and individual sheets. When the designer is mentioned it is in such terms as "engraved by an eminent Artist" or "engraved by the most distinguished Artists" (Davida Tenenbaum Deutsch, "Needlework Patterns and Their Use in America," *Antiques* 139 [February 1991], pp. 368–81).

54. See, for instance, for a rare example of a woman designer, Mrs. Condy, who advertised in 1742 that, for the benefit of her students, "she draws Patterns of all sorts, especially, Pocket-Books, . . . Screens, . . . Chimney-Pieces . . . for Tent-Stitch in a plainer manner and cheaper than those which come from London" (*Boston Evening Post,* March 15, 22, 29, 1742, as quoted in Seybolt, *Schools,* p. 28).

55. Davida Tenenbaum Deutsch, "The Polite Lady: Portraits of American Schoolgirls and Their Accomplishments, 1725–1830," *Antiques* 135 (March 1989), pp. 742–53 at 742.

56. Deutsch, "Polite Lady," p. 744.

57. *Journal and Letters of Philip Vickers Fithian, 1773–1774: A Plantation Tutor of the Old Dominion* (Williamsburg, Va.: Colonial Williamsburg, 1965), p. 42.

58. *Travels in New England and New York,* ed. Barbara Miller Solomon (Cambridge, Mass., 1969), pp. 371–72, as quoted in Deutch, "Polite Lady," p. 749.

59. Vertue, *Notebooks* (vol. 5 of Vertue's seven) (1747) (V.20, [4], B.M. 29) (Walpole),

vol. 26, p. 154, as cited in Shelley M. Bennett, "A Muse of Art in the Huntington Collection," in *British Art, 1740–1820: Essays in Honor of Robert R. Wark,* ed. Gulland Sutherland (San Marino, Calif.: Huntington Library, 1992), p. 58.

60. The interpretation of the artwork on Mrs. Hubbard's plinth as an embroidery pattern is found in Deutch, "Needlework Patterns," p. 378.

61. Bermingham, *Learning,* pp. 3–19; David Rosand, "The Crisis of the Venetian Renaissance Tradition," *l'Arte* 3, nos. 11–12 (1970), pp. 5–53; Baldassare Castiglione, *The Book of the Courtier,* trans. George Bull (1518; Harmondsworth: Penguin, 1976).

62. *Copley-Pelham Letters,* pp. 65–66.

63. Rosand, "Crisis," pp. 25–29.

64. Leon B. Alberti, *Della pittura,* ed. Malle, p. 103, quoted in Rosand, "Crisis," p. 25.

65. Rosand, "Crisis," pp. 25, 29, 32.

66. Bermingham, *Learning,* p. 3.

67. Louise Lippincott argues provocatively that British eighteenth-century history paintings—in spite of theory and public claims—were, in fact, "morally and economically dangerous," entangling both producers and consumers in questionable speculative ventures, while portraits "taught morality, enforced loyalty, and represented tradition." "Subsequent to their manufacture, portraits existed outside the commercial market, belonging instead to what might be called a traditional or gift economy," concluding that "in terms of the marketplace, portraits occupied the moral high ground," "Expanding on Portraiture: The Market, the Public, and the Hierarchy of Genres in Eighteenth-Century Britain," pp. 75–88, in *The Consumption of Culture, 1600–1800: Image, Object, Text,* ed. Ann Bermingham and John Brewer (London: Routledge, 1995), pp. 76, 82, 83.

68. *The Copley Family* was exhibited at the Royal Academy in 1777 within months of the artist's settling in to a new professional life in London. The papers in his hand have been variously described as "a set of drawings" and "some plans" (Emily Ballew Neff, *John Singleton Copley in England* [Houston: Museum of Fine Arts, Houston, 1995], pp. 23, 92–93).

69. William L. Pressly, "The Challenge of New Horizons: Copley's 'rough and perilous Asent' 'of that mighty Mountain where Everlasting Lauriels grow,'" pp. 23–59, in Neff, *Copley in England,* p. 53.

70. Sir Joshua Reynolds, *Discourses on Art,* ed. Robert R. Wark (New Haven: Yale University Press, 1975), pp. 257–58.

71. Norman Bryson, *Vision and Painting: The Logic of the Gaze* (New Haven: Yale University Press, 1983), p. 163; condition report, *Joshua Henshaw,* FAMSF, June 26, 1990: "The right cuff seems to have been reworked at least 3 times. There have been losses in the impasto due to relining. Most of the work is tightly painted, and both glazing and scumbling were used."

72. Castiglione, *Courtier,* pp. 67, 70, quoted in Bermingham, *Learning,* p. 5.

73. Neff, *Copley in England,* pp. 19, 53.

74. Copley's reference to a book of antique statues may have referenced one of the large picture volumes, such as those produced by François Perrier in France, or, less likely, he could have intended the more modest (and unillustrated) work by Jonathan Richardson, *An Account of Some of the Statues, Bas-reliefs, Drawings and Pictures in Italy with Remarks* (London: J. Knapton, 1722); for a discussion of Copley's anatomy drawings see

Jules David Prown, "An *Anatomy Book* by John Singleton Copley," *Art Quarterly* 26 (Spring 1963), pp. 31–46, reprinted in Jules David Prown, *Art As Evidence: Writings on Art and Material Culture* (New Haven: Yale University Press, 2001), pp. 12–25; for a list of the books probably included in Copley's library, see Jules David Prown, *John Singleton Copley* (Cambridge, Mass.: Harvard University Press, 1966), vol. 2, pp. 397–99.

75. John Gwynn, *An Essay on Design* (London, 1749), pp. 32–34.

76. Quoted in Carl Degler, *Out of Our Past: The Forces That Shaped Modern America* (New York: Harpers, 1959), p. 47.

77. For a rumination on this point see Jules D. Prown, "Mind in Matter: An Introduction to Material Culture Theory and Method," pp. 69–95, in Prown, *Art as Evidence*, p. 69.

78. *Copley-Pelham Letters*, p. 65.

79. For entrance requirements to Harvard, see Middlekauff, *Ancients and Axioms*, pp. 76–77.

80. "Architector" [pseud.], "Dissertation on Architecture," *Universal Magazine* 1 (1747), supplement, pp. 378–81; 2 (January 1748), pp. 12–14; 2 (February 1748), pp. 63–64; 2 (March 1748), pp. 110–12.

81. *Biographia Britannia* 1, v. 3, p. 10f.

82. In the 1870s, colonial houses in general and Berkeley's "Whitehall" in particular were being held up to architects as architectural antidotes to "the ambitious dwellings of the present day" that lacked the comfort, warmth, and domestic virtue of these venerable structures, *New York Sketch-Book of Architecture* 1, no. 12 (December 1874), p. 1.

83. Another example, one with pilasters (capped with imported English Portland stone capitals) rather than freestanding columns, the Foster-Hutchinson house in Boston of 1690–92, is discussed in Abbott Lowell Cummings, "The Beginning of Provincial Renaissance Architecture in Boston, 1690–1725," *Society of Architectural History Journal* 42, no. 1 (March 1983), pp. 43–53 at 46–48.

84. Francis S. Drake, *The Town of Roxbury* (Roxbury: Author, 1878), pp. 327–29.

85. Brinley, Berkeley, Smibert, and the architect of King's Chapel, Peter Harrison, all had ties in both Newport and Boston and were instrumental in moving design ideas between these two important urban centers. Brinley's grandson, many years later, married the daughter of Newport's premier cabinetmaker, John Townsend (see chapter 7). Direct English prototypes for "Datchet House" include drawings by Sir James Thornhill and Nicholas Hawksmoor (see H. M. Colvin, comp., *A Catalogue of Architectural Drawings of the Eighteen and Nineteenth Centuries in the Library of Worcester College, Oxford* [Oxford: Clarendon Press, 1964], figs. 119, 120, 121).

86. *Sibley's Harvard Graduates*, vol. 8, pp. 118–24; Benjamin Pickman, "Some Account of Houses and Other Buildings in Salem," 1793, George B. Loring, ed., *Historical Collections of the Essex Institute* 6, no. 3 (June 1864), pp. 94, 98; perhaps the best-known house of this era built on an H-plan around a grand central reception space is Stratford in Westmoreland County, Va.; models include not only Palladio (e.g., Villa Thiene, Cigogna, 1554–56, *Quattro Libri*, vol. 2, p. 62) but also James Gibbs whose *Book of Architecture* (London, 1728) included plans, elevations, and section drawings of such similar structures as Sudbrook House, Petersham, Surrey, 1715–19, plate 40. H-plan houses are also associated with Tudor building, but those discussed here associate that

footprint with the recessed portico used by Palladio, Inigo Jones, James Gibbs, and others, as a variant on the more iconic Italianate centered pedimented portico.

87. Alexander Hamilton, Carl Bridenbaugh, ed., *Gentleman's Progress: The Itinerarum of De. Alexander Hamilton* (Williamsburg, Va.: Colonial Williamsburg, 1948), pp. 120–21.

88. "Architector" [pseud.], *Universal Magazine* 1 (1747), p. 378.

89. Saunders, *Smibert*, p. 114; the nationalizing implications of the advent of domestically produced design books in the following century in terms of builders, professional architects, and popular building is adroitly explored by Dell Upton in "Pattern Books and Professionals: Aspects of the Transformation of Domestic Architecture in America, 1800–1860," *Winterthur Portfolio* 19, nos. 2–3 (Summer-Autumn 1984), pp. 107–50.

90. Bainbridge Bunting, *Harvard: An Architectural History* (Cambridge, Mass.: Belknap Press of Harvard University Press, 1985), p. 25.

91. Copley owned at least one architectural design book, James Gibbs, *Book of Architecture* (1728); Prown, *Copley*, vol. 1, p. 16, n. 3).

92. *Copley-Pelham Letters*, pp. 131, 134, 136–38, 147, 162, 169, 175; Prown, *Copley*, vol. 1, pp. 64–65.

93. Michel de Montaigne, "De la vanité," *Essais*, first published 1580, vol. 3, chap. 9, cited in Haskell and Penny, *Antique*, p. 45.

Chapter 7. Money, Art, Family, and the Cabinetmakers of Newport

An earlier version of this essay was published under the title "'Such Furniture as Will Be Most Profitable': The Business of Cabinetmaking in Eighteenth-Century Newport," *Winterthur Portfolio* 26, no. 1 (Spring 1991), pp. 27–62.

1. "Witchcraft a Felony to Be Punished with Death" (1729) and "An Act to Prevent Disorderly Indian Dances" (1729), in *Rhode Island Laws and Statutes, 1683–1730* (Newport: James Franklin, 1730), pp. 170, 185; see also *Acts and Laws of His Majesty's Colony of Rhode Island . . . from 1745 to 1750* (Newport: James Franklin, 1752), p. 93. By the early eighteenth century most Native Americans in Rhode Island were employed as slaves or servants by the English settlers; as the early Rhode Island historian John Callender put it: "These Narragansets do now [1739] in a Manner cease to be a People, . . . being either scattered about where the English will employ them, or sheltered under the Successors of Ninegret, a Sachem that refused to join in the war, and so has preserved his lands [and freedom] to his Posterity" (John Callender, *Historical Discourse on Rhode Island from 1638 to the End of the First Century* [Boston: S. Kneeland and T. Green, 1739], p. 78). The census of 1774 reported 1,482 Indians in Rhode Island (John Russell Bartlett, ed., *Records of the Colony of Rhode Island*, vol. 7: 1770 to 1776 [Providence: A. Crawford Greene, 1862], p. 253). Concerning the slavery, involuntary indenture, and importation of Native Americans in Rhode Island in 1676–1778, see Almon Wheeler Lauber, *Indian Slavery in Colonial Times Within the Present Limits of the United States* (New York: Columbia University and Longman's, Green, 1913), pp. 110, 128–30, 151, 180, 187, 191–92, 199, 205–6, 235, 248. Concerning the situation of free Native Americans, mulattos, and mustees living on reservation lands in eighteenth-century Rhode Island, see William S. Simmons and Cheryl L. Simmons, eds., *Old Light on Separate Ways: The Narragansett Diary of Joseph Fish, 1765–1776* (Hanover, N.H.: University Press of New England, 1982).

2. Robert Honyman, "Journal of a Trip from Port Royal [Va.] to Boston 1775" (mss. 818, Huntington Library, Art Galleries, and Botanical Gardens), pp. 64, 81.

3. Virgil, *Eclogue* IV, lines 37–45; Tristam Burges, "The Spirit of Independence: An Oration Delivered Before the Providence Association of Mechanics and Manufacturers at Their Annual Election, April 14, 1800" (Providence: B. Wheeler, 1800).

4. Callender, p. 117; for a discussion of self-sufficiency in early America see Carole Shammas, "How Self-Sufficient Was Early America?" *Journal of Interdisciplinary History* 13, no. 2 (Autumn 1982), pp. 247–72; for an opposing view, see James A. Henretta, "Families and Farms: *Mentalité* in Pre-Industrial America," *William and Mary Quarterly,* 3rd ser., 35, no. 1 (January 1978), pp. 3–32; Even in his discussion of an urban community Henretta emphasizes a sense of loss with the replacement of a homogeneous "subsistence" agricultural economy by market consumerism (James A. Henretta, "Economic Development and Social Structure in Colonial Boston," *William and Mary Quarterly*, 3rd ser., 22, no. 1 [January 1965], pp. 75–92. For a discussion of the two prevailing schools of thought concerning the colonial American economy—the staples approach and the Malthusian, or frontier, tradition—see John J. McCusker and Russel R. Menard, *The Economy of British America 1607–1789* (Chapel Hill: Institute of Early American History and Culture, University of North Carolina Press, 1985). For an analysis of the very different Puritan/Congregationalist fishing communities of Gloucester and Marblehead, Massachusetts (emphasizing the survival of a communitarian culture and the limitation of both commercial development and the discordant effects of commercial individualism), see Christine Leigh Heyrman, *Commerce and Culture: The Maritime Communities of Colonial Massachusetts, 1690–1750* (New York: W.W. Norton, 1984).

5. [Peleg Sanford], *The Letter Book of Peleg Sanford of Newport, Merchant (Later Governor of Rhode Island), 1666–1688,* ed. Howard M. Chapin (Providence: Rhode Island Historical Society, 1928); Lynn Withey, *Urban Growth in Colonial Rhode Island: Newport and Providence in the Eighteenth Century* (Albany: State University of New York Press, 1984), pp. 1–6, 15–22, 29, 33–34. Carl Bridenbaugh identified 44 merchants active in Newport and Portsmouth before 1690, and he argues persuasively that from the outset Rhode Island landowners were focused on agribusiness rather than subsistence farming (Carl Bridenbaugh, *Fat Mutton and Liberty of Conscience: Society in Rhode Island, 1636–1690* [Providence: Brown University Press, 1974], pp. 27–60, 137–39). For a discussion of the founding of Rhode Island, its tradition of dissent from Puritan orthodoxy and religious pluralism, see Bruce C. Daniels, *Dissent and Conformity on Narragansett Bay: The Colonial Rhode Island Town* (Middletown, Conn.: Wesleyan University Press, 1983), and David S. Lovejoy, *Religious Enthusiasm in the New World: Heresy to Revolution* (Cambridge, Mass: Harvard University Press, 1985).

6. Janet Schaw, *Journal of a Lady of Quality, Being the Narrative of a Journey from Scotland to the West Indies, North Carolina, and Portugal, in the Years 1774 to 1776*, ed. Evangeline Walker Andrews (New Haven: Yale University Press, 1922), p. 87. See also Bridenbaugh, *Fat Mutton*, pp. 57–60, 122–26; *Commerce of Rhode Island, 1726–1800* (Boston Society, 1914), vols. 9–10 of 7th ser., Collections of the Massachusetts Historical Society, vol. 1, p. 183; and Caroline Hazard, *Thomas Hazard, Son of Robert, Called College Tom* (Boston: Houghton Mifflin, 1893), pp. 63–65.

7. Ezra Stiles Papers: Miscellaneous 1758–62, p.375; and Ezra Stiles Papers: Journals and Memoires, 1760–1762, p. 88, Ezra Stiles Papers, Beinecke Library, Yale University;

Carl Bridenbaugh, *Cities in Revolt: Urban Life in America, 1743–1776* (New York: Oxford University Press, 1955), p. 216; Withey, *Urban Growth*, p. 115.

8. Stiles, Journals, p. 88; for a discussion of monetary values in the eighteenth-century Atlantic marketplace, see John J. McCusker, *Money and Exchange in Europe and America, 1600–1775: A Handbook* (Chapel Hill: University of North Carolina Press, 1978).

9. Considerably more have been noted since the numbers were put at 76 cabinet-makers, 11 chairmakers, and 4 carvers by Morrison H. Heckscher, "The Eighteenth-Century Furniture of Newport, Rhode Island," *Apollo* 111, no. 219 (May 1980), pp. 354–61, at 356. See also Wendell D. Garrett, "The Newport Cabinetmakers: A Corrected Checklist," *Antiques* 73, no. 6 (June 1958), pp. 558–61. No doubt further research will disclose an even greater number.

10. Joseph K. Ott, "Rhode Island Housewrights, Shipwrights, and Related Craftsmen," *Rhode Island History* 31, nos. 2–3 (May and August 1972), pp. 68–70.

11. Jonathan L. Fairbanks and Robert F. Trent, *New England Begins: The Seventeenth Century*, 3 vols. (Boston: Museum of Fine Arts, 1982); Abbott Lowell Cummings, ed., *Rural Household Inventories: Establishing the Names, Uses, and Furnishings of Rooms in the Colonial New England Home, 1675–1775* (Boston: Society for the Preservation of New England Antiquities, 1964), pp. xiii–xxi, 3–108.

12. Peter Thornton, *Seventeenth-Century Interior Decoration in England, France, and Holland* (New Haven: Yale University Press, 1978), pp. 55–63; Sanford records in his letter book the purchase and sale of silver items, ivory-handled knives, laces, and silks (Chapin, *Letter Book*, pp. 45–46, 51); for a sense of a wealthy New Englander's household furnishings in the seventeenth century see Cummings, *Rural Household Inventories*, pp. 9–13, 15–18, 35–37, 54–57.

13. Cary Carson, "Doing History with Material Culture," in *Material Culture and the Study of American Life,* ed. Ian M. G. Quimby (New York: W. W. Norton, 1978), pp. 41–64; Cary Carson, "The Consumer Revolution in Colonial British America: Why Demand?" in *Of Consuming Interest: The Style of Life in Eighteenth-Century America*, ed. Cary Carson, Peter Albert, and Ronald Hoffman (Charlottesville: University Press of Virginia, 1994), pp. 483–697.

14. Henry Glassie, *Folk Housing in Middle Virginia: A Structural Analysis of Historic Artifacts* (Knoxville: University of Tennessee Press, 1975).

15. Neil McKendrick, "Commercialization and the Economy," in *The Birth of a Consumer Society: The Commercialization of Eighteenth-Century England*, ed. Neil McKendrick, John Brewer, and J. H. Plumb (Bloomington: Indiana University Press, 1982), pp. 9–194.

16. Newport's eighteenth-century artists included John Smibert (1688–1751) whose career is discussed in Chapter 6, Robert Feke (c. 1707–?1751), Joseph Blackburn (c. 1700–c. 1765), Samuel King (1749–1820), Charles Reak (fl. c.1775), Washington Allston (1779–1843), and the engraver, pastelist, and print seller Samuel Okey (fl. 1765–1780), who settled in Newport in 1773; most of these worked in Newport only briefly.

17. Landscapes at which their contemporaries marveled included the country estates of Godfrey Malbone, Samuel Elan, Charles Bowler, and Abraham Redwood; see Antoinette F. Downing and Vincent J. Scully, Jr., *The Architectural Heritage of Newport Rhode Island: 1640–1915* (New York: Bramhall House, 1967), pp. 38, 42–43; Richard H. Rudolph, "Eighteenth-Century Newport and Its Merchants II," *Newport History* 51,

part 3, no. 171 (Summer 1978), pp. 45–60, at 46; Sarah S. Cahoone, *Visit to Grand-Papa; or, A Week at Newport* (New York: Taylor and Dodd, 1840); mss 253184, Huntington Library, Art Galleries, and Botanical Gardens; "List," Charles Blaskowitz, *A Topographical Chart of the Bay of Narraganset [and] . . . Rhode Island* (London: Wm. Faden, 1777).

18. Clifford Geertz, "Art as a Cultural System," in Clifford Geertz, *Local Knowledge: Further Essays in Interpretive Anthropology* (New York; Basic Books, 1983), pp. 94–120.

19. The pressures of a twentieth-century market, which placed a premium on Newport-owned objects made for and used by elite customers, appear to have suppressed evidence of more widespread and heterogeneous trade and provenance.

20. Stiles, Journals, p.88; these figures are congruent with Withey, *Urban Growth*, pp. 51–52, 123–32); Alice Hanson Jones, *Wealth of a Nation to Be: The American Colonies on the Eve of the Revolution* (New York: Columbia University Press, 1980), p. 291; and Henretta, "Economic Development," pp. 91–92.

21. Virginia Bever Platt, "Triangles and Tramping: Captain Zebediah Story of Newport, 1769–1776," *American Neptune* (Salem, Mass.: Peabody Essex Museum), 33, no. 4 (October 1973), pp. 294–303; see also Ralph E. Carpenter, Jr., *The Arts and Crafts of Newport Rhode Island, 1640–1820* (Newport: Preservation Society of Newport County, 1954), p. 17.

22. William Ellery (1790s), quoted in Withey, *Urban Growth*, p. 101.

23. *Acts and Laws*, pp. 83–91, 99.

24. Town Meeting, November 26, 1767, as quoted in Jeanne Arthur Vibert, "The Market Economy and the Furniture Trade of Newport, Rhode Island: The Career of John Cahoone, Cabinetmaker, 1745–1765" (master's thesis, University of Delaware, 1981), p. 12.

25. Marilyn Kaplan, "The Jewish Merchants of Newport, 1740–1790," *Rhode Island Jewish Historical Notes* 7, no. 1 (1975), pp. 12–32 at 14, 24; *Acts and Laws*, 1747, p. 47; Withey, *Urban Growth*, pp. 20, 79, 80, 81.

26. John Comer, *The Diary of John Comer*, ed. C. Edwin Barrows (Providence: Rhode Island Historical Society, 1893), p. 56 (the drowning occurred on October 14, 1728). The impressive house built by Stephen Mumford about 1685 is extant (17 Broadway, Newport); see also Shammas, "How Self-Sufficient," p. 265; and Bridenbaugh, *Fat Mutton*, p. 23.

27. Ezra Stiles, *Itineraries,* p. 106. Ezra Stiles Papers, Beinecke Library, Yale University. See also [John Aplin], *Dialogue Between the Governor of the Colony of Rhode Island and a Freemen of the Same Colony* (Newport: James Franklin, 1762).

28. Platt, "Triangles and Tramping," p. 299. See also Virginia Bever Platt, "Tar, Staves, and New England Rum: The Trade of Aaron Lopez of Newport, Rhode Island, with Colonial North Carolina," *North Carolina Historical Review* 48. no. 1 (January 1971), pp. 1–22.

29. Geertz, "Art as a Cultural System," p. 97. Michael Moses, *Master Craftsmen of Newport: The Townsends and Goddards* (Tenefly, N.J.: MMI Americana Press, 1984); Heckscher, "Eighteenth-Century Furniture," pp. 354–61; Carpenter, *Arts and Crafts*. For the most thorough review of this literature, see Gerald W. R. Ward, "'America's Contribution to Craftsmanship: The Exaltation and Interpretation of Newport Furniture,"

in *American Furniture*, vol. V, ed. Luke Beckerdite (Milwaukee: Chipstone Foundation, 1999), pp. 224–48.

30. For contemporary views on the role of "art" in national prosperity, see E. A. Johnson, *Predecessors of Adam Smith: The Growth of British Economic Thought* (New York: Prentice-Hall, 1957), pp. 259–77.

31. *Rhode Island Laws*, pp. 3, 4, 131, 151, 209; *Acts and Laws*, 1746, pp. 11, 13, 14, 24; 1747, p. 49; see also Daniels, *Dissent and Conformity*, pp. 76–90, 101–5; and Withey, *Urban Growth*, pp. 57–62. This cautionary attitude toward strangers is not unique to Newport; while the specific mechanisms for controlling access to voting status and to public charity differed from colony to colony, the principle was common to all.

32. *Acts and Laws*, p. 11; [Aplin], *Dialogue Between the Governor*.

33. Rudolph, "Eighteenth-Century Newport and Its Merchants II," 53–59; Charles Bowler, "An Address to the Gentlemen of the Colony of Rhode Island," April 28, 1757, mss. LO3494 Huntington Library, Art Galleries, and Gardens.

34. Rev. John Woodbridge of Killington, Connecticut, 1702, quoted in Bridenbaugh, *Fat Mutton*; p. 4. Daniels, *Dissent and Conformity*, pp. 3–8, 108–10; Downing and Scully, *Architectural Heritage*, p. 18.

35. Kaplan, "Jewish Merchants," pp. 12–29. The extent of participation in the Friends' Yearly Meeting of Rhode Island is graphically illustrated by John Alsop's manuscript map of 1782 identifying and charting distances between the 77 member meetings in New England (John Carter Brown Library, Brown University, Providence, R.I.). On the local level, the dates of the Yearly Meetings in the immediate vicinity of Newport (Rhode Island and Massachusetts) are included in the local almanac along with such other useful information as the value of coinage in European currencies, routes and ferries, and so forth (John Anderson, *Anderson Improved, Being an Almanack and Ephemeris,* 3 vols. [Newport: Solomon Southwick, 1772–1775]).

36. Richard H. Rudolph, "Eighteenth-Century Newport and Its Merchants I," *Newport History* 51, part 2, no. 170 (Spring 1978), p. 35; "A Club Formed by the Jews, 1761," *Newport Historical Magazine* 4 (July 1883), pp. 58–60; gaming was illegal until well into the century, but it seems to have been tolerated on a gentlemanly level (*Acts and Laws*, 1749, p. 69).

37. *Rhode Island Laws*, 1663–1730, pp. 50, 155, 170; *Acts and Laws* 1750, pp. 93–94.

38. Bartlett, *Records* (1862), p. 253; *Heads of Families at the First Census of the United States Taken in the Year 1790: Rhode Island* (Washington, D.C.: Government Printing Office, 1908), pp. 9, 19–23.

39. *Acts and Laws*, 1749, p. 68. Divorce was permissible if adultery had occurred or if one member had absented himself or herself seven years. An instance (in 1729) is recorded as notable news by John Comer: the differences between Sarah and John Brown of Providence evidently stemmed from "drink to excess" with the result that one party "left town" presumably for the requisite seven years (Comer, *Diary of John Comer*, pp. 81, 93).

40. Townsends married into the Cole, Easton, Goddard, Cornell, Barker, Weaver, and Taylor families.

41. John Osborne Austin, *The Genealogical Dictionary of Rhode Island; Comprising Three Generations of Settlers Who Came Before 1690* (Albany, N.Y.: J. Munsell's Sons, 1887), pp. 50–51.

42. Wendell Garrett, "The Goddard and Townsend Joiners of Newport: Random Biographical and Bibliographical Notes," *The Magazine Antiques* 121, no. 5 (May 1982), pp. 1153–55; Darold D. Wax, "Thomas Rogers and the Rhode Island Slave Trade," *American Neptune* 35, no. 4 (October 1975), pp. 289–301 at 298; Rudolph, "Eighteenth-Century Newport and Its Merchants II," p. 46; Rudolph, "Eighteenth-Century Newport and Its Merchants I," p. 31, Kaplan, "Jewish Merchants," p. 21.

43. Lawrence Stone, *The Family, Sex and Marriage in England, 1500–1800* (London: Weidenfeld and Nicolson, 1977). See also Peter Dobkin Hall, *The Organization of American Culture, 1700–1900: Private Institutions, Elites, and the Origins of American Nationality* (New York: NYU Press, 1984), pp. 38–39, 42–47, 60–68, 70–72 (his sources for this period, however, are unreliable). In eighteenth-century Newport, parental, sibling, and marriage linkages are noted almost exclusively on the tombstones of women and infants.

44. This practice suggests a woman marrying "down" or, conversely, her husband marrying "up" to advantages he did not have in his family of origin. This tendency in medieval marriages is noted by Georges Duby, *The Knight, the Lady and the Priest*, trans. Barbara Bray (New York: Pantheon, 1983).

45. Joseph K. Ott, "Lesser-Known Rhode Island Cabinetmakers: The Carliles, Holmes Weaver, Judson Blake, the Rawsons, and Thomas Davenport," *The Magazine Antiques* 121, no. 5 (May 1982), pp. 1156–63 at 1161; Ethel Hall Bjerkoe, *The Cabinetmakers of America* (New York: Doubleday, 1957), p. 176; Henry Ayrault, Account Ledger, 1736–1743, folio 10 ff, ms 361, Newport Historical Society (hereafter cited as NHS).

46. Receipt for goods bought in 1765 by Thomas Vernon from Edmund Townsend: "Received the Contents in full for my Master Edmd. Townsend/ James Goddard" (NHS).

47. Garrett, "Goddard Townsend Joiners," pp. 1153–55.

48. John Cahoone, ledger, 1749–1760, ms 78 (NHS), analyzed by Vibert, "Market Economy," pp. 1–75; Charles F. Montgomery, *American Furniture: The Federal Period in the Henry Francis du Pont Winterthur Museum* (New York: Viking, 1966), pp. 19–26; Martin Eli Weil, "A Cabinetmaker's Price Book," *American Furniture and Its Makers: Winterthur Portfolio* 13, ed. Ian M. G. Quimby (Chicago: University of Chicago Press, 1979), pp. 175–92; see also Burges, "Spirit of Independence."

49. Of the seven journeymen who worked for John Cahoone between 1749 and 1760, for instance, three became independent taxpaying cabinetmakers, two appear to have remained in Newport as journeymen wage earners at least until 1770, and two apparently left town (Vibert, "Market Economy," p. 36).

50. Montgomery, *American Furniture*, p. 19. Some scholars, such as Gary Nash, have termed this a transition from "a paternalistic labor system" to a "free labor system," but the ameliorative, evolutionary model inherent in these terms glosses over multiple complexities and difficulties (see Gary Nash, *The Urban Crucible: Social Change, Political Consciousness and the Origins of the American Revolution* [Cambridge, Mass.: Harvard University Press, 1979], pp. 258–60).

51. The aptest example of price fixing by the masters is the Providence agreement of February 19, 1756 (Crawford Papers, Rhode Island Historical Society), printed in *The John Brown House Loan Exhibition of Rhode Island Furniture* (Providence: Rhode Island Historical Society, 1965), pp. 174–75.

52. Margaretta M. Lovell, "Boston Blockfront Furniture," in *Boston Furniture of the*

Eighteenth Century, ed. Walter Muir Whitehall (Boston: Colonial Society of Massachusetts, 1975), pp. 77–135; Morrison H. Heckscher, "John Townsend's Block-and-Shell Furniture," *The Magazine Antiques* 121, no. 5 (May 1982), pp. 1144–52; Liza Moses and Michael Moses, "Authenticating John Townsend's and John Goddard's Queen Anne and Chippendale Tables," *The Magazine Antiques* 121, no. 5 (May 1982), pp. 1130–43; Moses, *Master Craftsmen,* pp. 1–344. Bernard Berenson (1865–1959) established the principles of connoisseurship and the authentication of masterworks in published lists that have been particularly useful in the market.

53. Cahoone, Ledger Book, pp. 28, 35, 37, 69, 85; Job Townsend, Ledger Book, pp. 1, 2 ms. 504, NHS; "OG" might also refer to the line of the pediment; however, Cahoone elsewhere in this ledger seems to use the term "OG Head" to describe an S-curved pediment (p. 78).

54. Adam Smith, *The Wealth of Nations,* book IV, "Of Systems of Political Economy," reprinted in Robert L. Heilbroner, ed., *The Essential Adam Smith,* pp. 258–90 (New York: W. W. Norton, 1986), p. 284.

55. Pride as the rationale for labeling is given in Heckscher, "John Townsend," p. 150; and Brock Jobe and Myra Kaye, *New England Furniture: The Colonial Era: Selections from the Society for the Preservation of New England Antiquities* (Boston: Houghton Mifflin, 1984), p. 33.

56. Rhode Island State Archives, Providence, quoted in Vibert, "Market Economy," p. 24.

57. Newport characteristics are charted, for instance, in Carpenter, *Arts and Crafts,* pp. 21–23; Lovell, "Boston Blockfront Furniture" pp. 79–94; and Wendy Cooper, *In Praise of America: American Decorative Arts, 1650–1830* (New York: Knopf, 1980), pp. 156–209.

58. When a tax on shipping was instituted to maintain the lighthouse on Beavertail, "vessels as shall import Spars, Planks and Boards, from the Province of New Hampshire" were explicitly exempted, presumably as an encouragement to the importation of lumber (*Acts and Laws,* pp. 66, 67). That part of the island was still forested in the eighteenth century is evident from legislation forbidding "firing [burning] the Woods" on the island near the city "at unseasonable times of the Year" resulting in damage to hay, fencing, etc. (*RI Laws and Statutes,* 1704: pp. 51–52; 1722: p. 127; *Acts and Laws,* 1751: pp. 98–99). These were evidently patchy second-growth copses not useful for lumber periodically cleared of underbrush by fire. On the export of lumber from Rhode Island, see also Joseph K. Ott, "Rhode Island Furniture Exports, 1783–1800, Including Information on Chaises, Buildings, Other Woodware and Trade Practices," *Rhode Island History* 36 no. 1 (February 1977), pp. 3–13 at 7. That much of this export lumber was casual cargo is suggested by such requests as a Norwich merchant made of his Newport associate concerning his schooner: "to fill her up [over the principal cargo of flour and rum] I wish you to procure as many Pine Boards as Capt. Pierce judges he can take." Christopher Champlin Papers, 1777–1790, ms HM41781, Huntington Library, Art Galleries, and Botanical Gardens.

59. John T. Kirk, *American Chairs: Queen Anne and Chippendale* (New York: Knopf, 1972), pp. 195–98.

60. Charles F. Montgomery, "Regional Preferences and Characteristics in American Decorative Arts: 1750–1800," in *American Art: 1750–1800, Towards Independence,* ed.

Charles F. Montgomery and Patricia E. Kane (Boston: New York Graphic Society, 1976), pp. 50–65.

61. William Hogarth, *The Analysis of Beauty: Written with a View of Fixing the Fluctuating Ideas of Taste* (London: J. Reeve, 1753).

62. McKendrick, "Commercialization," pp. 1–99; Dwight E. Robinson, "The Importance of Fashions in Taste to Business History: An Introductory Essay," *Business History Review* 37, nos. 1–2 (Spring–Summer 1963), pp. 5–36.

63. David Hume, "Of the Standards of Taste," in *Essays Moral, Political and Literary*, ed. Eugene F. Miller (Indianapolis: Liberty Classics, 1985), pp. 226–49.

64. Carpenter, *Arts and Crafts*, p. 199; census 1774, in Bartlett *Records* (1862), p. 34. For a detailed analysis of the accounts of one contemporary household and shop, see Louise Lippincott, *Selling Art in Georgian London: The Rise of Arthur Pond* (New Haven: Yale University Press, 1983), pp. 75–159.

65. Downing and Scully, *Architectural Heritage*, pls. 7, 95; Christopher Townsend's shop measures 12′ × 24′ (Jobe and Kaye, *New England Furniture*, p. 7); another only 8′ × 16′ (1782 damage claim by Mary Mumford [Rhode Island State Archives]); and that of Constant Bailey was described as "one Joyner's shop 16 foot by 22 a storey and half with three Joyner's Benches" in his damage claim of 1782 (Rhode Island State Archives).

66. Philip Zea, "Construction Methods and Materials," in Jobe and Kaye, *New England Furniture*, pp. 73–100 at 94–95.

67. Both Job and Christopher Townsend purchased brasses at least once a week: Aaron Lopez, Account Book, ms. 476 (NHS); Henry Ayrault, Account Ledger, 1736–1743, ms. 361 (NHS). As chairs usually did not use brass hardware, nor did tables without hinged leaves, their production is not visible in these accounts. Other documents of suppliers of hardware include Thomas Richardson, Petty Account Book, ms. 487 (NHS); John Bannister and George Minot, Ledger, 1727–28 ms. 368 (NHS); and the Day book, 1733–34 of an unknown retailer misidentified as Solomon Townsend, ms. 703 (NHS). These hardware importers were supplying ship owners and large landowners, but their primary business was with the town's woodworkers—shipwrights, gunsmiths, housewrights, and coopers as well as furniture craftsmen.

68. Garrett, "Goddard and Townsend Joiners," p. 1154. The will is dated June 30, 1785.

69. Ezra Stiles, 1776, Letters vol. IV, p. 219, Ezra Stiles Papers, Beinecke Library, Yale University. Thinking perhaps the sentiment too vernacular, Stiles crossed out the last twelve words of this paragraph.

70. Robert Trent, "New England Joinery and Turning Before 1700," in Fairbanks and Trent, *New England Begins*, vol. 3, pp. 501–10; Zea, "Construction Methods."

71. Austin, *Genealogical Dictionary*, pp. 50–51, 236, 239; *A Memorial of John, Henry, and Richard Townsend and Their Descendants* (New York: W. A. Townsend, 1865), pp. 92, 120–22; Waldron Phoenix Belknap, Jr., *American Colonial Painting: Materials for a History* (Cambridge, Mass.: Belknap Press of Harvard University Press, 1959), p. 11; Benjamin Thompson, *History of Long Island, Containing an Account of the Discovery and Settlement; with Other Important and Interesting Matters to the Present Time* (New York: E. French, 1839), pp. 495–96.

72. Austin, *Genealogical Dictionary*, p. 239; Belknap, *American Colonial Painting*,

p. 11. Thomas is spoken of as "Captain," Sherrif of Newport, when he is accused in 1698 of allegedly permitting a pirate to escape (John Russell Bartlett, *Records of the Colony of Rhode Island and Providence Plantation 1678 to 1706* [Providence, 1858], pp. 312, 333). Thomas's son from a former marriage, John, married his wife's niece, Rebecca Almy, and his nephew Solomon married his stepdaughter Catherine Almy.

73. It was a quadruple alliance, in fact, because Solomon's brother James married Catherine's sister Audrey, but they resided in Oyster Bay on Long Island (Belknap, *American Colonial Painting*, p. 11; *Townsend Memorial* p. 94).

74. These woodworkers were in the Massachusetts branch of the Townsend family: Robert (c. 1695–) and James (c. 1640–). Clifford K. Shipton, ed., *Sibley's Harvard Graduates* (Cambridge, Mass,: Charles William Sever, 1873) , vol. 4, p. 143; Homer Worthington Brainard, *Some Lines of the Townshend-Townsend Families of Old England, New England and Minnesota* (n.p., 1931); among the Coles of Swansey, Mass. (near Newport), John and Ebenezer were joiners, and James a housewright in the early eighteenth century.

75. Jobe and Kaye, *New England Furniture*, p. 351; Austin, *Genealogical Dictionary*, p. 236; Job Townsend Ledger Book, p.2.

76. William Davis Miller, *The Silversmiths of Little Rest, Rhode Island* (Kingston, R.I.: D. B. Updike, 1928), pp. 3–4. Miller points out that Samuel Casey's economic prowess was fueled by currency counterfeiting as well as by silversmithing.

77. Adam Smith, introduction to *Wealth of Nations*, Book I, Part II, in Heilbroner, ed., *The Essential Adam Smith* (New York: W. W. Norton, 1986), p. 223.

78. Austin, *Genealogical Dictionary*, pp. 292–95.

79. Austin, *Genealogical Dictionary*, pp. 292–95, Downing and Scully, *Architectural Heritage*, pp. 47; 64; Cahoone, *Visit*, pp. 98–99.

80. Austin, *Genealogical Dictionary*, pp. 292–95; H. Ayrault, Ledger, folios 94, 100 (1738); Charles Wigneron, physician, Ledger, 1725–26, ms. 520 (NHS).

81. Austin, *Genealogical Dictionary*, pp. 292–95; James N. Arnold [comp.], *Vital Record of Rhode Island, 1636–1850* (Providence: Narragansett Historical Publishing, 1895), vol. 7, p. 100.

82. Bjerkoe, *Cabinetmakers*, p. 213.

83. Quaker Records, Newport, 1767; Garrett, "Goddard and Townsend Joiners," p. 1158.

84. Lists of witnesses of the marriages of Hannah Townsend and John Goddard in 1746, of Susannah Townsend and James Goddard in 1750, and of Job Townsend, Jr., and Deborah Taylor in 1753 are recorded in Waldo C. Sprague [comp.], *Vital Records of Newport, Rhode Island* (Wollaston, Mass.: 1953), pp. 207, 217–18, 235.

85. Job Townsend (1726–1778), Ledger and Daybook, ms. 504 (NHS). For a transcription of the Ledger (1750–1760) and Daybook (1760–1762) of Job Townsend, Jr., see Martha H. Willoughby, "The Accounts of Job Townsend, Jr.," in *American Furniture*, vol. V, ed. Luke Beckerdite (Milwaukee: Chipstone Foundation, 1999), pp. 109–61.

86. Stiles, Letters, vol. IV, December 23, 1766, p. 219.

87. Cahoone, Ledger, 1749–1760, pp. 11–75; the cabinetmakers working for him included Job Clark (91 case pieces, 1 table, 1 bedstead); Benjamin Tayre (30 case pieces); Jonathan Brier (11 case pieces); Jonathan Swett (5 case pieces); and Moses Norman (1 case piece).

88. Vibert, "Market Economy," pp. 30–37, 50, 52. The ledger does not include cash sales, which probably constituted about 25 percent of his business.

89. Cahoone, Ledger, p. 68; John Banister, Letter Book, 1739–1746, 1739, p. 202, ms. 525 (NHS).

90. Richard Whitehorne, hatter, Cahoone Ledger, p. 16; Bannister, Letter Book, 1740, p. 234; John Stoneman, scrivener, paid Cahoone "By Writing," Cahoone, Ledger, p. 72.

91. Cahoone, Ledger, pp. 22, 26, 27, 36, 76, 63.

92. Cahoone, Ledger, p. 36.

93. Cahoone, Ledger, p. 26.

94. Prices are difficult to compare because of summary descriptions of objects, inflation over the course of the decade, and the incomplete shift from old tenor to new tenor in 1740 at an exchange rate of £1/0/0 old tenor = £0/0/9 new tenor; 0/0/8 new tenor (also termed Lawful Money) = 0/0/6 English money (sterling) = 1 pwt 22 9/20 gr silver (values established 1763 and published in Anderson, *Almanack*, 1775). Cahoone sold Metcalf Bowler a mahogany table for £12 in 1752 (Cahoone, Ledger, p. 26), the same year Job Townsend sold Samuel Casey a mahogany table for £12/10/0 (J. Townsend, Ledger, p. 2), suggesting a rough equivalent of cost and quality.

95. See Vibert, "Market Economy," p. 45.

96. Stiles, "Journals and Memoirs," 1760–1762 vol. 7, pp. 124–27 (Ezra Stiles Papers, Beinecke Library, Yale University).

97. Joseph Belcher witnessed the marriage in 1750 of James Goddard and Susannah Townsend (Sprague, *Vital Records*, p. 218) and in 1755 purchased a mahogany table for £28 from John Cahoone (Cahoone, Ledger, p. 54); Stephen Ayrault, one of Newport's wealthiest merchants, purchased, in partnership with Phillip Wilkerson, 10 items for export from Cahoone in 1755 (Cahoone Ledger, p. 47), and in 1766 he bought 6 chairs from Job E. Townsend (Bjorke, *Cabinetmakers*, p. 216); Joseph Proud, an English-born Quaker chairmaker (Joseph K. Ott, "Abraham Redwood's Chairs?" *The Magazine Antiques* 119, no. 3 [March 1981], p. 672), attended the wedding in 1746 of John Goddard and Hannah Townsend, and, in 1757 bought from Cahoone "a Case of Black Walnutt Drawers, OG Head £95" (Cahoone, Ledger, p. 73). In the Job Townsend Account book for the 1750–1759 period, only two customers, Capt. George Hunt and Capt. John Collins, also appear in Cahoone's customer list. Among the craftsmen, Constant Bailey chartered a sloop with Cahoone (his coreligionist) in 1749 to export furniture wares to North Carolina and in 1752 exchanged a set of furniture legs for mahogany and chestnut boards with Job Townsend.

98. A. P. Newton, ed., *Calendar of State Papers, Colonial Series, America and the West Indies, 1734–35* (London, 1953), item 20, as quoted in Barry A. Greenlaw, *New England Furniture at Williamsburg* (Williamsburg, Va.: Colonial Williamsburg Foundation, 1974), p. 1.

99. Receipt, 1746 (NHS); Christopher Townsend to Jonathan Holmes, Middletown, N.J., 1770 (private collection, facsimile, Winterthur Museum Library, Ph-226). The original Townsend brothers were patentees, along with two Holmes brothers of a large tract of land in Monmouth County, N.J., a century before (Comer, *Diary*, p. 118); Abraham Redwood, Letter Book, ms. 644, vol. 1, p. 55, NHS; Aaron Lopez, Account Books, ms. 201, p. 9, ms. 476, n.p., ms. 555, p. 114, ms. 560, n.p., ms. 556, p. 114, ms. 710,

pp. 12, 95, ms. 718, pp. 35, 946, ms. 0, pp. 7, 259, 260, NHS. Of these four Townsend patrons, Holmes and Redwood were relations.

100. Redwood, Letter Book, vol. l, p. 55. The confusion of currency exchange suggested by the equivalents noted here and always taken back to silver by weight is typical of international mercantile exchanges in the eighteenth century. The Newport *Almanack* not only gave the tides, phases of the moon, weather prediction, public election dates, court sittings, religious holidays, receipts for remedies for common ailments, routes to nearby towns, and Friends Yearly Meetings but also gave a detailed table of currency exchange for English, Spanish, Portuguese, and other coins (Anderson, *Almanack*).

101. Charter Party Agreement, 1749, ms. box 112, folder 22, NHS.

102. Lopez purchased from John Townsend, John Goddard, Edmund Townsend, Samuel Vinson, George Weeden, Charles Wigneron, Constant Bailey, William Davis, Benjamin Pabodie, and Benjamin Tayer (Aaron Lopez Account Books [NHS ms. 201, 476, 555, 560, 781, and O], Ledger [NHS ms. 560], Memorandum Book [NHS ms. 710], and Letter Book [NHS ms. 655]).

103. Josiah Blakely to Aaron Lopez 1779–80, Business Correspondence, Christopher Champlin Papers, ms. m41767, Huntington Library, Art Galleries, and Botanical Gardens; Kaplan, "Jewish Merchants," pp. 16, 18–25; Platt, "Triangles and Tramping," pp. 294–303.

104. Kaplan, "Jewish Merchants," pp. 19, 21, 24.

105. Lopez, Account Book, ms. 476, NHS.

106. Stiles, Itinerary, vol. 3, p. 591.

107. Receipts: 43–79 (John Townsend, 1769), 43–83 (Pitman, 1769), 43–84 (Vinson, 1771), 43–80 (Vinson, 1773), 43–91 (Thomas Townsend, 1781); John Banister, Account Book, no. 386 p. 7, 1750, NHS; Ott, "Rhode Island Furniture Exports," p. 3.

108. Both Banister's and Lopez's estates are marked on Charles Blaskowitz, *A Topographical Chart of the Bay of Narraganset [and] . . . Rhode Island* (London: Wm. Faden, 1777); Cahoone, *Visit,* p. 184.

109. Vibert, "Market Economy," pp. 19–21.

110. In the nineteenth century, it was these New York City and West Indies markets that were remembered: "All the cabinetmakers in Bridge and Washington Streets, employed a large number of hands, manufacturing furniture, for which a ready market was found in New York and the West Indies. The stores of David Huntington and Benjamin Baker were also on the Point; both these men were extensively engaged in manufacturing furniture, which they shipped to New York, and the West Indies Benjamin Peabody, cabinetmeker who carried on a large trade with Surinam . . . was an ingenius man" (Thomas Hornsby, "Newport, Past and Present," *Newport Daily Advertizer,* December 8, 1849, p. 2, col. 1, as quoted in Vibert, "Market Economy," p. 25).

111. *Charter of the Fellowship Club* [Marine Society], *instituted at Newport Dec. 5 AD 1752 and Incorporated* . . . (Newport: Wm. and J. H. Barber, 1819), Sept. 5, 1758 and July 5, 1796; Carpenter, *Arts and Crafts,* p. 13, Ott, "Furniture Exports" p. 10; unknown author, Date Book, ms. 703, p. 46, NHS; Ott, "Lesser-Known Cabinetmakers," p. 1161; Stiles, Journal, vol. 1, p. 163; see also Vibert, "Market Economy," pp. 39–40.

112. Ott has determined that in other areas, by contrast, such as Providence, cabinetmakers did not actively trade abroad, but worked entirely through merchant middlemen (Ott, "Furniture Exports," p. 10). Newport also "exported" training as we find in the case

of Thomas White, a Quaker native of Virginia who was present at the 1750 wedding of James Goddard and Susannah Townsend in Newport, and subsequently established a cabinetmaking business in North Carolina, producing objects with "Newport" fabrication and design characteristics (Sprague, *Vital Records,* p. 218; John Bivens, "Rhode Island Influence in the Work of Two North Carolina Cabinetmakers," in *American Furniture* vol. V, ed. Luke Beckerdite (Milwaukee: Chipstone Foundation, 1999), pp. 78–108.

113. While reports indicate that West Indian nabobs lived in great elegance, it is also clear that the rich goods that constituted their material world were entirely imported, there being virtually no local artisans of luxury goods; this phenomenon was attributed in such remarks as Robert Poole's "few white People [are] employed about any Sort of laborious Work" to the institution of slavery (Robert Poole, *The Beneficent Bee; or Traveller's Companion* [London: E. Duncomb, 1753], p. 215; see also Schaw, *Journal,* p. 123).

114. Schaw, *Journal,* pp. 136–37.

115. Ott, "Furniture Exports," p. 10.

116. Ott, "Furniture Exports," pp. 10–11; Garrett, "Goddard and Townsend Joiners," pp. 1153–55; George Gibbs Channing, *Early Recollections of Newport, R.I. from the Year 1793 to 1811* (Newport: A. J. Ward; Charles E. Hammett, Jr., 1868), p. 151.

117. Bjorke, *Cabinetmakers,* p. 107; Jobe and Kaye, *New England Furniture,* p. 13.

118. Nathaniel Greene, outside Newport, to John Sullivan, August 23, 1778 (ms. GR203 Huntington Library, Art Galleries, and Botanical Gardens); census, 1774, in Bartlett, *Records,* 1862, p. 299. The speed with which half the populace of the town fled is suggested by this excerpt from a damage claim filed after the war's conclusion by one cabinetmaker: "we lost all our close [clothes] . . . [except] that what we had on when we Left home and that was when the fleet was Coming in the harbor" (Jonathan Cahoone, Rhode Island State Archives; facsimile Winterthur Museum Library, document Ph-424); Bridenbaugh, *Cities in Revolt,* p. 216. In 1800, the population of Newport was 6,999; sixty years after the British occupation the city still had not recovered its prewar population (Cahoone, *Visit,* p. 36, Withey, *Urban Growth,* p. 115). New York, which was similarly occupied, fared better than Newport because the devastation of war and occupation was somewhat offset by the city's role as the continent's center for British and loyalist privateers and their prizes.

119. Unknown author, Notebook of Events, 1778–1781 (ms. HM1587, Huntington Library, Art Galleries, and Botanical Gardens), n.p.; Cahoone, *Visit,* pp. 23–24.

120. Joshua Bradley, "A Funeral Sermon on the Death of Paul Mumford [b. 1734] who Departed this Life July 20, 1805 in the 72 year of his Age" (Newport: Oliver Farnsworth, 1805), p. 24.

121. Tristam Burges, *The Spirit of Independence: An Oration Delivered Before the Providence Association of Mechanics and Manufacturers at Their Annual Election April 14, 1800* (Providence: B. Wheeler, 1800), p. 9.

Conclusion

1. Charles Harrison, "The Effects of Landscape," pp. 203–39, in *Landscape and Power,* ed. W. J. T. Mitchell (Chicago: University of Chicago Press, 1994), p. 212.

2. William Faulkner, *Requiem for a Nun,* act 1, scene 3.

INDEX

*References to figure and plate numbers are printed in **boldface** type*

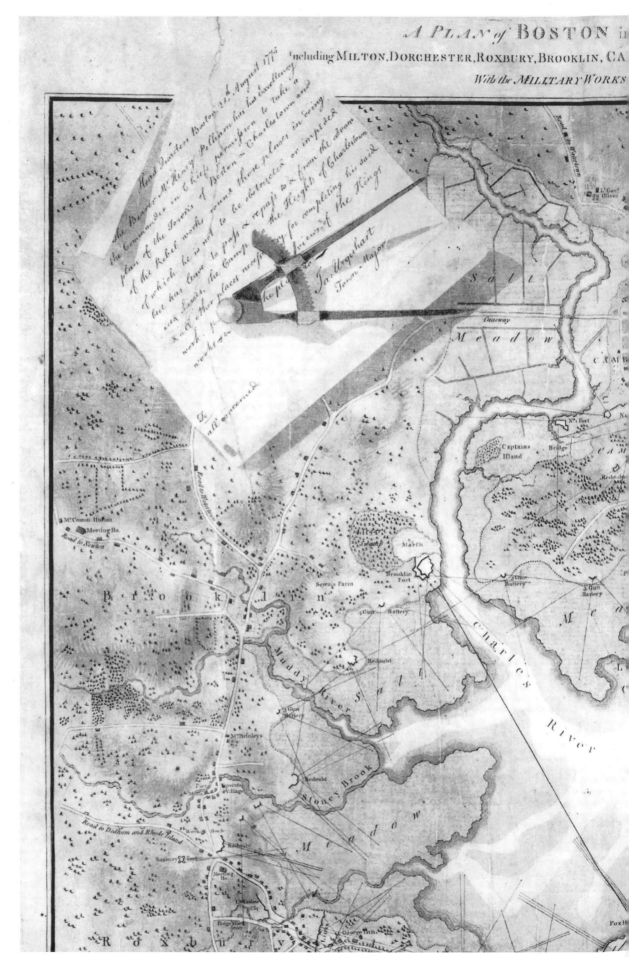

Head Quarters Boston 23rd August 1775
The Bearer Mr Henry Pelham has his Excellency
the Commander in Chief permission to take a
plan of the Towns of Boston - Charlestown and
of the Rebel works round those places in being
to which he is not to be obstructed or impeded
but has leave to pass & repass to & from the town
& to other places necessary for completing his said
work.
Jas Urquhart Town Major

Road to Watertown

Salt

Causway

Meadow

CAMB

De... all appointed

Road to Watertown

No 1 Fort

Na

Captains Island

Bridge

CAM

Redoubt

McConn Husain

Meeting Ho.

Road to Newton

Marsh

Brooklin Fort

Gun Battery

Gun Battery

B r o o k l i n

Sewals Farm

Gun Battery

M e a

Charles

4 Gun Battery

Muddy River

S a l t

Redoubt

Gun Battery

McBrinleys

River

Redoubt

Stoney Brook

Village

Road to Dedham and Rhode Island

M e a d o w

Redoubt

Roxbury Fort

Meeting Ho.

R o x b u r y

George Inn

Fox I...